FIRST IMPRESSIONS

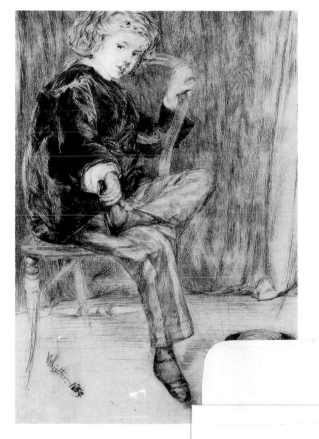

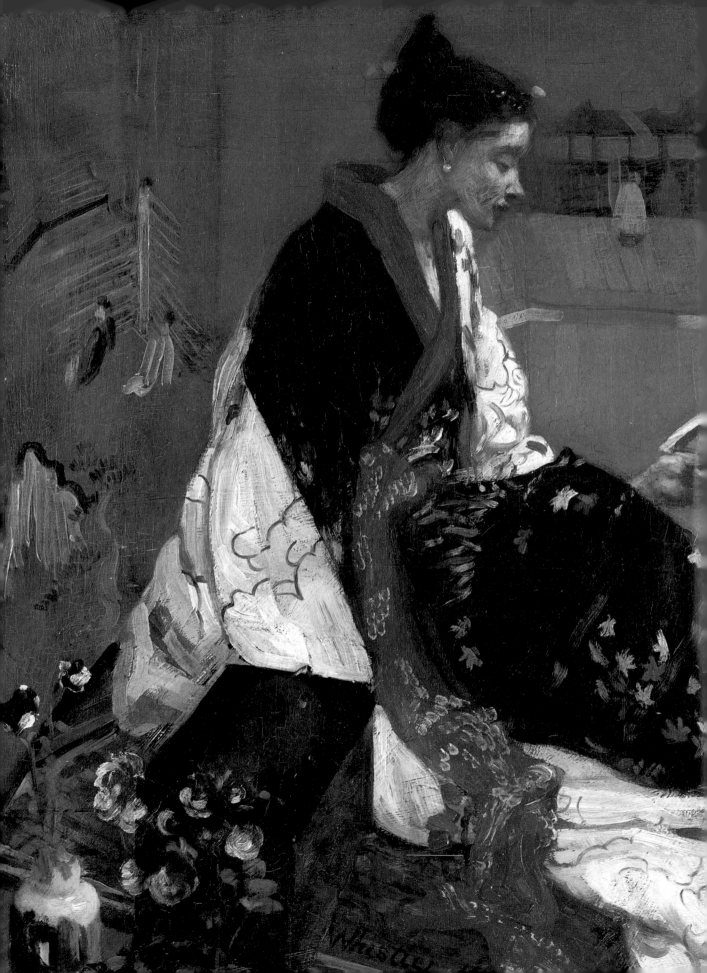

First Impressions

JAMES McNEIL WHISTLER

Avis Berman

HARRY N. ABRAMS, INC., PUBLISHERS

FOR MY PARENTS

SERIES EDITOR: Robert Morton
EDITOR: Christine Liotta
DESIGNER: Joan Lockhart
PHOTO RESEARCH: Catherine Ruello

Library of Congress Cataloging-in-Publication Data

Berman, Avis.
James McNeill Whistler / Avis Berman.
p cm. — (First Impressions)
Includes index.
Summary: A biography of the nineteenth-century American artist who spent
most of his life in Europe and is known for his flamboyant personality, as
well as his innovative painting and printmaking techniques and famous
portrait of his mother.
ISBN 0—8109—3968—1
1. Whistler, James McNeill, 1834—1903—Criticism and interpretation—
Juvenile literature. [1. Whistler, James McNeill, 1834—1903. 2. Artists.]
I. Title. II. Series.
N6537.W4B47 1993
760'. 092—dc20
[B] 93—9453
 CIP
 AC

Printed and bound in Hong Kong

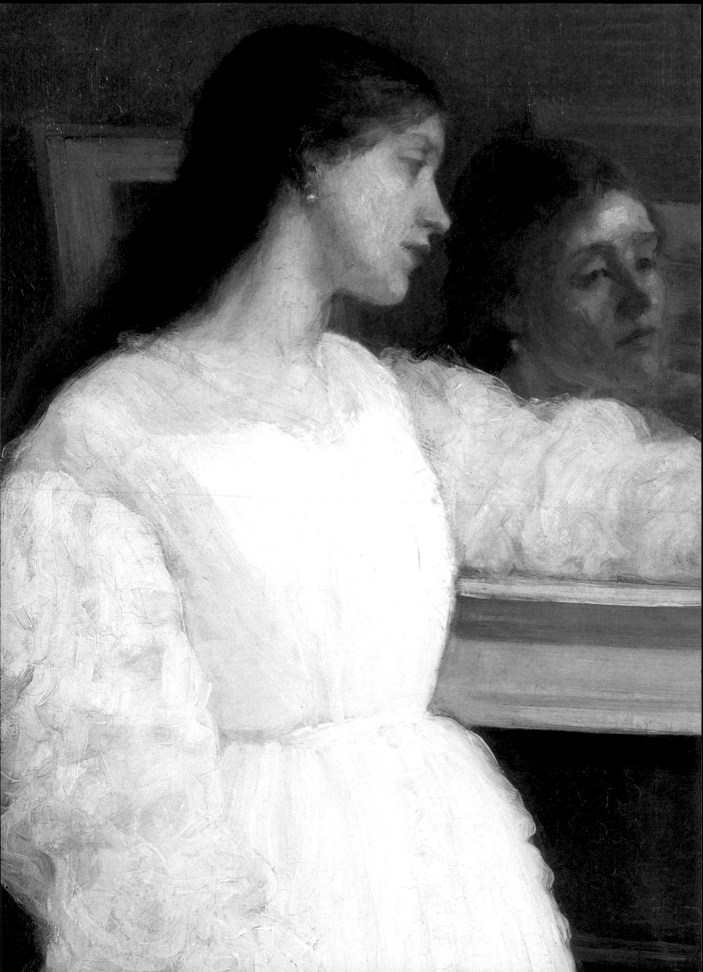

1

"I WISH TO BE A PAINTER"

When it came to the question of where he was born, James Whistler used his imagination. He was famously casual about his birthplace, feeling that an artist could be born wherever he chose. Most often, he chose Baltimore, Maryland, or St. Petersburg, the imperial capital of Russia. Yet Whistler was prepared when a snobbish society woman turned up her nose at his real place of birth in Lowell, Massachusetts. "Whatever possessed you to be born in a place like that?" she asked. "The explanation is quite simple," replied Whistler. "I wished to be near my mother."

Whistler's fibs and jokes about his origins illustrate a larger belief that is reflected in his work as well. He felt that a painting should show no signs of sweat or toil. The final result should look effortless — a harmonious arrangement of color, line, and form that produces an effect of mystery and grace. In his words, "A picture is finished when all trace of the means used to bring about the end has disappeared."

The idea that an artist should be judged on how well he responds to and transforms the world around him, and not on how long it takes him to do it, is never questioned today. But it was shocking and revolutionary in the England of Queen Victoria, where Whistler lived for most of his adult life. A canvas was supposed to tell a story, preferably one that drove home a moral. A painter who

SYMPHONY IN WHITE, NO. 2: THE LITTLE WHITE GIRL. *(Detail)* 1864

7

didn't fill a canvas with sermons and details was considered sloppy and untrained, and was often accused of shirking his duty.

But Whistler didn't bow to popular taste. He knew that we don't notice every hair on a person's head or every leaf on a tree. He chose subjects that English artists ignored, like the mood and atmosphere of London close by the river Thames. Studying the city's thick, swirling fogs, its buildings enveloped in mist, and the onset of twilight on the Thames, Whistler developed his own style, which was stripped of fuss and minutiae. For this he was scorned, and many of his most important works went unsold for years.

In life, too, Whistler sought to erase or blur details and to present what was left as he saw fit. While he was creating memorable portraits, seascapes, and city scenes, Whistler was also making himself into a celebrity. Turned out in a white suit, a wide-brimmed hat, and square-toed patent leather pumps, he sauntered down the streets of London and Paris, a monocle fixed in his right eye and his long cane rapping the pavement. Calling on friends and stopping by the shops and cafés, Whistler gave the impression that spending long hours in the studio was the furthest thing from his mind. But this was the public man. In private, he worked hard and took immense pains with his art.

Whistler loved publicity, and took pride in his scathing wit, which he was never afraid to use. Not even his paying clients were spared. A sitter who was angry about his portrait said to Whistler, "Do you consider *that* a great work of art?" Whistler immediately shot back, "Do you consider yourself a great work of nature?"

Whistler's outrageous behavior irritated the English art world even more than his strange, "unfinished" canvases did. Artists and critics thought that the pictures were a fraud and that the man was a fool, but Whistler refused to change. He stood up for his art in the studio, in the press, and even in the courtroom. Some of these feuds were silly and unnecessary, but there is no doubt that James Whistler was a daring and original artist. He was the first American painter to embrace what we now recognize as modern notions of space, form, and content.

Whistler's approach to painting, which is *suggestive* rather than *descriptive*, and his plea that works of art should be judged for their visual qualities, pointed the way toward the twentieth century.

Regardless of what he would say later, James Whistler was born on July 11, 1834, in Lowell, Massachusetts, the first child of Anna Mathilda McNeill and George Washington Whistler. Mr. Whistler's first wife had died in 1827, leaving him with three children—George, Joseph, and Deborah—whom Anna raised as her own. Within a few years of James's birth, four more boys were born: William, Kirk, Charles, and John.

James Whistler's grandfather on his father's side, John Whistler, was a professional soldier. He had fought in the American Revolution and the War of 1812, and helped to establish Fort Dearborn, which later became the city of Chicago. John Whistler and his wife had fifteen children, including George Washington Whistler, who was born in

SYMPHONY IN WHITE, NO. 2: THE LITTLE WHITE GIRL. *1864 Whistler believed that art should suggest, not tell. The young woman seems lost in thought, but what she is thinking about is not disclosed.*

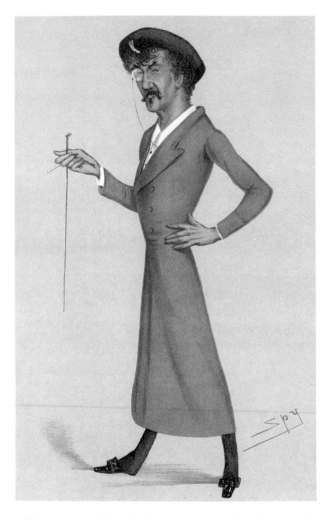

A SYMPHONY. *1878*
*This caricature by Leslie
Ward (known as "Spy")
vividly shows Whistler as the
world knew him. The artist
liked the image because it
made him look tall and
accentuated his trim waist.*

1800. Like his father, George also intended to be a soldier, and at the age of fourteen, he was appointed to the United States Military Academy at West Point, New York. The academy had been established during the presidency of Thomas Jefferson to teach young men the science of war and to develop a corps of officers. At school, George proved to be a talented draftsman, standing first in his class in drawing. This was a highly prized skill, for officers were expected to be able to draw accurate maps. When George graduated in 1819 with a rank of second lieutenant, the United States was at peace and not in need of officers. But since officers had to understand how artillery and other machines worked, as well as how to build fortifications, West Point trained its cadets in engineering. America was expanding westward, and George could see that qualified engineers like himself would be needed to design roads, bridges, and canals.

On his mother's side, James Whistler was descended from the McNeills, a Scottish family who arrived in the colonies in the eighteenth century and settled

in North Carolina. Anna McNeill's brother, William Gibbs McNeill, was a cadet at West Point at the same time as George Whistler and the two became friends. By the late 1820s, both George and William were experienced civil engineers who were learning how to plan and construct railroad lines. They were working for the Baltimore and Ohio Railroad, and the McNeill family moved to Maryland to be near William. George Whistler, now a widower with three small children, noticed Anna McNeill. George's career in railroads meant frequent changes of address because he had to go where the work was. George and Anna were separated, but wrote to each other for several years. They were married in 1831.

In 1834, Anna, George, and his three children moved to Lowell, a new town northeast of Boston that was created for the purpose of manufacturing cloth. In the mid-1820s, rows of red-brick cotton mills were built, and hundreds of workers were hired to run the looms, which turned out yards of cotton faster than anyone in America had ever seen. Lowell was not a genteel town—it existed for the purpose of making money. This may be why James Whistler, who would pride himself on being a gentleman, avoided being associated with it. In fact, it was because fortunes were made in Lowell that James came to be born there. The town needed a railroad that would transport people and goods to and from Boston. George Whistler was hired to be in charge of building it, and when the family arrived, Anna was pregnant.

Soon after James was born, the railroad line between Lowell and Boston was finished and the Whistlers moved several more times until 1840, when George Whistler was offered the greatest commission of his life. Czar Nicholas I, the emperor of Russia, realized that his country would benefit enormously if its vast distances could be traversed by rail. In 1839 and 1840, his agents toured America and England, inspecting railroad engines and tracks. They also were looking for men who could take charge of such a colossal task. The Czar had in mind a line that would stretch across Russia from Europe to Asia. The first link in this chain would be a railroad that connected Russia's two greatest cities, Moscow and St. Petersburg. This undertaking would require 420 miles of track, 200

bridges, and 70 aqueducts. The Czar's scouts recommended that George Whistler be hired for the job. In 1842 Czar Nicholas invited George Whistler to become chief consulting engineer for the St. Petersburg—Moscow railway. George accepted, and left for Russia in August of 1842.

His family followed him a year later. The departure was very painful for Anna because two of the boys, Joseph and Kirk, had died, and George Jr., the eldest son, now in his twenties, wanted to stay in America. After visiting her relatives in England, Anna and the four younger children went by sea to Hamburg, Germany, and then traveled eastward by carriage throughout the night. The Whistlers took ship for St. Petersburg, but tragedy struck again. Charles, who was two, fell sick and died during the voyage. From then on, Anna was always worried about the health of her children, especially Jimmie, who was more delicate than the others.

FLOWER MARKET, DIEPPE. *1885*

Whistler learned how to summarize an entire scene or mood in a few brushstrokes.

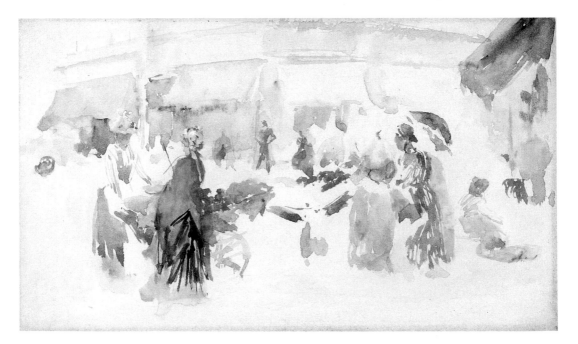

When they sailed up the Neva River and landed in St. Petersburg on September 28, 1843, the boys exclaimed over the gilded spires and domes of the Russian churches they saw from the dock. The Whistler family now consisted of Anna and three children: Deborah, who was eighteen, Jimmie, who was nine, and William (nicknamed Willie), who was seven. All Anna could think about was breaking the terrible news of Charles's death to her husband.

In St. Petersburg, life was glamorous and strange for the newcomers. George Whistler was paid $12,000 a year, and the family lived well. They had a large house with servants in the best district, but to get fresh milk, they had to keep a cow in the yard. As the Czar lived in St. Petersburg, there was a party or a concert or an opera nearly every night. Special events were marked by dazzling displays of fireworks. As day slipped into evening, the ladies of the court, dressed in the latest silks and satins from Paris, twinkled like ornaments in their carriages. Even the long Russian winters were a source of joy for Jimmie and Willie, who ice skated on the Neva nearly every day.

Jimmie thrived on the excitement of being abroad. At ten years old, he was a bright, outgoing, curious boy with dark, curly hair and long, slender hands. He and Willie were being educated as gentlemen in the aristocratic atmosphere of Czarist Russia. As a cousin recalled, "the boys were brought up like little princes." They had dancing lessons and learned Russian, German, and French. Best of all, Jimmie was seeing and studying art. From the time he was four, the adults around him had commented on his remarkable flair for drawing. At first Jimmie was tutored by an advanced art student, but after a few months he was ready to enter a real art school.

In April of 1845, Jimmie enrolled in the Imperial Academy of Fine Arts, the official art school of Russia. Roughly three hundred students attended four levels of classes. Jimmie did so well on the entrance examination that he was allowed to skip the first level. The instruction was traditional: classes consisted of copying plaster casts of classical statues, and he attended class three times a week. When examined a year later in March of 1846, Jimmie, who was not yet twelve, ranked

twenty-eighth in a class of more than one hundred students.

The Russian climate and the effects of drinking unsanitary water weakened the health of everyone in the Whistler household. Both parents and children regularly came down with colds, coughs, and influenza; John, who was George and Anna's last child, died, and Jimmie was sick throughout 1844, 1845, and 1846. In early January of 1847, he was stricken with a more serious illness—an attack of rheumatic fever, which weakened his heart. For the first three months of 1847, Jimmie was bedridden and not allowed to move. Even drawing, his favorite pastime, was considered too dangerous an activity.

Looking for ways to help her younger brother pass the time, Deborah borrowed a book of engravings by William Hogarth, the eighteenth-century English artist whose paintings and prints cast a critical eye on all classes of London society. Jimmie devoured Hogarth's portrayals of everyday life, in which the artist poked fun at foolishness in places high and low. The engravings were lively and inventive, and Hogarth's robust style must have cheered up the sickly boy. Jimmie even began to look on his illness as a blessing in disguise. "If I had not been ill," he declared, "perhaps no one would have thought of showing them [the engravings] to me."

Looking at Hogarth's work, Jimmie saw what an artist could do with an energetic line and shadings of black and white. And he may have noted the difference between Hogarth's subjects—the facial expressions and actions of ordinary English people—and the plaster casts and antique statues of his own academic training. Jimmie's youthful admiration for Hogarth lasted all his life.

Jimmie recovered from his illness, but his health remained fragile, and Anna thought a change of climate was essential. In June of 1847, she and the children sailed for a lengthy stay in England. Deborah, now twenty-one, met and fell in love with Francis Seymour Haden, a London physician with artistic leanings. Everyone was pleased by the match, and George Whistler traveled from St. Petersburg to give the bride away. On October 16, 1847, Deborah became Mrs. Seymour Haden and moved to 62 Sloane Street, in the heart of London.

The Whistlers returned to Russia a month later, but their stay was brief. In 1848, an epidemic of cholera, a dread and often fatal disease, spread through St. Petersburg. At the same time, Jimmie had another attack of rheumatic fever and was bedridden again. For their own safety, Anna and the boys returned to England in July of 1848. At first they stayed with the Hadens, and Seymour fanned Jimmie's interest in art by giving him a paintbox. George Whistler encouraged his son by letter, but reprimanded him for not finishing off his work. (This complaint dogged Whistler throughout his life. His critics always wanted more detail and conventional touches than he believed necessary.) Jimmie attended a boarding school outside London, but stayed for only one term. His parents gave him permission to live with the Hadens and be privately tutored. Meanwhile, Anna and Willie went back to Russia.

Living in London under the Hadens' wing was enormously stimulating for Jimmie. He and his brother-in-law discussed art and went to museums and galleries. They probably did some sketching together, too. While Jimmie was in London, George Whistler commissioned William Boxall, a well-known artist of the day, to paint a portrait of his son. Boxall couldn't help noticing the boy's love of art, and he took him to see a collection of Raphael's drawings. Boxall also gave Jimmie a book about the Renaissance and its artists. These essays on the great Italian painters, along with Haden's guidance and Boxall's support, gave Jimmie courage. In January of 1849, he wrote to his father that he wanted to be an artist. "I wish to be one so *very* much and I don't see why I should not, many others have done so before," Jimmie declared. "I hope you will say 'Yes' in your next, and that Dear Mother will not object to it." The Whistlers, though proud of their son's talent, thought that being a painter was an impractical career choice. They advised him to consider becoming an architect or an engineer and to confine his drawing to his spare time.

Any such decisions suddenly became luxuries. George Whistler's health was weakened by overwork, and when he came down with cholera, his system couldn't stand the added strain. He died on April 7, 1849. Anna was now the head of the

family, and she decided to return with Jimmie and Willie to their own country. There was also the important question of money to be faced. Without George's salary, the family had to survive on an uncertain income based on dividends from stocks. This meant a very different way of life—one that bordered on poverty. Nevertheless, Anna was determined that her sons would have the best. The Whistlers moved to Pomfret, Connecticut, a country village with a good private school that she could afford. Jimmie was popular at school, though he didn't apply himself to his studies. He was more interested in drawing caricatures of his teachers and classmates.

Anna still did not want Jimmie to become a professional artist. His father and grandfather had been in the military, and she insisted that Jimmie follow family tradition. Anna felt that having her son become an officer would be the best way to honor her late husband's memory—and impose discipline on the fun-loving Jimmie. Furthermore, West Point had the finest engineering department in the country, and tuition, room, and board were free. On July 1, 1851, just before Jimmie turned seventeen, he entered the U.S. Military Academy at West Point.

When Jimmie arrived at West Point, its superintendent was Colonel Robert E. Lee, the future commander of the Confederate army. Handsome, dignified, and patient, he was respected by everyone at the Point. The classes were small, and very few young men were selected each year. An appointment had to come through a congressional representative or the President himself. Therefore, most candidates had not only outstanding abilities, but important family connections. The cadets were keenly aware that they were elite, and their sense of superiority reinforced Jimmie's own attitudes, which had been colored by years of closeness to the imperial court of Russia.

Cadets were issued a trim, gray uniform that further set them apart, and tradition required that every entrant receive a nickname as well. Jimmie was called "Curly," on account of his thick black hair, which he hated to have cut. His ringlets were his crowning glory in more ways than one. Only 5' 4" tall, Jimmie was sensitive about being short. But his hair, especially when fluffed up, added a

few inches to his height.

West Point emphasized correct conduct and the building of character. The virtues of duty, loyalty, honor, and courage were instilled through four years of strict supervision. A cadet's schedule was full from the 5:00 A.M. wake-up call to the final lights-out at 10:00 P.M. Every aspect of his life was regulated: there were exact times for eating, sleeping, attending classes, studying, drilling, parading, and bathing. Even talking was forbidden during certain hours.

Any deviation from these harsh rules earned a cadet a demerit. A cadet who got more than one hundred demerits in six months or two hundred in a year could be expelled.

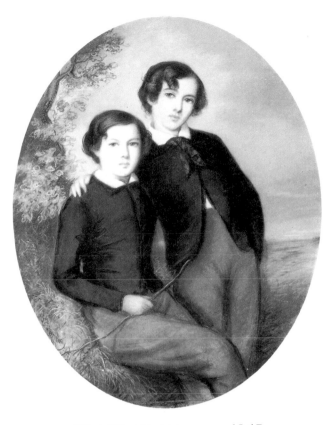

THE WHISTLER BROTHERS. *1845*
This portrait of Jimmie and Willie by Emile François Dessain was made while the Whistler family was in Russia. Jimmie is on the left.

"Curly" Whistler began to accumulate demerits from his first weeks at the Point, mostly for small offenses. He received black marks for laughing and talking in ranks, for not coming to order, for not carrying his musket properly, for swinging his arms too much while marching, for not shaving, for not getting a haircut, for not shining his shoes, and for playing cards after taps. But Jimmie kept track of how far he could go. When he approached the one-hundred or two-hundred limit, he buckled down and behaved perfectly until the term ended and he was

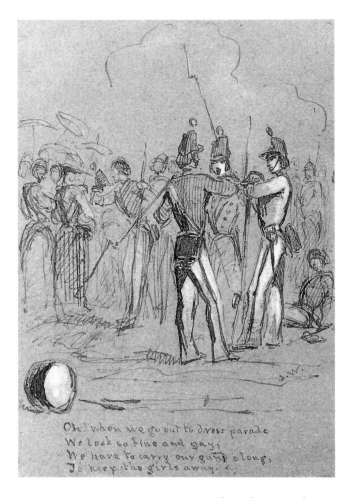

Oh! when we go out to dress parade
We look so fine and gay,
We have to carry our guns along,
To keep the girls away.

back to zero.

Although he had trouble with military discipline, Jimmie shone in drawing class, and he had a sympathetic teacher who recognized his talent. Robert W. Weir, the Point's professor of drawing, was a history painter and portraitist in touch with many prominent American artists. When he saw that Jimmie was a whiz at copying from the school's collection of prints and statues, Weir gave him more challenging assignments. Jimmie was urged to build up his powers of observation by making on-the-spot portraits, landscapes, and vignettes of cadets carrying out their duties.

Weir also ran an informal exhibition gallery for the cadets. He thought highly enough of Jimmie's work to frame ten of his drawings and hang them in this space. Jimmie shared his teacher's high estimate of his work. One day in art class, Jimmie was working on a sketch of a young girl. Weir walked from student to student, examining each one's drawing. After looking at what Jimmie had done, Weir went back to his own desk, picked up his brush, and approached him with the intention of correcting his drawing. When Jimmie saw Weir coming, he cried out,

"Oh, don't sir, don't! You'll spoil it!" Weir understood. He pulled back, and did not touch the sketch.

Unfortunately for Jimmie, he couldn't stay in the drawing class with Professor Weir all day. His soldierly skills were negligible, and he was a dreadful horseman. One day during cavalry drill he pitched forward and spun through the air over his horse, landing on the ground in front of his mount. At this his riding instructor said, "Mr. Whistler, I am pleased to see you for once at the head of your class!"

Now in his third year, Jimmie had scraped by in his classes and paced his demerits well enough to survive the rigors of a West Point education, and a career as an officer was just about guaranteed to him. Whether or not he could admit it to himself, he must have known he was not cut out for the military, but he saw no way out. Jimmie was torn between his own desire to become an artist and his need to uphold the family honor and obey his mother's wishes.

It has been suggested that Jimmie knew he wanted to drop out of West Point, but that he was afraid to say so. He may have hoped to engineer his own dismissal by pushing the Point into expelling him. First, Jimmie ran up his demerits so that he had more than the forbidden two hundred. His downfall, which also may have been deliberate, occurred in chemistry class. During an oral examination he was asked to discuss the properties of silicon. "Silicon is a gas," he began, and the instructor stopped him cold. "That will do, Mr. Whistler," he said, and ordered him to sit down. On June 16, 1854, Jimmie was expelled from West Point, more for his misbehavior than for having failed chemistry, but it was like him to concentrate on the latter and glamorize it into a witticism. Later on he would say, "If silicon had been a gas, I might have been a major general."

Long after his dismissal, James Whistler showed great fondness for his association with the Academy. He was proud of the Point's traditions, and he often brought up the escapades and flourishes of his cadet days. Being able to claim that you were a "West Point man" was the same as saying that you were the cream of the crop, if a little more subtly. Despite his expulsion from the Point, Whistler would subscribe to its code of loyalty and honor forever. He invoked it as strictly

as any commanding officer—even in situations when it did not apply.

But these feelings of affection were decades away. For the present, Jimmie went home to his mother in disgrace. Anna was angry and embarrassed by her son's bad showing. She insisted that he try to get himself reinstated. Jimmie was shamed into writing to the Secretary of War for a reversal, but there was no leniency. After being refused readmission to West Point, Jimmie visited friends and relatives in New York, Connecticut, and Baltimore before moving to Washington, D.C., to start over.

In November of 1854, James Whistler joined the Drawing Division of the U.S. Coast and Geodetic Survey, a government bureau responsible for making maps of the United States coastline. A month later, he was transferred to the engraving division, and as part of his training, he received invaluable technical instruction. Whistler was introduced to etching, a method of printmaking that he would not only master, but revolutionize.

The etching process is based on the fact that a groove cut into the surface of a metal (usually copper) plate will hold ink for making a printed impression. A plate is prepared by coating it with a thin film, made chiefly of wax, called the "ground." The ground is then darkened with smoke so that the etcher can easily see the design as he or she scratches it into the ground with a steel etching needle. The lines made by the needle expose the metal of the plate; unscratched areas remain protected by the ground. When the design is finished, the plate is immersed in a bath of acid. The acid dissolves the exposed metal in the scratched lines but doesn't penetrate the ground. If some lines need to be deepened to hold more ink, sections of the plate that don't require more treatment are "stopped out" by protecting them with another layer of ground. The plate is again dipped into the acid bath. This is called "biting," because the acid chews away the metal plate. Each line's breadth and depth depend on how long and how often it has been exposed to the acid. When a plate is bitten to the etcher's satisfaction, it is cleaned and polished to remove the ground. The cleaned plate is then inked and wiped, leaving ink only in the scratched lines. The print is "pulled" by running the inked

plate and sheets of damp paper through a special etching press.

Because so many effects are possible, etching lends itself to all sorts of variations. Lines can be hard or soft, thick or thin, deeply inked or hardly visible. They can zigzag, spiral, or straighten out. They can form shapes or shadows, and create character, texture, and mood. Whistler immediately grasped how original an etching could be, and he was fascinated by printmaking. Characteristically, Whistler added an individual twist to his first print. Above some carefully drawn bluffs overlooking a shoreline, he sketched a gallery of humorous portraits. The plate is remarkable for a first effort, but it gives no hint that in a few years Whistler would be hailed as the most important etcher since Rembrandt.

These touches, creative though they were, were not going to be tolerated at the Coast Survey, which had to turn out standard maps. Before long, Whistler absorbed the techniques of etching and got bored with the mechanical aspects of the job. He hardly ever arrived on time. "I was not late," he objected. "The office opened too early." In February of 1855, he left the Survey. Tired of being kept from what he really wanted to do, Whistler began acting out his true choice of a profession. He painted portraits, dressed to look "artistic," and talked of the carefree life that art students led in Paris.

In July of 1855, Whistler turned twenty-one. This meant financial independence, because he was entitled to some money from his father's estate. He no longer had to go along with his mother's ideas about what was best for him. He didn't have to work at jobs for which he was unsuited. Two weeks after coming of age, Whistler obtained a visa for France. There were to be no more delays. With an allowance of $350 a year, enough for him to live carefully as a student, Whistler was going to be an artist. And besides the allowance, he received another $700 in "loans" from relatives—perhaps as much as $15,000 today. Whistler was determined to study in Paris, the only place in the world that could provide the education and experience he craved. As his ship steamed out of New York Harbor in September of 1855, Whistler watched his native land fade into the distance. Did he know that he would never return?

2

STUDENT OF ART AND LIFE

In November of 1855, Whistler was exactly where he wanted to be—in the center of Paris, where the young and poor and ambitious were gathering as never before. His generosity and wisecracks helped him make friends easily with many other hopeful students. He wandered down the city's wide avenues, taking in the sights and sounds. The price of a cup of coffee or a glass of beer bought him a seat in the cafés, the chief meeting places of Paris's leading artists and writers. The atmosphere of these places crackled with energy as students, journalists, poets, and painters crowded around the small tables, arguing with each other for hours about what was happening in art, literature, politics, and society. The latest news and gossip were hurled back and forth, and no one was safe from insult.

Much of Whistler's day-to-day survival depended on his allowance, which arrived four times a year and never seemed to stretch far enough. After receiving his check, he would pay his debts, hunt up his friends, and treat them to a meal at a good restaurant. Next, his living quarters would improve. Whenever he had enough money, he would rent a room on the lower floor of a house and furnish it with a bed, a chair, and a chest or two. As his spending money melted away, he would move to a higher floor, and climb seven or eight flights of stairs to his new quarters. Then he would pawn or sell his furnishings, and eat cheaply. Once, when he was down to his last penny, Whistler pawned his coat for a cold drink

SYMPHONY IN WHITE, NO. 1: THE WHITE GIRL. *(Detail) 1862*

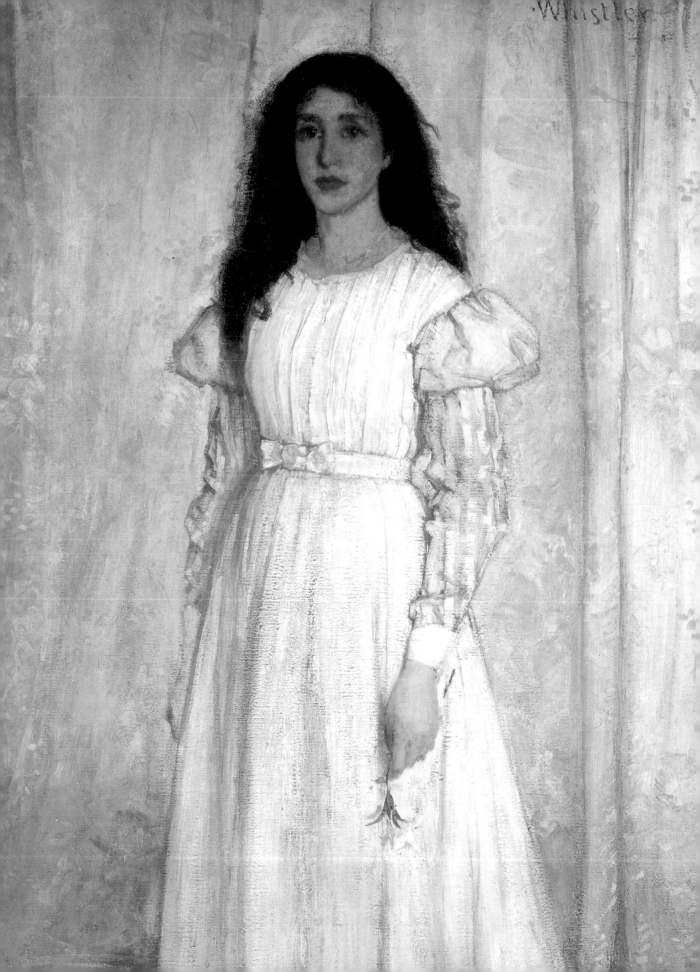

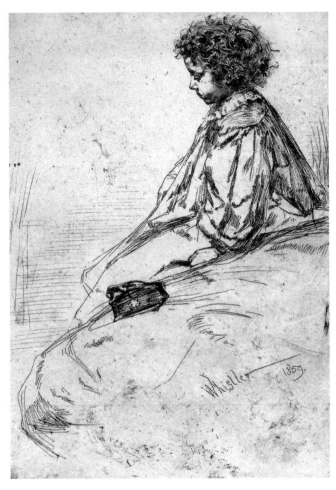

BIBI LALOUETTE. *1859*
*From his earliest days as an
artist, Whistler excelled at
portraying children.
Bibi's father was a
restaurant owner who kept
Whistler from going hungry
when his allowance
was gone.*

and went around in his shirt-sleeves for a few days. The whole cycle would begin again when his next check came.

After arriving in Paris, Whistler entered the studio of Charles Gleyre for instruction in painting. Six days a week, thirty or forty art students met in a large room whose walls were covered with caricatures and blobs of paint scraped off hundreds of previous palettes. The students customarily drew and painted from a nude model, either male or female. Gleyre could have confined himself to supervising the classroom routinely, but he went beyond what was required. He applauded when his students showed signs of originality instead of imitating what was successful. He taught craft, but his heart lay in fostering a personal means of expression.

Gleyre's guidance was crucial to Whistler's development as an artist; his recommendations became the basis of several of Whistler's own practices. For example, Gleyre advocated sketching from memory, believing that the results would be

24

more concentrated and energetic. Whistler, in coming upon a scene that he liked, would stare at it, storing up his impressions of forms and colors. Memorizing overall impressions was extremely helpful to Whistler because he was nearsighted. He could not always make out details, so if he could retain a movement or an expression without having to squint too much, it was easier for him to work.

Gleyre constantly urged his students to copy works in the Louvre, France's pre-

THE TITLE TO THE FRENCH SET. *1858*
An artist was a novelty in the rural villages Whistler visited, and crowds would gather when he worked. Whistler dedicated the French Set to "My old Friend Seymour Haden."

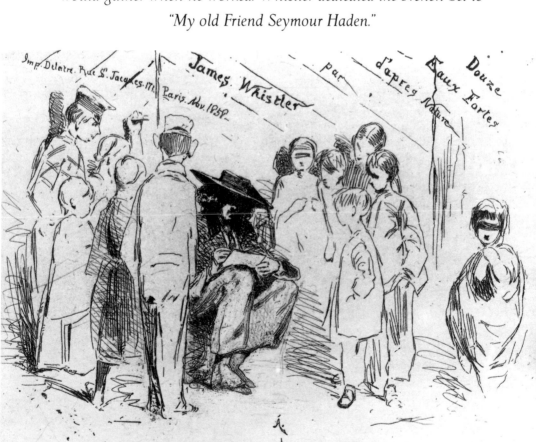

mier art museum. (Once an ancient royal palace in Paris, the Louvre was converted into a museum in the eighteenth century. It contains many of the world's greatest art treasures.) By painting their own versions of a masterpiece, the young artists could learn to analyze complex compositions and develop a sense of quality. Whistler often went to the Louvre, and it became his ultimate standard. "What is not worthy of the Louvre is not art," he said.

The paintings Whistler most revered in the Louvre were by Rembrandt and Velázquez, two of the greatest artists that Holland and Spain have ever produced.

AT THE PIANO. *1858–59*

This painting excited the admiration of Whistler's contemporaries. John Everett Millais praised the picture when he saw it at the Royal Academy, and John Phillip, another British artist, bought it out of the show.

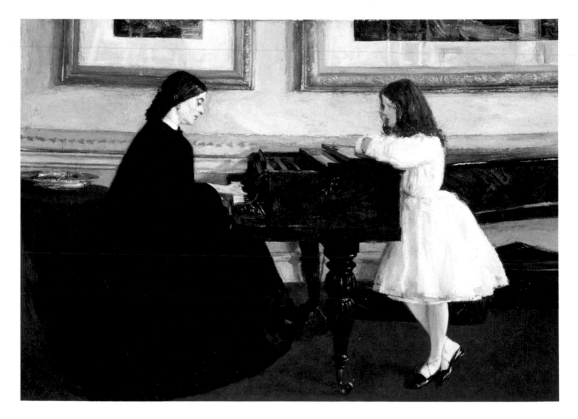

ANNIE HADEN. *1860*

Whistler loved to draw and paint his sister Deborah's family. He felt that this portrait of his niece was among his best etchings.

Both of these artists lived and worked during the seventeenth century, but to Whistler, they seemed more modern than many of the most successful painters then active in France. Unlike the bulk of the artists showing in the Paris Salon, the huge art exhibitions sponsored by the French government, Rembrandt and Velázquez described what they saw. They did not idealize or add a religious or historical frosting to give "importance" to their pictures. They presented human beings with intimacy and dignity and placed them in simple settings. The figures in their paintings merged into rich backgrounds of blacks, browns, and grays that created a dramatic atmosphere around them. This shadowy area isolated the sitters, yet it also highlighted their physical appearance and brought into prominence their inner feelings.

Competing with these masters for Whistler's attention was thirty-six-year-old Gustave Courbet, an artist who was not only very much alive, but a perpetual magnet of controversy. In 1855, the year Whistler moved to France, Courbet's works had been rejected by the art jury of the Exposition Universelle, an important international fair held in Paris. Courbet's explosive personality matched the

27

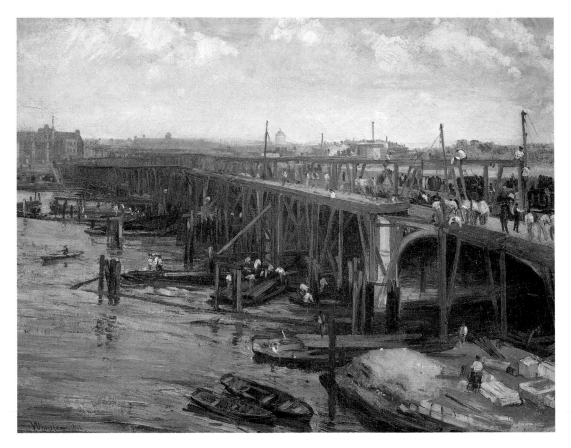

THE LAST OF OLD WESTMINSTER. *1862*

Despite the title, the subject is not the dismantling of the old bridge, but the removing of the scaffolding for the new one. Whistler's interest in the wooden pilings, the clusters of small boats, and the men at work is evident.

force of his art, and he did not go away quietly. Instead, he built his own gallery next to the fairgrounds, and displayed the very paintings the jury had turned down. The results caused a sensation. Courbet painted peasants who looked like peasants: they were not pink-cheeked angels, but tired laborers with calloused hands and bent backs. But such unidealized portrayals of working people were not considered worthy of art. Parisians were shocked by Courbet's subject matter,

which they found vulgar. His technique was criticized as being equally coarse. Courbet's paint was vigorously applied to the canvas, at a time when all traces of pigment were supposed to be smoothed into the surface.

Whistler's first successful works were inspired by Courbet. He painted and drew the poor people he had befriended in his neighborhood. Among his subjects were an old, half-blind flower-seller and the child of a local restaurant owner who had let him eat on credit when he had no money. Whistler was benefiting from what he learned outside the academic sphere, but since he was no longer in class, the other students assumed that he was not working. This was the genesis of Whistler's reputation as an idler.

Meanwhile, Whistler had not forgotten what he learned at the Coast Survey. In August of 1858 he proposed to a fellow student named Ernest Delannoy that they set off on an etching tour

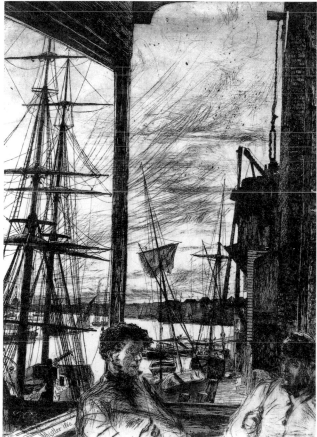

ROTHERHITHE. *1859*
Once again, this view from an inn on the Thames brings together Whistler's favorite subjects: sailors and dockmen, ships in port, and the stretch of buildings lining the river. The poet Charles Baudelaire praised the Thames etchings, singling out their "wonderful tangles of rigging, yardarms and rope, a hotpotch of fog, furnaces and corkscrews of smoke."

of northern France, Luxembourg, and Germany. Whistler carried a small knapsack to hold his clothes, sketchbooks, pencils, etching tools, and five or six copper plates. Traveling mostly by train, the two friends talked, drew, and etched their way through France, but by the time they reached Cologne, Germany, they were out of money. In return for their stay at an inn there, Whistler had to leave all his etched plates behind, promising the landlord that he would repay him as soon as he reached Paris. Whistler was beside himself—he feared that the innkeeper would not take care of the plates, and weeks of hard work might be lost. It cost him much agonizing, but there was nothing for him to do but leave the plates in Germany.

Whistler and Delannoy had to walk back to France. On the way, in exchange for a bowl of soup or a pile of straw to sleep on, they drew portraits of the people they met. In October of 1858, the two reached Paris. Whistler scraped together enough money to pay the innkeeper for the plates left in Cologne, finished some others, and began printing them at once. Known as the French Set, these thirteen etch-

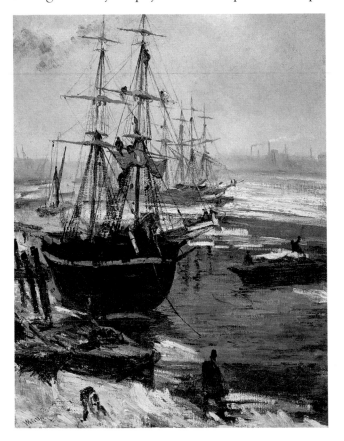

THE THAMES IN ICE. *1860*
Seymour Haden bought this canvas from Whistler for a meager ten pounds, giving him three pounds for each of the three days it took to paint the picture, plus one pound over. His reasoning galled Whistler, who would later insist, "An artist is not paid for his labor, but for his vision."

ings of people and places were praised by everyone who saw them for their directness and precision. Whistler was right to say that he accomplished more on his travels than he ever had done in his art classes.

While putting the finishing touches on the French Set, Whistler went to the Louvre and struck up a conversation with a young Frenchman copying in the museum. He was Henri Fantin-Latour, a shy and serious painter who also appreciated Courbet. Fantin-Latour and Whistler became good friends, encouraging and sympathizing with each other. When Whistler showed Fantin-Latour some proofs from the French Set, Fantin-Latour recognized his new friend's abilities and introduced him to other up-and-coming French artists in his circle. Holding court in the cafés, Whistler had everyone roaring with laughter when he described his adventures on the road back to Paris. His etchings and his wit had propelled him into the thick of artistic ferment in Paris.

In November of 1858 Whistler crossed the Channel to visit the Hadens in London. While staying with his sister and her family, he completed *At the Piano*, his first important painting. *At the Piano* shows Whistler's affection for the home where he was always made welcome. Deborah and her daughter, Annie, are absorbed in playing and listening to music. Mother and daughter are placed in perfect balance, and the horizontal design of the background contributes to the feeling of order and calm.

Whistler sent *At the Piano* to Paris for inclusion in the Salon of 1859, though he detested the majority of paintings seen there and would never paint anything calculated to please its juries. The judges were known to prefer the conventional works done by their friends, so unknowns like Whistler and Fantin-Latour, who were trying to forge their own styles, were rarely accepted. Emile Zola wrote that the Salon jury "hacks at art and offers the crowd only the mutilated corpse."

But for a young artist, having a work in the Salon could mean the difference between survival and failure. The Salon, which was held every two years until 1863 and annually after that, was the best way to gain recognition, make sales, and win commissions. Collectors would rarely buy a painting unless it had been

exhibited at the Salon, and Whistler was in no position to ignore the prestige that a Salon blessing offered. Therefore, he submitted *At the Piano*, along with two etchings from the French Set, for inspection.

The etchings were admitted, but *At the Piano* was too unconventional for the jury's taste. The painting was not of a historical scene, but rather depicted a modern subject—ordinary people in everyday dress. Neither of the women in the picture were "improved" by a flattering or sentimental portrayal, and worse yet, Whistler's decision to portray people and spaces with simple shapes and sketchy brushwork made the painting seem rough and smudgy. *At the Piano* was rejected by the Salon, as were canvases by Fantin-Latour and Édouard Manet. However, a local dealer invited several of the rejected artists, including Whistler and Fantin-Latour, to exhibit at his shop. Whistler was thrilled when Courbet himself visited the gallery and expressed his admiration for *At the Piano*.

In 1860 Whistler sent his canvas to the annual show of the Royal Academy of Arts, the most important art society in London. In its power to make or break an artist, the Royal Academy was to England what the Salon was to France, although the Academy was less biased than the Salon. The Academy accepted *At the Piano*, and it became the hit of the exhibition. The painting sold for thirty pounds, a nice sum of money for a work by a newcomer.

This early success was not typical of how advanced artists were received in London, but Whistler thought that his triumph would carry him forever. He decided to make England his main place of residence. His prospects seemed better there, and he wanted to be near the Hadens and their children.

Whistler rented a room in Wapping, a slum district on the Thames. He was struck by the flow and activity of river life, and he was set on capturing the alleys, warehouses, pubs, jetties, barges, and full-masted ships that made up the dockside and commercial areas. To proper Londoners, Wapping seemed a dirty, dangerous place to be avoided or ignored. But precisely because Whistler was not a native, his outlook was fresh. He could see the river as an untapped source of images waiting to be molded into art. He noticed the majestic webs made by the overlap-

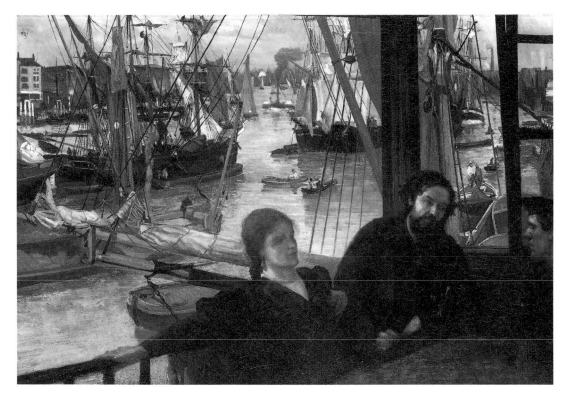

WAPPING ON THAMES. *1860−64*

To see how Whistler explored the same subject in paintings and etchings,
compare this oil to Rotherhithe. *The view is wider, and color is used to*
advantage to portray a sparkling day. In addition, a female figure has been
placed directly in the foreground. The model, Joanna Hiffernan,
became a central figure in Whistler's life.

ping of riggings and sails as the ships jostled each other at the piers. He revealed the beauty of the fog meeting the water, and the character of the rickety old wharves and bridges that were about to be torn down. In a way, Whistler's whole life had been a preparation for discovering the Thames as a subject. Had he not grown up on the banks of the Neva River in St. Petersburg and been a cadet on the crags overlooking the Hudson?

In what was now becoming an established way of working, Whistler pursued

the theme of urban river scenes in paintings and prints. He exploited the strengths of each medium superbly. The etchings, with their clear, minute lines, depict a sliver of a street or present a panoramic view of a long stretch of the riverbank. They were acclaimed as soon as they were shown. The critics compared Whistler to Rembrandt and declared him "the most admirable etcher of the present day."

The paintings, which are more fluid in execution, show Whistler's growing interest in catching momentary conditions of light, air, and climate. In *The Thames in Ice*, he recorded a cargo ship trapped in the frozen river, and evoked the cold and wind of a winter day. *Wapping*, which Whistler began painting in 1860, shows the traffic on the river from the viewpoint of three people on the balcony of a nearby inn. The picture marks the first appearance in his work of a young woman with a mass of coppery-red hair. A professional artist's model, her name was Joanna Hiffernan, and everyone called her "Jo."

Now in his late twenties, Whistler was a firm bachelor. It had taken him years to liberate himself from his parents' wishes for his future, and such independence was too hard-won to be given up. He understood very well that marriage would interfere with his work. To live the life of an artist, Whistler needed the freedom to come and go without having to answer to anyone. Then, too, his finances were uncertain. The funds

Etienne Carjat made this portrait of Whistler in about 1864. People often commented on Whistler's striking good looks. One acquaintance described him as "a pocket Apollo."

Whistler received from his relatives did not stop altogether until the late 1860s, but they did not always cover his studio and travel expenses. And as Whistler matured, his paintings became more radical and less popular, making them increasingly difficult to sell. Most of his professional income came from his prints, which sold for a fraction of what an oil would have fetched.

Whistler's resistance to marriage did not mean that he lacked for female company. He was a trim, handsome man with finely chiseled features accented by a dashing mustache and a plume of white hair in the middle of his dark locks. His looks attracted women, and his debonair manners, learned in the court of the Czar and polished at West Point, charmed them even more. Whistler had had some brief love affairs in Paris, but in London he began a longer-lasting relationship with Joanna Hiffernan. Jo was beautiful, intelligent, and willing to live with Whistler even though he wouldn't marry her. She kept his house, helped him sell his work, and was the model for some of his finest paintings. Whistler supported Jo to the best of his abilities, and they were together for more than ten years.

The most celebrated painting for which Jo posed was *The White Girl*, painted in 1861 and 1862. Using short, lively brushstrokes, Whistler portrayed Jo as a figure of frail, haunting mystery; her red hair stands out against the pale tones of her dress and the filmy background. He sent *The White Girl* to the Royal Academy, hoping for a repetition of his first success. This time the Academy felt that Whistler had gone too far. His painting told no story and advanced no moral. The canvas was rejected, so Whistler pinned his hopes on Paris and the Salon of 1863.

But the odds there were worse than ever. The spaces allotted to younger artists were few, and they were likely to be given to those whose art followed a safe and established path. *The White Girl*, as well as paintings by Manet, Fantin-Latour, Pissarro, and Cézanne, was turned down. The outcry over the rejected works was so intense that Napoleon III, the Emperor of France, decreed that the outcasts could have an exhibition of their own, in May of 1863.

The rejected artists were delighted by the chance to show up the Salon. Whistler correctly recognized that the event, nicknamed the Salon des Refusés,

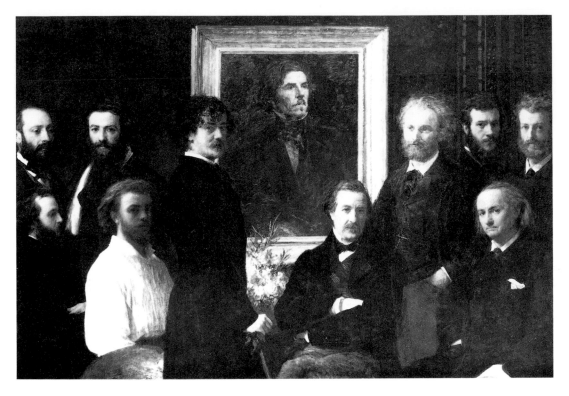

Henri Fantin-Latour. HOMAGE TO DELACROIX. *1864*
Whistler's closeness to the most advanced French artists and writers was
documented in Fantin-Latour's tribute to the painter Eugène Delacroix, an idol
of his generation. Whistler stands to the left of Delacroix's portrait; Fantin-
Latour, wearing a white shirt, is seated next to him. Standing opposite Whistler
is Manet; the figure on the extreme lower right is Baudelaire.

would become a landmark in the history of art. He saw that the publicity would
make the participants famous. To Fantin-Latour he wrote, "It's marvelous for us,
this business of the Exhibition of Rejected Painters! Certainly my picture must be
left there and yours too. It would be folly to withdraw them. . . ." The Refusés drew
thousands of people to their show, but most of them came to scoff. The insults
were directed chiefly at Whistler's *The White Girl* and Manet's *Déjeuner sur*
l'Herbe (Luncheon on the Grass). Manet's canvas was a target of outrage because

he showed a naked woman seated next to two fully clothed men, as if to imply that this is what Parisians really did when they went on a picnic.

Although his image of a woman was not as brazen as Manet's, Whistler also evoked a private moment by showing Jo in a loose dress with her hair down. Women did not appear in public unless they were tightly corseted into formal dresses and their hair was pinned up. The flow of the model's dress and hair suggested an intimate relationship with the artist—and the viewer. Zola, who saw Whistler's canvas at the show, said that "folk nudged each other and went almost into hysterics; there was always a grinning group in front of it."

The public had ridiculed Whistler, but his reputation among the most advanced artists and critics was secure. The Salon des Refusés was the first Whistler success to be sharpened by scandal. It was certainly not the last.

SYMPHONY IN WHITE, NO. 1: THE WHITE GIRL. *1862*
This mysterious and poetic work was a turning point in Whistler's art. In it, said one critic, Whistler "found the road he was destined to tread."

3

THE STRUGGLE FOR A STYLE

Whistler was now allied in spirit with the newest and most vital currents in French art, but his own work was moving in a different direction. The subdued tones and contemplative quality of *The White Girl* signaled a turning away from the broader, earthier realism of Courbet and his followers. Whistler was still looking for a style of his own, and his wide-ranging searches led him to explore the art of Japan.

The Japanese nation had purposely sealed itself off from the West. But in 1853, an American naval squadron landed outside of Tokyo and asked for permission to enter Japanese ports. Soon afterward, trade agreements were made with the West, and by the late 1850s a stream of Japanese goods—including prints and other artworks—poured into European markets. Artists were among the first to be fascinated by how the Japanese saw their world. The Japanese observed nature closely, but did not depict it literally. They were able to express a variety of feelings by a spare hint of an object's basic form; they did not copy every detail. An outline or a shape was enough to convey the impression that the artist was after. This pared-

MILLY FINCH. *Early 1880s*
Whistler always came up with unusual—and exhausting—poses for his models.
Milly Finch half-sits and half-reclines on a couch in Whistler's studio, but holding the fan above her head must have made it difficult for her to relax.

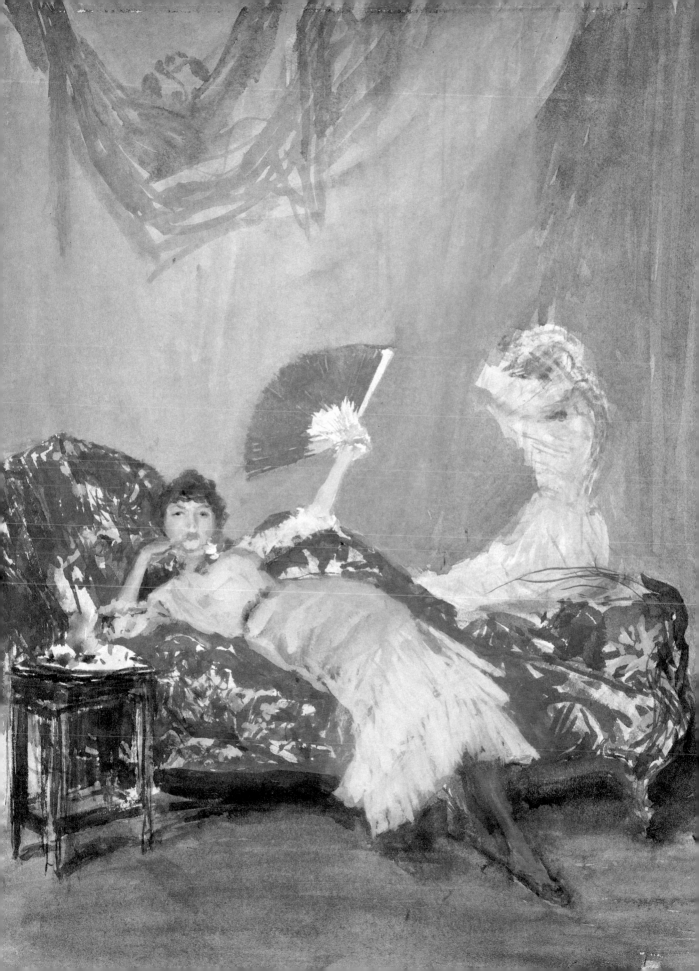

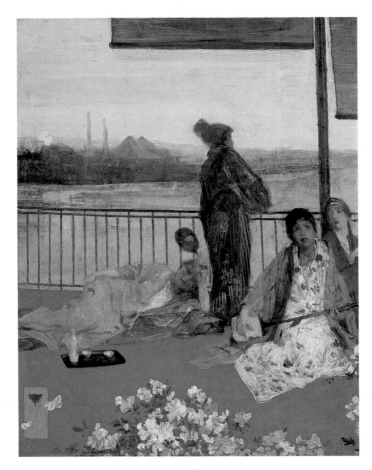

VARIATIONS IN FLESH
COLOUR AND GREEN: THE
BALCONY. *1864*
Whistler's dual fascination
with Japanese art and
industrial London is seen
in this view from the
artist's balcony in Chelsea.
The odd combination
displeased the critics.

down approach chimed with Whistler's own drive toward abstraction and restraint: he had begun to perceive that the subject of painting was painting itself. A work of art was not only a representation of a bowl of flowers or a king astride his horse or anything else an artist might choose to portray. It was a visual experience derived from an artist's use of the true language of painting—which is not the choice of a subject—but light, shade, color, texture, movement and placement of shapes.

Whistler began this new phase of his work by incorporating Oriental objects into his paintings as decorative props. Women dressed either in white or in a colorful kimono hold a fan or sit among some vases. The costumes and pottery seen in the canvases were Whistler's own, as he had become an avid buyer of Japanese prints and Chinese porcelains. Because of the exotic subject material, as well as Whistler's manner of painting it, these new canvases were sniffed at for their "carelessness" and "eccentricity" by the reviewers. They referred to them as "Japanese

impertinences." But the rich colors and patterns of the Oriental objects made the pictures attractive, and Whistler sold several to collectors and dealers.

Whistler's understanding of Japanese art continued to evolve and within a few years, his paintings and etchings would reflect the abstract nature of Japanese design. They were hazy, poetic renderings of fleeting moments. Foregrounds and backgrounds were blended together, and outlines began to melt away. This approach would deny Whistler the official acceptance he wanted. The public—and the Academy, for the most part—liked its pictures to be catalogues of easily recognizable details, whereas Whistler's landscapes and seascapes made viewers work too hard to see what he was getting at. Was that dash of color supposed to stand for the sail of a schooner? Were those black strokes just a jumble of marks or a hansom cab? Rather than enjoying using their imagination to fill in what they saw, viewers were impatient with Whistler for what they thought were bad jokes.

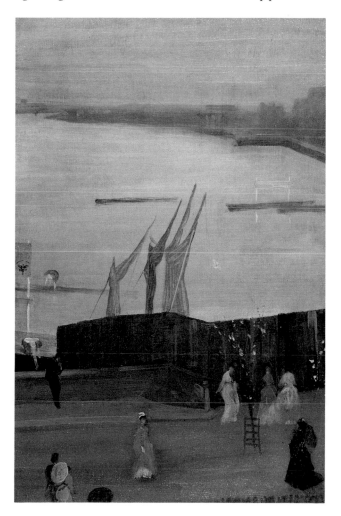

VARIATIONS IN PINK
AND GREY: CHELSEA. *1871–72*
An impression of a foggy day
on the Thames reveals
Whistler's growing
understanding of Oriental
design. The composition is
purposely off-center.

Whistler would not modify his stance, no matter how the public scoffed. He was determined that no sermons would be read into his paintings. To divorce his art further from sentiment or anecdote, he linked it to music, which must be listened to and understood directly. "As music is the poetry of sound, so is painting the poetry of sight, and the subject matter has nothing to do with harmony of

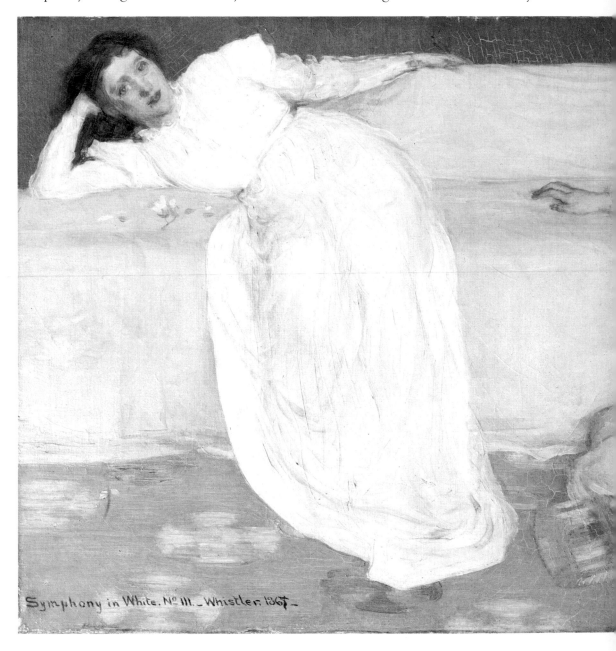

Symphony in White. N° III. – Whistler. 1867 –

sound or colour," Whistler said. Like music, he continued, "Art should be independent of claptrap—and should stand alone and appeal to the artistic sense of eye or ear without reference to such foreign emotions as devotion, pity, love, patriotism, and the like." This statement was the foundation of all Whistler's beliefs about art. His credo was called "art for art's sake," and he would stand up for it many times in the years to come.

To support these ideas, Whistler used musical terms, such as "arrangement" and "harmony," in the titles of many of his canvases. For example, he changed the name of one painting from *The Two Little White Girls* to *Symphony in White, No. 3*. This displeased many critics, who liked titles that would help them understand the meaning of a picture. One of them was Philip Hamerton, who worked for the *Saturday Review* and had previously belittled *The White Girl* in his report on the Salon des Refusés. This time, reviewing the Royal Academy show, he mocked Whistler by pointing out that, despite the title, one woman had *brown* hair, the other had

SYMPHONY IN WHITE, NO. 3. *1865–67*
When Whistler changed the title of this picture from The Two Little White Girls *to* Symphony in White, No. 3, *he ignited what would become a long-running battle with the English art press.*

reddish hair, and both of them had *flesh-colored* skin. Whistler did not ignore this attack. In a letter that he later sent to the newspapers for publication, Whistler sarcastically wrote, "Did this wise person expect white hair and chalked faces? And does he then . . . believe that a symphony in F contains no other note, but shall be a continued repetition of F F F? . . . Fool!" This exchange, which took place in 1867, was the opening gun in what would be Whistler's decades of war with the British art press.

Another factor in the changing course of Whistler's art was the new set of friends he made in England. In 1862 he and Jo moved to Chelsea, a part of London favored by artists and writers because it was full of cozy, old-fashioned houses built on the north bank of the Thames. Their house at 7 Lindsey Row (now 101 Cheyne Walk) had a clear view of the river. It was also two doors away from Walter and Henry Greaves, local boatmen and amateur painters. Unlike the learned critics, the Greaves brothers appreciated Whistler's art, and became his disciples. The Greaveses and Whistler would row up and down the river, drifting by the shadows of the boats and bridges at night, or rising early to see the sun come up on the water at some unexplored spot. Whistler brought chalk and a pad of paper on these rides; he would make tiny drawings as notes and memorize the rest of what he saw.

A more sophisticated Chelsea neighbor was the poet and artist Dante Gabriel Rossetti, who was also trying to swim against the tide of typical Victorian painting. Rossetti, a plump man with large gray eyes and a deep voice, was famous for his images of haunted, alluring women who seemed to be locked into worlds of their own. Some similarities existed between Rossetti's pictures of women and *The White Girl*; Whistler felt that Rossetti was in sympathy with his own aims.

Whistler responded to Rossetti's warm personality, saying that he was "a prince among men." The two were back and forth between each other's studios nearly every day. At night Rossetti gave rowdy dinners. Whistler, the painter Edward Burne-Jones, the poet Algernon Swinburne, and the novelist George Meredith were frequent guests. As Rossetti was an animal lover, his many pets sometimes

wandered into these parties, too. Kangaroos, armadillos, gazelles, and peacocks had the run of the house, and they could turn up anywhere. One night, Rossetti's favorite pet, a furry wombat, crawled round and round the dining table. Another time, an irate visitor found that the wombat had eaten her new hat. "Oh, poor wombat!" Rossetti cried. "It is *so* indigestible!"

The pattern of Whistler's life was altered during the winter of 1863–1864, when his mother announced that she was moving to London to live with him. Because of her North Carolina connections, Anna had sided with the South during the Civil War. (So did Whistler, because of his immediate family and because of his affection for his Southern relatives in Baltimore. Moreover, Whistler retained an intense admiration for Robert E. Lee.) Anna was no longer comfort-

A STREET IN OLD CHELSEA. *1880–85*

Whistler liked the patterns and textures created by the awnings, signs, windows, and doorways in this row of Chelsea shopfronts. A photograph of the street shows that his rendering of what he saw was extremely accurate.

able in the United States, and surely her son had room to spare.

Anna's decision agitated her son. Whistler loved his mother, but he was nearly thirty years old and he wanted to hold on to his privacy. Her arrival would mean that Jo could not stay at 7 Lindsey Row. One reason Whistler liked the Rossetti group was that Jo was welcome at their gatherings. This was in daring opposition to conventional society, which decreed that women who lived with men without being married to them could not be received in decent houses. The men, however, could be invited anywhere, and were. This must have struck Whistler as unfair, but Anna Whistler was sixty-eight years old and firm in her notions of right and wrong. Jo moved out, but she still came to pose at the studio. Whenever Anna went to the country for her health, Jo returned to 7 Lindsey Row.

In the fall of 1865, Whistler went to Trouville, a town on the northern coast of France, to paint. Jo met him there and they joined Courbet, who had arrived earlier. Courbet and Whistler worked on pale, luminous seascapes, but Courbet, captivated by Jo, also painted her portrait. These were happy days—the three worked and ate with gusto, and they

Dante Gabriel Rossetti.

GOLDEN WATER (PRINCESS PARISADE). *1858 Rossetti's pictures of women with cascades of long, beautiful hair preceded Whistler's by several years. Attracted to the jewel-like quality of medieval art, Rossetti preferred a more colorful palette than his friend did.*

46

swam in the sea. However, Courbet's very physical style of painting no longer appealed to Whistler. Later he wrote to Fantin-Latour saying that he wished he had never fallen under Courbet's spell because it had caused him years of struggle and confusion.

Back in London, Whistler was riddled with doubts about his position. His ambitions were so high that it was not enough for him to be a brilliant etcher or a painter of the Thames, though this would have satisfied many other artists. He felt that he had not reached his full potential or found a style that matched his true needs. Whistler had to keep testing himself, even if his experiments took him in the wrong direction or demoralized him. As he wrote to Fantin-Latour, "It's always the same—work that's so hard and uncertain. I am *so slow*. . . . I produce so little, because I rub out so much. Oh! Fantin, I know so little. Things don't go so quickly."

Whistler was experiencing other discouragements besides self-doubt. The critics abused his paintings because he did not fit into any of their pigeonholes. *The Times* grumbled about his need "to win our attention by doing everything unlike other people." His relationship with Jo was under strain—definitely from the separation brought about by Anna's presence, and also possibly from Courbet, who had taken a fancy to her in Trouville.

Perhaps because he needed to escape his personal and artistic conflicts, Whistler embarked on an impulsive journey. In January of 1866, he sailed for Valparaiso, Chile, where the citizens there were rebelling against the colonialism of Spain. Whistler may have been talked into the trip because of his problems at home. Or he may have bragged about being a West Point man and, having boasted of his military exploits, could not wriggle out of signing up without horrible embarrassment. By the time he reached Chile in March of 1866, the fighting man had evaporated and the artist had taken over. Wisely, he merely watched the military maneuvers—and painted.

Whistler was entranced by Valparaiso's beautiful harbor, which seemed to cradle the resting ships of the Spanish, British, and American fleets. He made several

pictures of vessels sailing from the harbor into the open sea. Valparaiso's misty atmosphere was captured by blending the colors of the sea, sky, clouds, and ships into each other and applying the paint in thin, liquid layers called washes. The subtle differences in substance and space come upon the viewer gently and gradually. Whistler's rendering of twilight, that indistinct time when the daylight fades and the night creeps over the landscape, was supremely original. What he had hit upon in Valparaiso—how to catch a transitory moment through understatement—would become indispensable to his art.

Whistler returned to England in late 1866, but the old problems were still awaiting him. He and his mother moved to 2 Lindsey Row (now 96 Cheyne Walk) in early 1867. He was reunited with Jo, but there must have been some patching up to do. Whistler left Jo alone for nearly a year, which she could not have liked. But while he was away she had gone to Paris to pose for Courbet, which may have helped to cushion Whistler's absence.

In April of 1867, Whistler went to Paris to view his work in two important exhibitions: the Salon of 1867, and the latest Exposition Universelle. In the latter, he was invited to show with the Americans after the British failed to ask him to exhibit with them. Whistler was miffed at being overlooked, and his long-standing quarrel with the English art world may have originated with this exclusion. In turn, his touchiness and pride were having an effect in Britain; it was during this time that Whistler had attacked Philip Hamerton after the critic sneered at *Symphony in White, No. 3*. As the artist's first biographers wrote, "Whistler's manner of resenting injury had a great deal to do with his future, and with the way he was treated in

ARRANGEMENT IN GREY: PORTRAIT OF THE PAINTER. *1872*

In this self-portrait, modeled after those by Rembrandt, Whistler's steady expression suggests his readiness to take on the world. The surface of the canvas reveals his habit of scraping down and reworking, but the overall results seem free of struggle. Note the butterfly signature in the background.

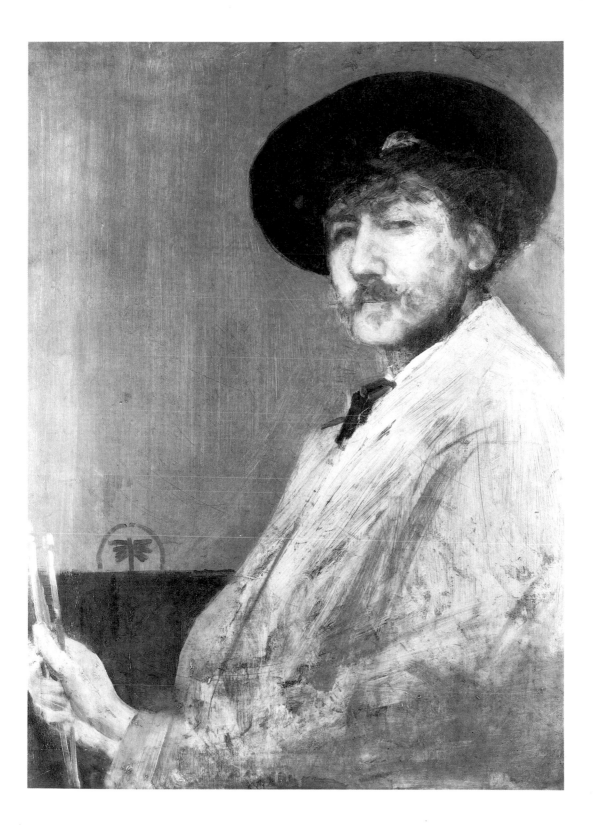

49

England. People who did not know him became afraid of him." They seized on their fear and dislike of the man as an excuse to dismiss his art.

In the studio Whistler was driving himself hard. Worried about his difficulties with drawing the figure, he spent the next two years working on large studies of idealized women wearing classical robes. He couldn't complete any of them. As a result, he had nothing to show at the Academy. Money was scarce, as Whistler had to rely on sales of his etchings and on advances against future work from understanding collectors. At one point Whistler was so broke that he couldn't afford a postage stamp, but he kept wrestling with the figure compositions. He was supposed to turn them over to his patrons, but the paintings did not meet his high standards. Whistler would never let any work he thought was poor out of his studio, even for money.

These struggles were hidden by the public image Whistler was now deliberately constructing for himself. Its roots were in the carefree pose he struck in Paris, but it was fed by his later insecurities. To hide his lack of confidence, Whistler learned to present a brave face to the world. He acted the part of the man who never faltered. Seen about town, he was a model of worldly elegance who seemed unaffected by pres-

Examples of butterfly signatures. A letter from Whistler usually bore a butterfly signature that summed up his feelings at the time. A butterfly drawn with outspread wings seems proud; another one shies away in disgust; another soars gracefully out of reach of its foes.

sure. His clothes, his monocle, and his lock of white hair advertised a man who gloried in being conspicuous. To stay in command, Whistler used his wit and charm as weapons, winning admirers to his cause, spearing his foes in print, and becoming famous in the process. The game Whistler played was phenomenally successful in that the art establishment accepted the image he projected. Yet wearing the mask had its price. Sometimes Whistler went to savage extremes to sustain his performance. Then his artistic achievement was overshadowed by his conduct. Whistler's public personality was often sarcastic and vain, but it was tempered by boldness, whimsy, and humor—which made it irresistible. Whatever Whistler was, no one could accuse him of being dull.

In about 1869, Whistler decided that a long signature across the bottom of a painting marred its design. He took his initials and worked them into a butterfly monogram. Whistler was overjoyed by the results. He could employ the butterfly not merely as a signature, but as a note of color or a compositional element. The butterfly and its possibilities so amused Whistler that he incorporated it into his overall public image. The emblem became as much a part of him as his monocle and his wide-brimmed hats. He signed his letters with it and even had it embossed on his silverware. In his correspondence, Whistler took great delight in cartooning the butterfly as a creature of many moods. It matched how he felt—dejected, lighthearted, or triumphant. For example, when Whistler skewered someone with his pen, the butterfly acquired a stinger, like a scorpion's.

Like the butterfly he adopted as a personal symbol, James Whistler was destined to undergo a great change. He would emerge from these years of experiment, and paint some of his most controversial and celebrated works.

51

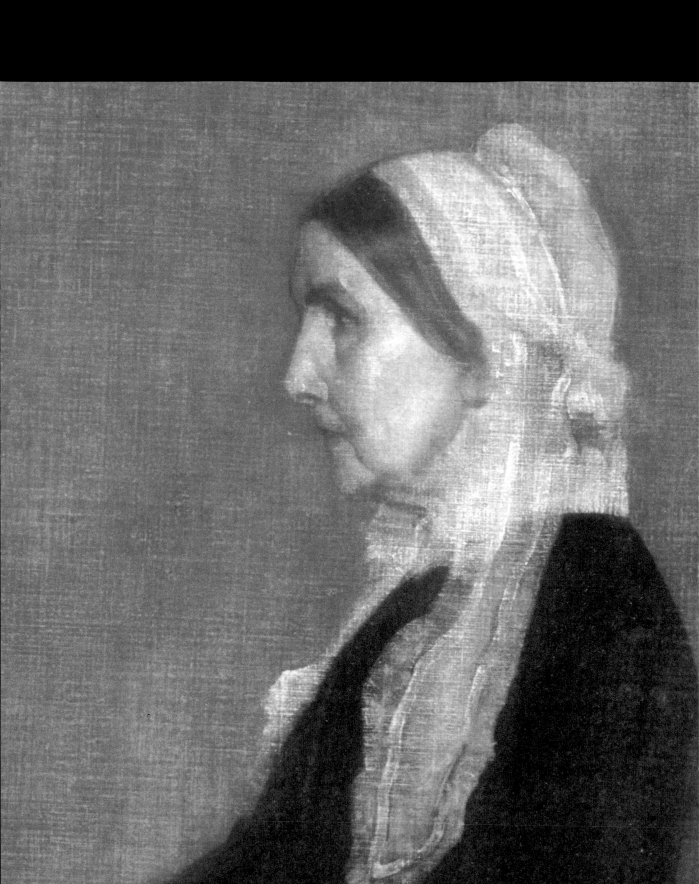

4

NOCTURNES, PORTRAITS, AND PEACOCKS

By 1871, Whistler was at the peak of his creativity. Frederick Leyland, a collector who had advanced money on the figure compositions, let Whistler abandon that agonizing project, and Whistler reacted as if he had been released from prison. Plunging into activity, he painted with gusto and gave parties at Lindsey Row. He soon became a colorful figure on the streets of London. His faith in himself renewed, Whistler was jauntier than ever.

Whistler's imagination was rekindled by the world around him. The Thames, always an inspiration, did not fail him now. Whistler finally could see that, in at least one phase of his art, he had matured completely. In the twilight impressions of Valparaiso, he had digested all of his sources and perfected a genre, a specific type of painting evocative of atmosphere and mood. In the early 1870s Whistler refined these discoveries further in choosing to paint Chelsea and the Thames by night. This was as inventive as it was daring—others had painted moonlit scenes, but Whistler was the first to convey the personality of a great city so strikingly. His images of the foggy gloom of London, with its faint lights and ghostly silhouettes, in a few touches of paint have influenced many later portrayals of the city.

ARRANGEMENT IN GREY AND BLACK: PORTRAIT OF THE PAINTER'S MOTHER. *(Detail)* *1871*

In composing his night scenes, Whistler united subject and style. After finding a view which pleased him, he would memorize it by heart, as if learning a poem, and then rush home to his studio to set up his palette. Whistler chose one or two prevailing tones and used them for the sky, air, and ground. He laid thin, dissolving washes of these shades on an absorbent canvas with long sweeps of the brush; in contrast, figures or points of illumination were flicked in with suggestive dots of pigment. Discussing the similarities between his night scenes and his portraits, which he also worked on late in the day, Whistler explained: "As the light fades and the shadows deepen, all the petty and exacting details vanish; everything trivial disappears, and I see things as they are, in great, strong masses. The buttons are lost, but the garment remains; the sitter is lost, but the shadow remains; the shadow is lost, but the picture remains."

Whistler was calling his new works Moonlights, but Leyland proposed Nocturnes, meaning not only related to the night, but also a dreamy, pensive composition for the piano. Whistler loved the pun and its tie with music. Thanking Leyland for the term, he wrote, "You have no idea what an irritation it proves to the critics and consequent pleasure to me . . . and does so poetically say all I want to say and *no more* than I wish." Nevertheless, the critics continued to attach stories to the Nocturnes. For *Nocturne: Grey and Cold—Chelsea Snow*, one writer picked out a figure in the foreground and said that the painting was about a traveler heading toward a well-deserved rest. Whistler felt as if he were banging his head against a brick wall. He fired back, "I care nothing for the past, present, or future of the black figure, placed there because the black was wanted at that spot. All that I know is that my combination of grey and gold is the basis of the picture."

Because the Nocturnes were understood by so few, Whistler turned to portraiture. He was hired to paint a young girl, and the work was in progress in June of 1871. The girl got tired of posing because Whistler demanded so much of her time, and one day she stopped coming. However, Whistler was eager to paint, and on an impulse he called out to his mother and said she must come to the studio at once. He was going to paint her not for the money, but for his own pleasure.

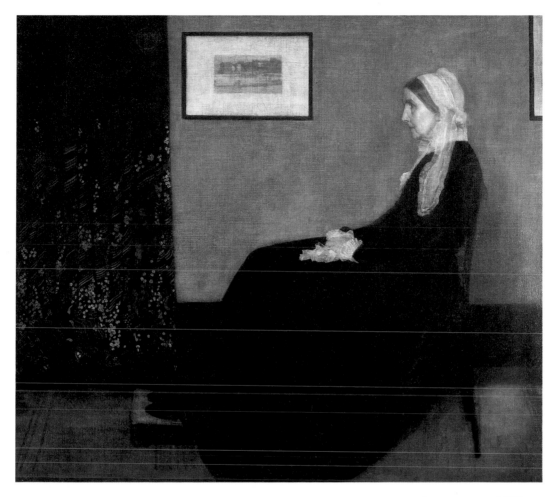

ARRANGEMENT IN GREY AND BLACK: PORTRAIT OF THE PAINTER'S MOTHER. *1871*
Whistler's portrait of his mother became his most famous work. After it was shown
in the United States, he was besieged with invitations to visit America. Whistler
declined them with regret, saying, "One hates to disappoint a continent."

Anna was proud and flattered to be painted by her son, as her days of fighting his
choice of career were long over. After Whistler had established himself as a pro-
fessional artist, Anna was persuaded that James was not only serious and deter-
mined, but gifted. From then on, she believed in her son as loyally as any mother,

saying, "God has given him the talent, and it cannot be wrong to appreciate it."

Anna would need all the appreciation she could summon, for posing for Whistler was an ordeal. His ceaseless perfectionism and his method of portraiture could translate into seventy or eighty sittings per canvas. Leyland called his sessions with Whistler "my own martyrdom." Whistler could not build up a composition gradually, section by section. If he did not get the effect he wanted at the end of a sitting, he scrapped what he had done. The new paint was scrubbed off, and the next session would begin at the same point as the previous one. On the other hand, when the work was going well, Whistler would get so involved in what he was doing that he would forget about the exhausted sitter, who would hold one pose for three or four hours. Anna Whistler, who was then in her late sixties, stood for two or three days without complaint. Finally, she asked if she might sit down for a while. Whistler, suddenly ashamed at his thoughtlessness, put his mother into a chair and pushed a footstool under her feet. And there it was—the pose he had been looking for.

Throughout the summer of 1871, Anna sat in the studio and Whistler spent hours at the easel. When he cried out, "No! I can't get it right! It is impossible to do it as it ought to be done!", she would lift her eyes heavenward and pray that the crisis would soon pass. There were many of these outbursts, but at the end of the summer, she heard him say, "Oh, Mother, it is mastered, it is beautiful!" Anna then saw herself—sober and dignified, but without any nostalgia or tearful emotion. She sat as she was, silhouetted in profile against the gray walls of her son's studio, with a patterned curtain and a Thames etching in the background. Whistler was unaware that his likeness of his mother would become one of the most famous portraits in Western art, but he knew he had succeeded in his task.

So it was with high hopes that he submitted the portrait to the Royal Academy's spring exhibition of 1872. But the Academy members thought the picture dull, and put it in a poor location. The hanging committee was proceeding to crowd other paintings around it, when William Boxall, the artist who had painted Whistler when he was a boy, threatened to resign unless the picture was given

more space. In other words, Boxall's influence was the reason Whistler's painting was done some justice, and everyone, including Whistler, knew it.

Furthermore, Whistler was counting on the portrait to get him into the Academy, but he was not elected. Whistler was deeply wounded by the rejection. After all, he was an exceptional artist, more original than any member of the Academy, but these mediocrities used their power to say he was not their equal. By denying him membership, the Academy also deprived Whistler of much potential income. The market for contemporary art in London was thriving, and an artist in the Academy's ranks could make money in it. When he was lucky, Whistler received several hundred pounds for a canvas, and always from an individual buyer. In contrast, fashionable academicians charged thousands of pounds for a picture, which they often sold to a public gallery. For example, British museums clamored for works by the immensely popular John Millais, a pillar of the Academy. In his prime, Millais made between twenty and forty thousand pounds a year, the equivalent of several million dollars in today's money. The print departments of British institutions bought Whistler's etchings, but his first sale of a painting to a museum did not occur until 1891, when he was fifty-six.

After 1872, Whistler never exhibited another painting at the Academy. He couldn't forget the poor reception of the portrait of his mother or his own exclusion from membership. From then on, the Academy was a fat target to be punctured by zestful verbal darts that were made for being quoted in the gossip columns. Whistler had reason to complain, but his cutting attacks alienated people. Not a practical man, and bent as he was on avenging every rebuff, no matter how slight, it was becoming obvious that Whistler not merely relished quarreling, but thrived on it. Fighting and feuding stoked his creative energies; they helped him defend his work and persevere in it. Until "official" understanding came, Whistler exhibited in the new galleries that were cropping up in London to accommodate him and other artists who felt frozen out of Academy shows.

There were upheavals in Whistler's private life, too. In 1869 Whistler had an affair with a parlormaid named Louisa Hanson, and on June 10, 1870, a son,

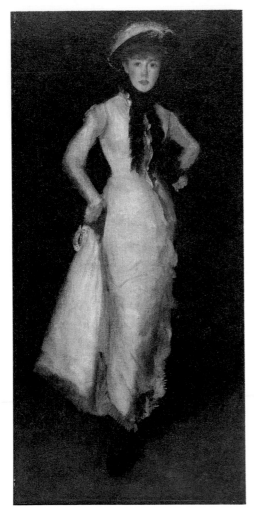

ARRANGEMENT IN BLACK AND WHITE. *c. 1876*
Maud Franklin replaced Joanna Hiffernan
in Whistler's life. Because Whistler had
trouble painting hands, he devised many
clever ways to avoid putting them in.
Here, they are bent back behind
Maud's wrists.

Charles Hanson, was born. Whistler called Charles "an infidelity to Jo," but Jo herself took charge of the baby. While Charles was still an infant, Jo and Whistler separated for good, yet Jo became the boy's guardian. She raised him, presumably with money from Whistler, because Charles was well-educated and sometimes visited his father. In fact, when he grew up, he became Whistler's secretary for a while. By our standards, Whistler was not a good parent, because he neglected his son. But by the standards of his time he did his duty—he said the boy was his and provided financial support. (In those days, illegitimate children were not often welcomed by their natural fathers.) And in 1873, Maud Franklin, an auburn-haired Englishwoman, replaced Jo as Whistler's mistress and chief model. Maud was spirited, graceful, and good at managing Whistler's always tangled business affairs.

None of these domestic rearrangements fazed Whistler, who was completely absorbed in a portrait that has been justly acclaimed as a masterpiece. Thomas Carlyle, the eminent Scottish historian and philosopher, lived in Chelsea, and he had liked the portrait of Anna Whistler. In 1872 he agreed to sit for Whistler, and

when he arrived, he declared, "Fire away, mon!" But Carlyle did not have Anna's endless patience, and Whistler would scream at him not to move. Carlyle, a stern man of seventy-seven, sized up the thirty-eight-year-old Whistler as an affected, chattering fop. He thought he would go mad from Whistler's scraping off and starting over. Carlyle was also angry and puzzled by Whistler's concentration on modeling the coat correctly, as if the face didn't count. But Whistler was right—the shape of the coat contributes to the picture's mass and vigor, and Carlyle's face, a vibrant patch of color amid the dark tones, speaks of the inner man. For all his trials, Carlyle changed his mind about Whistler when he saw that the finished canvas was devoid of puffed-up grandeur or posturing. Instead, he found a brilliantly plain portrait of power and insight that is unequalled in Victorian painting.

In August of 1875, Anna Whistler's doctors ordered her to leave London for her health. She moved to Hastings, on the Channel coast, where she lived until her death in 1881. After Anna's departure, Maud Franklin moved into the house and acted as Whistler's hostess at the breakfasts he gave nearly every Sunday. Whistler served American dishes—buckwheat pancakes were a specialty—and the talk ran to books, art, and gossip.

The guests also marveled at Whistler's decor. In a typical Victorian home, there could never be too many knickknacks. In his surroundings, as in his art, Whistler practiced restraint. There were a few pieces of furniture, but each was well-chosen, and the walls were either a subdued blue or gray. Leyland admired Whistler's taste, and in remodeling his London townhouse he consulted him.

Leyland had acquired an excellent collection of blue-and-white porcelain, and he wanted to display it, along with Whistler's *La Princesse du Pays de la Porcelaine* (The Princess from the Land of Porcelain), in his dining room. His architect had installed dark brown leather on the walls, and Leyland was unhappy with the results. Whistler offered to touch up the dining room, and Leyland advanced him four hundred pounds. Another six hundred would follow.

Whistler began in April of 1876, instructed to add some gold and yellow accents to the leather. But the changes were disappointing, and Whistler couldn't

leave the room as it was. His concept escalated from making a few alterations into creating an entire decorative environment. He covered the room in turquoise paint and gold leaf, in a pattern of exotic peacocks whose feathers and tails cascaded into showers of silver, blue, and gold. Whistler was intoxicated by the gorgeousness of his scheme, which had gone well beyond what Leyland had authorized.

As the weeks flew by, Whistler labored day and night, carried along by his own euphoria. As usual, when his work was going right, he could not see that anything he was doing might be objected to. Whistler took unpardonable liberties with Leyland by opening up his house and using it as his private club. The Peacock Room, as he named his work in progress, became the talk of the town. Whistler held teas there and received guests—some of the royal family even paid a visit.

Basking in his celebrity, Whistler held a press viewing on February 9, 1877, and had the gall to tell Leyland to stay away. "These people are coming not to see you or your house," he wrote. "They are coming to see the work of the Master, and you, being a sensitive man, may naturally feel a little out in the cold." The critics approved of the Peacock Room, but Leyland was furious. Whistler had covered up all traces of the brown leather and then sent Leyland huge bills for gold leaf and labor. Even worse, Whistler was playing the role of artistic genius while making Leyland out to be a dolt. Leyland had cause to be outraged, but Whistler could see things only from his own point of view. He had created something much more beautiful than what Leyland had expected. Therefore Leyland should overlook Whistler's behavior because of the marvelous results. Leyland was having none of this, but Whistler would not apologize—he saw himself as an unsung hero. In a cruel but prophetic letter, he wrote, "Ah, you should be grateful to me. I have made you famous. My work will live when you are forgotten. Still, perchance, in the dim ages to come, you may be remembered as the proprietor of the Peacock Room."

For the moment, however, Whistler lost almost as much as he gained, for the rupture between him and Leyland was permanent. In the summer of 1877, he was forbidden to enter Leyland's house, never to see the Peacock Room again during Leyland's lifetime. More important, he forfeited the friendship and finan-

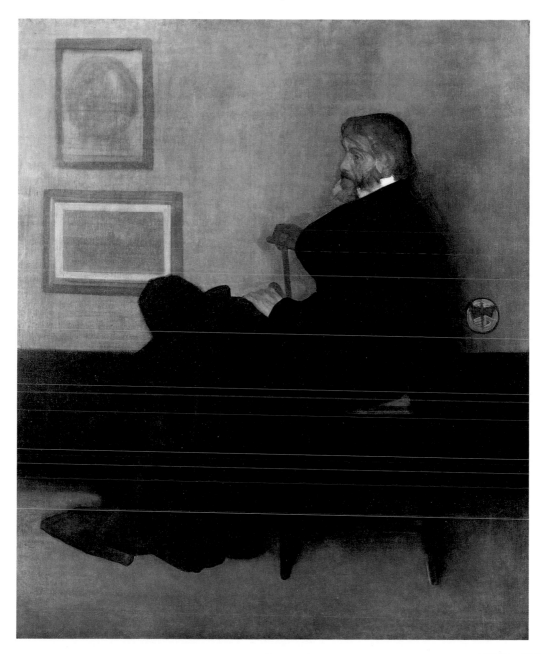

ARRANGEMENT IN GREY AND BLACK, NO. 2: PORTRAIT OF THOMAS CARLYLE. *1872–73*

After Whistler finished the portrait of his mother, he painted the writer Thomas
Carlyle in a similar yet more powerful pose. Whistler asked the National Portrait
Gallery in London to purchase the picture after Carlyle died, but he was laughed at.
No English museum bought a Whistler canvas during his lifetime.

61

cial support of a man who had helped him whenever he was lonely or destitute.

Whistler had behaved devilishly to Leyland, and the scandalous publicity might have sunk another man. But Whistler remained buoyant, never allowing his confident mask to slip. He was invited to be in the Grosvenor Gallery, a new venture opened by Sir Coutts Lindsay in 1877. The Grosvenor Gallery was planned as a showcase for progressive artists, and the inaugural exhibition had works by Rossetti, Burne-Jones, Millais, Edward Poynter, Whistler, and others. Whistler showed eight pictures, including a Nocturne called *The Falling Rocket*, an impression of a fireworks display at a public park in Chelsea. It didn't find a buyer, but the artist was a prime attraction at the reception. Wearing a long coat and swinging a cane, he strutted back and forth, chatting and joking.

Still embroiled in the Leyland affair, Whistler hadn't noticed the review of this exhibition by John Ruskin, the most important art critic in England. In the July 2, 1877, issue of a monthly pamphlet in which he broadcast his views on art and society, Ruskin reviewed the Grosvenor Gallery exhibition and found it wanting. After praising Burne-Jones and Millais, Ruskin warned that a grave mistake was made in including Whistler's *The Falling Rocket*. Whistler had painted the moment when the fireworks burst and began to disintegrate, which looked like daubs of nothing to Ruskin. The falling sparks were rendered by dynamic shots of color spattered and dripped across the dark background of the canvas. Such technical verve was lost on Ruskin. "For Mr. Whistler's sake, no less than for the protection of the purchaser," he thundered, "Sir Coutts Lindsay ought not to have admitted works into the gallery in which the ill-educated conceit of the artist so nearly approached the aspect of willful imposture. I have seen, and heard, much

PINK NOTE: THE NOVELETTE. *Early 1880s*
Maud Franklin is seen reading amid the understated surroundings of
Whistler's household.

of cockney impudence before now; but never expected to hear a coxcomb ask two hundred guineas for flinging a pot of paint in the public's face."

A few weeks after this diatribe appeared, Whistler and the artist George Boughton were at their club. Boughton was reading the paper when he came upon a report of Ruskin's remarks. He handed it to Whistler, who usually enjoyed roasting his adversaries. Boughton later said that he never forgot the look on Whistler's face as Ruskin's words sank in. After a few minutes, Whistler said, "It is the most debased style of criticism I have ever had thrown at me." "Sounds like a libel," Boughton suggested. "I intend to find out," Whistler replied, and stalked out of the club to get a lawyer.

HARMONY IN BLUE AND GOLD:
THE PEACOCK ROOM. *1876–77*
Whistler's grandest decorative scheme occupied him for much of 1876 and 1877. Whistler was described as "spending his days on ladders and scaffolding, lying, in a hammock, painting with a brush fastened to a fishing rod."

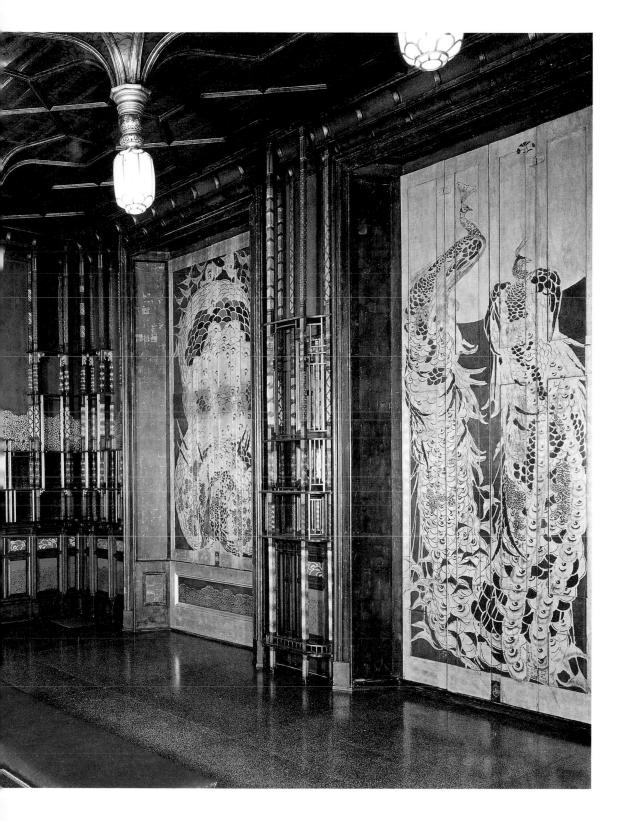

5

EXILE AND RETURN

On July 28, 1877, Anderson Rose, Whistler's counsel, filed a libel action against John Ruskin. He asked for one thousand pounds in damages, plus the costs of bringing the suit. Libel is a written statement published about someone without just cause and which exposes that person to public contempt. It is punishable by law. Rose contended that Ruskin had "greatly damaged Whistler's reputation as an artist." Thus the ground was laid for one of the most notorious courtroom cases of the nineteenth century.

Why did Whistler have to sue Ruskin when normally a caustic letter or a biting quip served his purposes? Ruskin had said he was an impostor, implying that what he created was not art. Such a violent condemnation by a writer of Ruskin's stature could endanger Whistler's standing as an artist and discourage buyers. Ruskin summarized *The Falling Rocket* as some smears of paint thrown against a canvas, which Whistler could not allow. The taunts that had first plagued him in Paris and then followed him to London were expertly played upon by Ruskin. Whistler was ultra-sensitive to the charges that he did not work, that he was lazy because he did not stuff his canvases with details, that he did not give value for money. The notion of his "flinging" paint around was intolerable. Only he knew the full extent of the planning and revising he lavished on an oil painting to make it look as if no labor had been involved. For Whistler in particular, years of study and invention would count for nothing if Ruskin went unchallenged. For artists in general, the right to render appearances in any way they saw fit was being

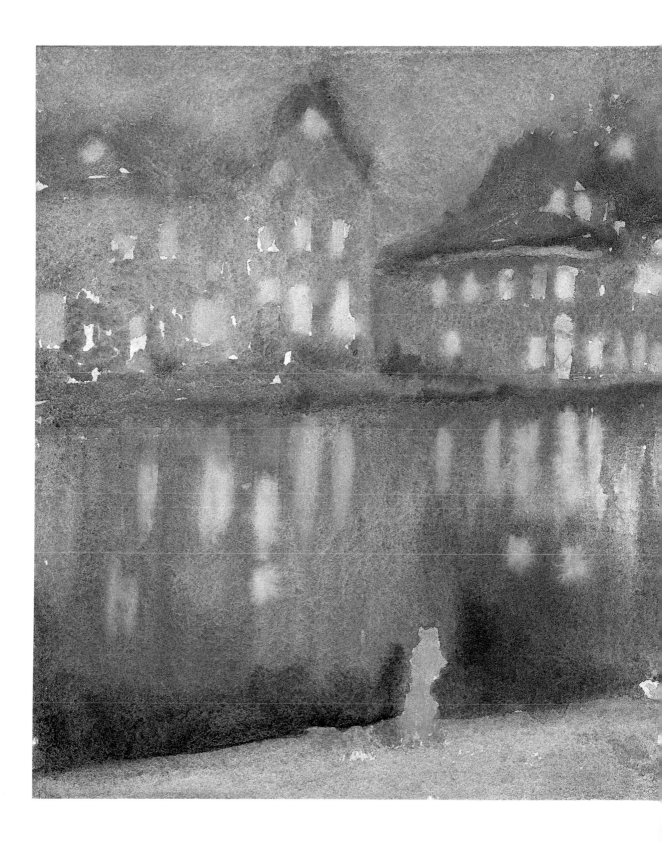

(left) NOCTURNE: GRAND CANAL,
AMSTERDAM. *1883–84*
In this extraordinary watercolor,
paint floats and spreads in all
directions, conveying the excitement
and unpredictability of the medium.
Working at top speed, Whistler
needed to control both the pattern he
made by lighted windows and
reflections and the large, ghostly
shapes of the buildings.

(right) NOCTURNE: GREY AND GOLD — CHELSEA SNOW, *1876*
Whistler was told that if he gave this painting a nice, instructive title, he could sell it for a good sum of money. He wouldn't—and didn't.

73

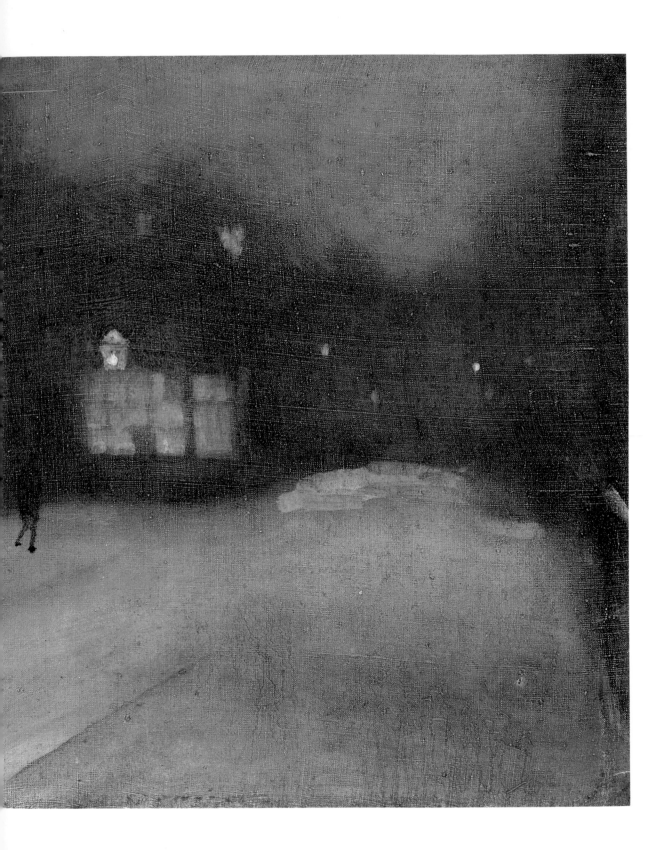

threatened.

The trial was delayed many months because Ruskin was mentally ill and on the verge of collapse. While Whistler waited, he collaborated with Edward Godwin, an architect he had known since the 1860s. The lease on the house in Lindsey Row was almost up, and Godwin offered to design a house for Whistler on a plot of land available on Tite Street, a few blocks away. Whistler was agreeable—he probably had a few hundred pounds left over from the Peacock Room, and he planned to pay the rest with profits from a school he was going to open. His budget was two thousand pounds, but Godwin and his contractor submitted bills for more than thirty-six hundred pounds, and Whistler was in alarming debt. Sales of his paintings were poor; buyers were awaiting the outcome of the trial. What he did sell did not benefit him much, because he had entrusted his work to an agent who was cheating him. Winning his suit now meant survival.

Whistler v. Ruskin came to trial on November 25, 1878. Ruskin was too ill to appear, but he helped line up authorities to swear that Whistler's work was a sham. Whistler was having no such success in securing witnesses. Many artists would not cross Ruskin for fear of jeopardizing their own positions. Others could hardly wait for Whistler to get his comeuppance. They felt that his arrogance and pugnacity deserved a fall, even if his cause was just. Many appeals later, Whistler found three people who would testify for him.

Whistler's counsel opened the proceedings by saying that the artist had long maintained an independent stance, and whether or not his ideas seemed eccentric, they should not be treated with contempt. As a professional artist, Whistler had suffered great injury by being labeled an impostor. Whistler was then asked to challenge Ruskin's statements. He disputed the charge that he was a "cockney" (a cheeky upstart, and a real insult for anyone as status-conscious as Whistler) by stating that he was born in St. Petersburg. This, of course, was false, but it was passed over. Then, to disprove that he was a foolish, ignorant "coxcomb," Whistler described his art studies in Paris. Finally, he testified that since the publication of Ruskin's review, he had not sold any Nocturnes at his asking price of two hun-

dred guineas (two hundred and ten pounds).

Then Ruskin's counsel, Sir John Holker, cross-examined Whistler on *The Falling Rocket.* "Is two hundred guineas what we would call a stiffish price?" Sir John inquired. "Very likely," rejoined Whistler, amid much laughter. A later question was another opportunity for a riposte. "Do artists endeavor to get the highest price for their work, irrespective of value?" "Yes," Whistler said, accompanied by more laughter, "and I am glad to see the principle so well-established." Sir John pressed on. "You send pictures to the gallery to invite the admiration of the public?" "That would be such vast absurdity on my part," Whistler replied, "that I don't think I could."

This amiable jousting continued until Sir John zeroed in on how long it took Whistler to execute *The Falling Rocket.* After he said "two days," Sir John, sure he had his prey, delivered the climactic blow: "And for the labor of two days, you ask two hundred guineas?" "No," Whistler retorted, "I ask it for the knowledge of a lifetime." Whistler struck a chord, even among the most unsympathetic spectators. The courtroom burst into applause.

Whistler concluded his testimony by saying that he had executed *The Falling Rocket* conscientiously. It was worth the price he had asked, and he would stake his reputation on it, or indeed, on any of his other works. He was followed by his three witnesses, who assured the court of his originality and ability as an artist. At the end of the day, the judge came out solidly for Whistler—Ruskin's review, he agreed, had exposed his work to ridicule and contempt. It was up to the defense to prove that it was fair and honest criticism.

The trial caused a furor, and on the second day the courtroom was packed. After Sir John argued that Whistler's paintings were not worthy of being called art, he summoned Ruskin's witnesses. First came Edward Burne-Jones, whom Whistler had thought of as a friend. He found Whistler's self-publicizing distasteful and condemned the work because "there is not so much appearance of labour in one of his pictures as there is in a rough sketch by another artist." Next on the stand was William P. Frith, an academician who turned out minutely painted crowd scenes.

He swore that Whistler's Nocturnes weren't serious works of art and compared them to wallpaper. Appearing last, Tom Taylor, art critic of *The Times*, implied that Whistler's paintings were worthless.

Closing arguments were made, and the jury began its deliberations. Eighty minutes later, it returned a verdict: Ruskin was found guilty of libel. Whistler won the case, but he was awarded damages of one farthing—one quarter of a penny, the smallest coin in the land. By this gesture, the jury suggested that the case should never have come to trial. Because the award was nominal, the judge declined to award Whistler the costs of bringing the suit. So in his battle against Ruskin, Whistler's victory was hollow. He was jubilant about winning, but he was financially ruined.

Instead of collecting a thousand pounds, plus the four hundred consumed by

the case, Whistler owed his lawyer and the court over five hundred pounds, and he still had to pay Godwin. Then the tradesmen of Chelsea descended. Whistler had stalled the grocer and the fishmonger with expectations of winning a thousand pounds from Ruskin. When they heard about the verdict, they closed in.

Whistler had never been so desperate. Within a year of his moving into his new house, creditors were on the point of seizing it and everything he owned. (Meanwhile, Whistler's rascally agent continued to make money.) And Maud was pregnant, for the second time in two years. One daughter, Ione, is thought to have been born in 1877; this one, Maud, was born in February of 1879. Neither parent must have wanted these children, but Maud later took responsibility for them. Whistler's household goods and some of his Japanese and Chinese art were auctioned off on May 7, 1879, but the proceeds didn't cover his debts. Whistler was

forced to declare bankruptcy, meaning that all of his possessions were turned over to his creditors. His house was put on the market, and another auction was scheduled. Many of the pictures were lost forever. The house was sold for twenty-seven hundred pounds in September of 1879, which essentially cleared Whistler's debts.

Penniless and homeless, Whistler faced complete artistic and financial humiliation. His bankruptcy was public knowledge and his career was shattered, but he refused to be broken. In public, Whistler's poise did not wilt. Telling Rossetti that he was in high spirits and full of plans, Whistler gratefully accepted a commission from the Fine Art Society, a commercial print gallery. He was offered six hundred pounds, plus expenses, to go to Venice and produce twelve etchings of the city. What choice did Whistler have? Having no place to live, and with little more than the

BEAD STRINGERS, VENICE. *1879–80*
Glass has been made in Venice for thousands of years, and stringing glass beads into necklaces and chains was a job often taken by women. Whistler's desire to show the bead stringers at work took him into the dark, narrow streets of the city's poorer quarters.

clothes on his back, he fled London in September of 1879.

The three months Whistler was supposed to spend abroad stretched into fourteen. He was determined to find a Venice that no one else had ever seen, so he spent his first weeks walking around and absorbing the atmosphere. He and Maud lived and worked in one room. They wore the same clothes over and over until Whistler's jackets and Maud's dresses were in tatters. They shivered through one of the coldest winters ever recorded in Venice. Whistler roamed the streets for hours, a copper plate and an etching needle clutched in his frozen hands.

But the privations were worth it. Whistler did find his own Venice, in out-of-the-way parts of the city far from the tourist haunts. He recorded his impressions in fifty etchings and more than a hundred pastels and watercolors that shimmered with bold, vibrant color. Whistler drew the crumbling palaces, the lagoons, and the doorways leading into shadowy courtyards. As with the French and Thames sets, he focused on ordinary people as they scratched out a living in the streets or workshops. His style was so original that it shocked more orthodox etchers. To convey the vaporous atmosphere of Venice, Whistler didn't wipe all the ink off the unmarked areas of his plates. The filmy residue registered as mist, moonlight, or a cloudy day. This was a remarkable achievement—Whistler had duplicated in his prints the tonal effects he attained in his oil paintings.

Although happy with what he was accomplishing in Venice, Whistler missed London terribly. Yet he could not go back until he had enough first-rate work to silence his enemies and reestablish himself. In November of 1880, Whistler and Maud returned, and the Venice etchings were exhibited a month later. The reviews were mixed, but people began to buy. The pastels, shown in January of 1881, were a financial, critical, and social success. The opening was standing-room only, and within a few days, sales topped a thousand pounds. Whistler was flying high.

London, the scene of Whistler's defeat, was once more his battleground. The wounds of the past five years were not healed by the triumph of a well-received show. Nor should it be forgotten that Whistler was in the miserable position of having to buy back his own works from the creditors who received them after he

HARMONY IN RED :
LAMPLIGHT. *1884–86*
Beatrice Godwin, who
was called Trixie for
short, married Whistler
in 1888. Her pleasure
in posing for him
shines through in
this portrait.

went bankrupt. He used some of the profits from the pastels to redeem his pictures and repay outstanding debts.

Whistler was convinced that most of the world was against him. True, the English critics had been all too eager to write him off, but he had brought many of his troubles on himself. With West Point strictness, he insisted on absolute loyalty and unreasonable allegiance. Anyone could suddenly be reclassified as a foe. When Whistler caught a friend speaking to Edward Burne-Jones, who had testified for Ruskin, he became incensed.

Although his actions seemed to deny it, Whistler still hoped for acceptance by English art officials, and was greatly affected by their snubs. In 1882, he asked the National Portrait Gallery in London to purchase his portrait of Carlyle. The director laughed and said, "Is this what painting has come to?" In France, however, the tide was turning. He had several successful exhibitions and earned enthusiastic reviews. In response, Whistler began living in Paris for months at a time. There he renewed his acquaintance with the painters Edgar Degas and Claude Monet, both of whom respected his work. He also became close to a group of French writers who were similarly appreciative. In London, Edward Godwin had remained an ally, and between 1884 and 1886, Whistler began a portrait of his wife, Beatrice. Called Trixie for short, she was an artist herself, strong-minded and exuberant. Trixie and Whistler got along splendidly, which Maud noticed. Before long, the two women hated each other.

During this time Whistler grew increasingly engrossed in championing his own cause and settling old scores. Sometimes he punished pompous criticism immediately, shooting off a scathing comment to the editor of a newspaper. These lines would often be published on the front page, and the victim squirmed helplessly under the Butterfly's assaults. The stupidest passages were carefully saved for future retaliation. After Whistler collected enough of these snippets, he printed them up in a catalogue, using the critics' own words against them. With these broadsides, Whistler flattened his foes and created controversy and publicity for himself.

Whistler also dedicated himself to spreading the art-for-art's-sake gospel he had proclaimed during the 1860s and which culminated in the Ruskin trial. Some of his fervor stemmed from a passion for justifying his views. But remembering the scorn he had endured, Whistler was indignant that several of his ideas were being promoted more successfully by the writer Oscar Wilde, whom Whistler had befriended and encouraged. Whistler felt that Wilde was stealing his best lines, which was the source of a famous exchange. After an exceptionally clever Whistler remark, Wilde said admiringly, "I wish I said that." "You will, Oscar," Whistler nodded, "you will."

On October 6, 1886, Edward Godwin died. Afterward, Trixie became a regular visitor to Whistler's studio. Maud was enraged at Trixie's interest in the man she had shared her life with for fourteen years, the man she had stayed with when he had lost everything. But Whistler was fond of Trixie and getting tired of Maud. Maud made a fatal error when she left—temporarily, she thought—to visit some friends. In her absence, Whistler married Trixie on August 11, 1888. Maud, who didn't deserve such heartless treatment, moved to Paris and survived by selling drawings and prints Whistler had given her.

A first-time bridegroom at fifty-four, Whistler found great happiness in his marriage. Trixie, in her early thirties, was equally devoted, and a welcomely cheerful influence. She curbed her husband's excesses by soothing him out of his worst moods and advising moderation. Whistler would never leave off sharpening his wits on art officialdom, but Trixie reined him in a little. The Whistlers were an excellent team, and they looked forward with confidence to the coming years.

6

THE GENTLE ART OF
VINDICATION

By 1890, Whistler's horizons had expanded well beyond England. He had shown extensively and to much acclaim in Austria, Belgium, France, Germany, and the United States. As an artist with an international reputation, he led progressive British painters to look beyond national boundaries and examine the rich artistic climate abroad. And from across the ocean, Charles Lang Freer, a Detroit industrialist and art lover, came to London to meet Whistler and assemble the largest single collection of his work in private hands. Would the Butterfly's sting become blunted by age, acceptance, and financial security?

The answer, of course, was no. Whistler's desire to be talked about was still keen. And to cease hostilities altogether would be to admit that he had been mistaken about all that he had fought for. Besides, a new generation of English artists had appeared, and they were charmed by Whistler's verbal swordplay. They rallied around him as a symbol of rebellion against a still-provincial English art world.

In 1889, Sheridan Ford, an American journalist, realized that a volume of Whistler's collected public statements, letters, and interviews would have wide appeal. Ford was given permission to gather material for the project, which would

HARMONY IN GREY AND GREEN: MISS CICELY ALEXANDER. *(Detail)* *1872–73*

essentially be a record of Whistler's protests and quarrels. As the work advanced, Whistler realized that Ford stood to make a handsome sum of money at his expense. As Ford pointed out, if each of Whistler's enemies purchased a copy, the first edition would be sold out in a week.

Whistler withdrew his authorization, discharged his unlucky collaborator, and prepared his own version. Published in June of 1890 as *The Gentle Art of Making Enemies,* the book made a great splash. Londoners chuckled over the accounts of old controversies—often altered in Whistler's favor—and his mocking replies. His spat with Hamerton, his skirmishes with Wilde, and his testimony at the Ruskin trial all made lively reading. Whistler adored *The Gentle Art,* and he had no trouble living up to the title. During the 1890s, he was involved in four lawsuits.

In early 1891, the city of Glasgow acquired the portrait of Carlyle for its art

gallery. It was the first painting by Whistler to enter a museum. This important purchase was followed by an even more prestigious one—the French government bought the portrait of Whistler's mother for the nation. Whistler exulted at this accolade. A picture of his was on its way to the Louvre, his ultimate standard of greatness.

Seeing that Whistler's stock was rising, the Goupil Gallery in London offered to hold an exhibition surveying his entire career. The show opened on March 21, 1892, and the artist expected the usual disdainful reactions. The critics were not only highly favorable, but vehement in how badly Whistler's work had been misjudged. The overwhelming opinion was that England had been unfair to an important talent.

THE LITTLE ROSE

OF LYME REGIS. *1895*

This portrait of eight-year-old Rosie Rendall is notable for its lively brushwork and glowing colors. Even at this stage of his work, Whistler felt that Rosie's warmth and directness represented a new breakthrough. "An artist's career always begins tomorrow," he said.

Whistler was vindicated, but the English gave offense again. Now that good reviews were being heaped upon his canvases, collectors rushed to sell them. They reaped huge profits, while the artist watched in disgust. Whistler hated the idea of England having any more of his work. He urged Freer to acquire as many examples as he could and remove them to the United States. And another American provided Whistler with a very sweet reward. In 1892, *The Falling Rocket* was sold to a New York buyer for eight hundred and forty pounds, or four times the price asked by the Grosvenor Gallery in 1877. Whistler crowed to his publisher that the picture went for "four pots of paint," and demanded that the news be sent to Ruskin.

The Whistlers' contentment was cut short as Trixie began to feel sick and weak. The couple consulted several specialists in late 1894, but Trixie only got worse. No doctor could have done anything; the diagnosis was stomach cancer, which was then an untreatable disease. Trixie went through two years of excruciating pain and suffering as the cancer spread. Watching Trixie waste away, Whistler was beside himself with grief. The end came on May 10, 1896. After Trixie was pronounced dead, Whistler rushed into the street, his hair flying. When a passerby he knew went up to him, Whistler cried out, "Don't speak, don't speak! It's terrible!" and ran away in despair.

Whistler never got over Trixie's death. He survived it by throwing himself into a round of activities. In 1898, a former model of his opened an art school in Paris, and Whistler offered to conduct visits, which brought in hordes of students. He had good intentions, but work and travel took priority over classes, and the school folded in 1901. In 1898 and 1899, as head of an international artists' society, Whistler directed two major art exhibitions in London. By accepting work by Manet, Rodin, Monet, Bonnard, Redon, Vuillard, Cézanne, and Toulouse-Lautrec, he again upheld the cause of modern art in England.

Whistler still reacted with glee if a tease of the Royal Academy could be pulled off, as when a letter arrived addressed to him at "The Academy, England." By the time the letter reached him, someone had written on the envelope, "Not known at the R. A." Whistler mailed the envelope to a newspaper for publication, adding,

BY THE BALCONY. *1896*
*As Whistler watched Trixie
fade away, he recorded her
image to help keep his
mind off the loss to come.*

"It is my rare good fortune to be able to send you an unsolicited, official, and final certificate of character."

Whistler worked on until his own health was undermined by various heart and chest ailments. During the summer of 1902 he became dangerously ill, and a London paper prematurely ran an obituary. Few people can have gotten more mileage out of their own death than Whistler, who saw that he was in the delicious position of being able to torment his foes from beyond the grave. Oozing politeness, he sent a letter to the editor correcting the errors in the article and saying how much it had improved his health.

The correspondence was a brilliant parting shot, but it did mark one of the Butterfly's last flutters in the spotlight. Throughout the next year, Whistler's physical condition deteriorated, and he died on July 17, 1903. He was buried in Chiswick Cemetery, near the river Thames. His grave is near the tomb of William Hogarth, Whistler's first idol, and perhaps the only English artist whose company he would enjoy having for eternity.

LIST OF ILLUSTRATIONS

PAGE 49: *Arrangement in Grey: Portrait of the Painter.* 1872.
Oil on canvas, 29$^{1}/_{2}$ x 21". The Detroit Institute of Arts; Bequest of Henry Glover Stevens in memory of Ellen P. Stevens and Mary K. Stevens

PAGES 50—51: *Butterfly Signatures.*
Courtesy the Freer Gallery, Smithsonian Institution, Washington, D.C.

PAGE 52 (detail) and PAGE 55: *Arrangement in Grey and Black: Portrait of the Painter's Mother.* 1871.
Oil on canvas, 57 x 64$^{1}/_{2}$". Musée d'Orsay, Paris

PAGE 58: *Arrangement in Black and White.* 1876.
Oil on canvas, 75$^{3}/_{8}$ x 35$^{3}/_{4}$". Courtesy the Freer Gallery of Art, Smithsonian Institution, Washington, D.C.

PAGE 61: *Arrangement in Grey and Black, No. 2: Portrait of Thomas Carlyle.* 1872—73.
Oil on canvas, 67$^{3}/_{8}$ x 56$^{1}/_{2}$". Glasgow Art Gallery and Museum

PAGE 62: *Pink Note: The Novelette.* Early 1880s.
Watercolor on paper, 9$^{15}/_{16}$ x 6$^{1}/_{8}$". Courtesy the Freer Gallery of Art, Smithsonian Institution, Washington, D.C.

PAGES 64—65: *Harmony in Blue and Gold: The Peacock Room (Northeast Corner).* 1876—77.
Oil paint and gold leaf on leather and wood, 167$^{5}/_{8}$ x 398 x 239$^{1}/_{2}$". Courtesy the Freer Gallery of Art, Smithsonian Institution, Washington, D.C.

PAGES 67—68: *Nocturne: Grand Canal, Amsterdam.* 1883—84.
Watercolor on paper, 9 x 11$^{1}/_{4}$". Courtesy the Freer Gallery of Art, Smithsonian Institution, Washington, D.C.

PAGE 69: *Nocturne in Blue and Gold: Valparaiso Bay.* 1866.
Oil on canvas, 29$^{3}/_{4}$ x 19$^{3}/_{4}$". Courtesy the Freer Gallery of Art, Smithsonian Institution, Washington, D.C.

PAGES 70—71: *Crepuscule in Flesh Colour and Green: Valparaiso.* 1866.
Oil on canvas, 23 x 29$^{3}/_{4}$". The Tate Gallery, London

PAGE 72: *Nocturne in Black and Gold, the Falling Rocket.* c. 1874.
Oil on wood panel, 23$^{3}/_{4}$ x 18$^{3}/_{8}$". The Detroit Institute of Arts; Gift of Dexter M. Ferry, Jr.

PAGES 73—74: *Nocturne in Grey and Gold: Chelsea Snow.* 1876.
Oil on canvas, 18$^{5}/_{8}$ x 24$^{5}/_{8}$". Fogg Art Museum, Harvard University Art Museums; Bequest of Grenville L. Winthrop

PAGE 77: *Cabinet Portrait of John Ruskin and William Bell Scott with Dante Gabriel Rossetti.* c. 1860.
Photograph by Willian Downey. Hulton Deusch Collection, London

PAGE 78: *San Giovanni Apostolo et Evangelistae.* 1880
Pastel, 11$^{13}/_{16}$ x 8$^{11}/_{16}$". Courtesy the Freer Gallery of Art, Smithsonian Institution, Washington, D.C.

PAGE 79: *Bead Stringers, Venice.* 1879—80.
Pastel, 10$^{7}/_{8}$ x 4$^{5}/_{8}$". Courtesy of the Freer Gallery of Art, Smithsonian Institution, Washington, D.C.

PAGE 81: *Harmony in Red: Lamplight (Beatrice Godwin).* 1884—86.
Oil on canvas, 75 x 35$^{1}/_{4}$". Hunterian Art Gallery, University of Glasgow; Birnie Philip Gift

PAGE 85 (detail) and PAGE 86: *Harmony in Grey and Green: Miss Cicely Alexander.* 1872—73.
Oil on canvas, 74$^{3}/_{4}$ x 38$^{1}/_{2}$". The Tate Gallery, London

PAGE 87: *The Little Rose of Lyme Regis.* 1895.
Oil on canvas, 20$^{1}/_{4}$ x 12$^{1}/_{4}$". Courtesy the Museum of Fine Arts, Boston; William Wilkins Warren Fund

PAGE 89: *By the Balcony (Trixie at the End of Her Life).* 1896.
Etching, 8$^{1}/_{2}$ x 5$^{1}/_{2}$". Courtesy of the Freer Gallery of Art, Smithsonian Institution, Washington, D.C.

PHOTOGRAPH CREDITS: Art Resource, New York ©The Tate Gallery, London: pages 85 (detail), 86; Service Photographique, Réunions des Musées Nationaux, Paris: pages 36, 52 (detail), 55; Rick Stafford ©Fogg Art Museum, Harvard University Art Museums: pages 73—74.

INDEX

Los números

Numbers

0 cero *seh-roh* zero	**10 diez** *DE'ES* ten	**20 veinte** *BAYN-teh* twenty
1 uno *OO-noh* one	**11 once** *ON-seh* eleven	**21 veintiuno** *bayn-tee-OO-noh* twenty-one
2 dos *DOSS* two	**12 doce** *DOH-seh* twelve	**30 treinta** *TRAYN-ta* thirty
3 tres *TRESS* three	**13 trece** *TREH-seh* thirteen	**40 cuarenta** *koo'ah-REN-ta* forty
4 cuatro *KOO'AH-troh* four	**14 catorce** *ka-TOR-seh* fourteen	**50 cincuenta** *seen-KOO'EN-ta* fifty
5 cinco *SEEN-koh* five	**15 quince** *KEEN-seh* fifteen	**60 sesenta** *ses-SEN-ta* sixty
6 seis *SAYSS* six	**16 dieciséis** *de'eh-see-SAYSS* sixteen	**70 setenta** *se-TEN-tah* seventy
7 siete *SEE-EH-teh* seven	**17 diecisiete** *de'eh-see-SEE'EH-teh* seventeen	**80 ochenta** *o-CHEN-ta* eighty
8 ocho *O-choh* eight	**18 dieciocho** *de'eh-see-O-cho* eighteen	**90 noventa** *noh-BEN-ta* ninety
9 nueve *NOO'EH-beh* nine	**19 diecinueve** *de'eh-see-NOO'EH-beh* nineteen	**100 cien** *SEE'EN* one hundred

Acknowledgments • Agradecimientos

DK would like to thank the following people: Sarah Ponder and Carole Oliver for design help; Marie Greenwood, Jennie Morris, Anna Harrison, and Lucy Heaver for editorial help; Angela Wilkes for language consultancy; Katherine Northam for digital artwork; Rose Horridge for picture research; Rachael Swann for picture research assistance; and Hope Annets, Mary Mead, Bethany Tombs, Todd and Sophie Yonwin for modelling.

The publisher would like to thank the following for their kind permission to reproduce their photographs: (Key: t = top, b = bottom, r = right, l = left, c = center) 31: www.aviationpictures.com/Austin J. Brown 1983 (tl); 31: Courtesy of FSTOP Pte. Ltd., Singapore (tc); 54: Corbis/Ronnie Kaufman (br); 55: Corbis/Craig Tuttle (tl); 55: Corbis/Craig Tuttle (tr); 55: Zefa/J. Jaemsen (cl);

55: Zefa/J. Jaemsen (cr); 55: Powerstock (bl); 72: Getty Images/Stone/Stuart Westmorland (tl); 82: Indianapolis Motor Speedway Foundation, Inc. (tc); 91: David Edge (tc); 91: Courtesy of Junior Department, Royal College of Music, London (br). All other images © Dorling Kindersley. For further information see www.dkimages.com

How are you?
¿Cómo estás?
KOH-moh es-TASS

What is your name?
¿Cómo te llamas?
KOH-moh tay yah-mas

Do you speak English?
¿Habla inglés?
ah-BLAH een-GLESS

Do you like...?
¿Te gusta...?
teh GOOS-ta

Do you have...?
¿Tienes...?
TE'EH-nes

Can I have...?
¿Me das...?
meh DAS

How much...?
¿Cuánto...?
KOO'AHN-toh

What's that?
¿Qué es eso?
KEH ESS E-sso

How many...?
¿Cuántos/Cuantas...?
KOO'AHN-toss/KOO'AHN-tass

Can you help me?
¿Me puedes ayudar?
meh POO'EH-des a-yoo-DAR

What time is it?
¿Qué hora es?
KAY oh-ra ES

Help!
¡Socorro!
so-KOR-rro

Stop!
¡Para!
PAH-rah

turn right/left
gira a la derecha/
a la izquierda
*HEE-rah a lah day-RAY-chah/
a la ees-KE'AIR-dah*

go straight ahead
sigue recto
SEE-gay RREK-toh

in front of
delante de
day-LAHN-teh day

next to
al lado de
ahl LAH-do day

Where is/are...?
¿Dónde está/están...?
DON-deh es-TAH/es-TAHN

¡Vamos!

Learn the months of the year!

January
enero
en-NEH-roh

February
febrero
fe-BREH-roh

March
marzo
MAR-soh

April
abril
a-BREEL

May
mayo
MAY-yoh

June
junio
HOO-ne'oh

July
julio
HOO-le'oh

August
agosto
a-GOS-toh

September
septiembre
sep-TEE'EM-breh

October
octubre
ok-TOO-breh

November
noviembre
no-BEE'EM-breh

December
diciembre
dee-SEE'EM-breh

Useful phrases

127

Useful phrases

Frases útiles

Learn the days of the week!

yes
sí
see

no
no
no

hello
hola
O-lah

goodbye
adiós
a-DE'OS

see you later
hasta luego
AS-ta LOO'EH-go

please
por favor
POR fah-VOR

thank you
gracias
GRAH-se'ahs

excuse me
perdón
pair-DON

I'm sorry
lo siento
lo SEE'EN-toh

my name is...
me llamo...
meh L'YAH-moh

I live in...
vivo en...
BEE-bo en

I am...years old.
tengo...años.
TEN-goh...AH-n'yos

I don't understand
no comprendo
noh kom-PREN-doh

I don't know
no sé
no SEH

very well
muy bien
MOO'EE BE'EN

Monday
lunes
LOO-ness

Tuesday
martes
MAR-tess

Wednesday
miércoles
MEE'ER-koh-less

Thursday
jueves
HOO'EH-bess

Friday
viernes
BE'AIR-ness

Saturday
sábado
SAH-ba-doh

Sunday
domingo
do-MEEN-goh

very much
mucho
MOO-choh

I do/don't like...
me/no me gusta...
meh/no meh GOOS-tah

Let's go!
¡Vamos!
BAH-moss

Happy birthday!
¡Feliz cumpleaños!
fay-LEES koom-play-AH-N'yos

Hola, me llamo Gabriel.

to use
usar
oo-SAR

to visit
visitor
be-see-TAR

to wait
esperar
ess-peh-RAR

to wake up
despertarse
dess-pair-TAR-seh

to walk
andar
ahn-DAR

to want
querer
keh-RAIR

I want yo quiero
you want tú quieres
he, she, (you polite) wants
él, ellas, (usted) quiere
we want
nosotros/as queremos
you want
vosotros/as queréis
they, (you polite plural) want
ellos, ellas, (ustedes) quieren

Jaime escribe un correo electrónico.

Laura lava los platos.

to warm
calentarse
kah-len-TAR-seh

to wash
lavar
lah-BAR

to wash (oneself)
lavarse
lah-BAH-seh

I wash myself
yo me lavo
you wash yourself
tú te lavas
he, she, (you polite) washes himself
él, ellas, (usted) se lava
we wash ourselves
nosotros/as nos lavamos
you wash yourselves
vosotros/as os laváis
they, (you polite plural) wash themselves
ellos/ellas, (ustedes) se lavan

to wash the dishes
lavar los platos
la-BAR los PLAH-tos

to watch
ver
BAIR

mirar
mee-RAR

to wave
saludar
sah-loo-DAR

to wear
llevar (puesto)
ye-BAR (poo'ESS-to)

to weigh
pesar
peh-SAR

to whisper
susurrar
soo-soor-RRAR

to win
ganar
gah-NAR

to wish
desear
deh-seh-AR

to wonder
preguntarse
preh-goon-TAR-seh

to work
trabajar
trah-bah-HAR

to work (function)
funcionar
foon-si'o-NAR

to wrap
envolver
en-bol-BAIR

to write
escribir
ess-kree-BEER

Eduardo escribe en su diario.

A B C D E F G H I J K L M N O P Q R S T U V W X Y Z

125

La niña saca una foto.

to take photos
sacar fotos
sah-KAR FOH-toss

to take away
quitar
kee-TAR

to take care of
cuidar
koo'ee-DAR

to take turns
hacer turnos
ah-SAIR TOOR-nos

to talk
hablar
ah-BLAR

to tape
grabar
grah-BAR

to taste
probar
pro-BAR

to teach
enseñar
en-seh-N'YAR

to tease
tomar el pelo
to-MAR el PEH-lo

to tell
contar
kon-TAR

to tell a story
contar una historia
kon-TAR OO-nah iss-TOH-ree'ah

to tell the time
decir la hora
deh-SEER lah O-rah

to thank
agradecer
ah-grah-deh-SAIR

to think
pensar
pen-SAR

to throw
tirar
tee-RAR

to tie
atar
ah-TAR

to touch
tocar
to-KAR

to train
entrenar
en-treh-NAR

to translate
traducir
trah-doo-SEER

to travel
viajar
be'ah-HAR

Isabel está pensando.

to treat (well)
tratar (bien)
trah-TAR (BE'EN)

to try
intentar
in-ten-TAR

to try on
probar
pro-BAR

to turn
girar
Hee-RAR

to twist
enrollar
en-ro-L'YAR

to type
escribir a máquina
ess-kree-BEER ah MAH-kee-nah

to understand
entender
en-ten-DAIR

to undo
deshacer
dess-ah-SAIR

to undress
desnudarse
dess-noo-DAR-seh

to unpack
deshacer la maleta
dress-ah-SAIR
lah mah-LEH-tah

Tira el balón, Luis.

to ski
esquiar
ess-kee-AR

to sleep
dormir
dor-MEER

to slide
resbalar
rress-ba-LAR

to slip
resbalar
rress-ba-LAR

to smell
oler
o-LAIR

to smile
sonreír
son-reh-EER

to snow
nevar
neh-BAR

to sound (like)
sonar (como)
so-NAR

Ángel está durmiendo.

to speak
hablar
ah-BLAR

I speak yo hablo
you speak tú hablas
he, she, (you polite) speaks
él, ella, (usted) habla
we speak
nosotros/as hablamos
you speak
vosotros/as habláis
they, (you polite plural) speak
ellos/ellas, ustedes hablan

to spell
deletrear
deh-leh-treh-AR

to spin
dar vueltas
DAR boo'EL-tahs

to spread
extender
eks-ten-DAIR

to stand
estar de pie
ess-TAR day PEE'EH

to stand up
ponerse de pie
po-NAIR-seh day PEE'EH

to start
empezar
em-peh-SAR

to stay
quedarse
keh-DAR-seh

*Lucia le **grita** a su amigo.*

to stick
pegar
peh-GAR

to sting
picar
pee-KAR

to stop
parar
pah-RAR

to stretch
estirar
ess-tee-RAR

to study
estudiar
ess-too-DEE'AR

to surf
hacer surf
ah-SAIR soorf

to surprise
sorprender
sor-pren-DAIR

to survive
sobrevivir
so-breh-be-BEER

to swim
nadar
nah-DAR

to take
tomar
to-MAR

*Marcia **extiende** el chocolate en los pasteles.*

Pablo **corre** rápido.

to relax
relajarse
rreh-lah-HAR-seh

to remain
quedar
keh-DAR

to remember
recordar
rreh-kor-DAR

to repair
reparar
rreh-pah-RAR

to rest
descansar
dess-kahn-SAR

to return
regresar
rreh-greh-SAR

to ride a bicycle
montar en bicicleta
mon-TAR en be-se-KLAY-tah

to ride a horse
montar a caballo
mon-TAR ah kah-BAH-l'yo

to roll
enrollar
en-ro-L'YAR

to rub
frotar
fro-TAR

to run
correr
kor-RRER

Raquel **lee** su libro.

to run after
perseguir
pair-seh-GEER

to save
ahorrar
ah-o-RRAR

to say
decir
deh-SEER

to score (a goal)
marcar
mar-KAR

to scratch
rascar
rahs-KAR

to search
buscar
boos-KAR

to see
ver
BAIR

to seem
parecer
pah-reh-SAIR

to sell
vender
ven-DAIR

to send
enviar
en-be-AR

to set the table
poner la mesa
po-NAIR lah MEH-sah

to share
compartir
kom-par-TEER

to shine
brillar
bree-YAR

to shout
gritar
gree-TAR

to show
mostrar
moss-TRAR

to sing
cantar
kahn-TAR

to sit
estar sentado/a
ess-TAR sen-TAH-do/ah

to sit down
sentarse
sen-TAR-seh

to skate
patinar
pah-tee-NAR

Mónica **monta** a caballo.

to plan
planear
plah-neh-AR

to plant
plantar
plahn-TAR

to play
jugar
Hoo-GAR

to play an instrument
tocar un instrumento
to-KAR oon in-stroo-MEN-to

to point
apuntar
ah-poon-TAR

to pour
echar
eh-CHAR

to practice
practicar
prak-tee-KAR

to predict
predecir
preh-deh-SEER

to prefer
preferir
preh-feh-REER

to prepare
preparar
preh-pah-RAR

to press
prensar
pren-SAR

to pretend
pretender
preh-ten-DAIR

to print
imprimir
im-pree-MEER

to produce
producir
pro-doo-SEER

to program
programar
pro-grah-MAR

to promise
prometer
pro-meh-TER

to protect
proteger
pro-teh-HAIR

to provide
proporcionar
pro-por-see'o-NAR

to pull
tirar
tee-RAR

to push
empujar
em-poo-HAR

to put
poner
po-NAIR

to put away
guardar
goo'ar-DAR

to rain
llover
l'yo-BAIR

to reach
alcanzar
ahl-kahn-SAR

to read
leer
leh-AIR

to realize
darse cuenta
DAR-seh KOO'EN-tah

to recognize
reconocer
rreh-ko-no-SAIR

to refuse
rechazar
rreh-chah-SAR

¡Echa el agua con cuidado!

¿Puedes pintar un cuadro?

121

to lift
levantar
leh-bahn-TAR

to like
gustar
goos-TAR

to listen (to)
escuchar
ess-koo-CHAR

to live
vivir
be-BEER

I live yo vivo
you live tú vives
he, she, (you polite) lives
él, ella, (usted) vive
we live
nosotros/as vivimos
you live
vosotros/as vivís
they, (you polite plural) live
ellos/ellas, (ustedes) viven

to lock
cerrar con llave
say-RRAR kon L'YA-bay

to look
mirar
mee-RAR

to look for
buscar
boos-KAR

to lose
perder
pair-DAIR

to love
querer
keh-RAIR

to make
hacer
ah-SAIR

to make a wish
pedir un deseo
peh-DEER oon deh-SEH-o

to make friends
hacer amigos
ah-SAIR ah-MEE-gos

to marry
casarse
kah-SAR-seh

to mean
querer decir
keh-RAIR deh-SEER

to measure
medir
meh-DEER

to meet
quedar con
keh-DAR kon

to mix
mezclar
mes-KLAR

to move
mover
mo-BAIR

to need
necesitar
neh-seh-see-TAR

to not feel well
encontrarse mal
en-kon-TRAR-seh mahl

to notice
notar
no-TAR

to offer
ofrecer
o-freh-SAIR

to open
abrir
ah-BREER

to own
tener
teh-NAIR

to pack
hacer la maleta
ah-SAIR lah mah-LEH-tah

to paint
pintar
pin-TAR

to pay
pagar
pah-GAR

to persuade
persuadir
pair-soo'ah-DEER

to pick up
recoger
rreh-ko-HAIR

Rosa abre la puerta.

Juan escucha música.

Eva mira cuidadosamente.

Maria se está divirtiendo.

to keep
mantener
mahn-teh-NAIR

to keep warm
abrigar
ah-bree-GAR

to kick
dar una patada
DAR OO-nah pah-TAH-dah

to kill
matar
mah-TAR

to kiss
besar
beh-SAR

to have a shower
ducharse
doo-CHAR-seh

to have breakfast
desayunar
dess-ah-yoo-NAR

to have dinner
cenar
seh-NAR

to have fun
divertirse
dee-bair-TEER-seh

to hear
oír
o-EER

to help
ayudar
ah-yoo-DAR

to hide
esconder
ess-kon-DAIR

to hit
pegar
peh-GAR

to hold
sujetar
soo-He-TAR

to hop
dar saltos
DAR SAHL-tos

to hope
esperar
ess-peh-RAR

to hurry
darse prisa
dar-seh PREE-sah

to hurt (oneself)
hacerse daño
ah-SAIR-seh DAH-n'yo

to imagine
imaginar
ee-mah-He-NAR

to include
incluir
in-kloo-EER

to inspire
inspirar
ins-pee-RAR

to invent
inventar
in-ben-TAR

to invite
invitar
in-be-TAR

to join
unirse
oo-NEER-seh

to jump
saltar
sahl-TAR

to know
saber
sah-BAIR

to land (in a plane)
aterrizar
ah-te-rree-SAR

to last
durar
doo-RAR

to laugh
reírse
reh-EER-seh

to lead
dirigir
dee-ree-HEER

to learn
aprender
ah-pren-DAIR

to lie
mentir
men-TEER

Las ranas dan grandes saltos por el aire.

119

to find
encontrar
en-kon-TRAR

to find out
averiguar
ah-beh-ree-goo'AR

to finish
terminar
ter-min-AR

to fit
caber
kah-BAIR

to float
flotar
flo-TAR

to fly
volar
bo-LAR

to fold
doblar
do-BLAR

to follow
seguir
seh-GHEER

to forget
olvidar
ol-be-DAR

to freeze
congelar
kon-Heh-LAR

to frighten
asustar
ah-soos-TAR

to get
obtener
ob-teh-NAIR

Dobla el papel.

to get on (a bus)
subirse
suh-BEER-seh

to get ready
prepararse
preh-pah-RAR-seh

to get up
levantarse
lev-an-TAR-seh

to give
dar
dar

to go
ir
ir

I go
yo voy

you go
tú vas

he, she, (you polite) goes
él, ella, (usted) va

we go
nosotros/as vamos

you go (plural)
vosotros/as váis

they, (you polite plural) go
ellos/as, (ustedes) van

to go camping
ir de camping
eer deh KAM-ping

to go on holiday
ir de vacaciones
eer deh bah-kah-thi-O-nes

to go out
salir
sah-LEER

to go shopping
ir de compras
eer deh KOM-prahs

to grow
crecer
kreh-THAIR

to guess
adivinar
ah-dee-be-NAR

to hang up (phone)
colgar
kol-GAR

to happen
suceder
soo-theh-DAIR

to hate
odiar
o-dee-AR

to have
tener
teh-NAIR

I have
yo tengo

you have
tú tienes

he, she, (you polite) has
él, ella, (usted) tiene

we have
nosotros/as tenemos

you have (plural)
vosotros/as tenéis

they, (you polite plural) have
ellos/as, (ustedes) tienen

Carlos desayuna tostades y hevos.

Alberto **hace** el jardín.

to die
morir
mo-REER

to dig
excavar
eks-kah-BAR

to disappear
desaparecer
dess-ah-pah-reh-SAIR

to discover
descubrir
dess-koo-BREER

to dive (from poolside)
tirarse de cabeza
tee-RAR-say day kah-BEH-sah

to do
hacer
ah-SAIR

I do yo hago
you do tú haces
he, she, (you polite) does
él, ella, (usted) hace
we do
nusotros/un hacemos
you do
vosotros/as hacéis
they, (you polite plural) do
ellos/ellas, (ustedes) hacen

to draw
dibujar
dee-boo-HAR

to dream
soñar
so-N'YAR

to dress up
disfrazarse
diss-frah-SAR-seh

to drink
beber
beh-BAIR

to drive
conducir
kon-doo-SEER

to dry
secar
seh-KAR

to earn
ganar
gah-NAR

to eat
comer
ko-MAIR

I eat yo como
you eat tú comes
he, she, (you polite) eats
él, ella, (usted) come
we eat
nosotros/as comemos
you eat
vosotros/as coméis
they, (you polite plural) eat
ellos/as, (ustedes) comen

to encourage
animar
ah-nee-MAR

Yo **como** pastel de chocolate.

to enjoy
disfrutar
diss-froo-TAR

to escape
escapar
ess-kah-PAR

to explain
explicar
eks-plee-KAR

to fall
caer
kah-AIR

to fall down
caerse
kah-AIR-seh

to feed
dar de comer
DAR day ko-MAIR

to feel
sentir
sen-TEER

to fetch
traer
trah-AIR

to fight
pelear
peh-leh-AR

to fill
llenar
yeh-NAR

to find
encontrar
en-kon-TRAR

¡**Da de comer** a los perros!

117

to clean
limpiar
lim-PEE-AR

to clear
despejar
dess-peh-HAR

to climb
escalar
ess-kah-LAR

to close
cerrar
seh-RRAR

to collect
coleccionar
ko-lek-se'oh-NAHR

to come
venir
beh-NEER

to come back
volver
bol-BAIR

to come from
venir de
beh-NEER day

to compare
comparar
kom-pah-RAR

to complain
quejarse
keh-HAR-seh

to contain
contener
kon-teh-NAIR

to continue
continuar
kon-tee-noo-AR

to cook
cocinar
ko-si-NAR

to copy
copiar
ko-PEE-AR

to cost
costar
kos-TAR

to count
contar
kon-TAR

to cover
cubrir
koo-BREER

to crack
abrir
ah-BREER

to crash
chocar
cho-KAR

to create
crear
kreh-AR

to cross
cruzar
kroo-SAR

to cry
llorar
yo-RAR

to cut
cortar
kor-TAR

to cut out
recortar
reh-kor-TAR

to cycle
montar en bicicleta
mon-TAR en be-se-KLAY-tah

to dance
bailar
bah'e-LAR

to decide
decidir
deh-see-DEER

to decorate
decorar
deh-ko-RAR

to describe
describir
dess-kree-beer

Cristina baila bien.

Ana cava en la arena.

116

to be cold/hot
tener frío/calor
teh-NAIR FREE-o/kah-LOR

to be hungry
tener hambre
teh-NAIR AHM-breh

to be scared of
tener miedo de
teh-NAIR mee'EH-do deh

to be thirsty
tener sed
teh-NAIR sehd

to become
hacerse
ah-SAIR-seh

to begin
empezar
em-peh-SAR

to behave
comportarse
kom-por-TAR-seh

to believe
creer
kree-AIR

Luisa lleva las bolsas.

to bend
doblar
do-BLAR

to bird-watch
observar los pájaros
ob-sair-BAR loss PAH-Har-ross

to bite
morder
mor-DAIR

to blow up (a balloon)
hinchar (un globo)
in-CHAR

to borrow
tomar prestado
to-MAR press-TAH-do

to bounce
rebotar
reh-bo-TAR

to brake
frenar
freh-NAR

to break
romper
rom-PAIR

to breathe
respirar
rres-pee-RAR

to bring
traer
trah-AIR

to brush
cepillar
seh-pee-YAR

to brush one's teeth
cepillarse
los dientes
seh-pee-YAR-seh
los dee-EN-tehs

to build
construir
kons-troo-EER

to bump into
encontrarse
en-kon-TRAR-seh

to buy
comprar
kom-PRAR

to call
llamar
yah-MAR

to carry
llevar
yeh-BAR

to catch
coger
ko-HAIR

to cause
causar
kah'oo-SAR

to celebrate
celebrar
seh-leh-BRAR

to change
cambiar
kahm-BE'AR

to charge (a phone)
cargar
kar-GAR

to check
comprobar
kom-pro-BAR

to choose
elegir
eh-leh-HEER

Coge la pelota.

115

Verbs

This section gives a list of useful verbs (doing words). The most basic form of a verb (to ...) is the infinitive. Useful verbs, such as "to be" *ser* and *estar* and "to have" *tener*, are written out so that you can see how they change depending on who is doing the action: I = yo; you = tú, usted; he/she = él/ella; we = nosotros/as; you (plural) = vosotros/as, ustedes; they = ellos/ellas.

In Spanish, you use the *usted* and *ustedes* forms of the verb when you want to be polite, especially with someone older than you.

Three of the most regular Spanish verbs are also written out: to speak = *hablar*, to eat = *comer*, and to live = *vivir*. There is a reflexive verb written out too. Reflexive verbs are often used where you would say "myself" or "yourself" in English, eg. to wash oneself = *lavarse*.

The verbs that are written out are shown in the present tense – they describe what is happening now or what you normally do.

to act
actuar
ack-too-AR

to agree
estar de acuerdo
ess-TAR deh ah-koo'ER-do

to ask
preguntar
preh-goon-TAR

to ask for
pedir
peh-DEER

to bake
hacer al horno
ah-SAIR ahl OR-no

to bark
ladrar
lah-DRAR

Hago pasteles al horno.

In Spanish there are two verbs for to be: *ser* and *estar*. *Ser* is used with your name, your profession, your nationality, and with descriptions; *estar* with positions and locations and to make the "ing" form of verbs.

to be
(permanent characteristic)
ser
sair

I am yo soy
you are tú eres
he, she, (you polite) is
él, ella, (usted) es
we are nosotros/nosotras somos
you are vosotros/vosotras sois
they, (you polite plural) are
ellos, ellas, (ustedes) son

Simón muerde una manzana.

to be (temporary quality)
estar
ess-STAR

I am yo estoy
you are tú estás
he, she, (you polite) is
él, ella, (usted) está
we are
nosotros/as estamos
you are
vosotros/as estáis
they, (you polite plural) are
ellos/ellas, (ustedes) están

to be able
poder
po-DAIR

to be born
nacer
NAH-sair

to be called
llamarse
yah-MAR-seh

Hincha un globo.

Speaking Spanish

In this dictionary, we have spelled out each Spanish word in a way that will help you pronounce it. Use this guide to understand how the word should sound when you say it. Some parts of a word are shown in capital letters. These parts need to be stressed.

Spanish letter	Pronunciation	Our spelling	Example
a	like *a* in c*a*t	a or ah	**casa** *KA-sa*
e	like *ea* in h*ea*d	e or eh	**hermano** *air-MAH-noh*
i	like *e* in m*e*	ai, ay or ee	**comida** *ko-ME-da*
o	like *o* in h*o*le	o or oh	**pelota** *pay-LO-tah*
u	like *oo* in g*oo*d	oo	**música** *MOO-see-kah*
j	like *h* in *h*appy but rougher	H	**jabón** *Hah-BON*
g (ga, go, gu)	like *g* in *g*et	g	**gato** *gah-to*
g (ge, gi)	like *h* in *h*appy but rougher	H	**gente** *HEN-tay*
g (gue, gui)	like *g* in *g*et	g	**guerra** *GAY-rrah*
c (ca, co, cu)	like *c* in *c*at	k	**camino** *ka-ME-no*
c (e, i)	like *s* in *s*eat	s	**cebra** *SAY-bra*
qu	like *k* in *k*itten	k	**queso** *KAY-so*
ñ	like *ni* in o*ni*on	n'y	**niño** *NEE-n'yoh*
h	*h* is silent, except after "c"	silent	**hermana** *air-MAH-na*
ch	like *ch* in mu*ch*	ch	**mucho** *MOO-choh*
ll	like *lli* in mi*lli*on	l'y	**caballo** *kah-BAH-l'yo*

uniforme escolar (n) (m)
school uniform

universidad (n) (f)
college

universo (n) (m)
universe

útil (adj)
useful

uva (n) (f)
grape

vaca (n) (f)
cow

vacaciones (n) (f)
vacation

vacío (adj)
empty

valiente (adj)
brave

vapor (n) (m)
steam

vaquero/vaquera (n) (m/f)
cowboy/cowgirl

vaqueros (n) (m)
jeans

varón (n) (m)
male

vaso (n) (m)
glass (drink)

vecino (n) (m)
neighbor

vegetariano/vegetariana (n) (m/f)
vegetarian

vela (n) (f)
candle; sail (of boat)

velero (n) (m)
sailboat

vendedor/vendedora (n) (m/f)
shopkeeper

ventana (n) (f)
window

verano (n) (m)
summer

verbo (n) (m)
verb

verde (adj)
green

verdura (n) (f)
vegetable

vestíbulo (n) (m)
hall

vestido (n) (m)
dress

veterinario/veterinaria (n) (m/f)
vet

viaje (n) (m)
trip, journey

vida (n) (f)
life

video (n) (m)
video player

videojuego (n) (m)
video game

viejo (adj)
old

viento (n) (m)
wind

violeta (adj)
purple

violín (n) (m)
violin

vosotros/vosotras (pron) (m/f, plu)
you

y (conj)
and (except before i/hi)

ya (adv)
already

yo (pron)
I (pron)

yogur (n) (m)
yogurt

zanahoria (n) (f)
carrot

zapatilla (n) (f)
slipper

zapatillas deportivas (n) (f)
sneakers

zapato (n) (m)
shoe

zona (n) (f)
zone

zoo (n) (m)
zoo

zorro (n) (m)
fox

zurdo (adj)
left-handed

tarea (n) (f)
homework

tarjeta (n) (f)
card

taxi (n) (m)
taxi

taza (n) (f)
mug, cup

tazón (n) (m)
bowl

té (n) (m)
tea

techo (n) (m)
ceiling

teclado (n) (m)
keyboard

tejado (n) (m)
roof

tela (n) (f)
cloth

teléfono (n) (m)
phone

teléfono celular (n) (m)
cellular phone

telescopio (n) (m)
telescope

televisión (n) (f)
television

tempestuoso (adj)
stormy

temporada (n) (f)
season

temprano (adv)
early

tenedor (n) (m)
fork

tenis (n) (m)
tennis

tenis de mesa (n) (m)
table tennis

tercero (adj)
third

término (n) (m)
end; term

termómetro (n) (m)
thermometer

ternero (n) (m)
calf (animal)

terrible (adj)
terrible

tía (n) (f)
aunt

tiburón (n) (m)
shark

tiempo (n) (m)
time

tiempo (n) (m)
weather

tiempo libre (n) (m)
free time

tienda (n) (f)
shop

tienda de campaña (n) (f)
tent

tierra (n) (f)
land, ground; soil

Tierra (n) (f)
Earth (planet)

tigre (n) (m)
tiger

tijeras (n) (f)
scissors

timbre (n) (m)
bell

tímido (adj)
shy

tío (n) (m)
uncle

tipo (n) (m)
kind, type

toalla (n) (f)
towel

tobillo (n) (m)
ankle

todo (adj/pron)
all, everything

todo el mundo (pron)
everybody

tomate (n) (m)
tomato

tormenta (n) (f)
thunderstorm

tornado (n) (m)
tornado

tortuga (n) (f)
tortoise; turtle

tos (n) (f)
cough

tostadora (n) (f)
toaster

trabajo (n) (m)
job

tractor (n) (m)
tractor

tráfico (n) (m)
traffic

traje (n) (m)
suit

traje de baño (n) (m)
swimsuit

tranquilo (adj)
peaceful, quiet

transbordador (n) (m)
ferry

transporte (n) (m)
transport

tras (prep)
after

travieso (adj)
naughty

tren (n) (m)
train

tren eléctrico (n) (m)
train set

triángulo (n) (m)
triangle

trigo (n) (m)
wheat

trineo (n) (m)
sled, sleigh

tripulación (n) (f)
crew

triste (adj)
sad

trompa (n) (f)
trunk (of animal)

tronco (n) (m)
trunk (of tree)

tropical (adj)
tropical

tú (pron)
you

tubo (n) (m)
tube

tucán (n) (m)
toucan

túnel (n) (m)
tunnel

turista (n) (m)
tourist

U

ubicación (n) (f)
location

último (adj)
last

un/una (article) (m/f)
a, an

uña (n) (f)
nail

uniforme (n) (m)
uniform

sediento (adj)
thirsty

segundo (adj)
second

seguro (adj)
safe; sure; certain

sello (n) (m)
stamp

selva tropical (n) (f)
rain forest

semáforo (n) (m)
traffic lights

semana (n) (f)
week

semanada (n) (f)
pocket money

semicírculo (n) (m)
semicircle

semilla (n) (f)
seed

señal (n) (f)
sign

sencillo (adj)
plain, simple

sendero (n) (m)
path

sentido (n) (m)
sense

serpiente (n) (f)
snake

servilleta de papel (n) (f)
paper towel

siempre (adv)
always

significado (n) (m)
meaning

siguiente (adj)
next

silbato (n) (m)
whistle

silencioso (adj)
quiet

silla (n) (f)
chair

silla de montar (n) (f)
saddle

silla de playa (n) (f)
deck chair

silla de ruedas (n) (f)
wheelchair

sillón (n) (m)
armchair

silvestre (adj)
wild

símbolo (n) (m)
symbol

sin (prep)
without

sin hacer ruido (adv)
quietly

sino (conj)
but

sitio web (n) (m)
Web site

snowboard (n) (m)
snowboard

sobre (n) (m)
envelope

sobre (prep)
about

sobrino/sobrina (n) (m/f)
nephew/niece

sofá (n) (m)
sofa

sol (n) (m)
sun

solamente (adv)
only

soldado (n) (m)
soldier

soleado (adj)
sunny

sólido (n) (m)
solid

solo (adj)
alone

sólo (adv)
just; only

sombra (n) (f)
shadow

sombrero (n) (m)
hat

sordo (adj)
deaf

sorprendente (adj)
surprising

sorpresa (n) (f)
surprise

sótano (n) (m)
basement

su (de él) (adj)
his

su (de ella) (adj)
her

su (de ello) (adj)
its

su/sus (adj) (sing/plu)
their

suave (adj)
gentle; smooth

suavemente (adv)
gently

submarino (n) (m)
submarine

subterráneo (adj)
underground

sucio (adj)
dirty

suelo (n) (m)
floor

suelto (adj)
loose

sueño (n) (m)
dream

suéter (n) (m)
sweater

suficiente (adj)
enough

superficie (n) (f)
surface

supermercado (n) (m)
supermarket

sur (n) (m)
south

suyo (de él) (pron)
his

suyo (de ella) (pron)
hers

tabla de surf (n) (f)
surfboard

tablero (n) (m)
board

tal vez (adv)
maybe

tallo (n) (m)
stem

tamaño (n) (m)
size

también (adv)
also; too

tambor (n) (m)
drum

tapa (n) (f)
lid

tapete (n) (m)
rug

tarde (adv)
late

tarde (n) (f)
evening

R

radio (n) (f)
radio

raíz (n) (f)
root

ramo (n) (f)
branch

rana (n) (f)
frog

rápido (adv)
fast

raqueta (n) (f)
racket

rascacielos (n) (m)
skyscraper

rastrillo (n) (m)
rake

rata (n) (f)
rat

ratón (n) (m)
mouse (animal); mouse (computer)

raya (n) (f)
stripe

real (adj)
real

realmente (adv)
really

receta (n) (f)
recipe

recibo (n) (m)
receipt

recreo (n) (m)
playtime; break

rectángulo (n) (m)
rectangle

recto (adj)
straight

recuerdo (n) (m)
souvenir

red (n) (f)
net

redondo (adj)
round

refrigerador (n) (m)
fridge

regadera (n) (f)
watering can

regalo (de cumpleaños) (n) (m)
(birthday) present

regla (n) (f)
ruler (measuring)

reina (n) (f)
queen

relámpago (n) (m)
lightning

reloj (n) (m)
clock; wristwatch

remo (n) (m)
oar

renacuajo (n) (m)
tadpole

reproductor de discos compactos (n) (m)
CD player

reproductor de DVD (n) (m)
DVD player

rescate (n) (m)
rescue

respuesta (n) (f)
answer

restaurante (n) (m)
restaurant

reto (n) (m)
challenge

revista (n) (f)
magazine

rey (n) (m)
king

rico (adj)
rich

rinoceronte (n) (m)
rhinoceros

río (n) (m)
river

rizado (adj)
curly

robot (n) (m)
robot

roca (n) (f)
rock

rodilla (n) (f)
knee

rojo (adj)
red

rompecabezas (n) (m)
puzzle

ropa (n) (f)
clothes

ropa interior (n) (f)
underwear

rosa (adj)
pink

rosa (n) (f)
rose

roto (adj)
broken

rubio (adj)
blonde

rueda (n) (f)
roundabout; wheel

rugby (n) (m)
rugby

rugoso (adj)
rough

ruidoso (adj)
noisy

ruta (n) (f)
route

S

sábana (n) (f)
sheet (on bed)

saco (n) (m)
sack

saco de dormir (n) (m)
sleeping bag

sal (n) (f)
salt

sala (n) (f)
living room

salario (n) (m)
pay

salida (n) (f)
exit

salón de clase (n) (m)
classroom

salvaje (adj)
wild

salvavidas (n) (m)
lifeguard

sandalia (n) (f)
sandal

sandía (n) (f)
watermelon

sándwich (n) (m)
sandwich

sangre (n) (f)
blood

sano (adj)
healthy

sapo (n) (m)
toad

sartén (n) (f)
frying pan

seco (adj)
dry

pingüino (n) (m)
penguin

pino (n) (m)
pine tree

pintura (n) (f)
painting

piscina (n) (f)
swimming pool

piso (n) (m)
floor (of a building)

piso de abajo (n) (m)
downstairs

pizarrón (n) (m)
blackboard

pizza (n) (f)
pizza

plancha (n) (f)
iron (clothes)

planeta (n) (m)
planet

plano (adj)
flat

planta (n) (f)
plant

plástico (adj)
plastic

plastilina (n) (f)
modelling clay

plata (n) (f)
silver

plataforma (n) (f)
platform

plátano (n) (m)
banana

plato (n) (m)
plate

playa (n) (f)
beach

pluma (n) (f)
pen; feather

plumier (n) (m)
pencil case

pobre (adj)
poor

poco profundo (adj)
shallow

policía (n) (f)
police

polilla (n) (f)
moth

pollito (n) (m)
chick

pollo (n) (m)
chicken

polo (n) (m)
pole

polución (n) (f)
pollution

polvo (n) (m)
powder; dust

popular (adj)
popular

por favor (adv)
please

por qué (adv)
why

por todos lados (adv)
everywhere

porque (conj)
because

posible (adj)
possible

postal (n) (f)
postcard

postre (n) (m)
dessert

pregunta (n) (f)
question

precio (n) (m)
price

premio (n) (m)
prize

presa (n) (f)
dam

presidente/presidenta (n) (m/f)
president

primavera (n) (f)
spring (season)

primero (adv)
first

primeros auxilios (n) (m)
first aid

primo/prima (n) (m/f)
cousin

princesa (n) (f)
princess

principal (adj)
main

príncipe (n) (m)
prince

problema (n) (m)
problem; trouble

probablemente (adv)
probably

producto lácteo (adj)
dairy

profundo (adj)
deep

programa (n) (m)
program

pronto (adv)
soon

propio (adj)
own

protector solar (n) (m)
sunblock

proyecto (n) (m)
project

prueba (n) (f)
quiz

pudin (n) (m)
pudding

pueblo (n) (m)
village

puente (n) (m)
bridge

puerta (n) (f)
door

puerta principal (n) (f)
front door

puerto (n) (m)
harbor

pulgar (n) (m)
thumb

pulsera (n) (f)
bracelet

puño (n) (m)
fist

puntaje (n) (m)
score

puntiagudo (adj)
pointed

punto (n) (m)
point

querido (adj)
dear (in a letter)

queso (n) (m)
cheese

quien/quién/quienes/quiénes (pron)
who

quieto (adj)
still

quizá/quizás (adv)
perhaps, maybe

pañuelos de papel (n) (m)
tissues

panza (n) (m)
stomach

papá (n) (m)
dad

papa (n) (f)
potato

papas fritas (n) (f)
French fries

papel (n) (m)
paper

papel higiénico (n) (m)
toilet paper

parada del autobús (n) (f)
bus stop

paraguas (n) (m)
umbrella

parasol (n) (m)
umbrella (for sun shade)

pared (n) (f)
wall

pareja (n) (f)
pair

parque (n) (m)
park

parque infantil (n) (m)
playground

parte (n) (f)
part

parte de arriba (n) (f)
top

parte de atrás (adj)
back

partido (n) (m)
match, game

pasado (n) (m)
past

pasajero/pasajera (n) (m/f)
passenger

pasaporte (n) (m)
passport

pasatiempo (n) (m)
hobby

paseo (n) (m)
walk

paso (n) (m)
step

pasta (n) (f)
pasta

pasta de dientes (n) (f)
toothpaste

pastel (n) (m)
cake

pata (n) (m)
paw; leg; foot (of animal or thing)

patínaje (sobre hielo/ en línea) (n) (m)
(ice/inline) skating

patito (n) (m)
duckling

pato (n) (m)
duck

patrón (n) (m)
pattern

pavimento (n) (m)
sidewalk

pavo (n) (m)
turkey

payaso/payasa (n) (m/f)
clown

paz (n) (f)
peace

pececito de colores (n) (m)
goldfish

pedal (n) (m)
pedal

pegajoso (adj)
sticky

pegatina (n) (f)
sticker

peine (n) (m)
comb

pelícano (n) (m)
pelican

película (n) (f)
movie

peligro (n) (m)
danger

peligroso (adj)
dangerous

pelo (n) (m)
hair

pelota (n) (f)
ball

peludo (adj)
hairy

peluquería (n) (f)
hair salon

pelvis (n) (f)
hipbone

peor (adj)
worst

pequeño (adj)
little, small

pera (n) (f)
pear

percha (n) (f)
coat hanger

perezoso (adj)
lazy

perfecto (adj)
perfect

periódico (n) (m)
newspaper

pero (conj)
but

perrito (n) (m)
puppy

perrito caliente (n) (m)
hot dog

perro (n) (m)
dog

perro pastor (n) (m)
sheepdog

persona (n) (f)
person

pesado (adj)
heavy

pestaña (n) (f)
eyelash

pez/peces (n) (m, sing/plu)
fish

piano (n) (m)
piano

picnic (n) (m)
picnic

pico (n) (m)
beak

pie (n) (m)
foot

piedra (n) (f)
stone

piel (n) (f)
skin; fur

pierna (n) (f)
leg (of person)

pieza (n) (f)
piece

pijama (n) (m)
pajamas

pila (n) (f)
battery

piloto (n) (m/f)
pilot

pimiento/pimienta (n) (m/f)
pepper

piña (n) (f)
pineapple; pinecone

pincel (n) (m)
paint brush

niños/niñas (n) (m/f)
children (n)

noche (n) (f)
night; evening

nombre (n) (m)
name

normalmente (adv)
usually

norte (n) (m)
north

nosotros/nosotras (pron) (m/f, plu)
we

nota (n) (f)
note

noticia/noticias (n) (f, sing/plu)
news

novio (n) (m)
boyfriend

novia (n) (f)
girlfriend

nube (n) (f)
cloud

nublado (adj)
cloudy

nuestro/nuestra (adj) (m/f, sing)
our

nuestros/nuestras (adj) (m/f, pu)
our

nuevo (adj)
new

nudo (n) (m)
knot

número (n) (m)
number

nunca (adv)
never

O

o (conj)
or

objeto (n) (m)
object

océano (n) (m)
ocean

ocupado (adj)
busy

oeste (n) (m)
west

oficina (n) (f)
office

oficina de correos (n) (f)
post office

oído (n) (m)
ear

ojo (n) (m)
eye

ola (n) (f)
wave

óleo (n) (m)
oil

olor (n) (m)
smell

operación (n) (f)
operation

opuesto (adj)
opposite

oreja (n) (f)
ear

orilla (del río) (n) (f)
bank (of river)

orilla del mar (n) (f)
seaside

oro (n) (m)
gold

orquesta (n) (f)
orchestra

oruga (n) (f)
caterpillar

oscuro (adj)
dark

osito de peluche (n) (m)
teddy bear

oso (n) (m)
bear

oso polar (n) (m)
polar bear

otoño (n) (m)
fall (season)

otra vez (adv)
again

otro (adj)
other

óvalo (n) (m)
oval

oveja (n) (f)
sheep

P

pacient (adj)
patient

padrastro (n) (m)
stepfather

padre (n) (m)
parent; father

página (n) (f)
page

país (n) (m)
country

paja (n) (f)
straw

pajarito (n) (m)
chick

pájaro (n) (m)
bird

pajita (n) (f)
drinking straw

pala (n) (f)
shovel, spade

palabra (n) (f)
word

paleta (n) (f)
ice pop

pálido (adj)
faint, pale

palmera (n) (f)
palm tree

palo (n) (m)
stick, pole

pamela (n) (f)
sunhat

pan (n) (m)
bread

panadería (n) (f)
bakery

panda (n) (m)
panda

panecillo (n) (m)
roll

panqueque (n) (m)
pancake

paño (n) (m)
washcloth

paño de cocina (n) (m)
dish towel

pantalla (n) (f)
screen

pantalones (n) (m)
pants

pantalones cortos (n) (m)
shorts

pañuelo (n) (m)
handkerchief

más de/más que (adj)
more than

máscara (n) (f)
mask

mascota (n) (f)
pet

matemáticas (n) (f)
math

materia (n) (f)
subject

mayúscula (n) (f)
capital

me (pron)
me

media (n) (f)
stocking

medianoche (n) (f)
midnight

medias (n) (f)
tights

medicina (n) (f)
medicine

medida (n) (f)
measurement

medio (n) (m)
middle

medio ambiente (n) (m)
environment

medusa (n) (f)
jellyfish

mejor (adj)
better

mejor (pron)
best

melón (n) (m)
melon

mensaje (n) (m)
message

mensaje escrito (n) (m)
text message

menú (n) (m)
menu

mercado (n) (m)
market

mermelada (n) (f)
jam

mes (n) (m)
month

mesa (n) (f)
table

metal (n) (m)
metal

metro (n) (m)
subway

mezcla (n) (f)
mixture

mi/mis (adj) (sing/plu)
my

microondas (n) (m)
microwave

miel (n) (f)
honey

mientras (conj)
while

mil/millar
thousand

millón
million

mineral (n) (m)
mineral

minusválido (adj)
disabled

minuto (n) (m)
minute (of time)

mismo (adj)
same

mitad (n) (f)
half

mochila (n) (f)
backpack

moda (n) (f)
fashion

mojado (adj)
wet

molino de viento (n) (m)
windmill

moneda (n) (f)
coin

mono (n) (m)
monkey

monopatín (n) (m)
skateboard

monstruo (n) (m)
monster

montaña (n) (f)
mountain

mosca (n) (f)
fly

motocicleta (n) (f)
motorcycle

motor (n) (m)
motor

mucho (adj)
(a) lot

muebles (n) (m)
furniture

muerto (adj)
dead

mujer (n) (f)
woman

multa (n) (f)
ticket

mundo (n) (m)
world

muñeca (n) (f)
doll

muñeco de nieve (n) (m)
snowman

murciélago (n) (m)
bat (animal)

museo (n) (m)
museum

música (n) (f)
music

músico/música (n) (m/f)
musician

muy (adv)
very

N

nacional (adj)
national

nada (pron)
nothing

nadie (pron)
nobody

naranja (n) (f)
orange (fruit)

nariz (n) (f)
nose

natación (n) (f)
swimming

naturaleza (n) (f)
nature

negocio (n) (m)
business

negro (adj)
black

nenúfar (n) (m)
water lily

nido (n) (m)
nest

niebla (n) (f)
fog

nieve (n) (f)
snow

ninguna parte (adv)
nowhere

niño (n) (m)
boy

niño/niña (n) (m/f)
child

lechuga (n) (f)
lettuce

lectura (n) (f)
reading

lejos (adv)
far; away

lengua (n) (f)
tongue

lento (adj)
slow

león (n) (m)
lion

león marino (n) (m)
sea lion

leopardo (n)
leopard

lesión (n) (f)
injury

letra (n) (f)
letter (or alphabet)

ley (n) (f)
law

libélula (n) (f)
dragonfly

librería (n) (f)
bookstore

libreta (n) (f)
notebook

libro (n) (m)
book

ligero (adj)
light (in weight)

limón (n) (m)
lemon

limonada (n) (f)
lemonade

limpio (adj)
clean

línea (n) (f)
line

lío (n) (m)
mess

líquido (n) (m)
liquid

liso (adj)
smooth, flat

lista (n) (f)
list

lista de la compra (n) (f)
shopping list

listo (adj)
ready; clever

llanta (n) (f)
tire

llave (n) (f)
key

lleno (adj)
full

lleno de gente (adj)
crowded

lluvia (n) (f)
rain

lo (pron)
it

lobo (n) (m)
wolf

lonchera (n) (f)
lunchbox

loro (n) (m)
parrot

los (article) (m, plu)
the

luego (conj)
then

lugar (n) (m)
place

luna (n) (f)
moon

lupa (n) (f)
magnifying glass

luz (n) (f)
light

luz del sol (n) (f)
sunlight

madera (n) (f)
wood

madrastra (n) (f)
stepmother

madre (n) (f)
mother

maduro (adj)
ripe

maestro/maestra (n) (m/f)
teacher

magnético (adj)
magnetic

mago (n) (m)
magician

mala hierba (n) (f)
weed

maleta (n) (f)
suitcase

malo (adj)
bad

mamá (n) (f)
mom

mamífero (n) (m)
mammal

mañana (adv)
tomorrow

mañana (n) (f)
morning

mancha (n) (f)
spot

mando a distancia
(n) (m)
remote control

mandos (n) (m)
controls

manga (n) (f)
sleeve

mano (n) (f)
hand

manopla (n) (f)
mitten; oven mitt

manta (n) (f)
blanket

mantequilla (n) (f)
butter

manzana (n) (f)
apple

mapa (n) (m)
map

maquillaje (n) (m)
make-up

máquina (n) (f)
machine

mar (n) (m)
sea

marca (n) (f)
mark

marcador (n) (m)
marker

marco (n) (m)
frame

marea (n) (f)
tide

margarita (n) (f)
daisy

marinero/marinera
(n) (m/f)
sailor

marioneta (n) (f)
puppet

mariposa (n) (f)
butterfly

mariquita (n) (m)
ladybug

marisco (n) (m)
seafood

humano (n) (m)
human

humo (n) (m)
smoke

huracán (n) (m)
hurricane

I

idea (n) (f)
idea

idioma (n) (m)
language

igual (adj)
equal

imán (n) (m)
magnet

importante (adj)
important

imposible (adj)
impossible

incluso (adv)
even

información (n) (f)
information

informe (n) (m)
report

inglés (n) (m)
English

injusto (adj)
unfair

inmediatamente (adv)
immediately

inodoro (n) (m)
toilet

insecto (n) (m)
insect

insignia (n) (f)
badge

instrucción (n) (f)
instruction

instrumento (n) (m)
instrument

inteligente (adj)
smart

interesante (adj)
interesting

internacional (adj)
international

Internet (n) (f)
Internet

inundación (n) (f)
flood

invernadero (n) (m)
greenhouse

invierno (n) (m)
winter

invitación (n) (f)
invitation

isla (n) (f)
island

izquierda (n) (f)
left (side)

J

jabón (n) (m)
soap

jardín (n) (m)
garden

jardinería (n) (f)
gardening

jardinero/jardinera (n) (m/f)
gardener

jarra (n) (f)
jug

jaula (n) (f)
cage

jirafa (n) (f)
giraffe

joya (n) (f)
jewel

joyería (n) (f)
jewelry

judo (n) (m)
judo

juego (n) (m)
play; game

juego de tablero (n) (m)
board game

Juegos Olímpicos (n) (m)
Olympic Games

jugador/jugadora (n) (m/f)
player

jugo (n) (m)
juice

jugo de naranja (n) (m)
orange juice

juguete (n) (m)
toy

jungla (n) (m)
jungle

juntos/juntas (adv) (m/f)
together

K

karate (n) (m)
karate

koala (n) (m)
koala

L

la (article) (f, sing)
the

lagarto (n) (m)
lizard

lago (n) (m)
lake

lámpara (n) (f)
lamp

lana (n) (f)
wool

langosta (n) (f)
lobster

lápiz (n) (m)
pencil

lápiz de color (n) (m)
colored pencil

lápiz de labios (n) (m)
lipstick

largo (adj)
long

las (article) (f, plu)
the

lata (n) (f)
can

lata de pintura (n) (f)
paint can

lavabo (n) (m)
sink (in bathroom)

lavadora (n) (f)
washing machine

lazo (n) (m)
loop

lección (n) (f)
lesson

leche (n) (f)
milk

girasol (n) (m)
sunflower

giro (n) (m)
turn

glaciar (n) (m)
glacier

globo (n) (m)
balloon

globo aerostático (n) (m)
hot air balloon

globo terráqueo (n) (m)
globe

gobierno (n) (m)
government

gol (n) (m)
goal

golf (n) (m)
golf

goma (n) (f)
eraser

gordo (adj)
fat

gorila (n) (m)
gorilla

gorra (n) (f)
cap

gorro de lana (n) (m)
wool hat

gota (n) (f)
drop

gran/grande (adj)
big; great

granero (n) (m)
barn

granja (n) (f)
farm

granjero/granjera (n) (m/f)
farmer

grifo (n) (m)
faucet

grúa (n) (f)
crane

grueso (adj)
thick

grulla (n) (f)
crane

grupo (n) (m)
group

guante (n) (m)
glove

guerra (n) (f)
war

guía (n) (f)
guide

guijarro (n) (m)
pebble

guisante (n) (m)
pea

guitarra (n) (f)
guitar

gusano (n) (m)
earthworm

H

hábitat (n) (m)
habitat

hacia (prep)
toward

hacia atrás (adv)
backward

halcón (n) (m)
hawk

hambriento (adj)
hungry

hámster (n) (m)
hamster

harina (n) (f)
flour

hasta (adv)
even

hasta (prep)
until

hecho (n) (m)
fact

helado (n) (m)
ice cream

helecho (n) (m)
fern

helicóptero (n) (m)
helicopter

helicóptero de la policía (n) (m)
police helicopter

hembra (n) (f)
female

heno (n) (m)
hay

hermano/hermana (n) (m/f)
brother/sister

hermoso (adj)
hay

héroe/heroína (n) (m/f)
hero

herramienta (n) (f)
tool

hervidor (n) (m)
kettle

hielo (n) (m)
ice

hierba (n) (f)
grass

hijo/hija (n) (m/f)
son/daughter

hilo de pescar (n) (m)
fishing line

historia (n) (f)
history

histórico (adj)
historical

historieta (n) (f)
comic

hockey (n) (m)
hockey

hockey sobre hielo (n) (m)
ice hockey

hogar (n) (m)
home

hoja (n) (f)
leaf; sheet (of paper)

hola
hi

hombre (n) (m)
man

hombro (n) (m)
shoulder

hongo (n) (m)
mushroom

hora (n) (f)
hour

horario (n) (m)
timetable; schedule

horario (de una tienda) (n) (m)
opening hours

hormiga (n) (f)
ant

horno (n) (m)
oven

horrible (adj)
horrible

hospital (n) (m)
hospital

hotel (n) (m)
hotel

hoy (adv)
today

hueso (n) (m)
bone

huevo (n) (m)
egg

experto (n) (m)
expert

explorador (n) (m)
explorer

explosión (n) (f)
explosion

extinto (adj)
extinct

extraño (adj)
strange; unusual; foreign

extremadamente (adv)
extremely

fábrica (n) (f)
factory

fabuloso (adj)
fabulous

fácil (adj)
easy

factura (n) (f)
bill

falda (n) (f)
skirt

falso (adj)
false

familia (n) (f)
family

famoso (adj)
famous

fantástico (adj)
fantastic

**farmacéutico/
farmacéutica (n) (m/f)**
pharmacist

faro (n) (m)
lighthouse

favorito (adj)
favorite

feliz (adj)
happy

felpudo (n) (m)
mat

fémur (n) (m)
thigh bone

feo (adj)
ugly

feria (n) (f)
fair

festival (n) (m)
festival

fideo (n) (m)
noodle

fieltro (n) (m)
felt

fiesta (n) (f)
party

figura (n) (f)
shape

filo (n) (m)
edge

fin (n) (m)
end

fin de semana (n) (m)
weekend

final (n) (m)
end

fino (adj)
thin

flauta (n) (f)
flute

flecha (n) (f)
arrow

flor (n) (f)
flower

foca (n) (f)
seal

fondo (n) (m)
bottom

forma (n) (f)
shape

forro polar (n) (m)
fleece (clothing)

fósil (n) (m)
fossil

foto (n) (f)
photo

frambuesa (n) (f)
raspberry

frase (n) (f)
phrase

fregadero (n) (m)
sink (in kitchen)

fresa (n) (f)
strawberry

fresco (adj)
cool; fresh

frijoles (n) (m)
beans

frío (adj)
cold

fruta (n) (f)
fruit

fuego (n) (m)
fire

fuera (adv)
outside

fuera de (prep)
out of

fuerte (adj)
strong

furgoneta (n) (f)
van

fútbol (n) (m)
soccer (game)

fútbol americano (n) (m)
football (game)

futuro (n) (m)
future

gafas (n) (f)
glasses

gafas de agua (n) (f)
goggles

gafas de sol (n) (f)
sunglasses

galleta (n) (f)
cookie

**ganador/ganadora
(n) (m/f)**
winner

garaje (n) (m)
garage

garra (n) (f)
claw; paw

garrapata (n) (f)
tick

garza (n) (f)
heron

gasolina (n) (f)
gasoline

gatito (n) (m)
kitten

gato (n) (m)
cat

gaviota (n) (m)
seagull

gemelo/gemela (n) (m/f)
twin

gente (n) (f)
people

gigante (n) (m)
giant

gimnasia (n) (f)
gymnastics

edredón (n) (m)
comforter

efecto (n) (m)
effect

ejercicio (n) (m)
exercise

ejército (n) (m)
army

el (article) (m, sing)
the

él (pron)
he

elástico (n) (m)
rubber band

eléctrico (adj)
electrical

elefante (n) (m)
elephant

ella (pron)
she

ello (pron)
it

ellos/ellas (pron) (m/f, plu)
they

emergencia (n) (f)
emergency

emocionado (adj)
excited

empate (n) (m)
tie

empinado (adj)
steep

en primer lugar (adv)
first

encantador (adj)
lovely

enchufe (n) (m)
plug

enciclopedia (n) (f)
encyclopedia

encima de (prep)
on top of

enfadado (adj)
angry

enfangado (adj)
muddy

enfermedad (n) (f)
illness

enfermero/enfermera (n) (m/f)
nurse

enfermo (adj)
sick, ill

enorme (adj)
huge

ensalada (n) (f)
salad

entonces (conj)
then

entrada (n) (f)
entrance

entre (prep)
between

entrenador/entrenadora (n) (m/f)
coach

entusiasta (adj)
enthusiastic

equipaje (n) (m)
luggage

equipo (n) (m)
team; equipment

error (n) (m)
mistake

escalera (n) (f)
ladder; stairs

escalón (n) (m)
step

escarabajo (n) (m)
beetle

escoba (n) (f)
broom

escondidas (n) (f)
hide-and-seek

escritorio (n) (m)
desk

escritura (n) (f)
writing

escuela (n) (f)
school

ese/esa (adj)
that

ése/ésa (pron)
that one

espacio (n) (m)
space

espaguetis (n) (m)
spaghetti

espalda (n) (f)
back (body)

español (n) (m)
Spanish

espantoso (adj)
frightening

especial (adj)
special

espectáculo (n) (m)
show

espectáculo de marionetas (n) (m)
puppet show

espejo (n) (m)
mirror

esponja (n) (f)
sponge

esposo/esposa (n) (m/f)
husband/wife

esqueleto (n) (m)
skeleton

esquí (n) (m)
ski

esquina (n) (f)
comer

esta noche (adv)
tonight

estación (n) (f)
station; season

estación de tren (n) (f)
railway station

estampado (n) (m)
pattern

estanque (n) (m)
pond

estante (n) (m)
shelf

estatua (n) (f)
statue

este (n) (m)
east

este/esta (adj)
this

éste/ésta (pron)
this one

estómago (n) (m)
stomach

estrecho (adj)
narrow

estrella (n) (f)
star

estrella de mar (n) (f)
starfish

estricto (adj)
strict

estudiante (n) (m/f)
student

estúpido (adj)
stupid

evento (n) (m)
event

exacto (adv)
just

examen (n) (m)
exam

excelente (adj)
excellent

expedición (n) (f)
expedition

experimento (n) (m)
experiment

cúpula (n) (f)
dome

curioso (adj)
curious

curso (n) (m)
term, semester

curvado (adj)
curved

dados (n) (m)
dice

de madera (adj)
wooden

de/desde (prep)
from

de moda (adj)
fashionable

de mucho viento (adj)
windy

de nuevo (adv)
again

de repente (adv)
suddenly

de verdad (adv)
really

debajo (prep)
below; under

débil (adj)
weak

decoración (n) (f)
decoration

dedo (n) (m)
finger

dedo del pie (n) (m)
toe

delantal (n) (m)
apron

delfín (n) (m)
dolphin

delgado (adj)
thin

delicioso (adj)
delicious

demasiado (adv)
too

dentista (n) (m/f)
dentist

dentro (prep)
into; inside

deporte (n) (m)
sport

deprisa (adv)
quickly

derecha (n) (f)
right (side)

desafío (n) (m)
challenge

desayuno (n) (m)
breakfast

descubrimiento (n) (m)
discovery

desfile (n) (m)
parade

desierto (n) (m)
desert

despacio (adv)
slowly

despertador (n) (m)
alarm clock

desplantador (n) (m)
trowel

después (conj)
then

después (de) (prep)
past; after

detrás (prep)
behind

día (n) (m)
day

diagrama (n) (m)
diagram

diamante (n) (m)
diamond

dibujo (n) (m)
picture; drawing

diccionario (n) (m)
dictionary

diente (n) (m)
tooth

diferente (adj)
different

difícil (adj)
difficult

digital (adj)
digital

diminuto (adj)
tiny

dinero (n) (m)
money

dinero en efectivo (n) (m)
cash

dinosaurio (n) (m)
dinosaur

dirección (n) (f)
address; direction

dirección de correo
electrónico (n) (f)
email address

directamente (adv)
directly

disco (n) (f)
disco

disco compacto (n) (m)
CD

disco duro (n) (m)
hard drive

discurso (n) (m)
speech

disfraz (n) (m)
costume

distancia (n) (f)
distance

divertido (adj)
fun

divorciado (adj)
divorced

doctor/doctora (n) (m/f)
doctor

dolor de cabeza (n) (m)
headache

dolor de oído (n) (m)
earache

donde/dónde (adv)
where

dormitorio (n) (m)
bedroom

dos veces (adv)
twice

dragón (n) (m)
dragon

ducha (n) (f)
shower

durante (prep/conj)
during, while

duro (adj)
tough; hard

e (conj)
and (before i/hi)

eco (n) (m)
echo

ecuador (n) (m)
equator

edificio (n) (m)
building

claro (adj)
light, pale (in color); clear

clavícula (n) (f)
collar bone

cliente/clienta (n) (m/f)
customer; shopper

coche de bomberos (n) (m)
fire engine

coche de carreras (n) (m)
racing car

coche de policía (n) (m)
police car

cocina (n) (f)
stove; kitchen

coco (n) (m)
coconut

cocodrilo (n) (m)
crocodile

código postal (n) (m)
zip code

codo (n) (m)
elbow

cohete (espacial) (n) (m)
(space) rocket

cojín (n) (m)
cushion

col (n) (f)
cabbage

cola (n) (f)
line; glue; tail (of animal)

colibrí (n) (m)
hummingbird

colina (n) (f)
hill

collar (n) (m)
necklace; collar

colmena (n) (f)
hive

color (n) (m)
color

colorido (adj)
colorful

columpio (n) (m)
swing

comedor (n) (m)
dining room

cometa (n) (f)
kite

comida (n) (f)
food

cómo (adv)
how

como (prep)
like

cómoda (n) (f)
chest of drawers

cómodo (adj)
comfortable

compañero/compañera (n) (m/f)
partner

computadora (n) (f)
computer

computadora portátil (n) (f)
laptop

con (prep)
with

concha (n) (f)
shell

concierto (n) (m)
concert

concurso (n) (m)
contest

conejillo de indias (n) (m)
guinea pig

conejo (n) (m)
rabbit

congelador (n) (m)
freezer

continente (n) (m)
continent

copo de nieve (n) (m)
snowflake

corazón (n) (m)
heart

corbata (n) (f)
tie

cordero (n) (m)
lamb

corona (n) (f)
crown

correcto (adj)
right; correct

correo (n) (m)
mail

correo electrónico (n) (m)
email

cortacésped (n) (m)
lawn mower

cortina (n) (f)
curtain

corto (adj)
short

cosa (n) (f)
thing

cosecha (n) (f)
crop; harvest

cosechadora combinada (n) (f)
combine harvester

costa (n) (f)
coast; shore

costilla (n) (f)
rib

crema (n) (f)
cream

cremallera (n) (f)
zipper

creyón (n) (m)
crayon

criatura (n) (f)
creature

cruce (n) (m)
crossing

cuadrado (n) (m)
square

cualquier/cualquiera (pron)
anybody; anything

cuando/cuándo (adv)
when

cuarto (n) (m)
quarter; room

cuarto de los niños (n) (m)
nursery

cubierta (n) (f)
deck

cubo (n) (m)
bucket; cube

cubo de la basura (n) (m)
trash can

cuchara (n) (f)
spoon

cuchillo (n) (m)
knife

cuello (n) (m)
collar; neck

cuenta (n) (f)
bill; bead

cuento (n) (m)
story

cuerda (n) (f)
rope; string

cuerda de saltar (n) (f)
jump rope

cuerno (n) (m)
horn (of animal)

cuero (n) (m)
leather

cuerpo (n) (m)
body

cueva (n) (f)
cave

cuidadoso (adj)
careful

cumbre (n) (f)
summit

cumpleaños (n) (m)
birthday

camello (n) (m)
camel

camino (n) (m)
road, route

camión (n) (m)
truck

camisa (n) (f)
shirt

camiseta (n) (f)
T-shirt

campana (n) (f)
bell

campo (n) (m)
countryside; field

cangrejo (n) (m)
crab

canguro (n) (m)
kangaroo

canica (n) (f)
marble (toy)

canoa (n) (f)
canoe

cansado (adj)
tired

capa (n) (f)
layer; cloak

caparazón (n) (m)
shell

capital (n) (f)
capital

capucha (n) (f)
hood

cara (n) (f)
face

caracol (n) (m)
snail

caramelo (n) (m)
candy

carne (n)
meat; flesh

caro (adj)
expensive

carrera (n) (f)
race

carretilla (n) (f)
wheelbarrow (n)

carrito de compras (n) (m)
shopping cart

carro (n) (m)
cart

carta (n) (f)
letter; card; menu

cartel (n) (m)
poster

cartero/cartera (n) (m/f)
mail carrier

cartón (n) (m)
cardboard

casa (n) (f)
house; home

casado (adj)
married

casco (n) (m)
helmet

casi (adv)
nearly; almost

castillo de arena (n) (m)
sandcastle

cazo (n) (m)
saucepan

cebolla (n) (f)
onion

cebra (n) (f)
zebra

ceja (n) (f)
eyebrow

cena (n) (f)
dinner

centro (n) (m)
center

cepillo de dientes (n) (m)
toothbrush

cepillo de pelo (n) (m)
hairbrush

cera (n) (f)
wax

cerca (adv)
near

cerca (n) (f)
fence

cercano (adj)
close

cerdo (n) (m)
pig

cereal (n) (m)
cereal

cerebro (n) (m)
brain

cerilla (n) (m)
match

cerrado (adj)
closed

césped (n) (m)
lawn

cesta (n) (f)
basket

chaleco (n) (m)
vest

chaleco salvavidas (n) (m)
life jacket

champú (n) (m)
shampoo

chaqueta (n) (f)
jacket

chef (n) (m/f)
chef

chicle (n) (m)
chewing gum

chico/chica (n) (m/f)
boy/girl

chimenea (n) (f)
chimney

chimpancé (n) (m)
chimpanzee

chincheta (n) (f)
thumbtack

chiste (n) (m)
joke

chocolate (n) (m)
chocolate

chocolate caliente (n) (m)
hot chocolate

chubasquero (n) (m)
raincoat

ciclismo (n) (m)
cycling

cielo (n) (m)
sky

ciencias (n) (f)
science

científico/científica (n) (m/f)
scientist

cierto (adj)
true

ciervo (n) (m)
deer

cine (n) (m)
cinema

cinta (n)
ribbon; cassette

cinta métrica (n) (f)
tape measure

cintura (n) (f)
waist

cinturón (n) (m)
belt

circo (n) (m)
circus

círculo (n) (m)
circle

cirugía (n) (f)
surgery

cisne (n) (m)
swan

cita (n) (f)
date

ciudad (n) (f)
town; city

batería (n) (f)
drum kit

batido (n) (m)
milk shake

baúl (n) (m)
chest

baúl de los juguetes (n) (m)
toy box

bebé (n) (m)
baby

bebida (n) (f)
drink

béisbol (n) (m)
baseball

belleza (n) (f)
beauty

beso (n) (m)
kiss

biblioteca (n) (f)
library

bicicleta (n) (f)
bike

bicicleta de montaña (n) (f)
mountain bike

bien (adv)
well; fine

bienvenido (adj)
welcome

bigote (n) (m)
moustache; whisker
(of animal)

billón
billion

binoculares (n) (f)
binoculars

blanco (adj)
white

blando (adj)
soft

blusa (n) (f)
blouse

boca (n) (f)
mouth

bocina (n) (f)
horn (of vehicle)

bola (n) (f)
ball

bola de nieve (n) (f)
snowball

boleto (n) (m)
ticket

bolsa (n)
pouch; bag

bolsa de la compra (n) (f)
shopping bag

bolsa de la escuela (n) (f)
school bag

bolsa de plástico (n) (f)
plastic bag

bolsillo (n) (m)
pocket

bolso (n) (m)
purse; handbag

bombero/bombera (n)
(m/f)
firefighter

bombilla (n) (f)
light bulb

bonito (adj)
nice; pretty, beautiful

bosque (n) (m)
forest

bota (n) (f)
boot

bote (n) (m)
boat

bote de remos (n) (m)
rowboat

bote salvavidas (n) (m)
lifeboat

botella (n) (f)
bottle

botón (n) (m)
button

boya (n) (f)
buoy

brazo (n) (m)
arm

brillante (adj)
shiny; brilliant

brisa (n) (f)
breeze

brújula (n) (f)
compass

bueno (adj)
good

bufanda (n) (f)
scarf

búho (n) (m)
owl

bulbo (n) (m)
bulb (of plant)

burbuja (n) (f)
bubble

buzón (n) (m)
mailbox

C

caballero (n) (m)
knight

caballo (n) (m)
horse

cabeza (n) (f)
head

cabra (n) (f)
goat

cacahuate (n) (m)
peanut

cada (adj)
each; every

cadena (n) (f)
chain

cadera (n) (f)
hip

café (adj)
brown

café (n) (m)
coffee; café

caimán (n) (m)
alligator

caja (n) (f)
box; checkout

caja de cerillas (n) (f)
matchbox

caja registradora (n) (f)
cash register

cajón (n) (m)
drawer

calabaza (n) (f)
pumpkin

calcetín (n) (m)
sock

calculadora (n) (f)
calculator

calendario (n) (m)
calendar

cálido (adj)
warm

caliente (adj)
hot

calle (n) (f)
street

calmado (adj)
calm

calor (n) (m)
heat

cama (n) (f)
bed

cámara (n) (f)
camera

camarero/camarera (n)
(m/f)
waiter/waitress

cambio (n) (m)
change

alumno/alumna (n) (m/f)
student

amable (adj)
kind; gentle

amarillo (adj)
yellow

ambulancia (n) (f)
ambulance

amigable (adj)
friendly

amigo/amiga (n) (m/f)
friend

anaranjado (adj)
orange

ancho (adj)
wide

anciano/anciana (n) (m/f)
old person

ancla (n) (m)
anchor

anillo (n) (m)
ring

animal (n) (m)
animal

antena (n) (f)
antenna

antes (prep)
before

antorcha (n) (f)
torch

apariencia (n) (f)
appearance

apartamento (n) (m)
apartment

aparte (adv)
apart

apretado (adj)
tight

araña (n) (f)
spider

árbol (n) (m)
tree

arbusto (n) (m)
bush

arco (n) (m)
arch

arcoiris (n) (m)
rainbow

ardilla (n) (f)
squirrel

área (n) (m)
area

arena (n) (f)
sand

arete (n) (m)
earring

armario (n) (m)
wardrobe

arriba (adv)
upstairs

arroz (n) (m)
rice

arte (n) (m)
art

artista (n) (m/f)
artist

ascensor (n) (m)
elevator

asistente (n) (m/f)
assistant

asombroso (adj)
amazing

astronauta (n) (m/f)
astronaut

astrónomo/astrónoma (n) (m/f)
astronomer

asustado (adj)
frightened

atardecer (n) (m)
sunset

aterrador (adj)
frightening

ático (n) (m)
attic

atlas (n) (m)
atlas

atletismo (n) (m)
athletics

auto (n) (m)
car

autobús (n) (m)
bus

autopista (n) (f)
highway

aventura (n) (f)
adventure

avión (n) (m)
airplane; jet

avispa (n) (f)
wasp

¡Ay!
Ouch!

ayuda (n) (f)
help

azúcar (n) (m)
sugar

azul (adj)
blue

B

babuino (n) (m)
baboon

badminton (n) (m)
badminton

bailarín/bailarina (n) (m/f)
dancer; ballet dancer

bajo (adj)
low; short

bajo (prep)
under

balcón (n) (m)
balcony

ballena (n) (f)
whale

balón de fútbol (n) (m)
soccer ball

banco (n) (m)
bench; bank (for money)

banda (n) (f)
band

bandeja (n) (f)
tray

bandera (n) (f)
flag

baño (n) (m)
bathroom; bath

barato (adj)
cheap

barba (n) (f)
beard

barbacoa (n) (f)
barbecue

barbilla (n) (f)
chin

barco (n) (m)
ship; boat

barco de pesca (n) (m)
fishing boat

barrio (n) (m)
neighborhood

barro (n) (m)
mud

básquetbol (n) (m)
basketball

basura (n) (f)
trash

batalla (n) (f)
battle

bate (n) (m)
bat (for sport)

Spanish A–Z

In this section, Spanish words are in alphabetical order. They are followed by the English translation and a few letters to indicate what type of word it is – a noun (n) or adjective (adj), for example. Look at p56 to see a list of the different types of words.

Nouns in Spanish are either masculine or feminine. We have used (m) and (f) to tell you which they are. Sometimes a word in Spanish might mean more than one thing in English, so there might be two translations underneath.

Most of the nouns (naming words) here describe just one thing, so they are singular. To make a noun plural (for more than one thing) you usually just add an "s" – the same as in English. In Spanish though, the other words in the sentence change too – *el* becomes *los* and *la* becomes *las*. The adjectives also change, usually getting an extra "s" at the end. In Spanish, an adjective usually comes after the noun too.

a él/para él (pron)
him

a ella/para ella (pron)
her

a menudo (adv)
often

a mí (pron)
me

a través (prep)
through

a través de (prep)
across

a veces (adv)
sometimes

abajo (prep)
below

abecedario (n) (m)
alphabet

abeja (n) (f)
bee

abierto (adj)
open

abrigo (n) (m)
coat

abuela (n) (f)
grandmother

abuelo (n) (m)
grandfather

abuelos (n) (m, plu)
grandparents

aburrido (adj)
boring

acampada (n) (f)
camping

acantilado (n) (m)
cliff

accidente (n) (m)
accident

aceite (n) (m)
oil

acerca de (prep)
about

actividad (n) (f)
activity

adelante (adv)
forward

adentro (prep)
into

adicional (adj)
extra

adulto (adj)
adult

advertencia (n) (f)
warning

afilado (adj)
sharp

afortunado (adj)
lucky

afuera (adv)
outside

agenda (n) (m)
calendar

agua (n) (m)
water

aguacate (n) (m)
avocado

águila (n) (m)
eagle

aguja (n) (f)
needle

agujero (n) (m)
hole

ahora (adv)
now

ajedrez (n) (m)
chess

al revés (adv)
upside down; backward

ala (n) (m)
wing

ala delta (n) (f)
hang-glider

alacena (n) (f)
cupboard

aleta (n) (f)
fin; flipper

alfabeto (n) (m)
alphabet

alfombra (n) (f)
carpet

alfombrilla del ratón (n) (f)
mouse pad

algas (n) (f, plu)
seaweed

algo (pron)
something

algodón (n) (m)
cotton

alguien (pron)
someone

algunos (adj)
some

allí/allá (adv)
over there, there

almohada (n) (f)
pillow

almuerzo (n) (m)
lunch

alrededor (adv)
around

alrededor (prep)
about

alto (adj)
loud; tall; high

wing
el ala

wife (n)
la esposa
ess-POH-sa

wild (adj)
salvaje
sal-BA-Hay

wind (n)
el viento
BE'EN-to

windmill (n)
el molino de viento
mo-LEE-no day BE'EN-to

window (n)
la ventana
ben-TAH-na

windy (adj)
de mucho viento
day MOO-cho BE'EN-to

wing (n)
el ala
AH-la

winner (n)
el ganador
ga-na-DOHR

la ganadora
ga-na-DO-ra

winter (n)
el invierno
in-BE'AIR-no

with (prep)
con
KOHN

without (prep)
sin
SEEN

wolf (n)
el lobo
LOH-bo

woman (n)
la mujer
moo-HAIR

wood (n)
la madera
ma-DAY-ra

wooden (adj)
de madera
day ma-DAY-ra

wool (n)
la lana
lah-na

wool hat (n)
el gorro de lana
GO-rroh day LAH-na

word (n)
la palabra
pa-LAH-bra

world (n)
el mundo
MOON-do

worm (n)
el gusano
goo-SAH-no

worse (adj)
peor
pay-OHR

worst (adj)
el peor
pay-OHR

writing (n)
la escritura
ess-kree-TOO-ra

Y

yacht
el yate

yacht (n)
el yate
IA-tay

year (n)
el año
AH-n'yo

yellow (adj)
amarillo (m)
ah-mah-REE-l'yo

yesterday (adv)
ayer
ah-YAIR

yogurt (n)
el yogur
ee'oh-GOOR

you (pron)
tú
TOO

young (adj)
joven
HO-ben

your (pron)
tu
your

youth hostel (n)
el albergue
ahl-BAIR-gay

Z

zebra
la cebra

zebra (n)
la cebra
SAY-bra

zip code (n)
el código postal
KOH-de-go pos-TAHL

zipper (n)
la cremallera
kray-ma-L'YAY-ra

zone (n)
la zona
SOH-na

zoo (n)
el zoo
SO'OH

zipper
la cremallera

A B C D E F G H I J K L M N O P Q R S T U V W X Y Z

W

waist (n)
la cintura
seen-TOO-ra

waiter (n)
el camarero
ka-ma-RAY-ro

waitress (n)
la camarera
ka-ma-RAY-ra

walk (n)
el paseo
pa-SAY-o

wall (n)
la pared
pa-REHD

war (n)
la guerra
GAY-rrah

wardrobe (n)
el armario
ahr-MAH-re'o

warm (adj)
cálido (m)
KAH-le-do

warning (n)
la advertencia
ahd-bair-TEN-se'ah

washcloth (n)
el paño
PAH-n'yo

washing machine (n)
la lavadora
la-ba-DO-ra

wasp (n)
la avispa
ah-BEES-pa

watering can
la regadera

watch (n)
el reloj
ray-lOH

water (n)
el agua
AH-goo'ah

water lily (n)
el nenúfar
nay-NOO-far

watering can (n)
la regadera
ray-ga-DAY-ra

watermelon (n)
la sandía
san-DEE-a

wave (n)
la ola
O-la

wax (n)
la cera
SAY-ra

we (pron)
nosotros (m)
no-SOH-tros

nosotras (f)
no-SOH-tras

weak (adj)
débil
DAY-bil

weather (n)
el tiempo
TE'AYM-po

Web site (n)
el sitio web
SEE-te'o OO'EB

weed (n)
la mala hierba
MAH-la EE'AIR-ba

week (n)
la semana
say-MAH-na

weekend (n)
el fin de semana
FEEN-day say-MAH-na

welcome (adj)
bienvenido (m)
be'en-bay-NEE-do

well (adj)
bien
BE'EN

west (n)
el oeste
o-ESS-tay

wet (adj)
mojado (m)
mo-HAH-do

whale (n)
la ballena
ba-L'YAY-na

wheat (n)
el trigo
TREE-go

wheel (n)
la rueda
ROO'AY-da

wheelbarrow (n)
la carretilla
ka-rray-TEE-l'ya

wheelchair (n)
la silla de ruedas
SEE-l'yah day ROO'AY-das

when (adv)
cuando/cuándo
KOO'AHN-do

where (adv)
donde/dónde
DOHN-day

while (conj)
durante
doo-RAHN-tay

whisker (n)
el bigote
be-GO-tay

whistle (n)
el silbato
sil-BAH-to

white (adj)
blanco (m)
BLAHN-ko

who (pron)
quién/quiénes
KEE'EN/KEE'EH'nes

why (adv)
por qué
pohr KAY

wide (adj)
ancho (m)
AHN-cho

wave
la ola

A B C D E F G H I J K L M N O P Q R S T U V W X Y Z

turkey
el pavo

true (adj)

cierto (m)
SE'AIR-to

trunk (animal) (n)

la trompa
TROHM-pa

trunk (tree) (n)

el tronco
TROHN-ko

T-shirt (n)

la camiseta
ka-mee-SAY-ta

tube (n)

el tubo
TOO-bo

tunnel (n)

el túnel
TOO-nell

turkey (n)

el pavo
PAH-bo

turtle (n)

la tortuga (marina)
*tohr-TOO-ga
(mah-REE-nah)*

twice (adv)

dos veces
DOSS BAY-sess

twin (n)

el gemelo
Hay-MAY-lo

U

ugly (adj)

feo (m)
FAY-oh

umbrella (n)

el paraguas
pair-RAH-goo'ahs

uncle (n)

el tío
TEE-o

under (prep)

bajo
BAH-Ho

underground (adj)

subterráneo (m)
soob-tay-RRAH-nay-o

underwear (n)

la ropa interior
RRO-pa in-tay-RE'OR

unfair (adj)

injusto (m)
in-HOOS-to

uniform (n)

el uniforme
oo-nee-FOHR-may

universe (n)

el universo
oo-nee-BAIR-so

umbrella
el paraguas

handle
el mango

uniform
el uniforme

until (prep)

hasta
AHS-ta

unusual (adj)

extraño (m)
eks-trah-n'yo

upside down (adv)

al revés
ahl ray-BESS

upstairs (adv)

arriba
ah-RREE-ba

useful (adj)

útil
OO-teel

usually (adv)

normalmente
nor-mahl-MEN-tay

V

van (n)

la furgoneta
foor-go-NAY-ta

vegetable (n)

la verdura
bair-DOO-ra

vegetarian (n)

el vegetariano
bay-gay-tah-ree-AH-no

la vegetariana
bay-gay-tah-ree-AH-na

verb (n)

el verbo
BAIR-bo

very (adv)

muy
MOO'EE

vet (n)

el veterinario
bay-tair-ree-NAH-re'o

la veterinaria
bay-tair-ree-NAH-re'a

video (n)

el video
BEE-day-oh

video game (n)

el videojuego
BEE-day-oh-HOO'AY-go

village (n)

el pueblo
POO'AY-blo

violin (n)

el violín
be'o-LEEN

violin
el violín

A B C D E F G H I J K L M N O P Q R S **T U V** W X Y Z

A
B
C
D
E
F
G
H
I
J
K
L
M
N
O
P
Q
R
S
T
U
V
W
X
Y
Z

toothbrush
el cepillo de dientes

toilet paper (n)
el papel higiénico
pah-PELL ee-HAY-nee-ko

tomato (n)
el tomate
to-MAH-te

tomorrow (adv)
mañana
ma-N'YAH-na

tongue (n)
la lengua
LEN-goo'ah

tonight (adv)
esta noche
ESS-ta NO-chay

too (adv)
también
tam-BE'EN

tool (n)
la herramienta
air-rrah-MEE'EN-ta

tooth (n)
el diente
DEE'EN-tay

toothbrush (n)
el cepillo de dientes
say-PEE-l'yo day DEE'EN-tess

toothpaste (n)
la pasta de dientes
PASS-ta day DEE'EN-tess

top (n)
la parte de arriba
PAIR-tay day ahr-RREE-ba

torch (n)
la antorcha
ahn-TOHR-chah

tornado (n)
el tornado
tor-NAH-do

tortoise (n)
la tortuga
tohr-TOO-ga

toucan (n)
el tucán
too-KAN

tough (adj)
duro (m)
DOO-ro

tourist (n)
el turista
too-RISS-ta

toward (prep)
hacia
AH-se'ah

towel (n)
la toalla
to-AH-l'ya

town (n)
la ciudad
se'oo-DAHD

toy (n)
el juguete
Hoo-GAY-tay

toy box (n)
el baúl de los juguetes
bah-OOL day los Hoo-GAY-tess

tortoise
la tortuga

traffic lights
el semáforo

tractor (n)
el tractor
TRAK-tor

traffic (n)
el tráfico
TRAH-fee-ko

traffic lights (n)
el semáforo
say-MAH-for-ro

train (n)
el tren
TREN

train set (n)
el tren eléctrico
TREN ay-LEK-tree-ko

transport (n)
el transporte
trans-POHR-tay

trash (n)
la basura
bah-SOO-rah

trash can (n)
el cubo de la basura
KOO-bo deh lah bah-SOO-rah

tray (n)
la bandeja
ban-DAY-Hah

tree (n)
el árbol
AHR-bol

triangle (n)
el triángulo
tree-AHN-goo-lo

trip (n)
el viaje
BE'AH-Hay

tropical (adj)
tropical
tro-pe-KAHL

trouble (n)
el problema
pro-BLAY-ma

trowel (n)
el desplantador
dess-plahn-tah-DOR

truck (n)
el camión
ka-ME'ON

trunk
la trompa

tongue
la lengua

toad
el sapo

the (article)
el/la/los/las
ell/lah/los/las

their (adj)
su/sus
SOO/SOOS

then (conj)
después
dess-POO'ESS

there (adv)
allí (m) allá (f)
ah-L'YI/ah-L'YA

thermometer (n)
el termómetro
tair-MOH-may-tro

they (pron)
ellos (m) ellas (f)
EH-l'yos/EH-l'yas

thick (adj)
grueso (m)
GROO'EH-so

thin (adj)
delgado (m)
dell-GAH-do

thing (n)
la cosa
KOH-sa

third (adj)
tercero (m)
tair-SAY-ro

thirsty (adj)
sediento (m)
say-DEE'EN-to

this (adj)
este (m) esta (f)
ESS-tay/ESS-tah

thousand
mil/millar
MEEL/mee-L'YAR

through (prep)
a través
ah tra-BESS

thumb (n)
el pulgar
pool-GAR

thumbtack (n)
la chincheta
cheen-CHAY-tah

thunderstorm (n)
la tormenta
tor-MEN-tah

tick (n)
el boleto
boh-LAY-toh

ticket (n)
la entrada
en-TRAH-da

tide (n)
la marea
ma-RAY-ah

tie (n)
la corbata
kor-BAH-ta

tiger (n)
el tigre
TEE-gray

tight (adj)
apretado (m)
ah-pray-TAH-do

tights (n)
las medias
MAY-de'ahs

time (n)
el tiempo
TE'EM-poh

timetable (n)
el horario
o-RAH-re'oh

tiny (adj)
diminuto (m)
de-me-NOO-to

tire (n)
la llanta
L'YAHN-ta

tired (adj)
cansado (m)
kan-SAH-do

tissues (n)
los pañuelos de papel
pah-N'YU'AY-los day pah-PELL

toad (n)
el sapo
SAH-po

toaster (n)
la tostadora
toss-ta-DOR-ra

today (adv)
hoy
O'EE

toe (n)
el dedo del pie
DAY-do del PEE'EH

together (adv)
juntos (m) juntas (f)
HOON-tos/HOON-tas

toilet (n)
el inodoro
ee-no-DOH-ro

stripes
las rayas

whiskers
los bigotes

tiger
el tigre

tail
la cola

A B C D E F G H I J K L M N O P Q R S **T** U V W X Y Z

A B C D E F G H I J K L M N O P Q R

S
T

U V W X Y Z

sun (n)
el **sol**
SOHL

sunblock (n)
el **protector solar**
pro-tehk-TOR so-LAR

sunflower (n)
el **girasol**
Hee-ra-SOHL

sunglasses (n)
las **gafas de sol**
GAH-fas day SOHL

sunhat (n)
la **pamela**
pa-MAY-la

sunlight (n)
la **luz del sol**
LOOS dell SOHL

sunny (adj)
soleado (m)
so-lay-AH-do

sunset (n)
el **atardecer**
ah-tar-day-SAIR

supermarket (n)
el **supermercado**
soo-pair-mair-KAH-do

sure (adj)
seguro (m)
say-GOO-ro

swing
el columpio

surface (n)
la **superficie**
soo-pair-FEE-ce'eh

surfboard (n)
la **tabla de surf**
TAH-bla day SOORF

surgery (n)
la **cirugía**
see-roo-HEE-ah

surprise (n)
la **sorpresa**
sor-PRAY-sah

surprising (adj)
sorprendente
sor-pren-DEN-tay

swan (n)
el **cisne**
SISS-nay

sweater (n)
el **suéter**
SOO'EH-tair

swimming (n)
la **natación**
na-ta-SE'ON

swimming pool (n)
la **piscina**
piss-SEE-na

swimsuit (n)
el **traje de baño**
TRAH-Hay day BAH-n'yo

swing (n)
el **columpio**
ko-LO OM-pe'oh

symbol (n)
el **símbolo**
SEEM-bo-Io

tadpole
el renacuajo

table (n)
la **mesa**
MAY-sah

table tennis (n)
el **tenis de mesa**
TAY-niss day may-sa

tadpole (n)
el **renacuajo**
rray-nah-KOO'AH-Hoh

tail (n)
la **cola**
KOH-la

tall (adj)
alto (m)
AHL-to

tape measure (n)
la **cinta métrica**
SEEN-ta MAY-tree-ka

taxi (n)
el **taxi**
TAK-see

tea (n)
el **té**
TAY

taxi
el taxi

teacher (n)
el **maestro**
mah-ESS-tro
la **maestra**
mah-ESS-tra

team (n)
el **equipo**
ay-KEE-po

teddy bear (n)
el **osito de peluche**
o-SEE-to day
pay-LOO-chay

telescope (n)
el **telescopio**
tay-less-KOH-pee'oh

television (n)
la **televisión**
tay-lay-be-SEE' ON

tennis (n)
el **tenis**
TAY-niss

tent (n)
la **tienda de**
campaña
TEE'EN-da day
kam-PA-n'ya

term (semester) (n)
el **término**
TAIR-mee-no

terrible (adj)
terrible
tay-RREE-blay

text message (n)
el **mensaje escrito**
men-SAH-Hay
ess-KREE-to

that (adj)
ese (m) esa (f)
eh-say/eh-sah

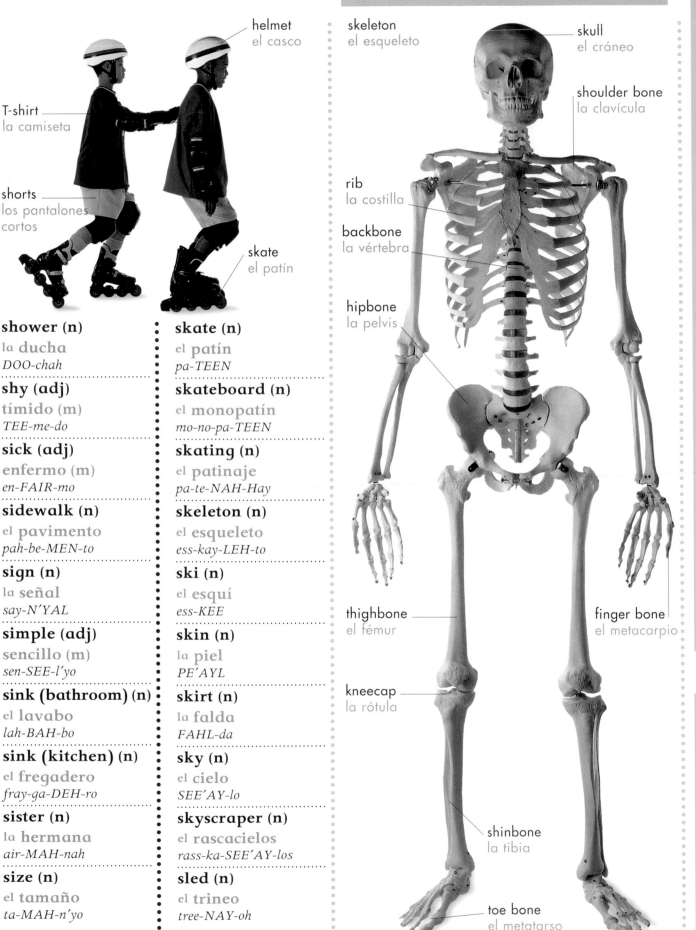

helmet
el casco

T-shirt
la camiseta

shorts
los pantalones
cortos

skate
el patín

skeleton
el esqueleto

skull
el cráneo

shoulder bone
la clavícula

rib
la costilla

backbone
la vértebra

hipbone
la pelvis

thighbone
el fémur

finger bone
el metacarpio

kneecap
la rótula

shinbone
la tibia

toe bone
el metatarso

shower (n)
la **ducha**
DOO-chah

skate (n)
el **patín**
pa-TEEN

shy (adj)
tímido (m)
TEE-me-do

skateboard (n)
el **monopatín**
mo-no-pa-TEEN

sick (adj)
enfermo (m)
en-FAIR-mo

skating (n)
el **patinaje**
pa-te-NAH-Hay

sidewalk (n)
el **pavimento**
pah-be-MEN-to

skeleton (n)
el **esqueleto**
ess-kay-LEH-to

sign (n)
la **señal**
say-N'YAL

ski (n)
el **esquí**
ess-KEE

simple (adj)
sencillo (m)
sen-SEE-l'yo

skin (n)
la **piel**
PE'AYL

sink (bathroom) (n)
el **lavabo**
lah-BAH-bo

skirt (n)
la **falda**
FAHL-da

sink (kitchen) (n)
el **fregadero**
fray-ga-DEH-ro

sky (n)
el **cielo**
SEE'AY-lo

sister (n)
la **hermana**
air-MAH-nah

skyscraper (n)
el **rascacielos**
rass-ka-SEE'AY-los

size (n)
el **tamaño**
ta-MAH-n'yo

sled (n)
el **trineo**
tree-NAY-oh

A B C D E F G H I J K L M N O P Q R **S** T U V W X Y Z

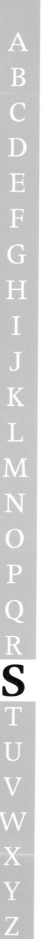

A B C D E F G H I J K L M N O P Q R S T U V W X Y Z

scissors
las tijeras

science (n)
las **ciencias**
SEE'EN-see'as

scientist (n)
el **científico**
see'ehn-TEE-fee-ko

la **científica**
see'ehn-TEE-fee-ka

scissors (n)
las **tijeras**
tee-HAY-ras

score (n)
el **puntaje**
poon-TAH-Hay

screen (n)
la **pantalla**
pan-TAH-l'ya

sea (n)
el **mar**
MAHR

sea lion (n)
el **león marino**
lay-ON ma-REE-no

seafood (n)
el **marisco**
ma-REES-ko

seagull (n)
la **gaviota**
ga-be-OH-ta

seal (n)
la **foca**
FOH-ka

seaside (n)
la **orilla del mar**
o-REE-l'ya dell MAHR

season (n)
la **estación**
ess-tah-SE'ON

seaweed (n)
el **alga**
AHL-ga

second (adj)
segundo (m)
say-GOON-do

seed (n)
la **semilla**
say-MEE-l'ya

semicircle (n)
el **semicírculo**
say-me-SEER-koo-lo

sense (n)
el **sentido**
sen-TEE-do

shadow (n)
la **sombra**
SOHM-bra

shallow (adj)
poco profundo (m)
POH-ko pro-FOON-do

shampoo (n)
el **champú**
cham-POO

shape (n)
la **figura**
fe-GOO-ra

shark (n)
el **tiburón**
te-boo-RON

sharp (adj)
afilado (m)
a-fee-LAH-do

she (pron)
ella
eh-l'ya

sheep (n)
la **oveja**
o-BAY-Hah

sheepdog (n)
el **perro pastor**
PAIR-rro pass-TOR

sheet (on bed) (n)
la **sábana**
SAH-ba-na

shelf (n)
el **estante**
ess-TAHN-tay

shell (n)
la **concha**
KOHN-cha

shiny (adj)
brillante
bree-L'YAN-tay

ship (n)
el **barco**
BAR-ko

shirt (n)
la **camisa**
ka-MEE-sa

shoe (n)
el **zapato**
sa-PAH-to

shop (n)
la **tienda**
TEE'AYN-da

wool
la lana

sheep
las ovejas

shopkeeper (n)
el **vendedor**
ben-day-DOR

la **vendedora**
ben-day-dor-RAH

shopper (n)
el **cliente**
klee-EN-tay

la **clienta**
klee-EN-tah

shopping bag (n)
la **bolsa de la compra**
BOL-sah day la KOM-prah

shopping cart (n)
el **carrito de compras**
ka-RREE-toh day KOM-prahs

shopping list (n)
la **lista de la compra**
LEES-tah day la KOM-prah

shore (n)
la **costa**
KOSS-tah

short (adj)
corto (m)
KOR-to

shorts (n)
los **pantalones cortos**
pan-ta-LOH-ness KOR-tos

shoulder (n)
el **hombro**
OM-bro

shovel (n)
la **pala**
PAH-la

show (n)
el **espectáculo**
ess-pehk-TAH-koo-lo

S

ring (n)
el anillo
ah-NEE-l'yo

ripe (adj)
maduro (m)
mah-DOO-ro

river (n)
el río
REE-oh

road (n)
el camino
ka-MEE-no

robot (n)
el robot
rro-BOT

rock (n)
la roca
ROH-ka

rocket (n)
el cohete
ko-AY-tay

roll (n)
el panecillo
pah-neh-SEE-l'yo

roller skating (n)
el patinaje
pah-tee-NAH-hay

roof (n)
el tejado
tay-HA-do

room (n)
el cuarto
KOO'AR-toh

root (n)
la raíz
rah-EES

rope (n)
la cuerda
KOO-AIR-da

rose (n)
la rosa
RROH-sa

rough (adj)
rugoso (m)
rroo-GO-so

round (adj)
redondo (m)
rray-DON-do

roundabout (n)
la rueda
RROO'AY-dah

route (n)
la ruta
ROO-ta

row boat (n)
el bote de remos
BOH-tay day REH-mos

rubber band (n)
el elástico
eh-LAHS-te-ko

rug (n)
el tapete
tah-PAY-tay

rugby (n)
el rugby
RROOG-be

ruler (measuring) (n)
la regla
RAY-glah

saddle
la silla de montar

sack (n)
el saco
SAH-ko

sad (adj)
triste
TRISS-tay

saddle (n)
la silla de montar
SEE-l'yah day mon-TAR

safe (adj)
seguro (m)
say-GOO-ro

sail (n)
la vela
BAY-la

sailboat (n)
el velero
bay-LAY-ro

sailing (n)
navegar
na-bay-GAR

sailor (n)
el marinero
mah-ree-NAY-ro

salad (n)
la ensalada
en-sa-LAH-da

salt (n)
la sal
SAHL

same (adj)
mismo (m)
MEES-moh

sand (n)
la arena
ah-RAY-na

sandal (n)
la sandalia
san-DAH-le'ah

sandcastle (n)
el castillo de arena
kass-TEE-l'yo day
ah-RAY-na

sandwich (n)
el sándwich
SAHND-oo'ich

saucepan (n)
el cazo
KAH-so

scarf (n)
la bufanda
boo-FAHN-da

school (n)
la escuela
ess-KOO'AY-la

school bag (n)
la bolsa de la
escuela
BOL-sah day la
ess-KOO'AY-la

school uniform (n)
el uniforme escolar
oo-nee-FOHR-may
ess-ko-LAR

scarf
la bufanda

A B C D E F G H I J K L M N O P Q **R** **S** T U V W X Y Z

Q R

racing car
el coche de carreras

A B C D E F G H I J K L M N O P Q R S T U V W X Y Z

quarter (n)
el cuarto
KOO'AR-toh

queen (n)
la reina
RRAY-na

question (n)
la pregunta
preh-GOON-tah

quickly (adv)
deprisa
day-PREE-sa

quiet (adj)
tranquilo (m)
tran-KEE-Io

quietly (adv)
sin hacer ruido
SIN ah-SAIR roo'ee-DO

quiz (n)
la prueba
PROO'AY-ba

queen
la reina

rabbit (n)
el conejo
ko-NAY-ho

race (n)
la carrera
ka-RRAY-ra

racing car (n)
el coche de
carreras
KO-chay day
ka-RRAY-ras

racket (n)
la raqueta
rrah-KAY-ta

radio (n)
la radio
RRAH-de'oh

railway station (n)
la estación de tren
ess-tah-SE'ON day TREN

rain (n)
la lluvia
LYU-be'ah

rain forest (n)
la selva tropical
SELL-bah tro-pe-KAHL

rainbow (n)
el arcoiris
ar-ko-EE-ris

raincoat (n)
el chubasquero
choo-bas-KAY-roh

rake (n)
el rastrillo
rrass-TREE-l'yo

raspberry (n)
la frambuesa
fram-boo'AY-sa

rat (n)
la rata
RRAH-ta

reading (n)
la lectura
lek-TOO-ra

ready (adj)
listo (m)
LEES-to

real (adj)
real
rray-AHL

really (adv)
realmente
rray-AHL-MEN-tay

receipt (n)
el recibo
rray-SE-bo

recipe (n)
la receta
rray-SAY-ta

rectangle (n)
el rectángulo
rrehk-TAN-goo-lo

red (adj)
rojo (m)
RROH-Ho

remote control (n)
el mando a
distancia
MAN-do ah
dees-TAN-se'ah

report (n)
el informe
in-FOR-may

rescue (n)
el rescate
rress-KAH-tay

restaurant (n)
el restaurante
ress-ta'oo-RAN-tay

rhinoceros (n)
el rinoceronte
rree-no-say-RON-tay

ribbon (n)
la cinta
SEEN-tah

rice (n)
el arroz
ah-RROS

rich (adj)
rico (m)
RREE-koh

right (side) (n)
la derecha
day-RAY-chah

right (correct) (adj)
correcto (m)
kor-RREK-to

playground (n)
el parque infantil
PAHR-kay in-fan-TEEL

playtime (n)
el recreo
ray-KRAY-oh

please (adv)
por favor
POR fah-VOR

plug (n)
el enchufe
en-CHOO-fay

pocket (n)
el bolsillo
bol-SEE-l'yo

pocket money (n)
la semanada
say-mah-NAH-da

point (n)
el punto
POON-to

pointed (adj)
puntiagudo (m)
poon-te'ah-GOO-do

polar bear (n)
el oso polar
O-so poh-LAR

pole (n)
el polo
POH-lo

police (n)
la policía
poh-le-SEE-ah

police car (n)
el coche de policía
KO-chay day poh-le-SEE-ah

police helicopter (n)
el helicóptero de la policía
eh-le-KOP-tay-ro day lah poh-le-SEE-ah

pollution (n)
la polución
poh-loo-SE'ON

pond (n)
el estanque
es-TAN-kay

poor (adj)
pobre
POH-bray

popular (adj)
popular
po-poo-LAHR

possible (adj)
posible
po-SEE-blay

post office (n)
la oficina de correos
o-fe-SEE-nah day ko-RRAY-ohs

postcard (n)
la postal
pos-TAHL

poster (n)
el cartel
kar-TELL

potato (n)
la papa
PA-pa

pouch (n)
la bolsa
BOL-sah

powder (n)
el polvo
POHL-boh

present (n)
el regalo
ray-GAH-lo

president (n)
el presidente
pray-see-DEN-tay
la presidenta
pray-see-DEN-tah

puppet
la marioneta

pretty (adj)
bonito (m)
boh-NEE-toh

price (n)
el precio
PRAY-se'oh

prince (n)
el príncipe
PREEN-se-pay

princess (n)
la princesa
preen-SAY-sah

prize (n)
el premio
PRAY-me'oh

probably (adv)
probablemente
pro-BAH-blay-MEN-tay

problem (n)
el problema
pro-BLAY-mah

program (n)
el programa
pro-GRAH-ma

project (n)
el proyecto
pro-YEHK-to

pudding (n)
el pudin
POO-deen

pumpkin (n)
la calabaza
ka-la-BAH-sa

puppet (n)
la marioneta
mah-re'oh-NAY-ta

puppet show (n)
el espectáculo de marionetas
ess-pehk-TAH-koo-lo day mah-re'oh-NAY-ta

puppy (n)
el perrito
pair-RREE-to

purple (adj)
violeta
be'oh-LAY-ta

purse (n)
el bolso
BOL-so

puzzle (n)
el rompecabezas
rrom-pay-kah-BAY-sas

purse
el bolso

A B C D E F G H I J K L M N O **P** Q R S T U V W X Y Z

81

A B C D E F G H I J K L M N O **P** Q R S T U V W X Y Z

pencil case (n)
el **plumier**
ploo-MEE'AIR

penguin (n)
el **pingüino**
peen-GOO'E-no

people (n)
la **gente**
HEN-tay

pepper (n)
la **pimienta**
pe-ME'EN-tah

perfect (adj)
perfecto (m)
pair-FEK-toh

perhaps (adv)
quizá
kee-SAH

quizás
kee-SASS

person (n)
la **persona**
pair-SOH-na

pet (n)
la **mascota**
mass-KOH-ta

piano
• el piano

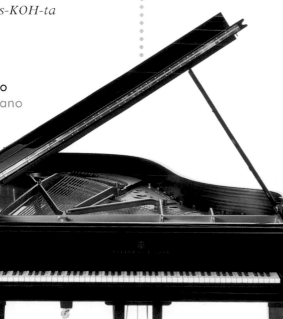

pharmacist (n)
el **farmacéutico**
far-mah-SAY'OO-te-ko

la **farmacéutica**
far-mah-SAY'OO-te-ka

phone (n)
el **teléfono**
tay-LAY-fo-no

photo (n)
la **foto**
FOH-to

phrase (n)
la **frase**
FRAH-say

piano (n)
el **piano**
PE'AH-no

picnic (n)
el **picnic**
PEEK-neek

picture (n)
el **dibujo**
de-BOO-Ho

pinecone
la piña

piece (n)
la **pieza**
PE'AY-sah

pig (n)
el **cerdo**
SAIR-do

pillow (n)
la **almohada**
al-moh'AH-da

pilot (n)
el/la **piloto**
pe-LOH-to

pine tree (n)
el **pino**
PEE-no

pineapple (n)
la **piña**
PEE-n'ya

pinecone (n)
la **piña**
PEE-n'ya

pink (adj)
rosa
RROH-sa

pizza (n)
la **pizza**
PEET-sa

place (n)
el **lugar**
loo-GAR

plane (n)
el **avión**
ah-BEE'ON

planet (n)
el **planeta**
plah-NAY-ta

plant (n)
la **planta**
PLAHN-ta

plastic (adj)
plástico (m)
PLASS-te-ko

plastic bag (n)
la **bolsa de plástico**
BOL-sah day PLASS-te-ko

plate (n)
el **plato**
PLAH-to

platform (n)
la **plataforma**
plah-ta-FOR-ma

play (n)
el **juego**
HOO'AY-go

player (n)
el **jugador**
Hoo-gah-DOR

la **jugadora**
Hoo-gah-DO-ra

pine tree
• el pino

80

N

necklace
el collar

nail (n)
la uña
OO-n'ya

name (n)
el nombre
NOM-bray

narrow (adj)
estrecho (m)
ess-TRAY-choh

national (adj)
nacional
na-se'oh-NAHL

nature (n)
la naturaleza
nah-too-rah-LAY-sah

naughty (adj)
travieso (m)
trah-bee-AY-soh

nest
el nido

near (adv)
cerca
SAIR-kah

nearly (adv)
casi
KAH-see

neck (n)
el cuello
KOO'EH-l'yo

necklace (n)
el collar
koh-L'YAR

needle (n)
la aguja
ah-GOO-Ha

neighbor (n)
el vecino
beh-SEE-no

la vecina
beh-SEE-nah

neighborhood (n)
el barrio
BA-rre'oh

nephew (n)
el sobrino
soh-BREE-no

nest (n)
el nido
NEE-doh

net (n)
la red
RRED

never (adv)
nunca
NOON-ka

new (adj)
nuevo (m)
NOO'AY-bo

news (n)
la noticia
no-tee-SEE'AH

newspaper (n)
el periódico
pay-ree-OH-de-ko

next (adj)
siguiente
see-GHEE'EN-tay

nice (adj)
bonito (m)
boh-NEE-toh

niece (n)
la sobrina
soh-BREE-na

night (n)
la noche
NOH-chay

nobody (pron)
nadie
nah-DE'AY

noisy (adj)
ruidoso (m)
roo'ee-DO-so

noodle (n)
el fideo
fee-DAY-oh

north (n)
el norte
NOR-tay

nose (n)
la nariz
nah-REES

note (n)
la nota
NO-tah

notebook (n)
la libreta
lee-BRAY-tah

noodles
los fideos

nothing (pron)
nada
NAH-dah

now (adv)
ahora
ah-OH-rah

nowhere (adv)
en ninguna parte
en neen-GOO-nah PAIR-tay

number (n)
el número
NOO-may-roh

nurse (n)
el enfermero
en-fair-MAY-ro

la enfermera
en-fair-MAY-ra

nursery (n)
el cuarto de los niños
KOO'AR-toh day loss NEE-n'yos

marker
el marcador

notebook
la libreta

A B C D E F G H I J K L M **N** O P Q R S T U V W X Y Z

77

A
B
C
D
E
F
G
H
I
J
K
L

M

N
O
P
Q
R
S
T
U
V
W
X
Y
Z

milk
shake
el batido

medicine (n)
la medicina
may-de-SEE-na

melon (n)
el melón
may-LON

menu (n)
el menú
may-NOO

mess (n)
el lio
LEE-oh

message (n)
el mensaje
men-SAH-He

metal (n)
el metal
may-TAHL

microwave (n)
el microondas
mee-kroh-ON-dahs

middle (n)
el medio
MEH-de'oh

midnight (n)
la medianoche
MEH-de'ah-NO-chay

milk (n)
la leche
LAY-chay

milk shake (n)
el batido
bah-TEE-do

million
millón
mee-L'YON

mineral (n)
el mineral
mee-nay-RAHL

minute (time) (n)
el minuto
mee-NOO-to

mirror (n)
el espejo
ess-PAY-Ho

mistake (n)
el error
eh-RROR

mitten (n)
la manopla
mah-NOH-pla

mixture (n)
la mezcla
MES-kla

modeling clay (n)
la plastilina
plas-te-LEE-na

mom (n)
la mamá
mah-MAH

money (n)
el dinero
de-NAY-roh

monkey (n)
el mono
MOH-no

mitten
la manopla

monster (n)
el monstruo
mons-troo-oh

month (n)
el mes
MESS

moon (n)
la luna
LOO-na

more than
más de
MAHS day

morning (n)
la mañana
mah-N'YA-na

moth (n)
la polilla
poh-LEE-l'ya

mother (n)
la madre
MAH-dray

motor (n)
el motor
MOH-tor

motorcycle (n)
la motocicleta
mo-to-see-KLAY-tah

mountain (n)
la montaña
mon-TAH-n'ya

mountain bike (n)
la bicicleta de
montaña
be-se-KLAY-tah day
mon-TAH-n'ya

mouse (animal) (n)
el ratón
rah-TON

**mouse (computer)
(n)**
el ratón
rah-TON

mouse pad (n)
la alfombrilla
del ratón
ahl-FOM-bree-l'ya
dell rah-TON

moustache (n)
el bigote
be-GOH-tay

mouth (n)
la boca
BOH-ka

movie (n)
la película
pay-LE-koo-lah

mud (n)
el barro
BAH-rro

muddy (adj)
enfangado (m)
en-fan-GAH-do

mug (n)
la taza
TAH-sa

museum (n)
el museo
moo-SAY-oh

mushroom (n)
el hongo
ON-go

music (n)
la música
MOO-see-ka

musician (n)
el músico
MOO-see-ko
la música
MOO-see-ka

my (adj)
mi/mis (sing/plu)
MEE/MEES

mushroom
el hongo

M

lizard (n)
el **lagarto**
lah-GAR-to

lobster (n)
la **langosta**
lan-GOSS-ta

location (n)
la **ubicación**
oo-be-ka-SE'ON

long (adj)
largo (m)
LAHR-go

loop (n)
el **lazo**
LA-sso

loose (adj)
suelto (m)
SOO'ELL-to

(a) lot (adj)
mucho (m)
MOO-choh

loud (adj)
alto (m)
AHL-to

lovely (adj)
encantador (m)
en-kan-tah-DOR

low (adj)
bajo (m)
BAH-Hoh

lucky (adj)
afortunado (m)
ah-for-too-NAH-do

luggage (n)
el **equipaje**
eh-kee-PAH-Heh

lunch (n)
el **almuerzo**
al-MO'AIR-soh

lunch box (n)
la **lonchera**
lohn-CHAY-rah

mask
la máscara

machine (n)
la **máquina**
MAH-kee-na

magazine (n)
la **revista**
ray-BES-tah

magician (n)
el **mago**
MAH-go

magnet (n)
el **imán**
e-MAHN

magnetic (adj)
magnético (m)
mag-NEH-te-ko

magnifying glass (n)
la **lupa**
LOO-pa

mail (n)
el **correo**
ko-RRAY'OH

mail carrier (n)
el **cartero**
kar-TAY-roh
la **cartera**
kar-TAY-rah

mailbox (n)
el **buzón**
boo-SON

main (adj)
principal
preen-se-PAL

make-up (n)
el **maquillaje**
mah-kee-L'YAH-Heh

male (n)
el **varón**
bah-RON

mammal (n)
el **mamífero**
mah-MEE-fay-ro

man (n)
el **hombre**
OM-bray

map (n)
el **mapa**
MAH-pa

marble (toy) (n)
la **canica**
ka-NEE-kah

mark (n)
la **marca**
MAR-ka

marker (n)
el **marcador**
mahr-ka-DOR

market (n)
el **mercado**
mair-KAH-do

married (adj)
casado (m)
ka-SAH-do

mask (n)
la **máscara**
MAHS-kah-rah

mat (n)
el **felpudo**
fell-POO-do

match (n)
el **partido**
pahr-TE-do

matchbox (n)
la **caja de cerillas**
KAH-Ha day
say-REE-l'yahs

math (n)
las **matemáticas**
mah-tay-MAH-tee-kas

maybe (adv)
quizás
kee-SASS

tal vez
tahl BESS

me (pron)
me
MAY

a mi
ah MEE

meal (n)
la **comida**
ko-ME-da

meaning (n)
el **significado**
seeg-nee-fee-KAH-do

measurement (n)
la **medida**
may-DEE-da

meat (n)
la **carne**
KAR-nay

melon
el melón

A
B
C
D
E
F
G
H
I
J
K
L
M
N
O
P
Q
R
S
T
U
V
W
X
Y
Z

L

lemon
el limón

ladder (n)
la escalera
ess-kah-LAY-rah

ladybug (n)
la mariquita
mah-ree-KEE-ta

lake (n)
el lago
LAH-go

lamb (n)
el cordero
kor-DAY-roh

lamp (n)
la lámpara
LAM-pah-rah

land (n)
la tierra
TE'AY-rrah

language (n)
el idioma
e-DEE'OH-ma

laptop (n)
la computadora
portátil
kom-poo-tah-DOO-rah
pohr-TAH-teel

last (adj)
último (m)
OOL-te-mo

late (adv)
tarde
TAHR-day

law (n)
la ley
LAY

lawn (n)
el césped
SESS-payd

lawn mower (n)
el cortacésped
kor-tah-SESS-payd

layer (n)
la capo
KAH-pa

lazy (adj)
perezoso (m)
pay-ray-SOH-so

leaf (n)
la hoja
OH-Hah

leather (n)
el cuero
KOO'AY-roh

left (side) (n)
la izquierda
lis-KE'AIR-da

left-handed (adj)
zurdo (m)
SOOR-doh

leg (n)
la pierna
PE'AIR-nah

lemon (n)
el limón
lee-MON

lemonade (n)
la limonada
lee-mo-NAH-da

leopard (n)
el leopardo
lay-oh-PAHR-do

lesson (n)
la lección
lek-SE'ON

letter (alphabet) (n)
la letra
LAY-trah

letter (mail) (n)
la carta
KAR-tah

lettuce (n)
la lechuga
lay-CHOO-gah

level (n)
el nivel
nee-BEL

library (n)
la biblioteca
be-ble'oh-TAY-ka

lid (n)
la tapa
TAH-pah

life (n)
la vida
BEE-dah

lifeboat (n)
el bote salvavidas
BO-tay sal-bah-BEE-das

lifeguard (n)
el salvavidas
sal-bah-BEE-das

life jacket (n)
el chaleco
salvavidas
chah-LAY-ko
sal-bah-BEE-das

light (n)
la luz
LOOS

light (in color) (adj)
claro (m)
KLAH-ro

light (in weight) (adj)
ligero (m)
tee-HAY-ro

light bulb (n)
la bombilla
bohm-BEE-l'ya

lighthouse (n)
el faro
FAH-ro

lightning (n)
el relámpago
ray-LAM-pah-go

like (prep)
como
KOH-mo

line (n)
la línea
LEE-nay'ah

lion (n)
el león
lay-ON

lipstick (n)
el lápiz de labios
LAH-pis day LAH-be'os

liquid (n)
el líquido
LEE-ke-do

list (n)
la lista
LEES-tah

little (adj)
pequeño (m)
pay-KAY-n'yo

living room (n)
la sola
SAH-la

lizard
el lagarto

J

jug
la jarra

jacket (n)
la **chaqueta**
chah-KAY-ta

jam (n)
la **mermelada**
mair-meh-LAH-da

jeans (n)
los **vaqueros**
bah-KAY-ros

jellyfish (n)
la **medusa**
meh-DOO-sa

jet (n)
el **avión**
ah-BE'ON

jewel (n)
la **joya**
HOH-ya

jewelry (n)
la **joyería**
Hoh-yay-REE-ah

job (n)
el **trabajo**
tra-BAH-Ho

joke (n)
el **chiste**
CHEES-tay

judo (n)
el **judo**
JOO-do

jug (n)
la **jarra**
HAR-rrah

juice (n)
el **jugo**
HOO-go

jump rope (n)
la **cuerda de saltar**
KOO'AIR-da day
sal-TAR

jungle (n)
la **jungla**
HOON-glah

just (adv)
sólo
SOH-lo

jeans
los vaqueros

K

kite
la cometa

kangaroo (n)
el **canguro**
kan-GOO-ro

karate (n)
el **karate**
ka-RAH-tay

kettle (n)
el **hervidor**
air-BE-dor

key (n)
la **llave**
L'YA-bay

keyboard (n)
el **teclado**
tay-KLA-do

kind (gentle) (adj)
amable
ah-MAH-blay

kind (type) (n)
el **tipo**
TEE-po

king (n)
el **rey**
RRAY

kiss (n)
el **beso**
BAY-so

kitchen (n)
la **cocina**
ko-SEE-na

kite (n)
la **cometa**
ko-MAY-ta

kitten (n)
el **gatito**
gah-TEE-to

knee (n)
la **rodilla**
rroh-DEE-l'ya

knife (n)
el **cuchillo**
koo-CHEE-l'yo

knight (n)
el **caballero**
kah-bah-L'YAY-ro

knot (n)
el **nudo**
NOO-do

koala (n)
el **koala**
ko-AH-la

kitten
el gatito

tail
la cola

A B C D E F G H I J K L M N O P Q R S T U V W X Y Z

island
la isla

Ī (pron)
yo
YO

ice (n)
el hielo
E'AY-lo

ice cream (n)
el helado
eh-LAH-do

ice hockey (n)
el hockey sobre
hielo
HOH-kay so-bray E'AY-lo

ice cream
el helado

ice pop (n)
la paleta
pah-LAY-ta

ice skating (n)
el patinaje sobre
hielo
*pah-te-NAH-Hay
SO-bray E'AY-lo*

idea (n)
la idea
ee-DEH-ah

ill (adj)
enfermo (m)
en-FAIR-mo

illness (n)
la enfermedad
en-fair-may-DAHD

immediately (adv)
inmediatamente
*in-may-DE'AH-tah-
MEN-tay*

important (adj)
importante
im-por-TAN-tay

impossible (adj)
imposible
im-poh-SEE-blay

information (n)
la información
in-for-ma-SE'ON

injury (n)
la lesión
leh-SE'ON

inline skating (n)
el patinaje en
línea
*pah-te-NAH-Hay en
LEE-nee'ah*

insect (n)
el insecto
in-SEK-to

inside (prep)
dentro
DEN-tro

instruction (n)
la instrucción
ins-trook-SE'ON

instrument (n)
el instrumento
ins-troo-MEN-to

interesting (adj)
interesante
in-tay-ray-SAN-tay

international (adj)
internacional
in-tair-nah-se'o-NAHL

Internet (n)
la Internet
In-tair-NEHT

ice skating
el patinaje sobre hielo

into (prep)
adentro
ah-DEN-tro

dentro
DEN-tro

invitation (n)
la invitación
in-be-tah-SE'ON

iron (clothes) (n)
la plancha
PLAN-chah

island (n)
la isla
EES-lah

it (pron)
ello
EH-l'yo

lo
LOH

its (adj)
su (de ello)
SOO

dress
el vestido

leg
la pierna

72

G

globe
el globo terráqueo

game (n)
el juego
HOO'AY-go

garage (n)
el garaje
gah-RAH-Hay

garden (n)
el jardín
Hahr-DEEN

gardener (n)
el jardinero
Hahr-dee-NAY-ro

la jardinera
Hahr-dee-NAY-rah

gardening (n)
la jardinería
Hahr-dee-nay-REE-ah

gas (n)
la gasolina
ga-soh-LEE-na

gentle (adj)
suave
SOO'AH-bay

gently (adv)
suavemente
SOO'AH-bay-MEN-tay

giant (n)
el gigante
Hee-GAN-tay

giraffe (n)
la jirafa
Hee-RAH-fah

girl (n)
la niña
NEE-n'ya

la chica
CHEE-ka

girlfriend (n)
la novia
no-BE'AH

glacier (n)
el glaciar
glah-SE'AHR

glass (drink) (n)
el vaso
BAH-so

glasses (n)
las gafas
GAH-fas

globe (n)
el globo terráqueo
GLO-bo tay-RRAH-kay-oh

glove (n)
el guante
GOO'AN-tay

glue (n)
la cola
KO-la

goal (n)
el gol
GOL

goat (n)
la cabra
KA-bra

goggles (n)
las gafas de agua
GAH-fas day AH-goo'ah

gold (n)
el oro
OH-ro

goldfish (n)
el pececito de colores
pay-say-SEE-toh day ko-LO-rehs

golf (n)
el golf
GOHLF

good (adj)
buen/bueno (m)
BOO'EN/BOO'EH-no

gorilla (n)
el gorila
go-REE-la

government (n)
el gobierno
go-BE'AIR-no

grandfather (n)
el abuelo
ah-BOO'AY-lo

grandmother (n)
la abuela
ah-BOO'AY-la

grandparents (n)
los abuelos
ah-BOO'AY-los

grape (n)
la uva
OO-ba

grass (n)
la hierba
YAIR-ba

great (adj)
gran (m)
GRAN

grande (f)
GRAN-day

green (adj)
verde
BAIR-day

greenhouse (n)
el invernadero
in-vair-nah-DAY-ro

ground (n)
la tierra
TE'AIR-rrah

group (n)
el grupo
GROO-po

guide (n)
la guía
GHEE-ah

guinea pig (n)
el conejillo de indias
ko-nay-HEE-l'yo day IN-de'ahs

guitar (n)
la guitarra
ghee-TAH-rrah

gymnastics (n)
la gimnasia
Heem-NAH-se'ah

guitar
la guitarra

A
B
C
D
E

F

G
H
I
J
K
L
M
N
O
P
Q
R
S
T
U
V
W
X
Y
Z

fishing line (n)
el hilo de pescar
EE-loh day pes-KAR

fist (n)
el puño
POO-n'yo

fit (adj)
en forma
en FOHR-ma

flag (n)
la bandera
ban-DAY-ra

flap (n)
la solapa
so-LAH-pah

flat (adj)
plano (m)
PLAH-no

fleece (clothing) (n)
el forro polar
FOR-rro po-LAR

flipper (n)
la aleta
ah-LAY-ta

flood (n)
la inundación
ee-noon-dah-se'on

floor (n)
el suelo
SOO'EH-lo

floor (building) (n)
el piso
PEE-so

flour (n)
la harina
ah-REE-nah

flower (n)
la flor
FLOR

flute (n)
la flauta
FLAH'OO-ta

fly (n)
la mosca
MOSS-ka

fog (n)
la niebla
NEE'EH-blah

food (n)
la comida
ko-ME-da

foot (n)
el pie
PEE'EH

football (game) (n)
el fútbol
americano
FOOT-bol
ah-mehr-I-CAHN-oh

foreign (adj)
extranjero (m)
eks-tran-HAY-ro

forest (n)
el bosque
BOSS-kay

fork (n)
el tenedor
tay-nay-DOR

forward (adv)
adelante
ah-day-LAHN-tay

fossil (n)
el fósil
FO-sil

fox (n)
el zorro
soh-rro

frame (n)
el marco
MAR-ko

free time (n)
el tiempo líbre
TEE'EM-po LE-bray

freedom (n)
la libertad
le-bair-TAHD

freezer (n)
el congelador
kon-Hay-la-DOR

French (n)
el francés
fran-SEHS

French fries (n)
las papas fritas
PAH-pahs FREE-tas

fresh (adj)
fresco (m)
FRAYS-ko

fridge (n)
el refrigerador
reh-free-Hay-ra-DOR

friend (n)
el amigo
ah-MEE-goh

la amiga
ah-MEE-gah

friendly (adj)
amigable
ah-mee-GAH-blay

frightened (adj)
asustado (m)
ah-soos-TA-do

frog (n)
la rana
RRAH-na

from (prep)
de
DAY

front door (n)
la puerta principal
POO'ER-tah preen-se-PAL

fruit (n)
la fruta
FROO-tah

frying pan (n)
la sartén
sar-TAYN

full (adj)
lleno (m)
L'YEH-no

fun (n)
divertido (m)
de-vair-TEE-do

fur (n)
la piel
PEE'EHL

furniture (n)
los muebles
MOO'EH-blays

future (n)
el futuro
foo-TOO-ro

frog
la rana

F

fashion
la moda

fabulous (adj)
fabuloso (m)
fah-boo-LO-so

face (n)
la cara
KAH-ra

fact (n)
el hecho
AY-cho

factory (n)
la fábrica
FAH-bre-kah

faint (pale) (adj)
pálido (m)
PAH-le-doh

fair (n)
la feria
FAY-re'ah

fall (season) (n)
el otoño
oh-TO-n'yo

false (adj)
falso (m)
FAHL-so

family (n)
la familia
fah-ME-le'ah

famous (adj)
famoso (m)
fah-MOH-so

fantastic (adj)
fantástico (m)
fan-TAHS-te-ko

far (adv)
lejos
LAY-Hos

farm (n)
la granja
GRAHN-Ha

farmer (n)
el granjero
grahn-HAY-ro

la granjera
grahn-HAY-rah

fashion (n)
la moda
MOH-da

fashionable (adj)
de moda
day MOH-da

fast (adv)
rápido (m)
RRAH-pe-do

fat (adj)
gordo (m)
GOHR-do

father (n)
el padre
PAH-dray

faucet (n)
el grifo
GREE-fo

favorite (adj)
favorito (m)
fa-boh-REE-to

feather (n)
lo pluma
PLOO-mah

felt (n)
el fieltro
FE'AYL-troh

female (n)
la hembra
EM-brah

fence (n)
la cerca
SAYR-kah

fern (n)
el helecho
ay-LAY-cho

ferry (n)
el transbordador
trans-bor-dah-DOR

festival (n)
el festival
fess-te-VAHL

field (n)
el campo
KAM-poh

fin (n)
la aleta
ah-LAY-ta

fine (adv)
bien
BE'EN

finger (n)
el dedo
DAY-doh

fire (n)
el fuego
FOO'AY-goh

fire engine (n)
el coche de
bomberos
KOH-chay day
bom-BAY-ros

firefighter (n)
el bombero
bom-BAY-ro

la bombera
bom-BAY-rah

first (adv)
primero
pre-MAY-ro

en primer lugar
en pre-MAYR loo-GAR

first aid (n)
los primeros
auxilios
pre-MAY-ros
ah'ook-SE-le'ohs

fish (n)
el pez
pes

fishing (n)
pescar
pes-KAR

fishing boat (n)
el barco de pesca
BAR-ko day PES-ka

eye
el ojo

fin
la aleta

fish
el pez

E

encyclopedia (n)
la enciclopedia
en-se-kloh-PEH-de'ah

end (n)
el fin
FEEN

English (n)
el inglés
enn-GLAYS

enough (adj)
suficiente
soo-fee-SE'AYN-teh

enthusiastic (adj)
entusiasta
en-too-SE'AHSS-tah

entrance (n)
la entrada
en-TRAH-da

envelope (n)
el sobre
SOH-bray

environment (n)
el medio ambiente
MEH-de'oh
am-BE'AYN-tay

equal (adj)
igual
ee-GOO'AHL

equator (n)
el ecuador
ay-koo'ah-DOHR

equipment (n)
el equipo
ay-KEE-poh

eraser (n)
la goma
GOH-ma

even (adv)
hasta
ASS-tah

evening (n)
la tarde
TAHR-day

event (n)
el evento
ay-BEN-to

every (adj)
cada
KAH-dah

everybody (pron)
todo el mundo
TOH-doh el MOON-doh

everything (pron)
todo
TOH-doh

everywhere (adv)
por todos lados
pohr TOH-doss LAH-doss

exam (n)
el examen
ek-SAH-men

excellent (adj)
excelente
ek-say-LAYN-te

excited (adj)
emocionado (m)
eh-mo-ce'oh-NAH-do

exercise (n)
el ejercicio
ay-Hair-CE-ce'oh

exit (n)
la salida
sa-LEE-da

expedition (n)
la expedición
eks-pay-de-CE'ON

expensive (adj)
caro (m)
KAH-roh

experiment (n)
el experimento
eks-pay-re-MEN-to

expert (n)
el experto
eks-PAIR-to

explorer (n)
el explorador
eks-ploh-rah-DOR

explosion (n)
la explosión
eks-plo-SE'ON

extinct (adj)
extinto (m)
eks-TEEN-to

extra (adj)
adicional
a-dee-se'oh-NAHL

extremely (adv)
extremadamente
eks-tray-MAH-dah-MEN-tay

eye (n)
el ojo
OH-Hoh

eyebrow (n)
la ceja
SAY-Hah

eyelash (n)
la pestaña
pays-TAH-n'ya

stamp
el sello

Museo de Arte Moderno
Avenida de San Juan, 350
Buenos Aires
ARGENTINA

envelope
el sobre

address
la dirección

arm
el brazo

exercise
el ejercicio

leg
la pierna

hand
la mano

foot
el pie

drawing (n)
el dibujo
dee-BOO-Ho

dream (n)
el sueño
SOO'AY-n'yo

dress (n)
el vestido
behs-TE-do

drink (n)
la bebida
beh-BE-da

drinking straw (n)
la pajita
pah-HEE-tah

drop (n)
la gota
GO-tah

drum (n)
el tambor
tam-BOHR

drum kit (n)
la batería
bah-tay-REE-ah

dry (adj)
seco (m)
SAY-ko

duck (n)
el pato
PAH-to

duck
el pato

duckling (n)
el patito
pah-TEE-to

during (prep)
durante
doo-RAHN-tay

dust (n)
el polvo
POHL-boh

DVD player (n)
el reproductor de DVD
rray-pro-dook-TOHR day day-bay-DEH

E

egg
el huevo

each (adj)
cada
KAH-dah

eagle (n)
el águila
AH-ghee-lah

ear (n)
la oreja
oh-RAY-Hah

el oído
oh-EE-do

earache (n)
el dolor de oído
doh-LOHR day oh-EE-do

early (adv)
temprano
tem-PRAH-no

earring (n)
el arete
ah-RAY-tay

Earth (planet) (n)
la Tierra
TE'AY-rrah

earthworm (n)
el gusano
goo-SAH-no

east (n)
el este
ESS-tay

easy (adj)
fácil
FAH-sil

echo (n)
el eco
AY-koh

edge (n)
el filo
FEE-loh

effect (n)
el efecto
ay-fek-to

egg (n)
el huevo
OO'AY-boh

elbow (n)
el codo
KOH-do

electrical (adj)
eléctrico (m)
ay-LEK-tree-ko

elephant (n)
el elefante
ay-lay-FAHN-tay

elevator (n)
el ascensor
ass-sayn-SOR

email (n)
el correo electrónico
ko-RRAY-oh ay-lek-TROH-ne-ko

email address (n)
la dirección de correo electrónico
dee-rek-se-ON day ko-RRAY-oh ay-lek-TROH-ne-ko

emergency (n)
la emergencia
ay-mehr-HEN-se'ah

empty (adj)
vacío (m)
bah-SE-oh

A B C **D** **E** F G H I J K L M N O P Q R S T U V W X Y Z

65

D

daisy
la margarita

dad (n)
el **papá**
pah-PAH

daisy (n)
la **margarita**
mar-gah-REE-tah

dam (n)
la **presa**
PREH-sah

dancer (n)
el **bailaría**
bah'e-lah-REEN

la **bailarina**
bah'e-lah-REE-nah

dandelion (n)
el **diente de león**
DE'AYN-tay day lay-ON

danger (n)
el **peligro**
peh-LEE-gro

dangerous (adj)
peligroso (m)
peh-lee-GRO-so

dark (adj)
oscuro (m)
ohs-KOO-roh

date (n)
la **cita**
SEE-ta

daughter (n)
la **hija**
EE-Hah

day (n)
ei **día**
DEE-a

dead (adj)
muerto (m)
MOO'AIR-toh

deaf (adj)
sordo (m)
SOR-doh

dear (special) (adj)
querido (m)
kay-RE-do

deck (n)
la **cubierta**
koo-BE'AIR-tah

deck chair (n)
la **silla de playa**
SEE-l'ya day PLAH-yah

decoration (n)
la **decoración**
day-ko-rah-SE'ON

deep (adj)
profundo (m)
proh-FOON-do

deer (n)
el **ciervo**
SE'AIR-boh

delicious (adj)
delicioso (m)
deh-lee-SE'OH-so

dentist (n)
el/la **dentista**
dehn-TISS-tah

desert (n)
el **desierto**
deh-SE'AIR-toh

desk (n)
el **escritorio**
ess-kre-TO-re'oh

dessert (n)
el **postre**
POS-tray

diagram (n)
el **diagrama**
de-ah-GRA-mah

diamond (n)
el **diamante**
de'ah-MAHN-tay

dice (n)
los **dados**
DAH-doss

dictionary (n)
el **diccionario**
deek-se'oh-NAH-re'oh

different (adj)
diferente
de-fay-REN-tay

difficult (adj)
difícil
de-FEE-cil

digital (adj)
digital
de-He-TAHL

dining room (n)
el **comedor**
koh-may-DOHR

dinner (n)
la **cena**
SAY-nah

dinosaur (n)
el **dinosaurio**
dee-noh-SAH'OO-re'oh

direction (n)
la **dirección**
dee-rek-SE'ON

directly (adv)
directamente
dee-REK-tah-MEN-tay

dirty (adj)
sucio (m)
SOO-se'oh

disabled (adj)
minusválido (m)
mee-noos-BAH-le-doh

disco (n)
la **disco**
DISS-ko

discovery (n)
el **descubrimiento**
des-koo-bree-ME'AYN-toh

dish towel (n)
el **paño de cocina**
PAH-n'yo day
ko-SEE-na

distance (n)
la **distancia**
diss-TAHN-se'ah

divorced (adj)
divorciado (m)
dee-bor-SE'AH-do

doctor (n)
el **doctor**
dok-TOHR

la **doctora**
dok-TO-rah

dog (n)
el **perro**
PAIR-rroh

doll (n)
la **muñeca**
moo-N'YEH-kah

dolphin (n)
el **delfín**
del-FEEN

dome (n)
la **cúpula**
KOO-poo-lah

door (n)
la **puerta**
POO'AIR-tah

downstairs (n)
el **piso de abajo**
PE-soh day a-BA-Hoh

dragon (n)
el **dragón**
drah-GON

dragonfly (n)
la **libélula**
lee-BEH-loo-lah

drawer (n)
el **cajón**
kah-HON

C

cake
el pastel

cabbage (n)
la col
KOL

café (n)
el café
ka-FAY

cage (n)
la jaula
HA'OO-lah

cake (n)
el pastel
pahs-TEHL

calculator (n)
la calculadora
kahl-koo-lah-DO-rah

calendar (n)
el calendario
kah-len-DAH-ree'oh

calf (animal) (n)
el ternero
tair-NAY-ro

calm (adj)
calmado (m)
kahl-MAH-do

camel (n)
el camello
kah-MAY-l'yo

camera (n)
la cámara
KA-mah-rah

camping (n)
la acampada
ah-kahm-PAH-da

can (n)
la lata
LAH-ta

candle (n)
la vela
VAY-lah

candy (n)
el caramelo
ka-ra-MAY-lo

canoe (n)
la canoa
ka-NO-ah

cap (n)
la gorra
GO-rrah

capital (n)
la capital
ka-pe-TAHL

car (n)
el auto
AH'OO-toh

card (greeting) (n)
la tarjeta
tar-HAY-tah

card (playing) (n)
la carta
KAHR-tah

cardboard (n)
el cartón
kar-TON

careful (adj)
cuidadoso (m)
koo'e-dah-DO-so

carpet (n)
la alfombra
ahl-FOM-brah

carrot (n)
la zanahoria
sah-nah-O-re'ah

cart (n)
el carro
KAR-rro

cash (n)
el dinero en
efectivo
de-NAY-roh en
ay-fek-TEE-bo

cash register (n)
la caja registradora
KAH-Hah rreh-Hiss-
trah-DOH-rah

cassette (n)
la cinta
SEEN-tah

cat (n)
el gato
GAH-to

caterpillar (n)
la oruga
o-ROO-gah

cave (n)
la cueva
KOO'AY-ba

CD (n)
el disco compacto
DISS-ko kom-PAK-toh

CD player (n)
el reproductor de
discos compactos
ray-proh-dook-TOHR
day DISS-koss
kom-PAK-tohs

ceiling (n)
el techo
TAY-cho

cellular phone (n)
el teléfono celular
tay-LAY-fo-no cel-loo-LAR

center (n)
el centro
SEN-troh

cereal (n)
el cereal
say-ray-AHL

certain (adj)
seguro (m)
say-GOO-ro

chain (n)
la cadena
kah-DAY-nah

chair (n)
la silla
SEE-l'yah

challenge (n)
el reto
RAY-toh

window
la ventana

door
la puerta

car
el auto

B

A
C
D
E
F
G
H
I
J
K
L
M
N
O
P
Q
R
S
T
U
V
W
X
Y
Z

boat (n)
el **bote**
BO-tay

body (n)
el **cuerpo**
KOO'AIR-po

bone (n)
el **hueso**
OO'AY-so

book (n)
el **libro**
LEE-bro

bookstore (n)
la **librería**
le-bray-REE-ah

boot (n)
la **bota**
bo-tah

boring (adj)
aburrido (m)
ah-boo-RREE-doh

bottle (n)
la **botella**
bo-TAY-l'yah

bottom (n)
el **fondo**
FON-do

bowl (n)
el **tazón**
tah-SON

box (n)
la **caja**
KAH-Ha

boy (n)
el **niño**
NEE-n'yoh

el **chico**
CHEE-ko

boyfriend (n)
el **novio**
NO-be'oh

bracelet (n)
la **pulsera**
pool-SAY-rah

brain (n)
el **cerebro**
say-RAY-bro

branch (n)
la **rama**
RRAH-mah

brave (adj)
valiente
bah-LE'EN-tay

bread (n)
el **pan**
PAN

break (n)
el **recreo**
ray-CRAY-oh

breakfast (n)
el **desayuno**
deh-sah-YOO-no

breeze (n)
la **brisa**
BREE-sa

butterfly
la mariposa

bubbles
las burbujas

bridge (n)
el **puente**
POO'EN-tay

bright (adj)
brillante
bree-L'YAN-tay

broken (adj)
roto (m)
RROH-toh

broom (n)
la **escoba**
ess-KO-bah

brother (n)
el **hermano**
air-MAH-noh

brown (adj)
café
ka-FAY

bubble (n)
la **burbuja**
boor-BOO-Hah

bucket (n)
el **cubo**
KOO-bo

building (n)
el **edificio**
eh-dee-FEE-se'oh

bulb (plant) (n)
el **bulbo**
BOOL-boh

buoy (n)
la **boya**
BOH-yah

bus (n)
el **autobús**
ah'oo-to-BOOSS

bus stop (n)
la **parada del autobús**
pah-RAH-dah del ah'oo-to-BOOSS

bush (n)
el **arbusto**
ar-BOOSS-to

business (n)
el **negocio**
nay-GO-se'oh

busy (adj)
ocupado (m)
oh-koo-PAH-do

but (conj)
pero
PAY-roh

butter (n)
la **mantequilla**
man-tay-KEE-l'ya

butterfly (n)
la **mariposa**
mah-re-PO-sah

button (n)
el **botón**
bo-TON

A

B

C
D
E
F
G
H
I
J
K
L
M
N
O
P
Q
R
S
T
U
V
W
X
Y
Z

bed (n)
la **cama**
KAH-mah

bedroom (n)
el **dormitorio**
dohr-me-TOH-re'oh

bee (n)
la **abeja**
ah-BAY-Hah

beetle (n)
el **escarabajo**
es-kah-rah-BA-Hoh

before (prep)
antes
AHN-tess

behind (prep)
detrás
day-TRAHS

bell (n)
la **campana**
kahm-PAH-nah

below (prep)
abajo
ah-BAH-Ho

debajo
day-BAH-Ho

belt (n)
el **cinturón**
sin-too-RON

bench (n)
el **banco**
BAHN-ko

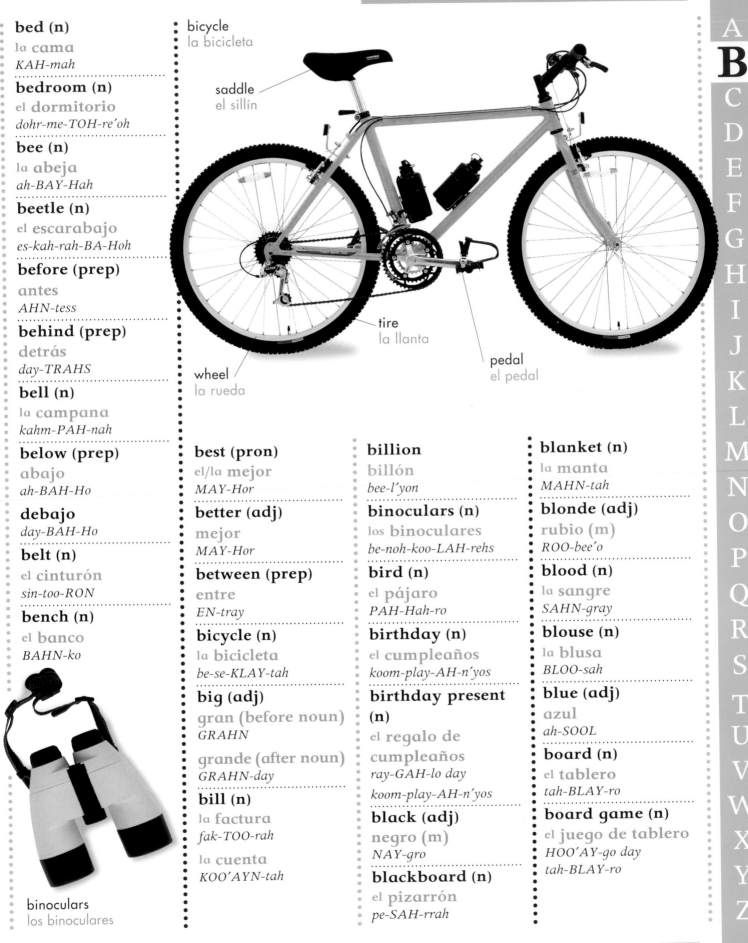

bicycle
la bicicleta

saddle
el sillín

tire
la llanta

pedal
el pedal

wheel
la rueda

binoculars
los binoculares

best (pron)
el/la **mejor**
MAY-Hor

better (adj)
mejor
MAY-Hor

between (prep)
entre
EN-tray

bicycle (n)
la **bicicleta**
be-se-KLAY-tah

big (adj)
gran (before noun)
GRAHN

grande (after noun)
GRAHN-day

bill (n)
la **factura**
fak-TOO-rah

la **cuenta**
KOO'AYN-tah

billion
billón
bee-l'yon

binoculars (n)
los **binoculares**
be-noh-koo-LAH-rehs

bird (n)
el **pájaro**
PAH-Hah-ro

birthday (n)
el **cumpleaños**
koom-play-AH-n'yos

birthday present (n)
el **regalo de cumpleaños**
ray-GAH-lo day
koom-play-AH-n'yos

black (adj)
negro (m)
NAY-gro

blackboard (n)
el **pizarrón**
pe-SAH-rrah

blanket (n)
la **manta**
MAHN-tah

blonde (adj)
rubio (m)
ROO-bee'o

blood (n)
la **sangre**
SAHN-gray

blouse (n)
la **blusa**
BLOO-sah

blue (adj)
azul
ah-SOOL

board (n)
el **tablero**
tah-BLAY-ro

board game (n)
el **juego de tablero**
HOO'AY-go day
tah-BLAY-ro

A B C D E F G H I J K L M N O P Q R S T U V W X Y Z

B

balloon
el globo

baboon (n)
el babuino
bah-boo-EE-no

baby (n)
el bebé
beh-BEH

back (adj)
de atrás
day ah-TRAHS

back (body) (n)
la espalda
ess-PAHL-dah

backpack (n)
la mochila
mo-CHEE-lah

backward (adv)
hacia atrás
A-se'ah ah-TRAHS

bad (adj)
molo (m)
MAH-lo

badge (n)
la insignia
in-SIG-ne'ah

badminton (n)
el bádminton
BAHD-meen-ton

bag (n)
la bolsa
BOL-sah

bakery (n)
la panadería
pah-nah-day-REE-ah

balcony (n)
el balcón
bahl-KON

ball (n)
la pelota
pay-LOH-tah
la bola
BO-lah

ballet dancer (n)
el bailarín
bah'e-lah-REEN
la bailarina
bah'e-lah-REE-nah

balloon (n)
el globo
GLOH-bo

banana (n)
el plátano
PLAH-tah-no

band (n)
la banda
BAHN-dah

bank (money) (n)
el banco
BAHN-ko

bank (river) (n)
la orilla
o-REE-l'ya

barbecue (n)
la barbacoa
bar-bah-KO-ah

barn (n)
el granero
grah-NAY-ro

baseball (n)
el béisbol
BAY'ESS-bol

basement (n)
el sótano
SO-tah-no

basket (n)
la cesta
SESS-tah

basketball (n)
el básquetbol
BAHS-ket-bol

bat (animal) (n)
el murciélago
moor-SE'AY-lah-go

bat (sports) (n)
el bate
BAH-teh

bath (n)
el baño
BAHN-n'yo

bathroom (n)
el (cuarto de) baño
(KOO'AR-toh de)
BAHN-n'yo

bat
el murciélago

battery (n)
la pila
PEE-lah

battle (n)
la batalla
bah-TAH-l'yah

beach (n)
la playa
PLAH-yah

bead (n)
la cuenta
KOO'EN-tah

beak (n)
el pico
PEE-koh

beans (n)
los frijoles
free-HO-lays

bear (n)
el oso
O-so

beard (n)
la barba
BAHR-bah

beautiful (adj)
bonito (m)
boh-NEE-toh

beauty (n)
la belleza
bay-L'YE-sah

because (conj)
porque
POHR-kay

bear
el oso

A

B
C
D
E
F
G
H
I
J
K
L
M
N
O
P
Q
R
S
T
U
V
W
X
Y
Z

angry (adj)
enfadado (m)
en-fah-DAH-do

animal (n)
el animal
ah-ne-MAHL

ankle (n)
el tobillo
to-BEE-l'yo

answer (n)
la respuesta
rres-poo'EES-tah

ant (n)
la hormiga
or-MEE-gah

antenna (n)
la antena
ahn-TAY-nah

any (adj)
cualquiera
koo-ahl-ke-AY-ra

anyone/anything (pron)
cualquiera
koo-ahl-ke-AY-ra

apart (adv)
aparte
ah-PAR-tay

apartment (n)
el apartamento
ah-par-tah-MEN-to

appearance (n)
la apariencia
ah-pah-RE'En-sia

apple (n)
la manzana
mahn-SAH-nah

apron (n)
el delantal
day-lahn-TAHL

arch (n)
el arco
AR-ko

area (n)
el área
AH-ray'ah

arm (n)
el brazo
BRAH-so

armchair (n)
el sillón
se-L'YON

army (n)
el ejército
eh-HAIR-se-to

around (prep)
alrededor
ahl-ray-day-DOR

astronaut
la astronauta

arrival (n)
la llegada
l'yay-GAH-da

arrow (n)
la flecha
FLAY-chah

art (n)
el arte
AR-tay

artist (n)
el/la artista
ar-TEES-tah

assistant (n)
el/la asistente
ah-siss-TEN-tah

astronaut (n)
el/la astronauta
ahs-tro-NAH'OO-tah

astronomer (n)
el astrónomo
ahs-TRO-noh-mo

la astrónoma
ahs-TRO-noh-ma

athletics (n)
el atletismo
aht-lay-tees-moh

atlas (n)
el atlas
AHT-lahs

attic (n)
el ático
AH-tee-ko

aunt (n)
la tía
TEE-ah

avocado (n)
el aguacate
ah-goo'ah-KAH-tay

armchair
sillón

avocado
el aguacate

A

English A–Z

In this section, English words are in alphabetical order, followed by the Spanish translation. There is information after each English word to show you what type of word it is. This will help you to make sentences. In Spanish, nouns (naming words) are either masculine (m) or feminine (f). If the Spanish word has *el* before it, it is masculine, if it has *la*, it is feminine.

(n) = noun (a naming word). Either masculine or feminine. Feminine nouns usually have an "a" at the end.

(adj) = adjective (a describing word). These words can change depending on whether the noun they are describing is masculine or feminine.

(adv) = adverb (a word that gives more information about a verb, an adjective, or another adverb)

(conj) = conjunction (a joining word, e.g., and)

(prep) = preposition (e.g., about)

(pron) = pronoun (e.g., he, she, it)

(article) = (e.g., a, an, the)

(sing) = singular (one thing) **(plu)** = plural (lots of things)

A

apple
la manzana

a (article)
un (m) una (f)
OON/OON-a

about (adv)
sobre/acerca de
SO-bray/ah-SAIR-kah day

above (prep)
sobre
SO-bray

accident (n)
el accidente
ahk-se-DEN-tay

across (prep)
a través de
ah trah-BESS day

activity (n)
la actividad
ahk-te-bi-DAHD

address (n)
la dirección
dee-rek-se'ON

adult (adj)
adulto (m)
ah-DOOL-toh

adventure (n)
la aventura
a-ben-TOO-rah

after (prep)
después de/tras
dess-poo'ESS/TRAHS

afternoon (n)
la tarde
TAR-day

again (adv)
otra vez
O-tra BES

de nuevo
day NOO'AY-boh

age (n)
la edad
ay-DAHD

air (n)
el aire
AH'E-ray

airplane (n)
el avión
ah-BEE'ON

airport (n)
el aeropuerto
ah-ay-ro-poo'AIR-to

alarm clock (n)
el despertador
dess-pair-tah-DOR

all (adj)
todo (m)
TO-do

alligator (n)
el caimán
kah-ee-MAN

almost (adv)
casi
KAH-see

alone (adj)
solo (m)
SOH-lo

alphabet (n)
el alfabeto
ahl-fah-BAY-to

el abecedario
ah-bay-say-DHA-re'oh

already (adv)
ya
YAH

also (adv)
también
tahm-BE'EN

always (adv)
siempre
SE'EM-pray

amazing (adj)
asombroso (m)
ah-som-BROH-so

ambulance (n)
la ambulancia
ahm-boo-LAN-se'ah

an (article)
un (m) una (f)
OON/OON-a

anchor (n)
el ancla
AN-klah

and (conj)
y (except before i/hi)
e

e (before i/hi)
eh

airplane
el avión

56

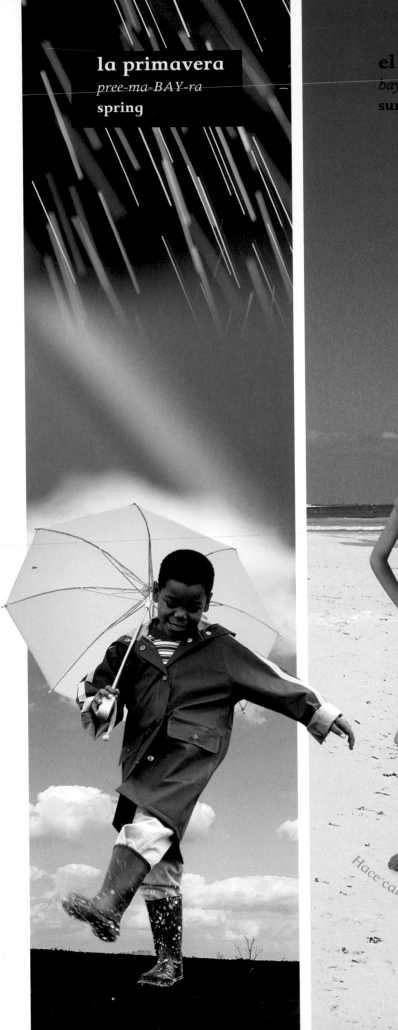

la primavera
pree-ma-BAY-ra
spring

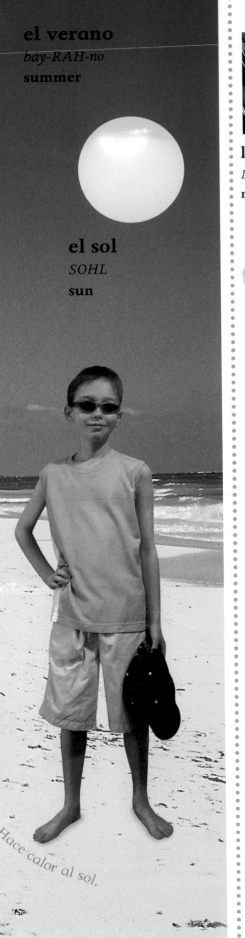

el verano
bay-RAH-no
summer

el sol
SOHL
sun

Hace calor al sol.

la lluvia
LYU-be'ah
rain

la nube
NOO-bay
cloud

el arcoiris
ar-ko-EE-ris
rainbow

las gafas de sol
GAH-fas day SOHL
sunglasses

la gorra
GO-rrah
cap

el muñeco de nieve

moo-N'YEH-ko day NEE'AY-bay

snowman

la nieve

NEE'AY-bay

snow

el gorro de lana

GO-rroh day LAH-na

wool hat

Hoy hace mucho viento.

el paraguas

pair-RAH-goo'ahs

umbrella

54

El tiempo
Weather

el otoño

oh-TO-n'yo

fall

los copos de nieve

KOH-pos day NEE'AY-bay

snowflakes

Me gusta hacer un muñeco de nieve.

Llevo un gorro, una bufanda y guantes.

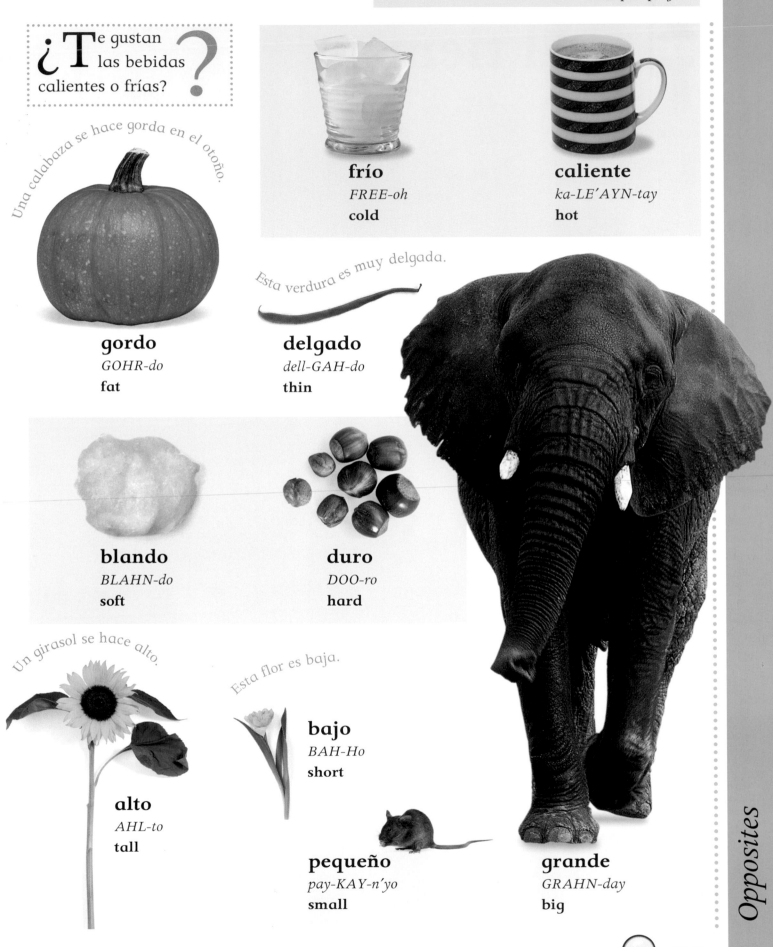

¿**T**e gustan las bebidas calientes o frías?

Una calabaza se hace gorda en el otoño.

frío
FREE-oh
cold

caliente
ka-LE'AYN-tay
hot

Esta verdura es muy delgada.

gordo
GOHR-do
fat

delgado
dell-GAH-do
thin

blando
BLAHN-do
soft

duro
DOO-ro
hard

Un girasol se hace alto.

Esta flor es baja.

bajo
BAH-Ho
short

alto
AHL-to
tall

pequeño
pay-KAY-n'yo
small

grande
GRAHN-day
big

Most pumpkins are orange, but you can grow white and blue ones!

Opposites

53

Los opuestos
Opposites

¡Ábrela bien!

rugoso
RROO-go-so
rough

liso
LEE-so
smooth

abierto
ah-BE'AIR-toh
open

mojado
mo-HAH-do
wet

cerrado
sair-RRAH-do
closed

seco
SAY-ko
dry

sucio
soo-se'oh
dirty

limpio
LEEM-pe'oh
clean

Extra words to learn

lento
LEN-to
slow

ligero
lee-HAY-ro
light

lleno
L'YEH-no
full

nuevo
NOO'AY-bo
new

pesado
pay-SAH-do
heavy

rápido
RRAH-pe-do
fast

vacío
bah-SE'oh
empty

viejo
BE'AY-Ho
old

¡La mayoría de las calabazas son anaranjadas, pero también se pueden cultivar blancas y azules!

el arcoiris
rainbow

el cuadrado
koo'ah-DRAH-do
square

el círculo
SEER-koo-lo
circle

el triángulo
tree-AHN-goo-lo
triangle

el diamante
de'ah-MAHN-tay
diamond

la estrella
ess-TRAY-l'ya
star

el rectángulo
rrehk-TAN-goo-lo
rectangle

Extra words to learn

blanco
BLAHN-ko
white

colorido
ko-lo-RE-do
colorful

el corazón
ko-rah-SON
heart

curvado
koor-BAH-do
curved

el óvalo
OH-bah-lo
oval

recto
RREK-to
straight

redondo
RRAY-don-do
round

el semicírculo
say-me-SEER-koo-lo
semicircle

el cubo
KOO-bo
cube

la bola
BO-lah
ball

All colors are a mixture of red, yellow, or blue.

Colors and shapes

51

Colores y figuras

Colors and shapes

rojo
RROH-Ho
red

anaranjado
ah-nah-ran-HAH-do
orange

amarillo
ah-mah-REE-l'yo
yellow

verde
BAIR-day
green

azul
ah-SOOL
blue

violeta
be'oh-LAY-ta
purple

rosa
RROH-sa
pink

café
ka-FAY
brown

negro
NAY-gro
black

curvado
curved

recto
straight

¿Cuál es tu color favorito y tu figura favorita?

Todos los colores son una mezcla de rojo, amarillo o azul.

la piel
fur

la lengua
tongue

**Extra words
to learn**

la aleta
ah-LAY-ta
fin

la cola
KOH-la
tail

el collar
koh-L'YAR
collar

la garra
GAH-rrah
claw

la pata
PAH-ta
paw

el pez
pes
fish

la pluma
PLOO-mah
feather

la veterinaria
bay-tair-ree-NAR-re'a
vet

el gatito
gah-TEE-to
kitten

el perro
PAIR-rroh
dog

Un loro tiene plumas de colores.

el pico
beak

el loro
LOH-roh
parrot

el pájaro
PAH-Hah-ro
bird

Sam cepilla al caballo.

el bigote
whisker

la cola
tail

el ratón
rah-TON
mouse

el caballo
kah-BAH-l'yo
horse

A cat sleeps about 16 hours a day.

Pets

49

Las mascotas

Pets

Mi perro se llama Miel.

la comida
food

el tazón
bowl

el perrito
pair-RREE-to
puppy

Mi tortuga se mueve muy despacio.

el hámster
HAHMS-tair
hamster

la tortuga
tohr-TOO-ga
tortoise

el conejo
ko-NAY-ho
rabbit

el collar
collar

el conejillo de indias
ko-nay-Hee-l'yo day IN-de'ahs
guinea pig

el gato
GAH-to
cat

el pececito de colores
pay-say-SEE-toh day ko-LO-rehs
goldfish

¿**D**e qué colores es la piel del conejillo de indias?

48 Un gato duerme unas 16 horas al día.

Extra words to learn

el atletismo
aht-lay-tees-moh
athletics

el ejercicio
ay-HAIR-CE-ce'oh
exercise

el hockey
HOH-kay
hockey

el hockey sobre hielo
HOH-kay so-bray E'AY-lo
ice hockey

el judo
JOO-do
judo

el karate
ka-RAH-tay
karate

la natación
na-ta-SE'ON
swimming

¿Te gustan los deportes y hacer ejercicio?

la vela
sail

el chaleco salvavidas
life jacket

tirarse de cabeza
tee-RAR-say day kah-BEH-sah
diving

navegar
na-bay-GAR
sailing

Yo remo.

el remo
oar

el bote
boat

la bola
ball

el guante
glove

remar
rray-MAR
rowing

el bate
bat

el béisbol
BAY-ESS-bol
baseball

la raqueta
racket

el caballo
horse

el rugby
RROOG-be
rugby

correr
ko-RRER
running

montar a caballo
mon-TAR ah kah-BAH-l'yo
horseback riding

el tenis
tay-niss
tennis

There are about 28 sports in the summer Olympic Games!

Sports

Los deportes

Sports

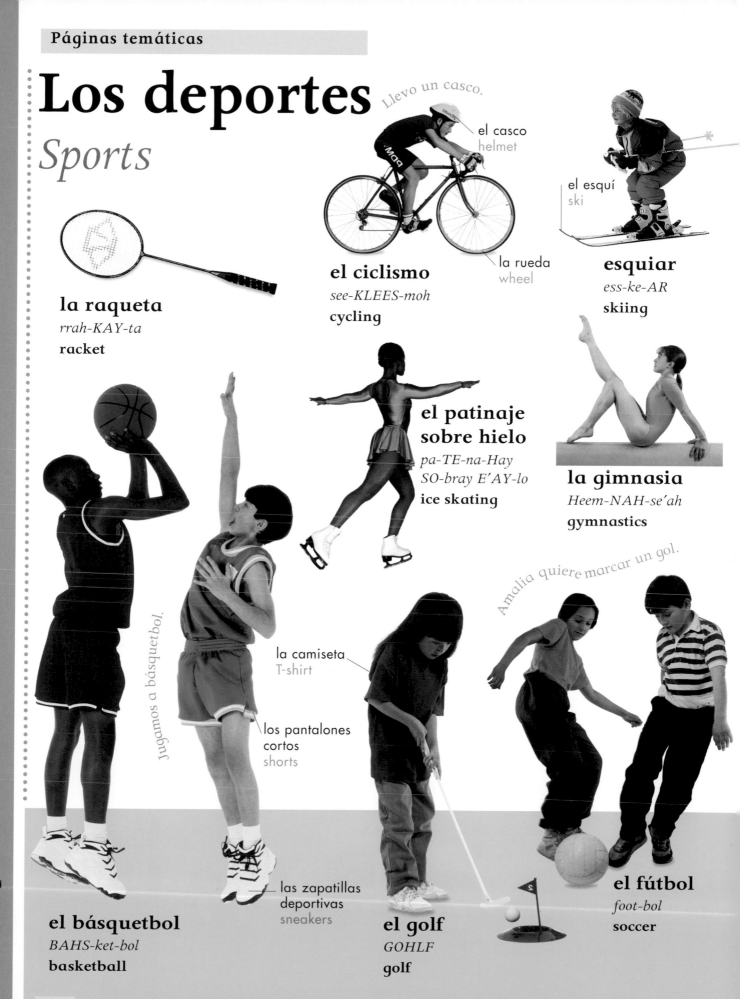

Llevo un casco.

el casco
helmet

el ciclismo
see-KLEES-moh
cycling

la rueda
wheel

el esquí
ski

esquiar
ess-ke-AR
skiing

la raqueta
rrah-KAY-ta
racket

**el patinaje
sobre hielo**
*pa-TE-na-Hay
SO-bray E'AY-lo*
ice skating

la gimnasia
Heem-NAH-se'ah
gymnastics

Jugamos a básquetbol.

Amalia quiere marcar un gol.

la camiseta
T-shirt

los pantalones
cortos
shorts

las zapatillas
deportivas
sneakers

el básquetbol
BAHS-ket-bol
basketball

el golf
GOHLF
golf

el fútbol
foot-bol
soccer

¡Hay unos 28 deportes en los Juegos Olímpicos de verano!

¿Ves mi almuerzo en la lonchera?

la lonchera
lohn-CHAY-rah
lunch box

la libreta
lee-BRAY-tah
notebook

la bolsa de la escuela
school bag

los libros
LEE-bros
books

¿**C**uántos **C**libros hay en esta página?

los marcadores
mahr-ka-DO-rays
markers

Busca tu país en un globo terráqueo.

el globo terráqueo
GLO-bo tay-RRAH-kay-oh
globe

el uniforme escolar
oo-nee-FOHR-may ess-ko-LAR
school uniform

la computadora
kom-poo-tah-DO-rah
computer

The longest pencil in the world is almost 65 feet (20 m) long!

School

La escuela
School

las tijeras
tee-HAY-ras
scissors

los lápices de colores
LAH-pee-says day ko-LO-rays
colored pencils

el pizarrón
pe-SAH-rrah
blackboard

la regla
RAY-glah
ruler

la goma
GOH-ma
eraser

el lápiz
LAH-pis
pencil

la pluma
PLOO-mah
pen

la libreta
notebook

el escritorio
ess-kre-TO-re'oh
desk

Los niños se sientan en escritorios en la clase.

Extra words to learn

el alfabeto
ahl-fah-BAY-to
alphabet

las ciencias
SEE'EN-see'as
science

el dibujo
dee-BOO-ho
drawing

la escritura
ess-kree-TOO-ra
writing

la lectura
lek-TOO-ra
reading

el maestro
mah-ess-tro
teacher

el salón de clase
sah-LON day KLAH-say
classroom

la silla
SEE-l'yah
chair

¡El lápiz más largo del mundo mide casi 65 pies (20 m)!

las gaviotas
ga-be-OH-tas
seagulls

Nos encanta jugar con la arena.

Llevo gafas de agua.

la estrella de mar
ess-TRAY-l'ya day MAHR
starfish

el helado
eh-LAH-do
ice cream

el alga
AHL-ga
seaweed

Hacemos un castillo de arena.

las gafas de agua
GAH-fas day AH-goo'ah
goggles

la silla de playa
SEE-l'ya day PLAH-yah
deck chair

la pamela
pa-MAY-la
sunhat

la arena
ah-RAY-na
sand

el castillo de arena
kass-TEE-l'yo day ah-RAY-na
sandcastle

43

el cubo

KOO-bo

bucket

la pala

PAH-la

shovel

el cangrejo

kan-GRAY-Ho

crab

la concha

KOHN-cha

shell

los guijarros

ghee-HAH-rros

pebbles

En la playa

At the beach

¡Me encanta nadar en el mar!

¿Te gusta ir a la playa?

Juego bajo mi sombrilla.

la roca

ROH-ka

rock

el protector solar
sunblock

Los renacuajos nadan en el estanque.

el nido
NEE-doh
nest

los renacuajos
rray-nah-KOO'AH-Hoh
tadpoles

la avispa
ah-BEES-pa
wasp

la antena
antenna

la mosca
MOSS-ka
fly

el ala
wing

¿**C**uántos **C**nenúfares hay en el estanque?

el estanque
es-TAN-kay
pond

el búho
BOO-oh
owl

la rana
RRAH-na
frog

Extra words to learn

el agua
ah-GOO'AH
water

el conejo
ko-NAY-ho
rabbit

la garza
GAR-sah
heron

el hábitat
AH-be-taht
habitat

el insecto
in-SEK-to
insect

la mala hierba
MAH-la EE'AIR-ba
weed

la mariposa
mah-re-PO-sah
butterfly

el pájaro
PAH-Hah-ro
bird

Toads usually have rough skin and frogs have smooth skin.

Nature

41

La naturaleza
Nature

Un nenúfar crece en el agua.

el pico
beak

la planta
PLAHN-ta
plant

la libélula
lee-BEH-loo-lah
dragonfly

el nenúfar
nay-NOO-far
water lily

el pato
PAH-to
duck

Muchos animales viven cerca de estanques.

el cisne
SISS-nay
swan

el sapo
SAH-po
toad

Los sapos normalmente tiene la piel rugosa y las ranas tienen la piel lisa.

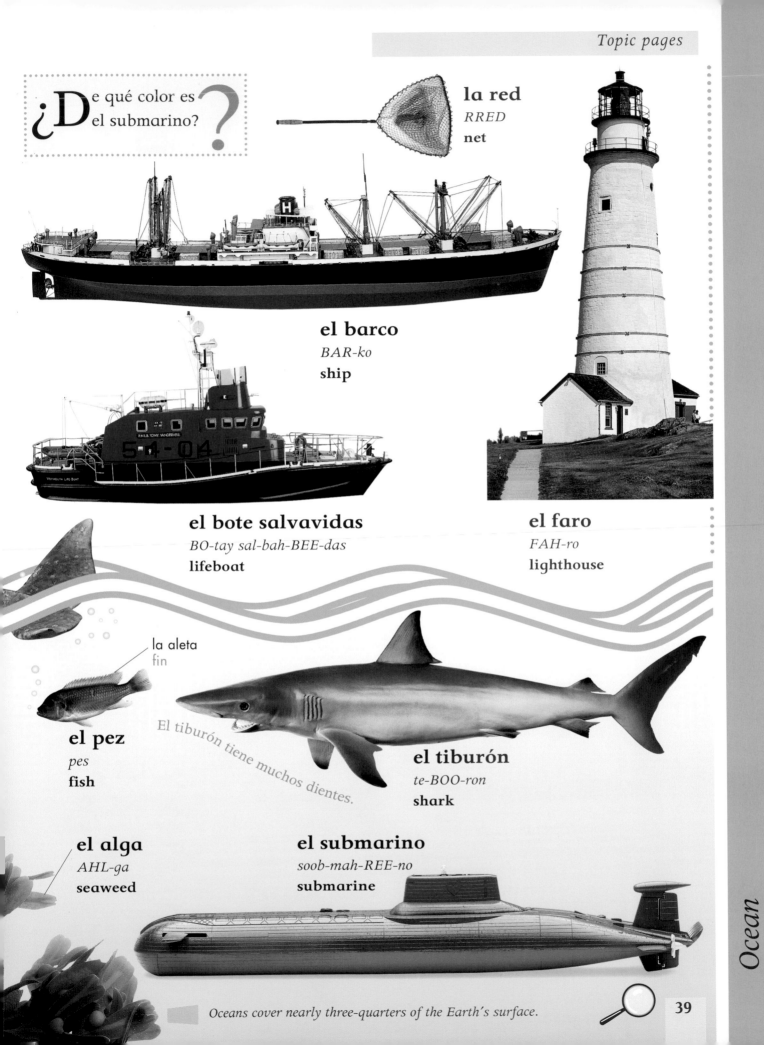

¿**D**e qué color es
el submarino?

la red
RRED
net

el barco
BAR-ko
ship

el bote salvavidas
BO-tay sal-bah-BEE-das
lifeboat

el faro
FAH-ro
lighthouse

la aleta
fin

el pez
pes
fish

El tiburón tiene muchos dientes.

el tiburón
te-BOO-ron
shark

el alga
AHL-ga
seaweed

el submarino
soob-mah-REE-no
submarine

Oceans cover nearly three-quarters of the Earth's surface.

Ocean

El océano

Ocean

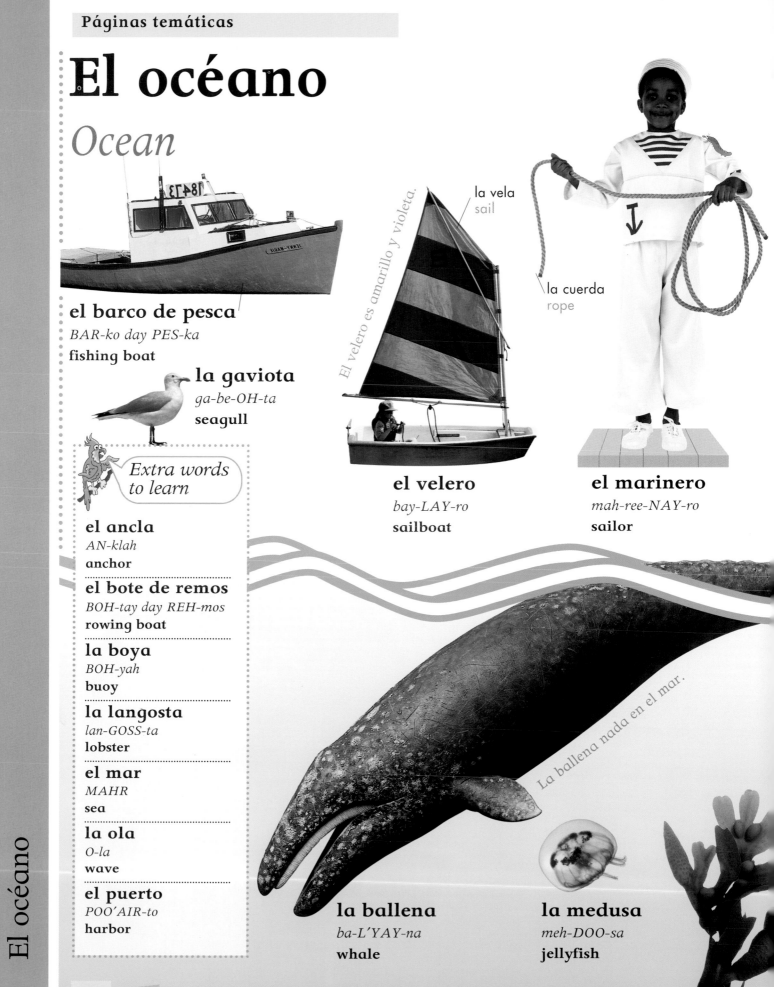

el barco de pesca
BAR-ko day PES-ka
fishing boat

la gaviota
ga-be-OH-ta
seagull

la vela
sail

El velero es amarillo y violeta.

la cuerda
rope

el velero
bay-LAY-ro
sailboat

el marinero
mah-ree-NAY-ro
sailor

Extra words to learn

el ancla
AN-klah
anchor

el bote de remos
BOH-tay day REH-mos
rowing boat

la boya
BOH-yah
buoy

la langosta
lan-GOSS-ta
lobster

el mar
MAHR
sea

la ola
O-la
wave

el puerto
POO'AIR-to
harbor

La ballena nada en el mar.

la ballena
ba-L'YAY-na
whale

la medusa
meh-DOO-sa
jellyfish

El océano

38 Los océanos cubren casi tres cuartas partes de la superficie de la Tierra.

el trigo
TREE-go
wheat

la cosechadora combinada
koh-say-chah-DO-rah kom-be-NAH-da
combine harvester

la cerca
SAYR-kah
fence

el pato
PAH-to
duck

la vaca
BAH-kah
cow

el heno
AY-no
hay

el caballo
kah-BAH-l'yo
horse

el pollo
PO-l'yo
chicken

los patitos
pah-TEE-tos
ducklings

37

el campo
KAM-poh
field

el tractor
TRAK-tor
tractor

el trigo
TREE-go
wheat

los corderos
kor-DAY-rohs
lambs

el perro pastor
PAIR-rro pass-TOR
sheepdog

En la granja

On the farm

El granjero usa el tractor.

la granjera
grahn-HAY-rah
farmer

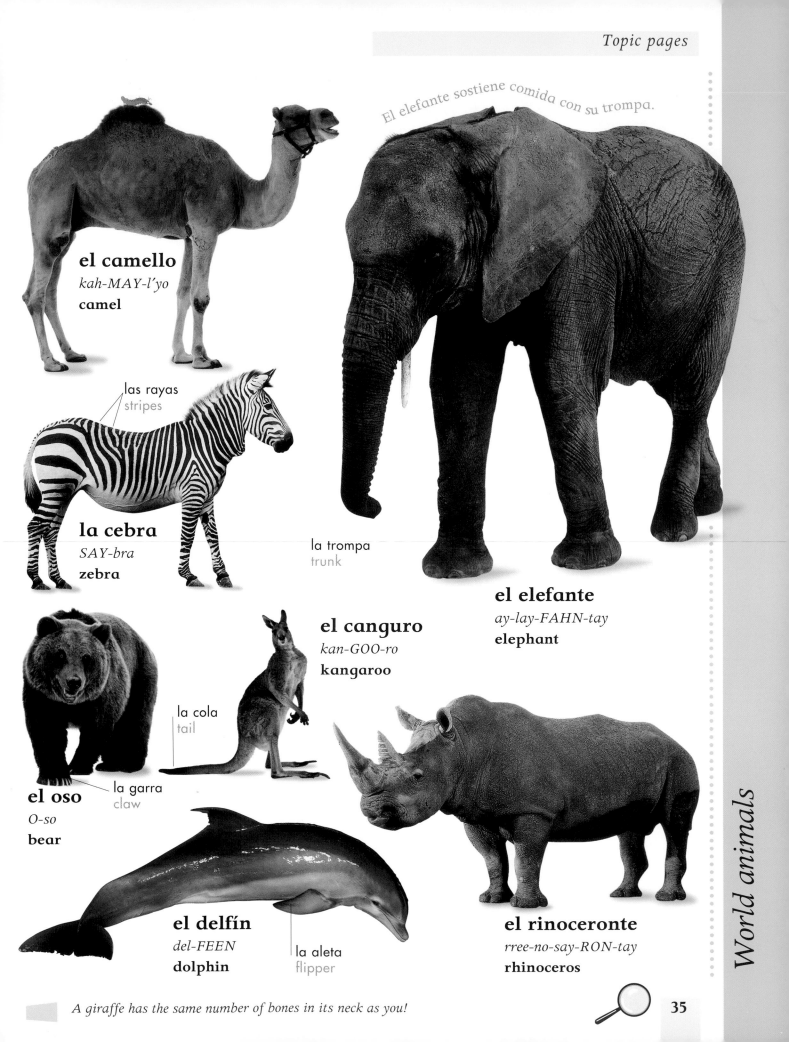

El elefante sostiene comida con su trompa.

el camello
kah-MAY-l'yo
camel

las rayas
stripes

la cebra
SAY-bra
zebra

la trompa
trunk

el elefante
ay-lay-FAHN-tay
elephant

el canguro
kan-GOO-ro
kangaroo

la cola
tail

el oso
O-so
bear

la garra
claw

el delfín
del-FEEN
dolphin

la aleta
flipper

el rinoceronte
rree-no-say-RON-tay
rhinoceros

A giraffe has the same number of bones in its neck as you!

World animals

35

Los animales del mundo *World animals*

el koala
ko-AH-la
koala

el ciervo
SE'AIR-boh
deer

el panda
PAHN-dah
panda

el oso polar
O-so poh-LAR
polar bear

la jirafa
Hee-RAH-fah
giraffe

¡La jirafa tiene un cuello largo!

la pata
paw

el león
lay-ON
lion

Extra words to learn

el babuino
bah-boo-EE-no
baboon

el caimán
kah-ee-MAN
alligator

el halcón
ahl-KON
hawk

el lobo
LOH-bo
wolf

el murciélago
moor-SE'AY-lah-go
bat

el pelícano
pay-LEE-kah-no
pelican

la tortuga
tohr-TOO-ga
tortoise

el zorro
soh-rro
fox

el pico
beak

la cola
tail

el pingüino
peen-GOO'E-no
penguin

¿Cuántos pájaros hay en esta página?

¡Una jirafa tiene el mismo número de huesos en el cuello que tú!

Un tucán come comida con el pico.

el loro
LOH-roh
parrot

el tucán
too-KAN
toucan

el ojo
eye

el pico
beak

la garra
claw

el águila
AH-ghee-lah
eagle

el árbol
AHR-bol
tree

el escarabajo
es-kah-rah-BA-Hoh
beetle

el insecto
in-SEK-to
insect

el lagarto
lah-GAR-to
lizard

el mamífero
mah-MEE-fay-ro
mammal

salvaje
sal-BA-Hay
wild

la selva tropical
SELL-bah tro-pe-KAHL
rain forest

la serpiente
sair-PEE'EN'tay
snake

la rana
RRAH-na
frog

la pata
foot

las rayas
stripes

las manchas
spots

el tigre
TEE-gray
tiger

el leopardo
lay-o-PAHR-do
leopard

The biggest jungle in the world is in South America.

Jungle animals

Los animales de la jungla

Jungle animals

el colibrí
ko-le-BREE
hummingbird

el ala
wing

el chimpancé
chem-pahn-SAY
chimpanzee

el murciélago
moor-SE'AY-lah-go
bat

la mariposa
mah-re-PO-sah
butterfly

la hormiga
or-MEE-gah
ant

la araña
ah-RA-n'ya
spider

el gorila
go-REE-la
gorilla

la polilla
poh-LEE-l'ya
moth

¿**Q**ué animales pueden volar**?**

el cocodrilo
ko-ko-DREE-lo
crocodile

La jungla más grande del mundo está en América del Sur.

Los animales de la jungla

la cesta
basket

Un globo aerostático flota en el aire.

el globo aerostático
GLO-bo ah-ay-ros-TAH-te-ko
hot air balloon

el tren
TREN
train

el equipaje
luggage

el auto
AH'OO-toh
car

el espejo
mirror

la motocicleta
mo-to-see-KLAY-tah
motorcycle

Extra words to learn

el autobús
ah'oo-to-BOOSS
bus

el cohete espacial
ko-AY-tay ess-pah-SE'AHL
space rocket

la entrada
en-TRAH-da
ticket

la furgoneta
foor-go-NAY-ta
van

el garaje
gah-RAH-Hay
garage

la gasolina
ga-soh-LEE-Na
gas

el horario
o-RAH-re'oh
timetable

el viaje
BE'AH-Hay
trip

¿**C**uántas ruedas hay en esta página?

el helicóptero de la policía
eh-le-KOP-tay-ro day lah poh-le-SEE-ah
police helicopter

el coche de policía
ko-chay day poh-le-SEE-ah
police car

la ambulancia
ahm-boo-LAN-se'ah
ambulance

The fastest fire engine reached 407 miles per hour (655 kph) in 1998.

Transportation

31

Los transportes

Transportation

el avión
ah-BEE'ON
plane

el transbordador
trans-bor-dah-DOR
ferry

el velero
bay-LAY-ro
sailboat

el taxi
TAK-see
taxi

el camión
ka-ME'ON
truck

Un autobús lleva a la gente de viaje.

la bicicleta
be-se-KLAY-tah
bicycle

el autobús
ah'oo-to-BOOSS
bus

Al rescate

To the rescue

la escalera
ladder

**el coche
de bomberos**
KOH-chay day bom-BAY-ros
fire engine

la llanta
tire

La locomotora más rápida alcanzó 407 millas por hora (655 kph) en 1998.

Los transportes

las cartas
KAHR-tahs
cards

los discos compactos
DISS-kos kom-PAK-tohs
CDs

el reproductor de discos compactos
ray-proh-dook-TOHR day DISS-koss kom-PAK-tohs
CD player

el videojuego
BEE-day-oh-HOO'AY-go
video game

el casco
helmet

¡Se mueve muy rápido!

el patinaje en línea
pa-te-NAH-Hay en LEE-nee'ah
inline skating

la marioneta
puppet

el espactáculo de marionetas
ess-pehk-TAH-koo-lo day mah-re'oh-NAY-ta
puppet show

¡Nos encantan los espectáculos de marionetas!

el disfraz
diss-FRAS
costume

el osito
de peluche
teddy bear

¿**T**e gustan los juegos de computadora?

The first laptop was made more than 20 years ago.

A jugar
Playtime

las escondidas
ays-kon-DEE-das
hide-and-seek

el juego de tablero
HOO'AY-go day tah-BLAY-ro
board game

la pelota
pay-LOH-tah
ball

el robot
rro-BOT
robot

el juego
HOO'AY-go
game

el juguete
Hoo-GAY-tay
toy

el libro
LEE-bro
book

la marioneta
mah-re'oh-nay-ta
puppet

los dados
DAH-doss
dice

la computadora portátil
kom-poo-tah-DOO-rah pohr-TAH-teel
laptop

la máscara
MAHS-kah-rah
mask

la muñeca
moo-N'YEH-kah
doll

el patinaje
pa-te-NAH-Hay
skating

Juego con mi tren eléctrico.

el tren
train

el lápiz de color
colored pencil

el dibujo
dee-BOO-ho
drawing

el rompecabezas
rrom-pay-kah-BAY-sas
puzzle

el tren eléctrico
TREN ay-LEK-tree-ko
train set

A jugar

La primera computadora portátil se fabricó hace más de 20 años.

las decoraciones
day-ko-rah-SE'O-nays
decorations

¡Feliz cumpleaños!

¡Esto es asombroso!

Quiero abrir los regalos.

los regalos de cumpleaños
ray-GAH-los day koom-play-AH-n'yos
birthday presents

los globos
GLOH-bos
balloons

la cámara
KA-mah-rah
camera

las galletas
ga-L'YE-tahs
cookies

el helado
eh-LAH-do
ice cream

los caramelos
ka-ra-MAY-los
candy

27

la bebida

beh-BE-da

drink

los sándwiches

SAHND-oo'ich-es

sandwiches

las tarjetas

tar-HAY-tays

cards

las velas

VAY-lahs

candles

el pastel

pahs-TEHL

cake

26

En la fiesta

At the party

Es divertido jugar con los globos.

Nos gusta bailar con la música.

el mago

MAH-go

magician

el reproductor de discos compactos

ray-proh-dook-TOHR day DISS-koss kom-PAK-tohs

CD player

la camarera
ka-ma-RAY-ra
waitress

el café
ka-FAY
café

la lista de la compra
LEES-tah day la KOM-prah
shopping list

el supermercado
soo-pair-mair-KAH-do
supermarket

Ella tiene muchas bolsas de compra.

la panadería
pah-nah-day-REE-ah
bakery

la librería
le-bray-REE-ah
bookstore

la clienta
klee-EN-tay
shopper

Extra words to learn

la caja
KAH-Hah
checkout

la caja registradora
KAH-Hah rreh-Hiss-trah-DOH-rah
cash register

la cuenta
KOO'AYN-tah
bill

el dinero en efectivo
de-NAY-roh en ay'fek-TEE-bo
cash

el precio
PRAY-se'oh
price

el recibo
rray-SE-bo
receipt

la tienda
tee'ayn-da
shop

el vendedor
ben-day-DOR
shopkeeper

Shopping

The first shopping cart was invented more than 60 years ago.

De compras
Shopping

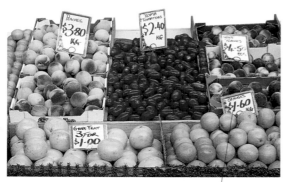

el mercado

mair-KAH-do

market

el precio / price

el dinero

de-NAY-roh

money

la bolsa de la compra

BOL-sah day la KOM-prah

shopping bag

Tengo que comprar comida.

Esperamos en la cola.

el carrito de compras

KA-RREE-toh day KOM-prahs

shopping cart

la cesta

SESS-tah

basket

De compras

24

El primer carrito de compras se inventó hace más de 60 años.

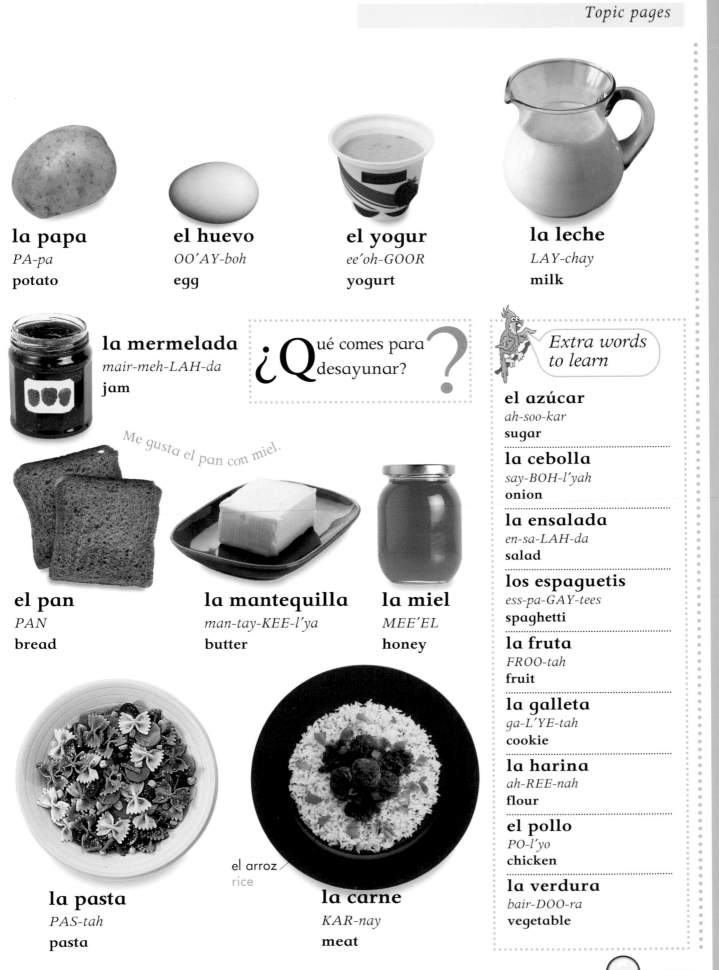

la papa
PA-pa
potato

el huevo
OO'AY-boh
egg

el yogur
ee'oh-GOOR
yogurt

la leche
LAY-chay
milk

la mermelada
mair-meh-LAH-da
jam

¿**Q**ué comes para desayunar?

Extra words to learn

el azúcar
ah-soo-kar
sugar

la cebolla
say-BOH-l'yah
onion

la ensalada
en-sa-LAH-da
salad

los espaguetis
ess-pa-GAY-tees
spaghetti

la fruta
FROO-tah
fruit

la galleta
ga-L'YE-tah
cookie

la harina
ah-REE-nah
flour

el pollo
PO-l'yo
chicken

la verdura
bair-DOO-ra
vegetable

Me gusta el pan con miel.

el pan
PAN
bread

la mantequilla
man-tay-KEE-l'ya
butter

la miel
MEE'EL
honey

la pasta
PAS-tah
pasta

el arroz
rice

la carne
KAR-nay
meat

A carrot is a vegetable and a root.

Food

23

La comida

Food

la semilla
seed

la piel
skin

el plátano
PLAH-tah-no
banana

la naranja
nah-RAHN-Hah
orange

la manzana
mahn-SAH-nah
apple

la sandía
san-DEE-a
watermelon

el tomate
to-MAH-te
tomato

la zanahoria
sah-nah-O-re'ah
carrot

la lechuga
lay-CHOO-gah
lettuce

la col
KOL
cabbage

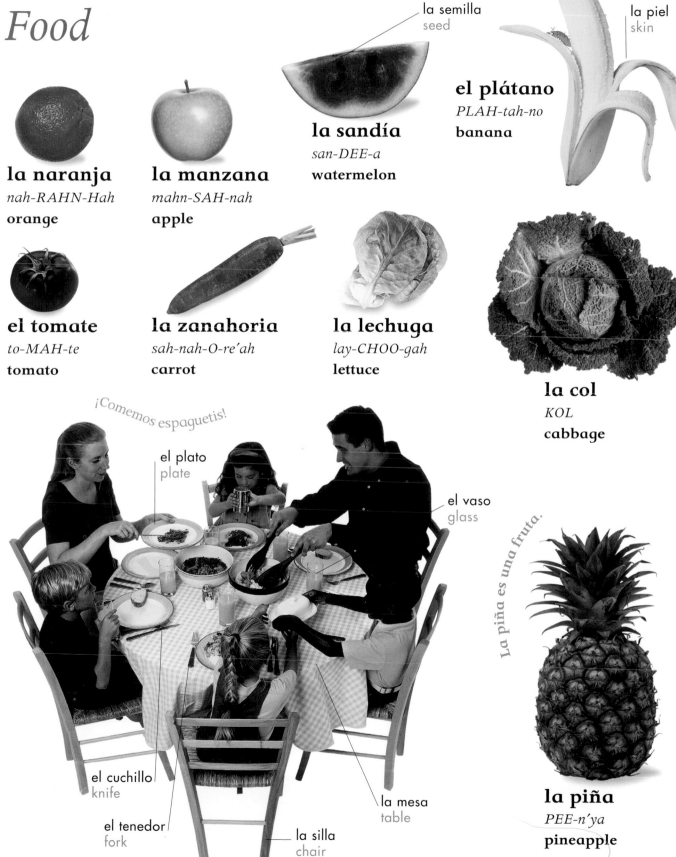

¡Comemos espaguetis!

el plato
plate

el vaso
glass

el cuchillo
knife

el tenedor
fork

la silla
chair

la mesa
table

La piña es una fruta.

la piña
PEE-n'ya
pineapple

22 Una zanahoria es una verdura y una raíz.

hacer surf
ah-SAIR SOORF
surfing

¿**C**uál es tu pasatiempo favorito?

En gimnasia, me estiro y salto.

la gimnasia
Heem-NAH-se'ah
gymnastics

sacar fotos
sah-KAR FOH-toss
taking photos

la pintura
peen-TOO-rah
painting

la escritura
ess-kree-TOO-ra
writing

Surfing began in Hawaii about 300 years ago.

Los pasatiempos
Hobbies

Mis flores crecen.

Estoy lista para ir a nadar.

la acampada
ah-kahn-PAH-do
camping

la natación
na-ta-SE'ON
swimming

la jardinería
Hahr-dee-nay-REE-ah
gardening

tocar un instrumento
toh-kar oon in-stroo-MEN-to
playing an instrument

observar los pájaros
ob-sair-BAR loss PAH-Hah-ross
bird-watching

Daniela practica cada día.

bailar
bah'e-lar
dancing

El surf empezó en Hawaii hace unos 300 años.

Los pájaros hacen ruido.

el árbol
AHR-bol
tree

el columpio
ko-LOOM-pe'oh
swing

el niño
NEE-n'yoh
boy

el balón de fútbol
bah-LON day foot-bol
soccer ball

Mi juego favorito es el fútbol.

la mariposa
mah-re-PO-sa
butterfly

el pájaro
PAH-Hah-ro
bird

la bicicleta
be-se-KLAY-tah
bicycle

la hoja
OH-Hah
leaf

la hierba
YAIR-ba
grass

la cometa
ko-MAY-ta
kite

**la cuerda
de saltar**
*KOO'AIR-da
day sal-TAR*
jump rope

el monopatín
mo-no-pa-TEEN
skateboard

las flores
FLOR-es
flowers

la rueda
RROO'AY-dah
roundabout

En el parque
In the park

¡Me encanta saltar!

la niña
NEE-n'ya
girl

Tres niños juegan en la rueda.

Extra words to learn

el auto
AH'OO-toh
car

la autopista
ah'oo-to-PEES-tah
highway

el banco
BAHN-ko
bank

el café
ka-FAY
café

la fábrica
FAH-bre-kah
factory

el metro
MAY-tro
subway

la parada del autobús
pah-RAH-dah del ah'oo-to-BOOSS
bus stop

el pavimento
pah-be-MEN-to
sidewalk

el teléfono
tay-LAY-fo-no
phone

la señal
say-N'YAL
sign

el semáforo
say-MAH-for-ro
traffic lights

el cine
SEE-nay
cinema

la luz
LOOS
light

el cruce
KROO-say
crossing

el taxi
TAK-see
taxi

el hotel
oh-TEL
hotel

Tokyo, the capital of Japan, is one of the biggest cities in the world.

En la ciudad

In the city

el autobús

ah'oo-to-BOOSS

bus

el rascacielos

rass-ka-SEE'AY-los

skyscraper

¿Qué hora **Q**es en el reloj azul? **?**

Las ciudades tienen edificios altos llamados rascacielos.

la casa

KAH-sah

house

el reloj

rray-LOH

clock

los apartamentos

ah-par-tah-MEN-tos

apartments

la calle

KAH-l'ye

street

la tienda

tee'ayn-da

shop

Tokio, la capital de Japón, es una de las ciudades más grandes del mundo.

¿**D**e qué color es la mariquita de esta página?

la concha
shell

el caracol
ka-ra-KOHL
snail

el gusano
goo-SAH-no
worm

el ala
wing

la mariposa
mah-re-PO-sah
butterfly

la abeja
ah-BAY-Hah
bee

la semilla
say-MEE-l'ya
seed

la mariquita
mah-ree-KEE-ta
ladybug

Las flores crecen en el jardín.

María está cavando en el jardín.

la flor
FLOR
flower

la oruga
o-ROO-gah
caterpillar

la tierra
TE'AY-rrah
soil

la pala
PAH-lah
spade

Usually butterflies fly in the day and moths fly at night.

El jardín
Garden

Extra words to learn

el bulbo
BOOL-boh
bulb

la cerca
SAYR-kah
fence

el césped
SESS-payd
lawn

el desplantador
dess-plahn-tah-DOR
trowel

la hoja
Oh-Hah
leaf

el invernadero
in-vair-nah-DAY-ro
greenhouse

la jardinera
Hahr-dee-NAY-rah
gardener

la regadera
ray-ga-DAY-ra
watering can

la carretilla
ka-rray-TEE-l'ya
wheelbarrow

el árbol
AHR-bol
tree

el tronco
trunk

el rastrillo
rrahs-TREE-l'yo
rake

el banco
BAHN-ko
bench

la hierba
YAIR-ba
grass

el cortacésped
kor-tah-SESS-payd
lawn mower

Normalmente las mariposas vuelan durante el día y las polillas vuelan por la noche.

¿Qué hay dentro del armario?

el tapete
tah-PAY-tay
rug

La alfombra es azul.

los libros
LEE-bros
books

Puedo tocar la guitarra.

el armario
ahr-MAR-re'o
wardrobe

la guitarra
ghee-TAH-rrah
guitar

la percha
PER-chah
coat hanger

la lámpara
LAM-pah-rah
lamp

el espejo
ess-PAY-Ho
mirror

el reloj
rray-loH
clock

la cama
KAH-mah
bed

la almohada
al-moh-AH-da
pillow

el edredón
ay-dray-DON
comforter

la silla
SEE-l'yah
chair

Mi dormitorio
My bedroom

la cómoda
KO-mo-dah
chest of drawers

Duermo en mi cama.

el videojuego
BEE-day-oh-HOO'AY-go
video game

Jugamos a juegos de tablero.

el ajedrez
chess

la alfombra
ahl-FOM-brah
carpet

Mi gato duerme debajo de mi cama.

Gracias por lavar los platos.

la alacena
cupboard

el fregadero
fray-ga-DEH-ro
sink

el congelador
freezer

Extra words to learn

la bandeja
ban-DAY-Hah
tray

el cubo de la basura
KOO-bo deh lah bah-SOO-rah
trash can

el hervidor
air-BE-dor
kettle

la jarra
HAR-rrah
jug

la lavadora
la-ba-DO-ra
washing machine

la plancha
PLAN-chah
iron

la taza
TAH-sa
cup

la tostadora
toss-ta-DOR-ra
toaster

el cuchillo
koo-CHEE-l'yo
knife

el tenedor
tay-nay-DOR
fork

el refrigerador
reh-free-Hay-ra-DOR
fridge

¿Te gusta hacer pasteles?

el delantal
day-lahn-TAHL
apron

la manopla
mah-NO-plah
oven mitt

el vaso
BAH-so
glass

The first gas stove was made in 1826.

Kitchen

9

La cocina

Kitchen

el cazo
saucepan

la sartén
sar-TAYN
frying pan

el plato
PLAH-to
plate

el horno
oven

la cocina
ko-SEE-na
stove

la cuchara
koo-CHAH-ra
spoon

la taza
TAH-sa
mug

el libro
book

el paño de cocina
PAH-n'yo day ko-SEE-na
dish towel

el tazón
tah-SON
bowl

el cazo
KAH-so
saucepan

¿**Q**ué hay en la cuchara?

La primera cocina de gas se fabricó en 1826.

La cocina

el cinturón
belt

los pantalones
pan-ta-LOH-ness
pants

la camiseta
ka-mee-SAY-ta
T-shirt

**los pantalones
cortos**
pan-ta-LOH-ness KOR-tos
shorts

**el traje
de baño**
*TRAH-Hay
day BAH-n'yo*
swimsuit

la chaqueta
chah-KAY-ta
jacket

la capucha
hood

la falda
FAHL-da
skirt

los vaqueros
jeans

el chubasquero
choo-bas-KAY-roh
raincoat

Los vaqueros y las zapatillas son mi ropa favorita.

las botas
BO-tahs
boots

¿**T**e gusta llevar
zapatos o
zapatillas deportivas?

Clothes

La ropa
Clothes

el botón
button

los calcetines
kal-say-TEE-nays
socks

la camisa
ka-MEE-sa
shirt

los vaqueros
bah-KAY-ros
jeans

la cremallera
zipper

la manga
sleeve

el bolsillo
pocket

Extra words to learn

las gafas
GAH-fas
glasses

el guante
goo'AN-tay
glove

el pijama
pee-HAH-ma
pajamas

la ropa interior
RRO-pa in-tay-RE'OR
underwear

el suéter
SOO'EH-tair
sweater

el vestido
behs-TE-do
dress

la zapatilla
sa-pa-TEE-l'ya
slipper

el zapato
sa-pah-to
shoe

el forro polar
FOR-rro po-LAR
fleece

la bufanda
boo-FAHN-da
scarf

el guante
glove

el abrigo
ah-BREE-go
coat

las zapatillas deportivas
sa-pah-tee-yahs day-por-TEE-bas
sneakers

Mi abrigo me mantiene calentita.

La ropa

¡Los vaqueros tienen más de 130 años!

Extra words to learn

la cara
KAH-ra
face

la ceja
SAY-Hah
eyebrow

el codo
KOH-do
elbow

el cuello
KOO'EH-l'yo
neck

el diente
DEE'EN-tay
tooth

la espalda
ess-PAHL-dah
back

la familia
fah-ME-le'ah
family

el pelo
PAY-lo
hair

la rodilla
rroh-DEE-l'ya
knee

la cabeza
kah-BAY-sa
head

el ojo
OH-Hoh
eye

la oreja
oh-RAY-Hah
ear

la nariz
nah-REES
nose

el hombro
OM-bro
shoulder

la boca
BOH-ka
mouth

el brazo
brah-so
arm

el estómago
ess-TOH-ma-go
stomach

la mano
MAH-no
hand

el dedo
DAY-doh
finger

Puedo estirar los brazos.

la pierna
PE'AIR-nah
leg

el pie
PEE'EH
foot

Lloro cuando estoy triste.

¡Él está emocionado!

triste
TRISS-tay
sad

emocionado
eh-mo-ce'oh-NAH-do
excited

el dedo del pie
DAY-do del PEE'EH
toe

¿**D**e qué color tienes los ojos?

All about me

There are about 206 bones in your body!

5

Acerca de mí

All about me

Soy alta.

el hermano
air-MAH-noh
brother

la hermana
air-MAH-nah
sister

el bebé
beh-BEH
baby

el abuelo
grandfather

la abuela
grandmother

los abuelos
ah-BOO'AY-los
grandparents

el padre
PAH-dray
father

la madre
MAH-dray
mother

Ésta es mi familia.

la niña
NEE-n'ya
child

la tía
TEE-ah
aunt

el tío
TEE-o
uncle

¡Somos felices!

feliz
fay-LEES
happy

Tom está enfadado.

enfadado
en-fah-DAH-do
angry

¡Tu cuerpo tiene unos 206 huesos!

How to use this dictionary

Find out how you can get the most from your dictionary. At the beginning of the book, there are Topic pages. These include lots of useful words on a particular subject, such as *Pets* and *In the Park*. Each word has its translation and help with how to pronounce it. The words on the Topic pages can be found in the English A–Z and in the Spanish A–Z. There are lots of other useful words here too. The verbs and a pronunciation guide are in another section. At the back of the book, there is a list of useful phrases for you to practice your Spanish with your friends.

Topic pages

Spanish topic heading

Spanish entry word

Spanish pronunciation

English translation

extra words on this subject

interesting fact

translation of topic heading

question for language practice

simple sentence with topic vocabulary

translation of interesting fact

English to Spanish A–Z

first word on the page with the Spanish translation

English entry word

Spanish translation

Spanish pronunciation

last word on the page with the Spanish translation

first letter of the words on the page

Look for me on the topic pages!

Contents

**LONDON, NEW YORK, MUNICH,
MELBOURNE, and DELHI**

Senior Editors
Hannah Wilson, Julie Ferris

Project Editor Anna Harrison

Editor Elise See Tai

Art Editors
Ann Cannings, Emy Manby

U.S. Editor Elizabeth Hester

DTP Designer David McDonald

Production Harriet Maxwell

Translator Candy Rodó

Managing Editor
Scarlett O'Hara

First American Edition, 2005

Published in the United States by
DK Publishing, Inc.
4th floor, 345 Hudson Street
New York, New York 10014

17

023-FD095-Jun/05

Copyright © 2005, Dorling Kindersley Ltd

A Cataloging-in-Publication record for this book
is available from the Library of Congress.
ISBN 978-0-7566-1370-9

Color reproduction by Colourscan, Singapore
Printed and bound in China

Discover more at
www.dk.com

DK First

SPANISH
Picture Dictionary

DK

there. Corruption is endemic, tribal loyalty is strong, and the economy is based on narco-trafficking (90 percent of the world's heroin comes from the Helmand River valley). IED networks buried throughout the region were killing our troops.

On the IED challenge, we sent special forces to find the networks, reverse-engineer them, and destroy them. We also banned the principal ingredient, ammonium nitrate, although that was a two-edged sword with negative implications on the strategic concept front because farmers were angered by the loss of their fertilizer. We were also able to investigate each site carefully using sophisticated biometric tools to find traces of the insurgents. This helped identify perpetrators in some cases.

Flash-forward three years. I vividly remember a trip I made in the spring of 2012 to Mazar-e Sharif in northern Afghanistan. Allied forces in the region were under the command of a German two-star officer. We were having a meeting with a group of local Afghans to discuss regional security. Out of the corner of my eye I saw a videographer enter the room with a very large 1980s-era camera. On the wall of the meeting room was a big photo of Ahmad Shah Massoud, known as "the Lion of the Panjshir," the leader of the Northern Alliance who was assassinated by a bomb hidden in just such a camera on the eve of 9/11. I saw the videographer working the room and coming closer and closer to me. I tried to catch the eye of members of my security detail and hoped that they had done their usual meticulous job. If they hadn't, it would have been too late. I smiled into the camera and quietly said my prayers. Turned out it was just a camera.

In addition to visiting allied forces all over Afghanistan, I made calls on virtually all of the fifty nations providing support to the effort. My travels took me to countries as diverse as Estonia, which incurred the highest per capita casualty rate of NATO member nations in Afghanistan, and New Zealand, which sent superb troops halfway around the world to help train fighters and conduct special operations in Afghanistan.

I made two trips to Australia and New Zealand to thank them for their contributions and consult on the way ahead. The Australians sent more than 1,500 troops, a significant contribution for a nation with a population of just over 20 million; the New Zealanders sent 220 people from a population base of just over 4 million. Like the British, the troops from both nations were exceptionally professional in everything they did. Indeed, the men and women from Oceania performed demanding special operations training the Afghan

security forces, flying aircraft in support of the demanding logistics tail, and engaging in the important work of the Provincial Reconstruction Teams.

In April 2010 I spoke about that effort at the Australian Defense Force Academy. In my remarks I highlighted the work of Corporal Brett Corrigan at the Provincial Reconstruction Team in training young Afghan men as carpenters. It was the perfect image for what needed to be done in Afghanistan: create a generation of builders instead of a generation of bombers.

I also showed a photograph of Captain Myles Conquest (great name!) of the Australian Army, who was part of the embedded partnering and training team with one of the Afghanistan *kandaks* (battalions) operating in Uruzgan Province. At the end of the day, our "success strategy" in Afghanistan will be based on our ability to train the Afghan security forces, as Captain Conquest was doing, so we can draw down our own troops.

What generally makes the news from Afghanistan are images of troops on patrol and IED attacks. What will make the peace—if anything will—will be allied troops helping Afghans learn how to make their own people feel secure. This will come through small steps such as teaching their police and military to read, building schools, and giving them options beyond bombs and opium.

By the time I left my post in Europe, more than 9 million Afghan children were in school (nearly 40 percent of them girls)—up from only 500,000 boys and no girls under the Taliban. More than 70 percent of Afghans had access to health care, nearly a fivefold increase from the Taliban days. And the 35 million people in the country had more than 17 million cell phones connecting them commercially and socially.

The news was decidedly not all good, of course. Most troubling was the occurrence of "green on blue" violence—attacks on U.S. and NATO forces by people wearing the uniform of our Afghan allies. Although the overall numbers of such attacks may not be large, each one has a terrible impact on morale and resolve. As Gen. John Allen ruefully told President Karzai, "We are willing to die for this cause, but we are not willing to be murdered for it."

The price that the United States and its allies have paid to try to bring some semblance of security to Afghanistan has been enormous. That tremendous cost was never far from my mind. I wrote more than 2,400 letters of condolence, the saddest part of my four-year tour by far. Each one hurt me, but I was feeling only the tiniest fraction of the pain a mother and father, a husband or wife or partner, a son or a daughter felt.

On one of my trips to Washington I spent some time at the Walter Reed National Military Medical Center in Bethesda, Maryland. It was a day of incredibly mixed emotions. I stopped by to see my own daughter Julia, then a Naval ROTC student at Georgetown, who was spending her summer practicing her nursing skills. I couldn't have been prouder of her. And then I spent some time with someone else's child—a young explosive ordnance disposal technician who just sixty days before had lost all four limbs in a blast in Afghanistan. He was already up and walking with the aid of prosthetics. Despite his difficulties the young sailor was upbeat and confident about his future. I was hoping to improve the wounded warrior's morale, but he had a much greater impact on mine. The young man asked me about my travels, my job, and my trips to Afghanistan and the Balkans. I gave him a brief description of what I did, and he said: "Wow, Admiral. That sounds pretty exhausting and probably pretty dangerous." I wanted to cry.

On another trip to Washington, on a cold, windy Saturday morning in December 2012, I went to Arlington National Cemetery, as I often do when I am in D.C. Laura and Julia were with me. We went to Section 60, where many of the more than a thousand young American men and women who died in Afghanistan on my watch are buried. I recognized names from condolence letters as we walked through those gardens of stone.

Many tokens of respect are left on the tops and sides of the uniform white headstones—pebbles, photos, bottles of beer, letters, and military medals among them. But as I walked down the rows, one headstone grabbed my attention. Improbably perched atop it were the four stars of a full general or admiral. I knew before I looked at the name that it would be the grave of a young Marine lieutenant named Robert Kelly. Robbie was the son of my dear friend, Marine general John Kelly. John and I served together on USS *Forrestal* in the early 1980s and spent many a night's liberty together in ports all around the Mediterranean. John and his wife had three children, including two sons in the Corps. Robbie, their youngest, was killed in Afghanistan, under my strategic command as the NATO supreme allied commander, on November 9, 2010. I vividly remember being informed of Robbie's death and then seeing John's eloquent tribute to him sent in response to the overwhelming flood of condolences the family received. Appendix A is a copy of John's moving e-mail to family and friends.

John, having just been promoted to his fourth star a few weeks before my visit to Arlington, must have preceded me to visit the graves by only a few

days. The four stars were a sad but fitting tribute to his son from a proud but heartbroken father.

I stood and looked at those four stars atop a white headstone on a cold December day, and my eyes filled with tears. I added one of my SACEUR commemorative coins to the top of the tombstone and walked on. What a cost that family and so many families have paid.

Was it all worth it? I suppose we don't know yet. I hope so. I think so. I want to believe so.

There has been much progress, of course, both militarily and in the civil society. Democracy is vibrant and real in Afghanistan. The nation has 350,000 well-trained and -equipped security forces, and they are doing reasonably well on the battlefield. Coalition forces are withdrawing on schedule, and all of Afghanistan is now under Afghan security force security—a 100 percent change since I arrived in the early spring of 2009. Life expectancy has jumped from forty-two under the Taliban to sixty-two, the largest increase ever recorded by the United Nations. Child and maternal mortality in childbirth have plummeted. The economy has grown 5–10 percent over the past decade.

But worries remain: narco-trafficking is still a big part of the economy, the Taliban are hanging around (although still very unpopular), the occasional IED and high-publicity attack occurs, the borders with Pakistan are still porous and provide sanctuary, and corruption—both institutional and day to day—is an ever-present problem. Although democracy appears to be vibrant in Afghanistan at this writing, its long-term viability is hard to predict.

Opium is perhaps my greatest worry. There are more than a million addicts in Afghanistan. A serious chunk of the economy comes from exporting opium, and the corruption it fuels is extremely corrosive. We need to address the demand side in Afghanistan (and in our own countries, of course); likewise, we can put pressure on the supply side by offering alternative crop programs; and finally, there are ways to squeeze the transit zone. We may end up partnering with Iran in the transit zone work, because much of the opium moves through that country despite significant effort by the Iranians to stop it.

Bottom line: I'd say we have about a two in three chance of success in Afghanistan. The key will be the international community's willingness to

continue to train and fund the Afghans' security forces. There is the beginning of a peace negotiation between the Taliban and the U.S.-Afghan sides that might bear fruit. Indeed, my guess is that the Taliban will eventually come to the bargaining table, gain a small place in the political process, and perhaps elect some officials who will continue to make life difficult for the people in their own districts and, to a lesser extent, in Kabul and the rest of the country. Until that happens, the insurgency will remain a part of the fabric of Afghanistan.

If Afghanistan, buoyed by democratic reforms, does move forward, propelled by the trillions of dollars' worth of minerals beneath its soil; if it reduces corruption, maintains its borders with Pakistan, educates its children, increases life expectancy even more—then yes, I suppose our efforts will have been worth the cost. No more a haven for terrorists in general and al-Qaeda in particular. But it will have been a near-run thing, as the Duke of Wellington said about Waterloo—a near-run thing indeed.

LIBYA
Qaddafi's Last Stand

*Absence was everywhere. Arches stood without the
walls and roofs of the shops they had once belonged
to and seemed, in the empty square under the open sky,
like old men trying to remember where they were going.*
—Hisham Matar, *In the Country of Men* (2006)

In September 1969, while I was beginning my sophomore year at Quantico High School on a Marine base in northern Virginia, Muammar al-Qaddafi was busy overthrowing King Idris of Libya, promoting himself to colonel, and seizing control of his country. I am sure I paid the event scant attention, even though I vaguely remember my father, a Marine colonel and combat veteran of World War II, Korea, and Vietnam, commenting over dinner, "I sure hope we don't have to return to the shores of Tripoli"—a reference, of course, to the first line of the Marines' hymn.

Qaddafi set out to reinvent Libya, taking a reasonably prosperous and well-educated society and dismantling it rapidly and efficiently. As Hisham Matar vividly brings to life in his stunning novel *In the Country of Men*, Qaddafi turned Libyan society against itself through an elaborate system of informers and spies, even using children to accuse their parents. His methods seemed to echo those of Stalin and other Soviet dictators, but in terms of creating a society totally based on the cult of personality and ruthless repression, the closest analogy would probably be the tragedy of North Korea, which, of course, continues to this day.

As the long decades of repression, torture, imprisonment, sponsorship of terrorism, and pursuit of weapons of mass destruction unfolded, Qaddafi gradually became a strangely farcical figure. Early in my tenure as SACEUR he came to stay at the same hotel in Lisbon in which all the heads of NATO's military had gathered for an important meeting. I awoke one morning to the noise of a desert tent being pitched on the manicured golf course outside my hotel window. It was a fully realized Arab desert dwelling, complete with firewood stacked outside the entrance, guarded by attractive women in traditional dress as well as a coterie of thuggish bodyguards. The tent was Qaddafi's personal dwelling, and I shuddered to think about what went on inside after dark.

Seeing the tent pitched outside my window made me reflect on points of intersection I had experienced with Libya over the years. Indeed, some of Qaddafi's actions over the four decades of his reign had a direct impact on my ongoing naval career. The most vivid recollections I have of operations involving Libya are of Mediterranean cruises on aircraft carriers in the 1980s, when we routinely performed "freedom of navigation" operations designed to reinforce the U.S. view that the Gulf of Sidra, which Qaddafi claimed, was indeed international waters. The dispute created a whole series of confrontations, and I often studied the air defenses of Libya in those days while assigned to the ship's company of the aircraft carrier *Forrestal*. Little did I know how valuable that knowledge would become many years later.

In the summer of 1981, two of my Naval Academy classmates, Lt. (later Vice Adm.) Dave Venlet and Lt. Larry "Music" Muczynski, were involved in shooting down two Libyan jets that fired missiles at their F-14 aircraft as part of those operations. Operation Eldorado Canyon, launched by President Ronald Reagan in 1986, struck targets in Libya in response to the terrorist bombing of a disco in Berlin that killed several U.S. servicemen. I was back at sea as operations officer in a brand-new Aegis cruiser then, and we were put on alert for potential operations in the Mediterranean.

But Qaddafi had already begun to change his public persona, morphing chameleon-like into "someone we could work with," and the international community gave him space to do so. Eventually, after seeing what happened to Saddam Hussein, he elected to renounce his own efforts to obtain weapons of mass destruction. Who would have guessed that the man Ronald Reagan called the "Mad Dog of the Middle East" in 1986 would still be around a quarter century later, long after much sturdier threats in the region had disappeared? Qaddafi's most lasting threat, of course, was to his own people.

And so in 2011, when I found myself leading the combat operations directed by an international coalition that fulfilled UN Security Council Resolutions (UNSCR) 1970 and 1973, I was not entirely unfamiliar with Libya and its people. Our mission ultimately contributed to the Libyan people's overthrow of a brutal regime and its leader.

Let's begin with the Arab Spring of 2011, which unleashed unpredictable forces across the region. After Tunisia erupted, the uprising that became known as the Libyan civil war had its origins in the city of Benghazi, which traditionally resented the oversight of Tripoli—a function of the complex patchwork of clans and tribes in the country. Just days after Hosni Mubarak's regime in Egypt fell in February 2011, demonstrations broke out in Benghazi. Qaddafi, intent on avoiding the fate of his neighbor, ordered his security forces to fire on the demonstrators. More demonstrations and harsher repression spread quickly across the entire country. What happened over the next seven months was both familiar and remarkable.

Civil war broke out, and Libya's civilian populace was brutalized. Qaddafi labeled his foes "rats" and vowed that he would "cleanse Libya house by house." I think Qaddafi watched the fall of Mubarak closely and decided to "shoot early and often" to break up protests.

The United States and our allies were torn by our conflicting desire to rescue the innocent and our innate fear of being drawn into a morass. We wanted to help the people of Libya topple a regime, but we did not want to own the problem for years to come. Colin Powell's "Pottery Barn rule" (You break it, you own it) was endlessly repeated in the media. As usual, the impulses that tend to dominate American foreign policy—the tug and tussle of realism versus idealism—began to play themselves out. In an idealistic sense, we wanted to intervene in what was clearly an unequal fight between a well-equipped and brutal regime and the people of Libya; realistically, we knew it would be expensive, potentially entangling, and not in the direct and vital interest of the security of the United States. There were powerful arguments on both sides of the coin, but the international community ultimately decided to intervene. It is worth reviewing the scenario to understand how we ended up doing so, the ways and means utilized, and the lessons that can be drawn from the operations—one of the centerpieces of my four years as the NATO operational commander and one about which I am quietly proud today.

As the Arab Spring unfolded in Libya, Qaddafi unleashed a brutal crackdown across his country. In response, by late February 2011 the UN Security

Council imposed sanctions on Libya, instituted an arms embargo, froze the country's assets, and referred possible crimes against humanity by Qaddafi to the International Criminal Court in The Hague. The initial UN Security Council resolutions were fairly general and did not provide the latitude to build an appropriate military response. Nonetheless, we began to do a fair amount of prudent thinking about what our response might be if NATO were called to participate. I began a series of weekly, then almost daily conversations with my superb NATO commander in Naples, Adm. Samuel J. Locklear III (who later was promoted to combatant command and is today the U.S. commander in the Pacific). Sam and I could both see what was coming, and we wanted to be ready.

Highlighting Qaddafi's pariah status, the Arab League suspended Libya's membership and called on the international community to impose a no-fly zone over the country to complement the ongoing arms embargo. On March 17, 2011, the UN Security Council authorized "all necessary measures" to protect civilians. Two days later, with strong pushing by the French and British—who conducted the initial airstrikes—the United States took the lead of an ad hoc coalition of nine countries in launching air and missile strikes against Libyan forces. One significant target was a large concentration of armored vehicles heading toward Benghazi, home to more than 750,000 people. Qaddafi's son Saif promised that Benghazi would run with "rivers of blood."

This initial operation, which I supported under my hat as U.S. European commander, was a good, short start to the operations. My counterpart Gen. Carter F. Ham, the commander of U.S. military operations in Africa, led the operation, and I directed my U.S. European Command team to provide full, open, and constant support to him. We sent aircraft, ships, and ammunition, and provided command and control on our Sixth Fleet flagship, USS *Mount Whitney*. In addition to Sam Locklear's leadership, we were lucky to have Vice Adm. Harry B. Harris Jr., the commander of the U.S. Sixth Fleet, deeply engaged in this initial operation. Harry is a superb operator with extensive experience in the Persian Gulf, and he put together a fine initial campaign. All of this worked fairly well, and the ad hoc coalition spared the people of Benghazi from what was certain to be a brutal assault. The initial strikes reduced the capability of Libya's air defense system within the first seventy-two hours, and we were also able to rapidly dispatch aircraft and naval vessels to enforce the UN resolutions.

By this time the United States wanted to get NATO into the lead, and it was clear the operation would roll over to us. This was affirmed in another UN Security Council resolution that authorized NATO to undertake the three key missions of no-fly zone, arms embargo, and above all protection of the Libyan people.

As the NATO operation was about to begin, I noted in my journal that "an important component in this battle is the space between Qaddafi's ears." We did not know what his exit strategy was. If we gave him the choice of death in a defiant fight in Libya or a jail cell in The Hague, I was pretty sure I knew which he would choose. The Chinese strategist Sun Tzu was a master of deception and maneuver and avoiding the climactic battle, but he also said, "When on death ground . . . fight." My guess was that Qaddafi knew the people of Libya would repay his forty years of brutality in kind and would have chosen in the end to fight.

On the other hand, I hoped throughout much of the eight-month campaign that if we could offer him a reasonable exit strategy—perhaps a nice desert tent with security, binding guarantees, and attractive bodyguards in Venezuela, North Korea, or Iran, say—maybe he would choose a path that would be less costly in human lives. How to convince him of this? Effective diplomatic planning and clear strategic communication along with a well-conceived and professionally executed military campaign that let him know there was no way out. The latter part was my responsibility, and I was determined to do everything possible.

We could not have had a better command team for the job. In addition to laconic Sam Locklear, a canny leader with a shock of white hair who towered over everyone at six-five or so, we also had a strong international team. Our Joint Task Force commander was Lieutenant General Charlie Bouchard, a bilingual French-speaking Canadian and experienced helicopter pilot. He was supported by the smooth Italian vice admiral Rinaldo Veri on the maritime side conducting the arms embargo from the sea. My lead planner was a German, and my British deputy, General Sir Richard Shirreff, and German four-star Air Force chief of staff Manfred Lange provided able support. The driver for the air strike campaign was Lt. Gen. Ralph "Dice" Jodice, a hard-charging U.S. airman who led my Air Component Command in Izmir, Turkey. They were a good group who got along well, checked their egos at the door, and were capable of disagreeing without becoming disagreeable. Such has not always been the case at NATO, going all the way back to Eisenhower, and I counted myself lucky.

Our operation proceeded well, but it had an unorthodox angle to it in the context of previous U.S. involvement in NATO operations. The United States was uncomfortable being the face and principal fist behind the operation. Even as NATO took over the continuing operations, we sought to give them a broader international flavor, both within the alliance and indeed by bringing in other partners from outside—including Arab nations.

NATO fairly swiftly agreed, and command of the operations shifted from Carter Ham as the U.S. Africa commander and me as the supporting European commander to the supreme allied commander in Europe—who was also me, of course. But this time I had the formal blessing of a broader political and military alliance. It was no longer the United States and a few friends pounding America's longtime foe Qaddafi, but rather a broad coalition of partners joining together to protect innocents in Libya. The transition was almost seamless. In 1992, when NATO decided to create a no-fly zone over Bosnia, more than six months elapsed between the enabling UN resolution and the first plane flying. In Libya we did it in eight days.

The NATO mission, which began on March 27, was dubbed Operation Unified Protector. Our tasks were threefold: enforce an arms embargo, maintain a no-fly zone, and protect civilians. The first two were relatively easy. The third proved quite hard.

Just a few days after Unified Protector kicked off, I came back to Washington to testify at a series of hearings on Capitol Hill. The three hearings had been scheduled months before but, with my luck, fell just as Libya was ramping up. So I was in essence the first senior official to appear before Congress since we had begun dropping bombs on Libya.

All three of the committees before which I appeared had members who were quite exercised that the president, in their view, had not "sufficiently consulted" them. I tried to stay out of that fight. But I inadvertently made news when asked a question about whether al-Qaeda was on the ground in Libya (the implication being that if we were helping the rebels, we might be helping terrorists). I responded that the opposition leadership was composed of good, responsible, and brave people fighting a terrible dictator and that I had been impressed by their hard work in a demanding situation. I added that, as always in chaotic situations like this one, groups opposed to the United States would seek to take advantage. Regarding al-Qaeda, I answered truthfully that we had seen a very small number of "tenuous flickers" in our intelligence. That material was classified, so I volunteered to provide the committees with a written classified summary.

The media, as they are wont to do, missed the nuance. Many of the resulting stories could be summarized as "Stavridis says al-Qaeda is hijacking the Libyan opposition!" Pundits and even some of our allies who should have known better described my comments as "alarming." JCS chairman Mike Mullen called and scolded me for "getting out there a little too far." Secretary of State Hillary Clinton let it be known through subordinates that I wasn't helping the cause. Susan Rice at the UN, a good friend and colleague, disagreed with me publicly. So much for the nuanced response.

On the war front, after an initially successful series of strikes, things began to bog down badly. Admittedly, we were trying to protect Libya's innocent population from standoff range. No one wanted to put a large contingent of NATO boots on the ground. But targeting the regime's forces and facilities, which were in close proximity to the people we were trying to defend, was quite difficult. The Libyan opposition forces had limited capability to defend themselves, much less civilians, and the operation dragged on for several months—giving some in the chattering classes license to describe the situation as a stalemate or to insist that Qaddafi would never be ousted without a more aggressive alliance intervention.

It wasn't just our own people who were complaining about the lack of progress. The Libyan opposition was regularly quoted in the press excoriating NATO's efforts—either through ignorance of what we were doing or, more frequently, through a desire to squeeze more support out of us. The opposition at that stage looked largely like extras from the Mad Max *Road Warrior* movies with their homemade artillery, battered Toyota pickup trucks bristling with surface-to-surface rockets, and endless demonstrations of machine guns firing into the air. They did not inspire a great deal of confidence. Sam Locklear commented to me that the campaign seemed to revolve around quick forays at the enemy lines, lots of ammo discharged in that general direction, then retrenchment to Benghazi for coffee and a reassessment. This happened over and over again. Even Sam, a famously even-tempered commander, was wondering when the opposition would gain and really hold some ground.

There was also frustration on the part of some political leaders. President Nicolas Sarkozy of France, Prime Minister David Cameron of Britain, and our own President Obama were among those who thought that NATO had not done enough militarily by the middle of the summer. But we were limited by the UN resolutions, which restricted us to "protecting the people of Libya." That was interpreted to mean we could not directly target Qaddafi or

members of his regime, put special forces on the ground, or bring in the big guns. We were not authorized to do everything necessary to ensure regime change because that was not our mission. As was so often the case during my four years in NATO, we maintained a carefully balanced position. A continuing lesson for all such interventions is that they will be slowed by the divergent views of members of the coalition, and we should not be surprised when things require prolonged negotiation and periods of frustration. It is a bit like Samuel Johnson's dog walking on his hind legs: "It is not done well; but you are surprised to find it done at all." That pretty much sums up my feelings watching the Libyan coalition operation unfold—I was grateful and amazed that it held together at all. And in the end we got the job done.

Fourteen member states of NATO and four non-NATO partners contributed to the operation. The United States certainly played a critical role, providing intelligence along with fueling and targeting capabilities. But other states made similarly indispensable contributions. France and the United Kingdom flew more than 40 percent of the sorties, together destroying more than a third of all the targets. Italy provided aircraft for reconnaissance missions and, along with Greece and Spain, access to a large number of air bases. Belgium, Canada, Denmark, Norway, and the United Arab Emirates deployed fighters for combat operations; and Jordan, the Netherlands, Spain, Sweden, Turkey, and Qatar helped enforce the no-fly zone. Many of these states, as well as Bulgaria and Romania, also deployed naval assets to enforce the arms embargo.

In April I visited Trapani Air Base in western Sicily, where a large contingent of multinational forces was operating in support of Libyan operations. As always, the closer to the fight, the better things tend to look. Side by side, Italians, Canadians, Brits, Americans, and representatives from each nation in the alliance were working together to enforce the UN Security Council resolutions.

As the operation unfolded, the challenge for me became time management. Afghanistan continued to be job one, and this was a particularly difficult period in that conflict. High casualties in the summer fighting season, a new commander coming online (Gen. John Allen was succeeding Gen. Dave Petraeus), and a fractious relationship with the Afghan government demanded a full share of my attention. A series of violent incidents in the Balkans had

more than 10,000 NATO and coalition troops engaged in a difficult and contentious peacekeeping mission. The rising tide of piracy off the east coast of Africa had to be dealt with as well. On top of all this, I was in the midst of downsizing the cumbersome NATO command structure with the goal of reducing it from some 15,000 total personnel to fewer than 9,000—a 35 percent decrease—to be accompanied by cutting the 11 major headquarters around Europe and North America to only 6. I was crazy busy.

I kept my finger on the pulse in Libya through daily intelligence updates partnered with weekly full briefings in my operations center in Mons, where a multinational team from all around the alliance and the coalition briefed the top military leaders. I would then turn around and provide updates and briefs to NATO headquarters up in Brussels, often assisted by my German chief of staff, General Lange, or our superb operations officer, Maj. Gen. Michelle Johnson (now a three-star and Superintendent of the U.S. Air Force Academy, where she was the cadet captain as a student and from which she became a Rhodes scholar). I left briefing the U.S. side of the house to Admiral Locklear and concentrated—as always—on helping keep the coalition together from a military perspective. My diplomatic "wing man," U.S. ambassador to NATO Ivo Daalder, did the political side of this, and we talked a couple of times a week to keep in sync.

Much has been made about the U.S. decision to supposedly "lead from behind," although I can't personally recall anyone in the Obama administration using that term. I categorized it to many people as simply "this is how alliances work." Different nations make a series of discrete sovereign decisions about what they want to bring to the table. In this case, the United States chose to focus on intelligence, targeting, air-to-air refueling, ordnance, and other "back office" functions. I think this was partly because of our other huge military commitments around the world, notably in Afghanistan; partly for cost reasons, because all of these operations are tremendously expensive; and partly to provide a clear sense that we were not going to become indefinitely entangled in Libya as we had done in Iraq and Afghanistan. That is not to say that the U.S. commitments were not crucial and vital—indeed, without them the mission would not have been successful. Many other allies chose to conduct strike operations or provide varying levels of support, and some chose to sit this one out. The key is not whether every ally does everything—the key is that taken together the allied effort provides the right combination of resources to accomplish the mission. That was the case in Libya.

In addition to the coalition, of course, the other key actor was the Libyan opposition. While united in their hatred of Qaddafi, they were divided in virtually every other way. The West was trying to do all that it could to keep them hanging together and to provide the basic tools (arms embargo, no-fly zone, strikes against Qaddafi's military, weapons, supplies, diplomatic support, freezing and then giving the regime's monetary assets to the opposition); but in the end, it was the opposition that had to take and hold ground.

Despite all the opposition's shortfalls, their raw courage and motivation combined with the help of arms and trainers flowing in from several nations began to increase their successes. By the middle of August, the opposition, with national support from a variety of countries, had gained enough strength to put Qaddafi on the defensive. Within two months the Libyan National Transitional Council had seized control of the entire country, and the rebels had captured and killed Qaddafi.

Having achieved our objectives, we ended Operation Unified Protector on October 31, 2011—222 days after it had begun. As armed interventions go, this was a relatively short period. While some of the participants were a little annoyed that I revealed my recommendation that we call a halt to the operation via the 140 characters allowed by Twitter, none seemed to mind that our military involvement was so brief.

I am certain that NATO's intervention saved tens of thousands of Libyans who otherwise would have died under Qaddafi's boot. While we were not perfect in minimizing "collateral damage," the antiseptic phrase that translates to "accidentally killing people you don't intend to," we were very, very good. All this was done without a single allied casualty. It was not, however, cost free. The United States spent about $1.1 billion on the mission; the allies' total expenditure equaled or exceeded that. Again, this is what alliances and coalitions do, and I'm satisfied overall with the sharing of effort in the Libya operation. Bottom line: we demonstrated that we could work together for a common goal without exceeding our initial aims or outlasting our welcome.

Indeed, the only coalition in the world capable of responding to a complex emergency like Libya is NATO. While some individual nations have significant reach, in a coalition setting—highly desirable for political legitimacy—only NATO has the standing command structure and integrated capabilities necessary to quickly plan and execute such complex operations.

For its first 40 years, NATO was a deterrence-focused organization oriented completely toward collective defense of the borders of its member

nations; in the 10 years after the fall of the Berlin Wall it became an organi-
zation focused on security cooperation via its own enlargement and democ-
ratization—through which it exported security. By 2011 it was an operational
alliance with 8 active operations under way on 3 continents and more than
170,000 troops engaged in "active service" at the peak of the Libyan operation.

The participation of Arab partners was critical to the Libyan operation's
success. The active involvement of Qatar, the United Arab Emirates, Jordan,
and Morocco demonstrated a new political reality of Arab League countries
flexing their military muscle. They were prompted to act by a situation far
removed from their own borders, perhaps because they realized that the Arab
Spring knew no borders and that their security concerns would be best served
by acting rather than standing by and watching. Whatever the trigger, it is
certain that Libya would have been far more difficult without their involve-
ment. At the political level it soothed potential frictions within the alliance,
providing a legitimacy that many reluctant allies demanded. Down at the tac-
tical level, the work of Qatari forces on the ground enabled the Libyan opposi-
tion troops to take Tripoli from the pro-Qaddafi forces, which would not have
been possible with NATO air and maritime power alone.

I will never forget walking through Charlie Bouchard's command center
in Naples and meeting the Arab officers assigned there as liaisons. I spoke
with each of them and sensed their pride at being involved directly in the
operations. What a moment for NATO, I thought. We are not nor do we want
to be the world's policeman, but the organization has an important role to
play in helping provide security in situations that call for it, especially when
they occur on the very borders of the alliance. The situation in Libya might
have resulted not only in the deaths of tens of thousands of innocent civilians
but in a mass migration across the Mediterranean as well. Our Arab friends
helped to prevent that and were excellent partners throughout.

In the end, fourteen allies and five non-NATO partners provided air and
naval forces for the operation in Libya, including a superb contribution from
Sweden. The Swedes did things with their Griffin fighters that still amaze me.
Together the allies flew more than 26,000 sorties, including more than 9,600
strike sorties. They hailed more than 3,700 ships and boarded well over 300.
They denied passage to 11 suspicious ships. Their bombs destroyed nearly
6,000 targets, from command and control bunkers to tanks, from surface-
to-air missiles and Scud launchers to ammunition dumps. All good numbers,
certainly, especially considering that collateral damage to civilians was held
to historically low numbers.

Having said that, it is important to realize that NATO's involvement in Libya was widely but not universally applauded. Russia in particular and China as well were extremely critical of the alliance's role in Libya; they are using it to prevent a similar UN resolution and operation in Syria, unfortunately. We operated under the UN Security Council mandate to establish a no-fly zone, provide an arms embargo, and protect the people of Libya from attacks. Our efforts in that regard were well within the bounds of the UN mandate and the norms of international law, but Russia saw it differently. Whenever I discussed this with Russian officials I found little room for common view. A quote by Ambassador Aleksandr Grushko, Russia's representative to NATO, gives a sense of the tension (yes, Russia has an envoy to NATO and is a member of our Partnership for Peace program—we operate with the Russians in a variety of positive ways): "These relations can only develop in the right direction if NATO observes the standards of international law. We can see that NATO's military infrastructure is coming closer to Russia's borders, and we have to take this factor into account in our defense planning." The comment shows a level of concern that is troubling indeed.

Some human rights groups also criticized the alliance after a handful of errant bombs caused civilian deaths. In each case we thoroughly investigated and took appropriate action. There was also an allegation that NATO ships had not been sufficiently responsive to refugees at sea. As a mariner, I took such allegations especially seriously, as did Admiral Locklear. We have both been ship captains ourselves, and we encountered many refugee situations at sea. After a thorough investigation, I remained convinced that our ships did the right thing throughout, and indeed conducted several rescue operations flawlessly in conjunction with Italian coast guard authorities. But it is important to listen to and respond to criticism. We will always do our best to minimize casualties—unlike our opponents, frankly.

While our intervention in Libya was an overall success, it was not an unqualified one. Fourteen NATO nations participated, but an equal number did not. Some abstained because of a lack of resources, but others, such as Germany, opted out for political reasons that were never quite clear to me. (Their staff officers on my staffs in NATO were nevertheless workhorses and did a brilliant job.) My sense is that many in the German government would have preferred to be in the fight directly, but I respect Germany's decision, as I do that of the other nations that chose not to send forces.

The resource issue is a serious one. On average, our European allies spend just 1.6 percent of their GDP on defense. The United States, in contrast,

spends more than 4 percent. As a result, this operation relied heavily—too heavily—on the United States in certain areas such as intelligence and aerial refueling.

President Obama said that "the Libyan intervention demonstrates what the international community can achieve when we stand together as one. NATO has once more proven that it is the most capable alliance in the world and that its strength comes from both its firepower and the power of our democratic ideals." NATO did indeed prove its worth. With a minimum of civilian casualties and using proxy ground forces the alliance was able to complete the missions for which the Arab League and the United Nations requested assistance. This does not mean that NATO should be galloping around the world changing regimes, but it does demonstrate that the alliance provides a capable tool for diplomats to consider employing in crisis response—so long as its capabilities are not permitted to atrophy.

How did it all come out in Libya? A mixed picture, to be sure. We set out to fulfill a UN Security Council resolution, and I think we did so in reasonably good fashion, especially when it came to protecting the people of Libya. But as subsequent events have shown, the conflict there is far from over. The "flickers of al-Qaeda" proved to be persistent, and that organization is today a dangerous part of the fabric of Libyan society, as it is in other countries involved in the Arab Spring. Efforts to get a constitution fully framed up and in place, along with a functioning government, have met with difficulties. There are sporadic outbreaks of terrorist-fueled violence around the country, including the one that tragically killed Ambassador J. Christopher Stevens and three other Americans in Benghazi.

Yet, over the long haul, I'd bet on a successful outcome. Libya won't be "Dubai on the Mediterranean" anytime soon, but it has a very real chance to become a functioning, democratic nation. It has money from oil, a reasonably educated population, and a middle class; not a bad set of ingredients. But it will have to overcome the legacy of Qaddafi, which will take time. France and the United States took years to reach stability after their revolutions in the late 1700s. The United States declared independence in 1776 but had no constitution until 1789, and Shay's Rebellion and the Whiskey Revolt tried the young nation's resolve during that time. It took decades for us to adopt a common currency. Thomas Jefferson said, "You should not expect to be carried to

democracy on a feather bed." Libya and the other nations affected by the Arab Spring are no exception. Yet I think the long throw of history is on the side of democracy, transparency, and, ultimately, decency. Let's hope so.

One thing that sticks in my mind is the ugly end of Muammar Qaddafi. In every sense he reaped what he sowed—if you don't think so, read *In the Country of Men*—but I am sorry he died in such a cruel and horrific way: dragged from a drainpipe, beaten, and shot. His demise represented anything but what we should hope for from a revolution that yearned for freedom, liberty, and the rule of law. Why didn't he accept a negotiated ending, perhaps a sinecure of some kind in a distant land? The answer to that question died with him. My guess is that some combination of his own endless ego, bad information delivered by a cowed set of subordinates, and a romantic attachment to his desert home led him to hope he could turn the tide. I mentioned Sun Tzu and his advice to "fight when on death ground"; in the end, Qaddafi found his death ground at the hands of the people he had brutalized for four decades.

The removal of Qaddafi did not eliminate tragedy in Libya, of course, as we saw on September 11, 2012, when U.S. facilities in Benghazi were attacked and Ambassador Chris Stevens and three other Americans were killed. The controversy over Benghazi continues to this day. The tragedy will haunt U.S. diplomatic security, and so it should. Such losses are rare, thankfully, and we need to learn the lessons they teach and implement our responses forcefully. I think that process is well under way. My only involvement that day was confined to ensuring that Gen. Carter Ham received all the forces he requested from the European theater, which he did. I think Carter did all that he could with the limited information available and the realities of trying to move forces into a chaotic situation on the ground in real time. All of us in the U.S. military hope to be guardians of the diplomats who represent our country so well, and every time we lose even one in tragic circumstances it cuts to our core.

I am often asked if the Libyan campaign is a model for future interventions. First, all interventions are dangerous, politically and militarily risky, and hard to justify under international law. There are good reasons the international community values so deeply the stability that the concept of sovereignty instills in the international order. Interventions are hugely unpredictable. An admiral I worked for a couple of decades ago said to me after I authorized firing missiles at Iranian jets in the Persian Gulf as a watch

stander: "Everything changes when you release ordnance." Very true. Combat is like kicking open a door to a very dark room: you just don't know what is waiting inside. Finally, every intervention is unique. Each country has its own culture, taboos, and traditions, and an intervention must take account of those if it is to be successful.

But having said all that, I *do* think we can draw some quick lessons from Libya that might inform the decision to engage elsewhere, perhaps in Syria, which as I write this has seen upward of 160,000 civilian casualties resulting from the revolution there.

1. There must be a pressing need in a humanitarian sense. This is the somewhat controversial international legal doctrine of "responsibility to protect," or R2P, as it is sometimes called. When large numbers of innocent civilians are being killed or threatened by disaster (manmade or natural), intervention must be considered.

2. Allies and coalitions are crucial. The age of unilateral action is rapidly passing. Despite all the frustrations, working with a coalition is vastly better than going it alone.

3. Regional support is vital. The presence of Arab coalition partners in Libya was key.

4. You must understand the language, culture, history, and hierarchy of any nation or region into which an intervention is considered.

5. Bring lots of capability: intelligence, surveillance, targeting, ordnance, ships, aircraft, and—if necessary (and hope that they are not necessary)—troops on the ground.

6. Try to minimize casualties. Interventions in today's world are about relieving human suffering, not increasing it. That means working with humanitarian organizations, energizing public-private connections, using only precision-guided munitions, and paying attention to refugees at sea and on the ground.

7. It will be expensive. More than you expect. Much more.

8. Bring lawyers, strategic communicators, and public affairs experts, and engage the media early, often, and continuously.

9. Do it under the auspices of the UN if at all possible. There may be times when it is not possible, but it is vastly better to intervene under legal norms provided by the UN.

10. Probably most important, good luck. You'll need it. In Libya, we had more than our normal share. It won't always be so.

Syria
Through a Glass Darkly

Only the dead have seen the end of war.
—George Santayana

T he twentieth-century philosopher George Santayana had something clever to say about pretty much everything, including the seeming inevitability of war. His most repeated old saw is that "those who do not remember the past are condemned to repeat it." Probably so; but an even bigger danger, in my eyes, is to think that every new world crisis is like the one before it and try to apply "lessons learned" indiscriminately. When it comes to Syria, the problem is not our failure to know and understand the past, but rather our need to realize just how bleak the future looks. Syria's future is unfortunately in line with Santayana's prediction that only those already dead will escape the fury of war, at least in that very troubled land.

For a couple of generations after the Vietnam War, American foreign policy experts and military leaders based their decisions on avoiding "the next Vietnam." No doubt the wars that started in Afghanistan in 2001 and in Iraq in 2003 will inspire politicians for decades to come to try to avoid repeating mistakes (both real and imagined) made in those deadly arenas. But if there is one type of crisis that lends itself most readily to perilous parallelism, it is humanitarian crises.

Our failure to act—or to act effectively enough—in such places as Rwanda, Darfur, and Srebrenica has sparked countless debates on other world hotspots. The debates generally center on several basic questions: Should we

get involved? What are the short- and long-term costs? Can we get someone else to do the heavy lifting for us? And if we intervene ourselves, how can we do so without being sucked into an endless morass? There are enormous questions of morality involved—but also legitimate concerns about how to avoid donning the badge of world policeman or biting off more than we can chew. Such questions arose broadly in the middle of the Arab Spring, but nowhere more acutely than over the issue of Syria.

Crises seem to spring up on the seams of U.S. combatant command zones, where one four-star leader's area of responsibility stops and another's starts. This was the case in Syria—a country for which the U.S. Central Command is responsible but that is surrounded by countries such as Turkey and Israel that fell into my domain at the U.S. European Command. Fortunately, as the Syrian crisis unfolded I was partnered with a good friend, Gen. James N. Mattis, the commander of U.S. Central Command.

Jim and I worked closely and seamlessly in Afghanistan, where he was the senior uniformed officer in the U.S. chain of command and I was the senior uniformed officer in the parallel NATO chain of command. Our generals in Afghanistan—Stan McChrystal, Dave Petraeus, John Allen, and Joe Dunforth—worked for both of us. Jim Mattis' job was to report to the secretary of defense and the president about U.S. activities, and mine was to report to the NATO secretary general and—through him—to the twenty-eight heads of state and government of NATO members as well as to the leaders of the additional twenty-two nations in the coalition. We ended up in a similar situation in Syria, although both NATO and the United States were working hard to keep their distance throughout my time in NATO command.

I met Jim Mattis for the first time in the late 1990s when he worked in the front office of the deputy secretary of defense and I was in a similar position in the office of Secretary of the Navy Richard Danzig. During those years the Navy suffered several embarrassments, including the accidental bombardment of an unauthorized target area on Vieques Island in Puerto Rico. I frequently found myself in front of General Mattis' desk explaining something we had done wrong. He was a one-star general at the time and I was a Navy captain, and so one rank below him. Fortunately for me, he was endlessly gracious, understanding, and helpful in spreading oil on the waters with the secretary of defense's senior leadership. He was also (and still is) a voracious reader, as am I. So we connected over books as well, notably the sea novels of Patrick O'Brian, something I wouldn't necessarily think a Marine general

would like. In short, Jim is a man of many parts and a good friend. That was quite helpful as we tried to make the best of a *very* bad situation in Syria—I from the perspective of NATO as well as that of my U.S. hat, which included Israel; and Jim from his sole U.S. hat as our representative in the Arab world.

And what a world the Arab lands had become by 2011. With uprisings breaking out across the Maghreb and Levant, the Middle East seemed literally to be on fire. Of all the situations—Tunisia, Libya, Egypt—the crisis in Syria had a different and far darker feel. The local populace had long been oppressed—as much as or more so than in any other country in the region. And it was clear that the government in power under Bashar al-Assad took a backseat to no other regime in applying torture, rape, disappearances, murder, and other crimes against humanity in maintaining its brutal hold on power. Bashar's father, Hafez, had been even worse, but Bashar was quickly making up the difference between them in terms of sheer killing.

At first, events in Syria seemed to track alongside the situations in Egypt, Libya, and elsewhere. There were spontaneous and then planned demonstrations, harsh crackdowns, and brief outbreaks of guerrilla and street fighting. But the tone in Syria quickly became different. On a visit to Israel in 2011 my counterparts shared their view—with which I agreed—that Assad would last longer than most people thought at the time. The Alawites, the religious sect from which the Assad family hails, had nowhere else to turn. Their choice was "slaughter or be slaughtered," as one Israeli official put it to me. No Sunni military leader had emerged as a credible challenge. We agreed that Assad would fall eventually but could not predict what would replace his regime. Israel was particularly vexed by Russia's arms sales to Syria. It was bad enough for the Russians to be arming Assad, the Israelis said, but worse, they had no idea who would inherit the weapons—which included more than a thousand tons of deadly chemical weapons such as sarin and VX.

The debate in the West was actually fairly simple: Do we stand aside, let Assad's brutality take its course, and allow a huge slaughter in the country? Or do we find a way to sort out the myriad opposition forces—pick some subset with whom we can live—and support them with either nonlethal or lethal aid, hoping for the best? If we simply stood by and watched, we would end up with considerable blood more or less on our hands; if we leaped into the breach, we would probably find ourselves tumbling into the trap of providing weapons that might very soon fall into unfriendly hands. A very poor set of choices.

Whenever I would go back to Washington to testify during this period, the various congressional factions would line up to ask me loaded questions (often in open session) to get me to support one side of the argument or the other. "Isn't it true, Admiral," people like Senator John McCain would say, "that if NATO created a no-fly zone over Syria it would put tremendous strain on the Assad regime?" I was happy to answer yes, although a no-fly zone was not the favored policy of the Obama administration. My personal belief was, and remains, in general agreement with Senator McCain's approach. We needed to follow roughly the model from Libya—institute a no-fly zone, enforce an arms embargo, protect the populace, and strongly encourage and arm the rebels. But that wasn't where the administration was heading, and there were legitimate questions about how much good the no-fly zone would do because most of the devastating attacks on rebel forces came from Syrian artillery rather than air power.

"Isn't it true, Admiral," other senators would ask, "that we really don't know who is in charge of the Syrian opposition and that any support we provide might actually aid people loyal to al-Qaeda?" Done wrong, yes, that would be true too. Of note, around this time I began to get a series of in-depth intelligence briefings. As usual, the intelligence community held a variety of opinions on where the opposition was headed. Most of the briefers felt, as I did, that eventually Assad would fall. But there was a passionate minority who believed that he would hold on to power, at least in some significant segments of Syria, probably including Damascus and certainly on the western Mediterranean seacoast, the traditional base of Alawite power.

Personally, I encouraged the intelligence community to "follow the money" and look at capital flow in and out of the country. It seemed to me that eventually Syria's foreign reserves would be depleted and the Syrian currency would have to be simply printed with nothing to back it up, leading to spiraling inflation and Assad's inability to pay his security forces. That would spell the end, I thought. As of this writing, that hasn't happened, probably because of financial (as well as political) support from Iran, Russia, and a few other nations.

—————————————◈—————————————

By mid-2012 the Arab Spring had turned into the Arab Awakening—having taken a hell of a lot longer than just a spring. The United States and its allies were largely treading water. The UN Security Council met seemingly

continuously and issued vapid proclamations because the Russians and Chinese blocked anything substantive. NATO's hands were tied by the need for a UN resolution calling for the use of force (which we had in Libya), and so the deadlock continued.

The world watched as roughly one thousand people died each month. We stood by as the regime murdered more than two hundred people in cold blood in a small village outside Hama.

At NATO we watched carefully and did some prudent planning in my headquarters in Brussels and down south in my operational HQ in Naples, well aware that at almost any moment circumstances could spiral out of control and force our hand. That nearly happened in 2012 when Syria shot down a Turkish surveillance plane, killing its crew of two. The Syrian armed forces represented no minor threat. Syria had 300,000 troops, 5,000 antiaircraft missiles, 1,000 ballistic missiles, and more than 1,000 tons of high-end chemical weapons. An attack on Turkey could trigger a response from the rest of the NATO alliance, with perhaps the most significant contributions from U.S. and allied warships in the Mediterranean.

As time dragged on, the humanitarian crisis worsened by the day. More than a million Syrians had been displaced within the country by mid-2012. Just two years later the number of Syrians displaced from their homes had risen to more than 7 million when both those within the country and those in refugee camps outside were counted. Camps just across the border in Turkey and to the south in Jordan struggled to accommodate the human wave flowing into them. Lebanon and even Egypt saw big upticks in refugee populations as well.

I felt that the situation was spiraling out of control. We had a responsibility to protect our allies, protect human life, and prevent an even worse disaster. By late 2012, I was convinced that we were failing our responsibilities and needed to take some level of action—at the least arming the rebels, even recognizing the risk that some weapons would "pass through" to terrorist groups. The place was awash in weapons anyway.

I made a trip to Turkey in the fall of 2012 to reassure the Turks, who—understandably—were deeply focused on the situation along their southern border. By this point 30,000 Syrians were dead, and there were 100,000 Syrian refugees already at Turkey's border and perhaps 1.5 million internal displaced refugees who might head for Turkey at any moment. Syria was a vicious regime bent on killing its way to success against a ruthless insurgency, while

Kurdish terrorists tried to take advantage of the situation, as did a rising component of al-Qaeda and other fellow travelers.

In Ankara, I met the burly chief of defense, General Nocet Ozdal, who was wearing fatigues and had a gun strapped to his waist. He was on his way to meet with his troops on the border. The deputy foreign minister seemed suspicious that we weren't doing enough to plan for NATO contingencies to defend Turkey. And the minister of defense only wanted to talk about ballistic missile defense of the capital. I tried to calm everyone down a bit, but it clearly wasn't taking. In fairness, if Americans had a similar situation on the Mexican border, we'd be in roughly the same place—needing a solution *right now*.

The threat of ballistic missile attack on Turkish cities could not be dismissed. Syria has hundreds of long-range ballistic missiles. Attacking Turkey would be a suicidal move, but who could responsibly tell the Turks that Assad was not capable of such a mindless act? A more likely concern was potential future massive refugee movements, which could be easily ignited by something as awful as large-scale chemical weapons use and by something as pedestrian as a harsh winter.

To help ease the Turks' legitimate fears, I agreed to an immediate deployment of Patriot missiles to counter potential missile threats from Syria. Given a number of recent cross-border incidents in which artillery and mortars had landed in Turkey and killed Turkish civilians, we were concerned about possible Scud (medium-range surface-to-surface missile) activity inside Syria. Scuds are particularly worrisome because they can carry chemical payloads. The Patriots have a limited range and were deployed in self-defense mode for the population centers in southern Turkey. This purely defensive deployment of six Patriot batteries helped protect major population centers in Turkey. Three nations—Germany, the Netherlands, and the United States—deployed two batteries of missiles each. We moved quickly, achieved consensus within NATO, and had the missiles in place and operational by January 2013—record speed for a NATO deployment.

Those who think such minor deployments must be a fairly simple effort underestimate what is involved. There are a number of moving parts to a deployment like this. Not only did we need to move a fair amount of actual missile hardware into Turkey—missiles, command and control, radars, transport, and hundreds of soldiers—we also had to put into action the command and control framework. In other words, we had to regulate how and when the missiles would be used and determine how they would fit into the overall

defense apparatus of Turkey. Fortunately, we already had the framework for command and control in the NATO standing defense plan agreed to by all twenty-eight member nations. Command and control flowed from my HQ in Belgium to NATO's Air Defense Command in Ramstein, Germany, and down to the Patriot batteries in Turkey—including full visibility and connectivity with the Turkish national air defense systems.

As the supreme allied commander for operations globally, I retained operational command responsibility for the deployment of the six Patriot batteries. Shortly after they were deployed, we trained and exercised the layers of command down to the actual Patriot battery to make sure we were ready to expeditiously engage any potential incoming missiles.

As the Syria crisis dragged on into the spring and summer of 2013, we did additional prudent thinking about how to defend the Turkish border and studied how, if we were so ordered, we would go about doing things like enforcing no-fly zones, securing Syrian chemical weapons sites, instituting arms embargoes at sea, creating safe zones for the population, separating the population near the borders, and a host of other difficult and politically unpalatable tasks. At a big meeting with the NATO ministers of foreign affairs, about half a dozen nations even disputed the existence of Syrian chemical weapons, unhelpfully dredging up old resentments about false allegations of Iraqi weapons of mass destruction. Getting a consensus view from twenty-eight nations to do *anything* in Syria would be hard, I knew, unless there was an explicit threat to the NATO (Turkish) border or very clear indicators (hard evidence) that a terrorist group was about to obtain chemical weapons.

Unfortunately, as is often the case in consensus-run organizations, NATO held to a slow, cautious (verging on plodding) pace. I was told by a wide variety of actors—both in NATO and on the U.S. side—to go slowly and be very publicly circumspect about any planning for Syria. I didn't think that made a great deal of sense, frankly. We had to face the reality that the Syria situation could create real waves in the alliance's zone of responsibility—through the dispersion of chemical weapons, the flow of terrorists into Europe, the creation of a zone of ungoverned space an hour's plane ride from southern France/Spain/Greece/Italy, or massive refugee movements.

By the time I departed NATO in late spring 2013 Syria had become a full-blown human disaster: well over 100,000 people killed, 2–3 million pushed out of the country into refugee camps, and another 3 million internally displaced and facing a brutal situation. Clearly, there were no good choices, but complete inaction seemed to be the worst of all.

As bad as things in Syria were when I left NATO, they quickly got worse. In late summer 2013 the U.S. government came to believe with high confidence that Syrian government forces had used chemical weapons on opposition men, women, and children. The Obama administration revealed that by its accounting, Assad's troops killed at least 1,429 people, including 426 children, in indiscriminate poison gas attacks. And yet the war-weary British Parliament blocked their prime minister's intent to have British forces participate in a punitive response. Then President Obama felt obliged to trim his sails and seek congressional concurrence before employing his inherent war powers.

Given the freedom of my new civilian status, I was able to publicly urge that the administration lean not only on Congress but on NATO as well. There is plenty of precedent for NATO to become involved. While it is always easier if there is a UN Security Council resolution to back up any military action, the Kosovo example proves that it is not a prerequisite.

The United States should not have to go it alone in situations like this. Certainly we have a responsibility to protect innocents, but that responsibility is no less for other NATO nations. While is it unreasonable to expect every NATO nation to participate—just as they did not in the case of Libya—many could be convinced that support for such an operation is in their national interest. NATO allies Turkey and France were poised to take part, and others could be convinced to stand up and make clear that the use of chemical weapons cannot be accepted or condoned.

Deciding on intervention is not a new problem. The British strongly considered intervening in the American Civil War but ultimately decided not to do so. In discussing that debate Sir William Harcourt said: "Intervention is a high and summary procedure which may sometimes snatch a remedy beyond the reach of law. Nevertheless, it must be admitted that in the case of intervention, as in that of revolution, *its essence is illegality and its justification is its success*" (emphasis added).

The outcome in Syria still hangs in the balance at this writing. It is impossible to estimate how many people will ultimately be killed in the civil war. What should we do in situations like this? How do we determine whether or not to intervene? In any decision to intervene internationally, several key criteria must be present.

First, there has to be a clear and present need. We (the international community) should not go lightly into an intervention, for any reason, within the borders of a sovereign state. Significant hurdles in international law must be overcome in order to legitimize any intervention. Doing so, and finding the balance between the rights of a sovereign state and the need of the international community to intervene, is the essence of the emerging doctrine of "responsibility to protect." Given the massive casualty rates and the huge movement of refugees (both internally and across borders), it seems to me that the Syrian crisis has long since passed the point at which the international community should feel even the slightest hesitance about intervening. Indeed, I believe we have crossed the line of responsibility and will find ourselves in a few years looking back with regret and a sense of shame.

Second, intervention—like any other international action involving force—should at least theoretically be sanctioned by the UN Security Council. While there are plenty of examples of force being used to try and resolve crises without UN sanction (e.g., the NATO intervention in Kosovo in 1999), it is always vastly better to have the UN imprimatur behind an intervention. In the case of Syria, such legitimation has been stymied by the reluctance of Russia (principally) and China (secondarily) to allow another intervention such as NATO's in Libya. There are complex reasons for this, ranging from the high premium both nations place on sovereignty to their contentious relationships with the United States over other issues. Nonetheless, we should collectively work as an international community to resolve such differences and find common ground on Syria.

Third, there is a regional voice to be heard. Unfortunately, in Syria the regional voices are split, with Iran, Lebanon (driven by Hezbollah and internal politics), and Iraq showing some level of sympathy and support for Assad; and Saudi Arabia, the Gulf states, Turkey, and Israel opposing him strongly. So again—as in the broader international community—it is difficult to meet this criterion.

Fourth, there is the pragmatic need to have a successful intervention strategy. The tactical model we followed in Libya is fairly compelling here. We should begin with an arms embargo on the Assad regime, then institute a no-fly zone over at least a part of the country and begin to arm, train, and support the rebels in a forceful way—picking and backing those factions that do not represent al-Qaeda and other harshly radical elements with direct ties to terrorism. That is the hard part. But if we do not take this path, we will likely

end up with one of two worst-case outcomes: either Assad will survive and will become even more difficult to deal with, and will harshly retaliate against his own people, emboldening Iran; or the radical elements in the opposition will ultimately overthrow Assad and we will end up with an al-Qaeda mini-state. Our only hope is to get behind the "right" elements of the opposition, as hard as that will be.

While the Libyan case study gives us a tactical approach to consider, the best historical *strategic* approach is probably the case of the Balkans in the 1990s. In the early to mid-1990s the Balkans were on fire. More than 100,000 people were killed in the interethnic/religious wars between Muslim Bosniaks, Roman Catholic Croats, and Orthodox Serbs. More than a million people were internally displaced in their countries, and another million were pushed across borders. In Bosnia, Serbs in Srebrenica massacred more than 8,000 Muslim men and boys. It all sounds a lot like Syria today.

How did the international community respond?

After a great deal of pushback from a wide variety of countries, the international community finally began to pull together. With UN backing and the support of regional states, a plan evolved for an international peacekeeping force—which included troops from NATO, Russia, and many other nations as well—that entered Bosnia and separated the combatants. A group of diplomats led by Richard Holbrooke forged the Dayton Accords. The accords were implemented amid much pessimism about the future, but they have largely held together. The results, while far from perfect, have been a good example of what can be done when international, interagency, and private-public sectors work together.

Can we make that model work in Syria?

I would say the odds are against it, unfortunately. What helped the Balkans come together was at least in part the region's proximity to Europe, and thus to centers of stability, capital, development, and security apparatus. None of that exists in the Levant. Indeed, the regional actors are actively opposing each other and pulling the Syrian body politic (such as it is) in opposite directions. Likewise, the major world powers have managed to line up on opposite sides of the scrimmage line in Syria. It seems unlikely that they will suddenly find common ground. Finally, the presence of weapons of mass destruction raises the stakes considerably in terms of potentially grave outcomes, and hence the reluctance on the part of some nations to intervene.

Overall, therefore, I am very pessimistic about how things will turn out in Syria. My guess is that ultimately the country will break apart and that

the various segments (Assad's Alawite/Shia western enclaves on the Mediterranean, Kurdish regions in the north and east, Sunni strongholds in the northwest and in the center, and the disputed major cities of Damascus and Aleppo) will not be reassembled. Like Humpty-Dumpty, the artificial construct that we knew as "Syria" seems unlikely to be put together again. Assad may survive and eventually reassemble the country, but the prospect seems unlikely to me. The potential for chaos, more bloodshed, and a very dark landscape seems high.

The lesson in all of this is that at times the dark end of the spectrum triumphs, despite the best efforts of many sincere people and organizations. For every relatively successful outcome in international relations—Europe after World War II, South Korea after the Korean War, the Irish peace talks a decade ago, Colombia today—there are endings that are not happy. At NATO, I felt fairly good about how our counterpiracy campaign worked out. I see continued progress in the Balkans. Libya was a success, albeit with further challenges in the country in the time ahead. Afghanistan shows a great deal of progress and I believe will succeed. But Syria, I think, will continue to be an ugly, harsh, brutal conflict with little hope of redemption.

Syria's best hope is intervention by the United States and other key actors, but at this moment that appears unlikely given the broad Middle East fatigue that is gripping the country. I wish there was an easier solution, or at least a more hopeful projection; but sometimes outcomes are dark, and that is the case in Syria.

POSTSCRIPT

As of late spring 2014, Assad's hand appears to be strengthening. The Ukrainian crisis, of course, is a godsend for him: it makes the possibility of Russian cooperation on a solution (dim at best) virtually nonexistent for the moment. Assad fully and totally endorsed the invasion of Crimea—no surprise there. And the beat goes on in terms of human tragedy: more than 160,000 dead and 7 million displaced (including more than 3 million pushed outside of borders). The opposition remains fractured; the international community is totally distracted by Ukraine; and Iranian support is flowing freely to the Syrian regime. There seems little in the future to augur improvement in the situation until the international community decides to impose a solution—which seems a distant hope at best.

THE BALKANS
Where Old Ghosts Die Hard

We don't have a dog in that fight.
—Secretary of State James A. Baker III at the start of the Balkans War

*Balkanize \ˋbȯl-kə-ˌnīz\ 1: to break up (as a region or group)
into smaller and often hostile units.*
—*Merriam-Webster's Collegiate Dictionary,* 11th edition

There is a good reason why this region in southeastern Europe has given its name to a fracturing of civil society. For hundreds and hundreds of years, no other part of the globe has been the seedbed of so much ethnic hatred, division, and death. Battleground for the Ottoman Empire, birthplace of the First World War, and Axis ally and scene of ethnic cleansing in World War II—the Balkans do not have a happy history.

Even the end of the Cold War and the crumbling of the Soviet bloc, positive events for most of the world, led only to more misery in the Balkans. As the state of Yugoslavia fell apart, its various republics declared independence and, with some regularity, declared war on each other. Each of the various regions is dominated by a different religion: Serbia by Orthodox Christians, Croatia by Catholics, and Bosnia-Herzegovina by Muslims, for example. And each region has a significant population of minorities representing the other religions. Centuries of bitter hatreds and a new lack of central authority created the perfect soil in which to grow oppression, terrorism, and genocide.

Just over a decade before I became supreme allied commander in Europe, the Balkans were also the scene of the first major combat operations that NATO undertook as an alliance. During this period I was the captain of a U.S. Navy destroyer, USS *Barry*, and spent countless hours in the Adriatic Sea. My ship was part of Operation Sharp Guard, intended to prevent weapons from coming ashore that could fuel more violence. I was a small part of a NATO mission, but I never imagined that fifteen years later I would be the NATO supreme commander.

My ship was assigned to duties as Red Crown, tasked with controlling the airspace in the Adriatic Sea off the east coast of Italy. We had an excitable British commodore in charge of a very international flotilla, and he seemed very pleased that he had a brand-new billion-dollar U.S. Aegis destroyer under his command. He urged me to be aggressive as a ship handler and to "lay my ship alongside any suspected gun-runner." Given that doing so would have resulted in severe damage to my very expensive ship and would probably result in me being summarily relieved, I was not overly enthusiastic about that. But we did our best to ensure that no weapons could get through to the Serbian regime that was brutally suppressing the population. It was very similar to the work we would do in Libya some years later.

NATO warplanes conducted a three-week bombing campaign in 1995 over Bosnia-Herzegovina against Serbian targets, and then again in 1999 in an effort to get Yugoslav forces to withdraw from Kosovo. In mid-1999 KFOR (Kosovo Force), a large contingent of NATO ground forces, entered what was at the time the Serbian province of Kosovo as peacekeepers. The Muslim population was being brutally killed by Serbian Army soldiers, and the international community—led by NATO—decided to intervene to protect the Muslim minority. Kosovo was eventually liberated and is a sovereign state today.

At its peak, KFOR had about 60,000 troops on the ground. At that time—and indeed for years afterward—the situation in the Balkans looked as intractable and hopeless as Afghanistan would look a decade later. All the horrors of Afghanistan and more were on display in the Balkans: murder, torture, rape, mass killings, stumbling international efforts, ancient hatreds, bitter antagonisms against outsiders who came to help but stayed to dominate. More than 100,000 people died in modern wars in the Balkans, and more than 1 million were pushed across borders and out of their homes. Some 8,000 men and boys were executed within a couple of days in Srebrenica in Bosnia-Herzegovina in

the worst war crime in Europe since World War II. It was an ugly situation, and I am glad NATO and other nations stepped into the breach.

Fortunately, by the time I became SACEUR much had changed for the better. At the start of my time in command, in spring 2009, the KFOR contingent had been reduced to about 15,000 troops. Slovenia, Croatia, and Albania had become members of NATO; Montenegro and Macedonia are today not far behind. While great progress had been made, I sometimes found it maddeningly difficult to keep the momentum going. My familiar nemesis—the need to obtain consensus from NATO's twenty-eight members and often from other nonaligned contributors to security efforts there—slowed decision making to a crawl.

Outside of Afghanistan and the operation in Libya, no other region took up more of my attention as SACEUR than did the Balkans. In trying to make sense of the area's labyrinthine politics I read deeply, hoping to gain some understanding of the ancient web of hatred that bedeviled the area. A book by Robert D. Kaplan was particularly helpful in getting a grip on the past and in convincing me of the steep uphill climb we had in the future. His evocative title, *Balkan Ghosts*, perfectly captures the themes of historical enmity and bitterness. I also profited greatly from *Empires of the Sea*, by Roger Crowley. This marvelous book smoothly unpackages the early clash of civilizations between sixteenth-century Europe and the expansive Ottoman Empire, with the Mediterranean as the principal zone of conflict. It describes in stark terms the brutality of combat from the siege of Malta to the climactic battle of Lepanto. This book is critical to understanding the Balkans today as well as the history of Turkey and Europeans' sense of destiny in the late middle ages.

During my tenure I made more than a dozen trips to the Balkans. While violence potentially could flare up at a moment's notice, the region—while far from ghost-free—had become a reasonably peaceful, functioning zone gradually integrating with Europe. To someone reading the news a decade before, that would have seemed quite literally an impossible dream. So on we marched, the international community and the people of the Balkans, dreaming of a better world and slowly, slowly building it.

Kosovo today is home to about 1.8 million people—mostly Muslims—and is now an independent country, much to the chagrin of Serbia, from which it seceded following the ethnic cleansing and the misrule of the 1990s. Serbia lost about 20 percent of its overall territory and population in the transaction and continues to refuse to recognize the new nation despite

diplomatic recognition from just over one hundred countries, including virtually all of NATO and the European Union. The NATO/EU holdouts include Spain, Romania, Greece, and Slovakia. Time is on the side of Kosovo, and I believe it is well on its way to full international recognition, especially given the recent efforts by the EU (led by Baroness Catherine Ashton) to reconcile Kosovo and Serbia.

Adding to the tension between the two nations is the fact that a dozen sites sacred to the Serbian Orthodox faith, including the monument at the Field of Blackbirds, where 65,000 died in an epic battle in 1389, are in the territory lost to Kosovo. On one of my trips I spent two days traveling around Kosovo—mostly by Blackhawk helicopter—to see some of the most sensitive cultural sites in the Balkans. Of particular note was the monastery at Decani, built in the 1200s by the Serbian Orthodox church and led at the time of my visit by Bishop Theodosije, a spiritual leader of thirty monks who continue to "tend their gardens" at this UNESCO World Heritage Site. I found it remarkable that such places would need to be protected, but my visit was intended to send the message that NATO would provide that protection.

During my trips to Kosovo I emphasized the three Ds—defense, diplomacy, and development—in my discussions. Nothing is possible without the first D: defense. Progress made in other world hotspots, such as Colombia and Iraq, came about as a result of our ability to create and train local security forces that could provide the local populace with the sense of safety necessary to achieve positive movement. The diplomacy piece was always up front and obvious, too. Hillary Clinton spent a great deal of time encouraging diplomatic processes to work in easing tensions. She was ably assisted by our ambassadors in the region, notably Mary Warlick in Serbia and Chris Dell in Kosovo. The European Union was also instrumental, and in the end it was the enticement of EU membership for Serbia that brought the Serbs to the bargaining table. The third D, development, was also crucial to our success. U.S. AID (Agency for International Development) programs led by Administrator Raj Shah and his people were complemented by similar efforts from a significant UN contingent in-country and from the EU. All of us pulling together on all three Ds moved Kosovo from disaster to a potentially successful state.

NATO and KFOR were certainly part of the defense effort. Working side by side with local forces, KFOR members conducted confidence-building exercises designed to show that the indigenous security elements were prepared to handle new outbreaks of violence and lawlessness. Our

success was not of NATO's making alone. A number of other countries, including Sweden, Finland, Switzerland, Austria, Morocco, and Ireland, were part of our coalition as well.

Typical of our effort was an exercise I monitored from atop a high tower in the town of Gazimestan as KFOR, EU Rule of Law Mission, and Kosovo police practiced repelling a violent demonstration. The combined forces included Slovaks, Swedes, Spanish, Italians, Germans, Americans, and Irish. It was a spirited and realistic exercise complete with more than a hundred role-playing "demonstrators." I was led through the tour by a tall Irish colonel who embodied the charm of that nation and was very proud of Ireland's role in building a peaceful process in a turbulent part of the world. Our challenge was to convince local authorities that NATO and allied forces would help protect sensitive religious sites (which seemed to be beacons for zealots of other religions to attack) and would assist local officials in providing a safe and secure environment. Our ultimate goal was to work ourselves out of a job as local forces gained experience and credibility.

Midway through my tour at NATO, after careful study of the security situation and progress by the international community in advancing positive civil-military cooperation, I was able to recommend to the North Atlantic Council that NATO's forces in Kosovo be reduced to 10,000. A year or so later we again were able to reduce our presence to 5,000 troops, of whom only 800 were Americans. I think this was the best and most tangible example of our progress. I often said that I wished we could bottle up our approach in the Balkans and apply it to Afghanistan. Such magical transference was impossible, of course, but it was always worth looking at what we had done in the Balkans for examples to be tried in Afghanistan; I combed through the U.S. efforts in Colombia in the same way.

I could never turn my attention completely away from the Balkans, of course. There was always the possibility of a reflash in the region. Tension and violence always shimmered just below the surface, like the shadow of a big fish swimming underneath you that could erupt at any moment and bite you, and with the small number of troops there at times we felt very exposed.

I made the second *D*—diplomacy—another critical part of my mission. In 2010 I made the first of my several trips to Serbia, the first such trip since my predecessor Gen. Wesley Clark was there in 1999. My goal was to get to know the Serbian leadership and to convince them to conduct confidence-building measures with our forces (and the nascent security forces

of Kosovo). We needed to get Serbia to look more to the west and less to Russia in the east. The bear is always lurking just over the horizon. Not long before my visit, Ambassador Dmitry Rogozin (Russia's envoy to NATO and eventually a close personal friend) and the local Russian ambassador had published op-eds urging Serbia to turn its back on NATO because of our alleged insensitivity and interference in Serbian internal affairs. That was hardly the way we wanted the situation to go, and I thought a visit to Serbia from the supreme allied commander might get the Serbs aimed in the right direction.

Aside from the highly emotional issue of Kosovo, I found the leadership in Belgrade ready to move forward on issues of common interest to us. They clearly wanted in to the European Union, and they knew that Russia did not have the long-term ability to deliver the development assistance and commercial enhancements that could make Serbia prosperous. I knew it would be a difficult slog, however, when I met with the head of the Serbian Orthodox church and was treated to a long lecture (delivered in a gentle, resigned, and spiritual way) about the sacred Orthodox sites in Kosovo. NATO, he reminded me, had bombed the Serbs a mere decade before and had stood in unity with their breakaway province of Kosovo.

The hard part of diplomatic efforts here is the deep, unending, and intractable hatred of the Serbian Orthodox Christians for the Muslim Kosovars. In this modern era, it is startling to realize how many terrible conflicts boil down, still, to religion. From Northern Ireland to Palestine to Indonesia to Sudan to the Arabian Gulf to the Balkans, humans still have an enormous appetite to kill each other over their religious beliefs. It sometimes seems that little has changed since the fifteenth and sixteenth centuries when Protestants and Catholics tore Europe apart and killed perhaps a third of the population of that "civilized" world in the Wars of the Reformation.

In a sense, we were trying to do what Nobel laureate Ivo Andrić depicts in his novel *Bridge over the Drina*. He describes a structure in Bosnia-Herzegovina as something with the power not only to bridge a river but to heal divisions (Muslim Bosnians and Orthodox Serbs in the town of Višegrad): "Of all the things created and built by humankind, nothing in my mind is better or worthier than bridges. They belong to all and treat all alike; they are useful, always built for a purpose, at a spot where most human needs entwine."

My diplomatic missions also included many trips to the capitals of countries contributing to the Balkans operations. For example, I spent some

time in Vienna. The Austrians (while not a NATO member because they've scrupulously maintained their neutrality) were big contributors to NATO missions in the Balkans. Austrian soldiers—very professional and well equipped—numbered in the hundreds in both Bosnia and Kosovo. Austria ran the Balkans for a century as part of the Austro-Hungarian Empire and still maintains considerable interest and understanding of the region. I went to Vienna to try and convince them to contribute a bit more as we squeezed other nations for troops in Afghanistan. I was modestly successful, and Austrians remain there in numbers today. The Swiss (who have the largest Kosovar population outside Kosovo in the world—who knew?) and the Swedes likewise continued to be strong contributors to the mission.

During another trip I spent a couple of good days in Bern, the capital of Switzerland. The Swiss are, of course, famously neutral in terms of international politics, yet they are good partners with NATO in places such as Kosovo. Indeed, more than two hundred exceptionally professional Swiss soldiers were supporting peace by ensuring a safe and secure environment in Kosovo at that time. While there I met with key officials in the Ministry of Defense and the Ministry of Foreign Affairs and had a robust conversation about the future of the Balkans.

Throughout the Balkans, the international community, including a significant military effort from NATO, helped bring the various sides to negotiations. The people of the Balkans, tired of war, were willing to compromise. Instead of reaching for guns, they chose to pursue prosecutions in the International Criminal Court.

The key for continued success will be steady and sustained international pressure on both Serbia and Kosovo to resolve their difficulties, which range from border disputes to customs arrangements along their extensive and contested border. NATO must also continue to provide steady support, and the twenty-eight nations and our partners (Austria, Finland, Sweden, Morocco, and others) who supply the troops are exerting no pressure to depart prematurely.

Of note, 2013 saw extraordinary progress in the Kosovo-Serbian dialogue, all facilitated by the European Union. I have watched with great admiration the work of Baroness Ashton, the EU's functional "minister of defense and state." She handles an immense portfolio with enormous patience, a calm and sensible demeanor, and relentless pursuit of peaceful outcomes. She reminds me of the British World War II posters that urged citizens to "Stay

Calm and Carry On." She has used the "carrot" of membership in the EU brilliantly in discussions with Serbia, constantly speaking to the better angels of the various factions in power. Today, when people in the Balkans want to solve a dispute, they don't reach for a rifle, as they would have in the past; they reach for the telephone to call Brussels.

Another difficult situation in the Balkans involves the complicated nation of Bosnia-Herzegovina. After the Dayton Accords were signed in the mid-1990s, that nation instituted (under guidance from the West) a tripartite government with representation from Serbs, Croats, and Bosniaks (Muslims). It is amazing to me that it manages to run at all, and the rotating presidency is complicated and always contentious. They nevertheless seem to be making progress, despite a strong push by the Serbian entity (Republika Srpska) for more autonomy. NATO retains a small mission there to help things along, but no large troop presence. That mission is carried out by the European Union, and thus far it is successful in preventing a reflash of hostilities between the various sides. How it will play out over the long haul is hard to predict, but hopefully the same dynamic we see in Kosovo—a desire for EU membership, a population weary of war and conflict, and a generational shift that buries old hostilities—will triumph. Let's hope so.

———————————————— ✦ ————————————————

The Balkans remain a complicated and increasingly ignored part of the world populated by corrupt mayors and idealistic schoolteachers, with money laundering done in a hundred different and creative ways; odd healthcare clinics run by political dissidents; beautiful fields of crops; sullen-eyed old ladies selling jugs of gasoline; Orthodox religious sites dating from the third century after Christ; major smuggling of fuel, cigarettes, and drugs; and a thousand other odd Balkan angles. But thanks to the cooperative effort of the international community—and plenty of defense, diplomacy, and development—there is at least a chance that the Balkan ghosts, so eager to reassert their centuries of violence, can finally be exorcised. The Balkans stand as an example of the ability of the international community (including NATO) to bring and enforce peace solutions to disagreements.

It was during the negotiations over bringing Kosovo and Serbia to the table together in the fall of 2012 that I saw Hillary Clinton at her best. It was clear that extremists in both countries were determined to keep up a state of low-grade insurgency that would serve the interests of no one, and could

possibly have sent the Balkans lurching back to the "bad old days" of the mid-1990s when the place looked a lot like Syria does today. There were riots, fires, blockades, and shootings, including a NATO soldier shot while trying to keep the peace. Things were sliding backward rapidly.

Given her deep background in the region, it should surprise no one that Secretary Clinton decided to lean in forcefully. She set up a series of meetings with key leaders at NATO that included Secretary General Anders Rasmussen and the European Union's top diplomat (Baroness Ashton). Convening them at a long table in Brussels, she laid out a forceful case that it was "now or never" for peace in the Balkans. She outlined the program in a few crisp sentences, devising a strategy that brought the full weight of Serbia's desire to join the EU into play, forced Kosovo to deal realistically with the Serbian minority inside its borders, and convinced NATO to stay forcefully engaged with thousands of troops on the ground. She also flew personally to the Balkans to carry the message to the leaders there.

What was remarkable was that she did this with very few cards in her hand. The United States by this point was contributing less than 10 percent of the troops in the mission; we were already leaning on the Europeans for help in Afghanistan; and there were no serious carrots or sticks she could put into play. What she did have was her own personal gravitas, a gracious and sensible way of dealing with everyone at the table, and a willingness to do whatever it took in terms of personal energy and commitment to deal with both Serbs and Kosovars. It was Hillary Clinton doing what she does best: using both emotional intelligence and intellectual capital, hard-earned over decades in this game, to move seemingly intractable sides together. And it worked.

ISRAEL

The Best of Times, the Worst of Times

Israel was not created in order to disappear—
Israel will endure and flourish. It is the child of hope
and the home of the brave. It carries the shield
of democracy and it honors the sword of freedom.
—John F. Kennedy, August 6, 1960

"The Zionist regime and the Zionists are a cancerous tumor." Israel is
a "bogus and fake Zionist outgrowth" that "will disappear."
—Mahmoud Ahmadinejad, August 17, 2012

M any people are surprised to learn that the commander of U.S. European Command is charged with military-to-military relations with Israel. Most think it would logically fall under U.S. Central Command along with the Arab and central Asian countries. Historically, however, the secretary of defense has preferred to keep Israel in an essentially "separate" account managed by a different combatant command. This gives Israel a sort of special status with a direct connection to Europe, and it allows the Israelis to discuss their issues with a combatant commander who is not primarily focused on the Arab nations and their security needs.

I'm glad of this, because I have strong and positive feelings about Israel. I've been there many, many times over the past four decades and have a great deal of admiration for the Israelis and their embattled course in history. The

Israelis are heroic in the face of grave danger and yet constantly kvetch about details. And they are hard to pin down on an issue: as any Israeli will tell you, "If there are two Israelis in the room, you'll have three opinions."

I visited the Holy Land for the first time as a young lieutenant in the late 1970s while assigned to the aircraft carrier *Forrestal.* We anchored outside and had to ride a liberty boat back and forth to the port city of Haifa. Such a beautiful city and such serious people, I remember thinking. On the boat returning to the carrier one night, I was joking with a friend about some recent Soviet advances in the world, saying that the way things were going we would all soon be speaking Russian. An Israeli Defense Force officer in the boat with us turned to me and in a voice dead of emotion said, "You may be speaking Russian in America one day, but here we'll continue to speak Hebrew." Serious folks indeed.

During my tenure as EUCOM commander I had the opportunity to return to Israel many times. Perhaps it was my Mediterranean heritage, but there was something about the Israelis' spirit and attitude that I found particularly intriguing and appealing. The single-mindedness that I first noticed more than three decades before was still plainly evident. And they make the best hummus in the world.

During my first visit in my EUCOM role I was the guest of then–Major General Benny Gantz, a tall, rangy special forces officer whom I had first met when he was Israel's defense attaché in Washington. Benny was a deputy chief of the Israeli Defense Staff at this time, and would eventually rise to chief. He and his lovely wife, Ravi, hosted a dinner for my wife and me at a beautiful restaurant in Tel Aviv. The conversation at that first meeting, as is usual in Israel, was all business. I tried several times to draw Benny into more social conversation, but we kept coming back to issues such as Iran, Turkey, and the Palestinian Authority. Over time that would change, and we eventually developed a solid and real friendship; but in the beginning he wanted to get a sense of where I stood on the big issues. I finally accepted the lack of small talk in these initial meetings, telling myself that if I lived in a small country of seven million Jews surrounded by hundreds of millions of Muslims, most of whom would like to push my nation into the sea, I'd probably be focused on defense too.

Iran was undoubtedly the main concern on Israel's plate that evening— and on most occasions thereafter. The Israelis made it clear that they would not permit Iran to obtain nuclear weapons, correctly believing that such

devices would pose an existential threat to their country. Their alignment on this issue—from the president and prime minister through the Ministries of Defense and Foreign Affairs, right down to the most junior soldiers and sailors—is striking. It is hard to image the U.S. government or even the U.S. military coming to uniform conclusions on anything.

Some, particularly in the West, believe that a nuclear-armed Iran would not mean the end of Israel. Surely, they say, Iran would not be crazy enough to nuke its nearby neighbor. But Israel, of all countries, has earned the right to be wary of those who have called for its extinction. And frankly, all you have to do is listen to Iranian rhetoric: they make no secret of their desire and intent to destroy Israel. When someone says, "Well, Iran may say it but doesn't really mean it," the Israelis will point out, correctly, that Hitler made his intentions clear in the early days, but no one outside Germany believed him.

Many other issues demanded the Israelis' attention as well, of course. One important one for me was their deteriorating relationship with our NATO ally Turkey. When I arrived at NATO in 2009, the Israelis enjoyed a strong geopolitical, economic, and especially military-to-military relationship with Turkey. But that quickly soured over a bitter incident at sea, proving once again that individual incidents can drive huge foreign policy shifts.

The catalyzing event for the sudden collapse in Turkish-Israeli relations was a 2010 incident in which a Turkish-owned merchant ship, the MV *Mavi Marmara*, was attempting to break through an Israeli naval blockade to deliver supplies to Gaza. Israel believed the ship was smuggling aid to terrorists; the Turks claimed otherwise. When Israeli commandos boarded the ship, the crew and passengers fought back, some using homemade weapons. Nine activists on board the ship were killed. The Turkish position was that the ship was on the high seas; it was illegally boarded by Israeli commandos; excessive and lethal force was used; and Israeli Defense Forces illegally killed Turkish citizens. The Israeli position was that *Mavi Marmara* was headed into Israeli waters with the intent to pass provisions to terrorists in Gaza; it was repeatedly warned to turn away; and the passengers on the ship attacked the Israeli forces with lethal weapons, including clubs and knives. It is impossible to prove exactly what happened in the melee, but each side bitterly blamed the other.

As a result, Turkey severed relations with Israel, shattering the two nations' previously excellent military-to-military cooperation. The Turks demanded a formal apology, compensation to the victims of the attack's

families, and a lifting of the blockade on Gaza. The Israelis refused, and the situation deteriorated badly. Prime Minister Recep Erdogan of Turkey began denouncing Israel in very broad terms throughout the Middle East and globally. This situation continued for several years. After the efforts of many nations—notably the United States—the Israelis finally apologized and agreed to hold talks on compensation. More discussion on ways to alleviate humanitarian concerns in Gaza is under way as well, although the occasional outburst of rocket attacks on Israelis from Gaza will continue to hamper progress in that regard.

Why are good relations between Turkey and Israel important to the United States? First, there are practical advantages that stem from having two staunch U.S. allies in a good military-to-military dialogue. Bringing Turkish and Israeli advanced aircraft together to train with U.S. forces provides advantages to all three nations. Second, as a NATO ally, Turkey's cooperation with Israel helps with NATO's Mediterranean dialogue, a loose configuration of joint exercises, training, and information sharing around the Med. Third, from a strategic perspective, it is in our interest to find nations that can be "on the side of Israel" in international settings and in the region because this will normally align with U.S. desires. I spent a fair amount of time over the four years trying to bring Turks and Israelis in senior military positions closer together. By the time I left in the summer of 2013, the worst effects of the incident at sea were behind us and there was some progress. But it is an important diplomatic initiative that will require further work.

Another huge and ever-present issue in any discussion with the Israelis is Palestine. At the time of my first meeting as EUCOM commander, Gaza and Hamas were key concerns, especially because of rockets launched from the Gaza Strip. The Hamas terrorists seemed to have obtained new Fajr rockets from Iran that had a range sufficient to reach Tel Aviv from the northern part of Gaza. Israel was smarting internationally from the Goldstone report, which sharply criticized the Israeli incursion into Gaza earlier that year. Operation Cast Lead, as it was called, resulted in more than a thousand Palestinian deaths (the Israelis insisted virtually all were terrorists or fellow travelers). Up north on the West Bank, relations with the Palestinian Authority (the Mahmud Abbas government) were reasonably good, although even here the Goldstone report heightened tensions.

The United States has been trying for decades to encourage both sides—Israeli and Palestinian—back to the bargaining table to try and hammer out a

two-state solution. The complications of Israeli settlements in the West Bank, ongoing violence both there and in and around the Gaza Strip, the separation politically of Hamas and the Palestinian Authority, wider tensions in the Levant, and—most important—the historical enmity between the two sides have prevented much progress. My role as EUCOM commander was to reassure and conduct exercises with the Israelis, provide support to the U.S. mission working with the Palestinian security forces, manage the large military assistance budget to Israel (nearly $3 billion annually), and try to encourage cooperation. We had significant ups and downs. The arrival on the scene of Secretary of State John Kerry provided some energy to the process as I was departing in mid-2013.

The disputed territory in the Middle East is among the world's most intractable problems—in a league with Kashmir and Cyprus in terms of longevity and difficulty. I sometimes think of the Israeli-Palestinian relationship as a key to the region, but on other days I know that even if we solved it, there are still problems aplenty in the Levant and near Middle East. As Henry Kissinger told me several years ago in Germany, "The solution to any problem is merely an admission ticket to the next challenge." Solving Israel-Palestine would be wonderful, but I doubt the tensions and challenges in the region would suddenly go away. Still, it remains a central focus for U.S. policy makers and makes long-term sense, if only to reassure Israel and reduce the tensions on its borders.

Generally, when a senior official visits another country the trip comprises a mixture of meetings, briefings, and cultural events. The latter are especially important when visiting Israel because the hosts go to great lengths to make sure their guest fully understands the forces that shape their collective psyche. During that first visit to Israel in 2010, Laura and I had a chance to walk a bit in the old city of Jerusalem, escorted by our tour guide, Joel—a pearlescent host even in the slight drizzle of a November afternoon. We spent more than an hour at Yad Vashem, the Israeli Holocaust museum—a place chilling and factual and unbelievable. A photo of a young mother shielding her child while a German soldier shoots her in the head. The Hall of Names, with photos and the stories of three million of the six million dead. A haunting video of Jews descending from trucks, shovels in hands, to dig their own graves—this before the more efficient ovens were built. As it has for millions of visitors, the site saddened me beyond words and helped me glimpse the utter determination of the Israelis when they say, "Never again." Indeed, Benny Gantz talked

with me often about the Holocaust, from which his mother barely escaped. "We feel the bones of a generation on our shoulders," he once said. A photo of his mother sits on his desk alongside those of his wife and four children.

When I returned to Washington for congressional testimony shortly after one of my early visits, I was asked what I thought the chances were for an Iranian nuclear strike on Israel. I said I believed they were low. Then I was asked what I thought the chances were of a preemptive Israeli attack in Iran. I said they were fairly high. Should that happen, I said, I believed it was the responsibility of the United States to stand with and defend Israel: there is no braver nation, nor a better ally to the United States.

The Arab Spring changed the zeitgeist in the Middle East, and not for the better from the Israelis' perspective. Many in the West originally looked at the events in Cairo's Tahrir Square in 2011 as an unalloyed good thing. That was not the view in Jerusalem, and events have proven the Israelis correct. My conversations with Israel's former chief of defense and my very good friend, Gabi Ashkenazi, made it clear that things were trending in the wrong direction. A sharp-eyed observer of events, Gabi was a moderating voice in Israel's military moves. He understood the challenges Israel faced and had a keen geostrategic sense. I think he realized before anyone else the direction things were going after the turmoil in Tunis, Libya, and Egypt, and knew the outcome for Israel was a generally bad one.

Israel was buffeted by the strong *shamal* winds of the Arab Spring. Its strong partnership with Egypt was shattered, and the Israeli embassy in Cairo was stoned and burned. Bedouins in the Sinai attacked Israeli soldiers, police, and tourists, and the supply route for illicit goods into the Gaza Strip was wide open. To make matters worse, Israel's relationship with Turkey, severely damaged by the flotilla incident a year before, was further cratered as charismatic Prime Minister Erdogan broadened his appeal to the Arab world by criticizing Israel. Syria was falling apart, and the devil the Israelis knew in Bashar al-Assad seemed more appealing than the chaos likely to follow a regime collapse. Protests were disrupting Jordan, Libya and Tunisia were struggling to put governments together, and the Palestinians were clamoring for statehood at the UN.

As the Arab Spring unfolded, I worked hard to get to Israel more frequently. I spent a couple of days with General Benny Gantz, who by this time

was chief of the Israeli Defense Staff. I found him bathed in gloom unleavened even by the normal Israeli black humor. While Iran remained a preoccupation, the Israelis were at the moment more concerned by the tumultuous events on their immediate borders. This was a remarkable turn of events: a neighboring country trying to get nuclear weapons and committed to Israel's destruction was no longer the chief worry. Struggling to find something positive to say, I pointed to the flags of Israel and the United States on the table at one of our conferences and said, "At least those two nations stand firmly together." Benny lit up for the only time in two days and said, "It is the only thing we can count on."

If you were an Israeli, it was indeed hard to find much cheer. On top of all the problems in the international scene, the country was experiencing massive protests over housing costs. At one point nearly 300,000 protesters took to the streets. On a population-adjusted basis, that would be roughly like 15 million U.S. citizens out in force. Fortunately the demonstration was peaceful, but it was shocking nonetheless to the Netanyahu government and a further distraction.

We discussed Syria, and they clearly thought Assad had more staying power than our analysis at the time indicated. They based this on the view that the Alawites in the end have no option but to stand and fight. They live on what Sun Tzu would call their "death ground," where their only option is to fight and win. If you think about it, this is somewhat a reflection of the Israeli self-view—without options to move on, there is only one path: fight to the end. They also clearly recognized that a violent, destabilized, and jihadist-dominated Syria would pose a greater threat to Israel than the Assad regime.

Regardless of the fate of Bashar al-Assad, Syria poses a threat along half of Israel's border. We exchanged a great deal of intelligence with the Israelis, spent hundreds of millions of dollars providing ammunition and other forms of visible reassurance (in addition to the $3 billion in standard military assistance), exercised endlessly (especially on missile defense), and did all we could to be ready to stand with Israel if the time came. Fortunately, the Israelis had plenty of their own capability and resourcefulness to count on as well.

Indeed, literally surrounded by threats, the Israelis are endlessly innovative in devising ways to defuse them. The best example is Iron Dome, an exciting new defensive missile system that protects against rockets, artillery shells, and short-range missiles. The system already has a proven 90 percent success rate of rocket interception. This is not a number from a laboratory,

but from actual use in defense of Israelis; it has saved many Israeli lives. I saw Iron Dome during one of my trips there and came away impressed. Built with significant funding support from the United States, it is an effective, modern, comprehensive, and low-cost defense solution—and an example of U.S. commitment to Israeli security. It is backed up by other antiballistic missile systems produced in Israel, such as the Arrow ABM, that partner with U.S. antiballistic missile systems such as Patriot, THAAD, and Aegis ships offshore that could stop Iranian ballistic missiles.

When it comes to Iran, Israel's biggest concern, of course, is a potential nuclear strike. As the saying goes, getting close counts in horseshoes and hand grenades. It is the same with a nuke. As the Iranians come closer and closer to having real capability to create nuclear weapons, which they are already capable of delivering via ballistic missiles, Israel faces a deeply existential threat. Despite the rhetoric of Iran's newly elected leader, Hassan Rouhani, there appears little doubt that Iran intends to continue to flout international norms, ignore crippling sanctions, and lean toward at least developing the ability to spring ahead to a bomb.

That threat is an unacceptable reality for most Israelis, and so they continue to debate whether or not to conduct a preemptive strike on the Iranian nuclear capability. The U.S. position—correct, in my view—is to give sanctions (and, hopefully, moderation in internal Iranian politics, perhaps a "Persian Spring") a chance to neutralize the threat. Yet, I certainly understand the Israelis' deep concern. At the time of this writing I'd say the odds are fifty-fifty that the Israelis will strike. If they do, the United States will be immediately in the middle of it. At a minimum we will be defending Israel instantly with our antiballistic missile systems, radars, and command and control systems. The Arabs and Turks (and many others) will have strong suspicions that the United States was at least complicit in the strike. Some say that we should simply "do the job ourselves" because of that. I disagree. We would be better served to get this done with sanctions or perhaps a containment strategy, much as we did with the Soviet Union in the Cold War.

This issue will play out over a decade or more, and interestingly, the outcome in Iraq will be an important factor. An Iran focused on next-door neighbor Iraq is an Iran less obsessed with Israel. There are also some highly classified covert means to approach this problem, ranging from cyberspace practices to special forces, that might give both the United States and Israel some options in between sanctions only and full-on kinetic strikes. Clearly,

all options need to be on the table, and this is a case where soft/smart power may not be enough at the end of the day.

On several occasions I traveled back to Washington to take part in war games in which senior defense officials tried to sort through U.S. actions should Iran make a clear breakthrough toward a nuclear weapon. The scenarios envisioned an Israeli strike and the United States conducting missile defense of Israel (my job, largely using my destroyers and cruisers and their Aegis systems). We also can provide intelligence, communications and command assistance, ammunition, and other means of support that would be very helpful to the Israelis. In the war game scenario, the Israeli strike led (logically enough) to Iran closing the Strait of Hormuz. This would be devastating to the world economy, and it would take us about thirty days to reopen the damn thing—the laws of physics would require that to clear the mines, take out Iran's strike ability, and knock back its command and control systems.

My friend Benny Gantz got himself in domestic political trouble when he was quoted in the Israeli media in the spring of 2012 as saying that he thought the Iranian leadership was "rational" and in the end would not opt to develop nuclear weapons. I hope and pray that he is right. But I know that Benny and the rest of the Israeli leadership are not relying on hope and prayer alone. Should Iran demonstrate a push toward weaponization of a nuclear device, all bets will be off.

Every two years the United States conducts a major combined military exercise with the Israelis. The 2012 exercise, dubbed Juniper Cobra, focused on missile defense, noncombatant evacuation, special operations, plus command and control throughout the Levant. Given all the turbulence in Syria, it seemed a good time for me to go to Israel again and provide some reassurance, practice the things we might have to do in the event of a crisis with Iran, and take a hard look at our procedures for getting civilians out of harm's way.

What I found in Israel was enlightening, with flashes of both positive and negative. As always, I enjoyed spending time with my host, Benny Gantz. I was also lucky to spend some of my three-day visit with his deputy, General Yair Naveh, a combat veteran of the highly decorated Golani Brigade. The two of them seemed concerned about three things in particular: (1) inroads by Iran throughout the region, notably into Sudan and Europe (witness the arms shipments going from Sudan into the Gaza Strip and the Hezbollah terrorist

bombing in Bulgaria that killed Israeli tourists); (2) increasing lawlessness in the Sinai Peninsula, Egypt's "Wild East," where a lethal combination of terrorists, Salafists, Bedouins, and criminal smugglers is wreaking havoc and overrunning both the Egyptian military and the international treaty monitoring force led by the United States; and (3) chemical weapon security in Syria, where a thousand tons of sarin and VX were under the control of a regime that looked more tenuous by the day. Those were certainly the right things to be worried about. I assured them we had all of those pictures in our mind as well.

We talked about Iran as well and agreed any kind of attack from Iran was unlikely in the immediate future given the economic pressures, the sanctions at work, and the relative slowdown in the Iranians' march to a nuclear weapon (more of a sand crab's crawl at the moment). But to be ready to defend Israel in a ballistic missile sense, we talked about prepositioning more assets (hard shelters, command and control, and perhaps Patriot batteries).

During this visit I went to Jaffa, perhaps the oldest continuously used harbor in the Mediterranean. One of the world's ultimate crossroads, it has at one time or another been in the hands of Arabs, Jews, Crusaders, Ottomans, Europeans, Asians, and Africans. As I looked out across the compact little harbor, I thought of how many cultures, languages, men, and women—free and slave, military and merchant—had sailed in and out of this place in the course of thousands of years. It helped put in perspective our own days, which are but a flicker in time. I looked up at the bright summer afternoon and saw clouds streaming across the flat blue sky, moving fast toward the Israeli coast. What am I looking at, I thought to myself. Clouds flowing across a summer sky: something that men and women have seen for millennia. I was looking at eternity.

———————————⊹———————————

During my final official trip to the region in 2013, I spent a day at sea with the Israeli Navy. They treated me to a pass-in-review by each class of Israeli ships, part of a training exercise and also a spirited way for a Navy admiral to spend his last day at sea on active duty. Benny Gantz was nice enough to give me the first Distinguished Ally of Israel Award. It meant the world to me.

As always with the Israelis, the focus was business. Benny and I talked about the region: Syria melting down with a thousand tons of chemical weapons up for grabs; Iran continuing in bitter intransigence and waging a twilight

war globally against Israel, the United States, and the West; Egypt a wildly mixed picture under the Muslim Brotherhood. Benny said, "The first ones to win a revolution never succeed; it is the second wave you have to watch." (I remembered that a few months later when the Morsi government in Egypt was ousted.) We also talked about Lebanon, a seething cauldron of interethnic and religious dispute; and the Kingdom of Jordan, shaking in the winds of the Arab revolutions, clinging like a leaf to a tree as winter approaches.

I ended my official relationship with Israel as I began it: with deep admiration for a nation born of tragedy, built on courage, and living in danger every day. Some say the Israelis could take more accommodating positions on things like the Palestinian issues, the Turkish incident, the Gaza blockade, and the Iranian machinations; my guess is that such accommodation is not in their DNA. Not after a thousand years of persecution, the long, dark experiences of World War II, and the repeated invasions of their land.

I visited the murder camps at Auschwitz in Poland on a gray winter day, shivering as I looked up at the wrought iron sign at the entrance: "Arbeit Macht Frei" (work will set you free). Six million Jews were murdered in those camps. The Israelis search for their names and record them with honor and dignity in the Hall of Names at Yad Vashem. They never forget, and they never intend to rely on the kindness of others. What the Israelis took away from the Holocaust—the Shoah, as they call it—was that it isn't work that makes you free; it is courage and determination and a relentless drive to survive and prosper. I salute them, and I hope and trust the United States will always stand with Israel. After my time among them, I know I shall.

RUSSIA
Why Can't We Just Get Along?

I cannot forecast to you the action of Russia.
It is a riddle, wrapped in a mystery, inside an enigma;
but perhaps there is a key. That key is Russian national interest.
—Winston S. Churchill, 1939

The biggest disappointment of my four years at NATO was our failure to build a good working relationship with Russia. I came in with high hopes, believing that I could be part of the reset of relations between Moscow and the West.

While there were many areas where both sides cooperated to our mutual benefit (counterpiracy, Afghanistan, counterterrorism, counternarcotics, etc.), the overall tenor of our association during my tenure went from cautious and skeptical but hopeful to outright icy. Events drove this progression: Libya (Russia hated what NATO did there); Syria (complete disagreement with most of the UN member nations); missile defense (no progress was made because the Russians mistakenly believed NATO's missile defense system threatened Russia); and the ongoing disagreement about Georgia and the Russian occupation.

The reasons for my hopes and disappointment were more than just strategic. For roughly the first half of my naval career, the Soviet Union was the single dominant threat on the near horizon. Nearly everything the U.S. military did was designed to deter—and failing that, defeat—what was viewed as the mighty Soviet armed forces. I spent many, many hours memorizing the

Soviet order of battle, the range of the USSR's missiles, the speed of its jets, the numbers of its fleet, and so on.

Despite that background, I have long been a huge admirer of Russian culture, particularly the literature. I've spent hundreds of hours—many more than with Russian military statistics—with the classics: Dostoyevski, Tolstoy, Lermontov, Bulkokov, Solzhenitsyn, Pushkin, and Turgenev; and more recent authors such as Babenko, Aksyonov, Sholokhov, and Shteyngart. Above all, I love the brilliant (and, sadly, unfinished) novel *Dead Souls* by Nikolai Gogol, which captures the indomitable character of Russia in all its unique spirit and bleak humor. There is much to care about, much to admire, and much to be learned from the literature of Russia. Someday, in my new academic incarnation, I will give a lecture about all I have learned from "the Russians."

When the Berlin Wall fell, the Iron Curtain was shredded and the former Soviet Socialist Republics were no longer a union; there was great cause for optimism in both the West and the East. Perhaps Americans were too optimistic. More than just quickly cashing and spending the peace dividend, we banished to the back of our minds two generations' worth of ill feelings and distrust. Throughout my tour in Europe, however, those who had lived not only under the shadow of the bear but also under its thick heel were quick to remind me that we should not presume that the woods are now safe. The Poles and the Baltics were particularly skeptical of the Russian bear hug.

After one of my frequent visits to Afghanistan, I made a refueling stop in Tbilisi, Georgia, on the way back to Mons. The airport manager, a chubby charmer in need of serious dental work, was more than willing to talk about the Russians (who had invaded Georgia the previous summer). He smiled a crooked smile and said, "I hope you are watching them." Frankly, Afghanistan was taking up 110 percent of my time at the moment, but my host urged me to not lose track of an old enemy. He referred to news reports that Russian submarines had recently begun operating unexpectedly off the U.S. coast after a hiatus of a dozen years. The Georgian said, "The big bad bear she waked up, and now she's going swimming." He laughed uproariously at his own joke and then trundled away to get fuel in our airplane. When we took off, I discovered he had also provisioned us with a dozen big bottles of good, strong Georgian beer. People in the shadow of the bear tend to like Americans, I reflected as we flew over the Black Sea en route to Belgium. It was pretty good beer.

During a visit to Poland early in my tenure I was hosted by the effervescent and crisply intelligent Polish chief of defense, General Franciszek Gągor.

He outlined the Polish worldview for me, which sees Russia as an endless dark force, a sort of cross between Darth Vader from *Star Wars* and Sauron from *Lord of the Rings*—the Poles have a dramatic streak. But they know their history: the Katyn massacre, where some 22,000 Polish officers and other prisoners of war were murdered in western Russia at the start of World War II, remains a fresh memory in their culture. When I tried to tell him that I didn't see Russia as much of a current threat, he looked kindly at me and said simply, "Jim, you need to understand that there are old ghosts here in Europe that perhaps you don't see in the United States, so far away across the great Atlantic Ocean." Fair enough.

The Baltic countries too have not forgotten the bad old days. I spent a week in Lithuania, Latvia, and Estonia early in my time at NATO and came away with a better understanding of why they worry so much about Russia. The past is vivid for them, and not far distant—real atrocities occurred in living memory. The KGB museum in Vilnius, Lithuania, brought the horrors home to me: tiny, cramped cells; icy floors that were flooded in the cold winters; killing cells with blood and bullet holes on the walls—all this was going on through the 1980s. The Vilnius museum was shocking, and certainly of a piece with similar museums in Tallinn, Estonia, and Riga, Latvia: all are catalogs of violence—murder, rape, torture, deportations, genocides of Jews. I saw a huge blown-up photo of four women at the edge of incarceration: an old woman in her seventies; her forty-year-old daughter, who was also probably the mother of two beautiful twenty-year-olds nearby—all of them wearing just long underwear and with arms linked protectively around each other, gazing into the camera, lost, lost, and lost. Heartbreaking. Mementos such as these are a reminder of why free countries need strong militaries.

In each of the former Soviet satellites, those old skeletons of history rattle in the wind. Russia casts a long shadow indeed in this part of the world, I was told again and again. But I said to each of my interlocutors that we could not afford to stumble back into the Cold War; it would be too costly in every dimension. You're afraid of shadows, I scoffed. It is Russia that is a mere shadow of what it once was, I said again and again. And yet, real and visceral fear remains here, and NATO quite correctly is viewed as the "first responder." As events in 2014 were to prove, not even a year after my departure, their view of Russia proved more real than I thought at the time.

In 2010 I made my first of three visits to Russia in my NATO role—I had visited several times before that, but not as SACEUR. With the Russian

chief of defense as my host, I visited Moscow and St. Petersburg. During my Cold War career days I never imagined being welcomed into the "belly of the beast" in such a way. The Soviet Union was the enemy. I never thought I'd have a chance to visit Red Square, meet with the Russian foreign and defense ministers, fire a symbolic cannon shot over the Neva River while tourists applauded, tour the revolutionary cruiser *Aurora*, and hold detailed discussions with the senior military officer in Russia—but I did all those things.

The general theme of our talks was how we could find zones of cooperation between Russia and NATO. I believed there could be many: counterpiracy, counternarcotics, counterterrorism, Afghanistan, missile defense, arms control, and transparency in military exercises were all topics on the table. These are real and practical ideas. All our conversations were based on the idea of Russia as a key strategic partner with NATO.

On my second visit, in 2011, I had meetings in Moscow and in Volgograd, far to the south and more commonly known by its pre–World War II name, Stalingrad. I spent a lot of time with my colleague General Nikolay Makarov, the energetic and thoughtful chief of the General Staff (the counterpart of the newly installed chairman of the Joint Chiefs of Staff, Gen. Martin Dempsey). General Makarov was working hard to reform the Russian military by reducing the number of officers, creating a new national command structure, focusing on high-technology weapons systems, and changing tactical approaches to include a brigade-level combat formation.

We also talked about the U.S. missile defense system for Europe, an eight-year project that was beginning to take shape at the time and is being phased in today. It consists of Aegis missile ships at sea (initially in the Mediterranean, with four of them homeported in Rota, Spain), land-based radars (the first is operating today in Turkey, and others will be online soon in Romania and Poland), and eventually land-based missile systems in those countries as well. The system focuses strictly on defending the sort of emerging ballistic missile threat we see from Iran and other actors. The U.S. missile defense system will eventually connect with a NATO structure, and the hope is eventually to achieve some level of coordination and cooperation with Russia.

Two other key topics that came up in all my conversations with Russian interlocutors were Afghanistan and counterpiracy operations; in both spheres we had good cooperation with the Russian Federation. Russia has been broadly supportive of coalition efforts in Afghanistan, including affording

us key transit rights, selling and donating equipment to the Afghans, and helping strongly on counternarcotics efforts. The counterpiracy operation is likewise a good model of cooperation, with Russian ships working alongside NATO vessels (and ships from the European Union, many Gulf states, China, and India as well). While the challenges off the Horn of Africa persist, Russia's cooperation and coordination have been very helpful, and we discussed how to improve them.

My interactions with the Russian Federation's ambassador to NATO, Dmitry Rogozin, and his wife, Tatiana, bolstered my respect for Russia. Despite his tendency to launch mercurial tweets trashing NATO policy, Rogozin, the son of a Hero of the Soviet Union, is a big, charming bear of a man. He is comfortable in French, Spanish ("I learned it in Cuba as a conscript in the Navy," he said with a wink), English, and several other languages in addition to his native Russian. Quick with a joke and a glass of champagne, he and his wife are also deeply religious and well read. They were frequent guests at our quarters, and on several occasions we visited them in Russia. Tatiana took us for a long day's walk around St. Sergius Lavra in the town of Sergiyev Posad, the Vatican of the Russian Orthodox faith, and we got to know their children and grandchildren. Tatiana is the daughter of a diplomat and speaks perfect English learned while living in Manhattan when her father was posted to the UN. The two personify the engaging, warm, toast-making, sentimental side of the Russian national character. While Dmitry and I had our share of professional disagreements (missile defense and Libya come to mind), we learned a great deal from each other, and our friendship continues to give me hope for the long-term prospects of friendship between our two nations.

Throughout the early days of my time at NATO I was reasonably optimistic about our relations with Russia because I figured that, in the end, they would have nowhere else to go. Suppose you were a Russian strategic planner. You look to the southeast and see China—not a likely partner. Central Asia, to the south, consists largely of Islamic countries with a culture that could not be less like your own. For the past decade the Russians have been trying to cobble together a "NATO light" with the Collective Security Treaty Organization (CSTO), which includes such stalwarts as Kazakhstan, Belarus, Ukraine, Moldova, Armenia, Tajikistan, and Turkmenistan—hardly the Warsaw Pact; and frankly, the Warsaw Pact wasn't that good.

The Russians need to face facts: by midcentury Turkey will surpass Russia in population. Russia's only realistic option is to try and integrate with

Europe. Therefore, logic says the Russians should work toward an accommodation with NATO, stop trying to split apart the United States and Western Europe (which is counterproductive and distorts their relations with Europe), and accept the inevitable. They have a lot of bad choices and one good one—working with the United States and Europe—and yet they show no signs of recognizing the signpost ahead of them.

Naturally, a great deal rests on how Vladimir Putin proceeds. Will he be the grand nationalist everyone expects? Or will he do a "Nixon goes to China" and work against type? Time will tell. I see about an 80 percent chance that he remains a difficult partner and a 20 percent chance that he does something ultimately good for the West (and for Russia).

There is something about the Russian psyche, especially as presented in leaders like Putin, that makes them difficult when things are not going their way. There are countries that can handle the transition from superpower to major power with grace and equanimity. While the sun does set on the British Empire these days, the Brits have managed the transition with poise and style that is noticeably missing among our Russian friends. It is more than just unwillingness to accept that they are not the global agenda setters that they once were; some of the Russian leadership also exhibit a level of near paranoia that makes negotiation with them problematic in the extreme.

To be sure, one of the reasons the Russians occasionally act irrationally is that they hold such a bad hand. Among just a few of the problems they are dealing with are a dwindling population, soaring alcoholism and substance abuse (they lose 30,000 young people a year to drug addiction), the Islamic terrorist threat from the Caucasus, rampant corruption, the exploding Chinese population at their doorstep, a broken governance system, and the headache of having more than 15,000 nuclear weapons to maintain and keep secure. They do not have much going for them economically beyond oil and gas—a "Yarborough," as they say in bridge: a hand without a single good card.

These problems have created a people deeply resentful of the West, whom they need to survive. At times, they seem not informed by their past but imprisoned by it. But there is no reason for the West to gloat or take any comfort from that. The world needs a stable Russia. It is a nation of extraordinary resilience with an amazing history and a culture with a streak of dark humor that can survive almost anything. Russia's future lies in the West. We must relegate the Cold War to the dustbin of history and build a true strategic partnership with Russia; the opportunities are many if we do.

I am surprised at how easily Americans now "assume away" Russia in our global calculations (I think the Russians are too). The Russians could still easily destroy the United States, although their own country would be destroyed in the nuclear exchange (unlikely, thankfully); they possess abundant natural resources (although their economy remains a one-trick pony); and they can either help us or hurt us a great deal on the international scene (witness the gridlock in Syria as a result of Russia's intransigence). If we do not find a way to work with the Russians and develop zones of cooperation, Russia may become a perpetual spoiler.

The High North also comes into the mix when we deal with Russia. We must avoid militarizing the Arctic. We need to ensure that this open space becomes a zone of cooperation, not a zone of confrontation, as it was during the Cold War. Cooperation in the Arctic today through such organizations as the Arctic Council can help build trust and focus our efforts in areas of mutual interest to maintain regional security.

The good news is that we have created several zones of cooperation with Russia over the past several years that are bearing reasonably good results. They include:

> *Counterpiracy operations.* Russian ships routinely operate in the same waters as NATO warships. While our mutual efforts are only loosely coordinated, the results are striking: piracy has declined more than 70 percent between 2010 (the peak) and 2013, and not a single ship has been hijacked since May 2012. The number of ships and mariners held hostage has plummeted. Overall, this is a very effective operation, made more effective by the presence of Russian warships.

> *Afghanistan.* Russia has contributed small arms and ammunition to the Afghan security forces and has sold MI-17 helicopters and provided maintenance training for the nascent Afghan Air Force. Perhaps most important, the Russians have been helpful with logistics, including allowing a transit arrangement that helps sustain the international support mission for Afghanistan.

> *Military exchanges and training exercises.* These have also been reasonably successful. Russian soldiers, sailors, and airmen have participated in exercises with U.S. and NATO nations. These exchanges—including port calls in Russia by NATO warships—have been well received by both militaries.

The High North/Arctic region. We all agree that this area of the world must remain a zone of cooperation and concur that the Arctic Council—with members from the United States, Russia, Norway, Denmark, Canada, Iceland, and several other key nations—is the best forum for discussions.

Counterterrorism and counternarcotics. We have reasonable cooperation and a shared sense of the challenges involved. As the Sochi Olympics approached, we offered assistance and shared information through a variety of channels to prevent a terrorist incident. In the counternarcotics world we work together on the flow of heroin from Afghanistan—a high priority for Russia.

The 2014 Olympics presented an opportunity for better interaction between East and West, and both sides took advantage of it. With the terrorist threat high as a result of radical elements in the nearby Caucasus, the Russians worked closely with Western and U.S. entities on counterterrorist information sharing, electronic surveillance technology, and physical security. No one wants a threat to our athletes, and the need for an "all hands on deck" effort provided useful connections. The confluence of athletes from the U.S./NATO nations and Russia competing together likewise brought together senior statesmen in Sochi—providing openings and opportunities to discuss the tough issues before us. Certainly, that is part of the vision of the games going back to the founders of the Olympic movement, although it is hard to point to any practical progress and easy to find the failures—1936 in Berlin (where Hitler used the games for propaganda), 1972 in Munich (with the deadly terrorist attack), and the 1980 and 1984 boycotts come to mind.

On the other hand, there are clearly challenges in the relationship. We have ongoing disagreements over Russian forces stationed in Georgia and missile defense. Russia sees the NATO missile defense system as posing a threat to its strategic intercontinental ballistic missile force. We strongly disagree. The system is clearly designed as defense against Iran, Syria, and other ballistic-missile-capable nations that threaten the European continent.

Russia has been extremely critical of NATO's role in Libya. We maintain that we operated under the UN Security Council mandate to establish a no-fly zone, enforce an arms embargo, and protect the people of Libya from attacks. Our efforts in that regard were well within the bounds of the Security Council resolution's mandate and the norms of international law. Russia

sees it differently, and whenever I discuss this with Russian interlocutors we find little room for common view. This tends to create a differing set of views about the dangerous situation in Syria as well.

The Snowden affair threw a bucket of ice water on our relationship with Russia. When Edward Snowden fled China and headed to the transit zone of the Moscow airport, I thought he had made a crucial mistake. I guessed that Russia would at best turn him over to the United States on an internationally recognized warrant, and at worst would expel him quickly, leading to opportunities to apprehend him. I was wrong. It is a reflection of how low our relations have sunk that Russia—a nation that will normally cooperate closely with us on criminal, terrorist, and narcotics matters—not only rejected our warrant but then granted Snowden a year's political asylum. It harkens back to the days of Philby, Burgess, and Maclean—British spies who sold out their country during the Cold War and escaped to the Soviet Union. I had thought we were well beyond such behavior, but this policy clearly came right from the top: Vladimir Putin himself. There are days when I think John McCain had it exactly right. Days after President George W. Bush famously said he had looked into Putin's eyes and saw his soul, McCain said, "I looked into Mr. Putin's eyes and I saw three letters: a *K* and a *G* and a *B*." Sadly, that is a pretty good summation of the leadership in Moscow today. Until Putin decides to warm up relations, the forecast is for chilly weather.

Life is full of choices—for nations as well as for people. There is a Russian proverb that says, "Every road has two directions." My hope is that through their mutual choices, NATO and Russia will find a way to travel together on the road ahead. My heart remains with Russia, although my head tells me the relationship ahead will be full of bumps.

Postscript

By the spring of 2014, events had turned decidedly worse in our relationship with Russia. Putin's darker angels had indeed won out (my 80 percent chance above), and he had led his nation on what will ultimately be a self-defeating move to invade Crimea. By annexing a large chunk of sovereign territory under the guise of a "referendum" conducted with tens of thousands of Russian troops (I almost wrote Soviet) staring at the voters, he brings back every bitter taste of the Cold War like a bad vodka hangover. I think it is a stretch to compare him to Hitler, but his actions badly rattle the old ghosts in Europe that my friend General Gągor of Poland warned me about years ago.

Sadly, it seems unlikely this will result in anything but roadblocks in issues far more important, frankly, than Ukraine: Syria, Iran, the High North, Afghanistan, counterterrorism, and counternarcotics; cooperation between Russia and the West in those areas is now badly at risk.

Whether Putin stops and consolidates Crimea, with a sympathetic Russian-speaking majority population and its excellent strategic warm-weather port at Sevastopol, remains to be seen. In my view, it would be a significant strategic mistake for him to press on and take more of Ukraine. Without Crimea, the rest of the population is less than 15 percent Russian speaking, an even harder case to make politically and diplomatically.

The key for the West—really, for the entire globe—is to ensure there is no repetition of the invasion into the rest of Ukraine or (improbably and VERY dangerously) into a NATO nation. Only 8 of the UN's nearly 200 member nations voted against the resolution condemning Russia's actions; they included Russia, Nicaragua, Bolivia, Cuba, Syria, and Belarus—hardly a sterling group of allies. So the good news is that there is near-universal opposition. The bad news is that Putin is not much interested in world opinion, generally speaking—especially now that the Olympics are over. So what should we do?

Politically, lead a global voice of condemnation in the UN and other fora. Throw Russia out of the G-8 permanently until the issues are resolved. Implement targeted sanctions and consider broader and stronger ones if further borders are crossed in the same manner. In terms of military support to Ukraine, boots on the ground is not a viable option; but we should share intelligence and information, provide arms and ammunition, conduct training and mentorship, consider mentors in-country, help with cyberprotection, and conduct exercises with the Ukrainian armed forces. The NATO command structure should be energized and ready, and the NATO Rapid Deployment Force should be exercised vigorously. NATO should strengthen its resolve, conduct exercises in the member nations near the Russian border, and move additional forces there. The U.S. drawdown in Europe should be paused, and perhaps reversed. And our cyberdefenses across the alliance should be strengthened. These actions hopefully will have a deterrent effect on Russian designs. It is highly unlikely that Russia wants seriously to tangle with NATO, which outspends it roughly eight to one on military expenditures.

Having said all that, we still need to find a modus vivendi with Russia. It is too big, and too dangerous given its nuclear weapons, to be ignored or isolated. And we would all benefit from cooperation in the areas I mentioned earlier. So we need diplomatic interaction and dialogue and must find a way forward that permits Ukrainians to decide their own future within the

remaining borders of their state. The U.S./NATO relationship with Russia must focus pragmatically on what we can do of mutual benefit, continue to condemn the actions in Crimea, bolster NATO resolve and defense, and allow Ukraine free choices on its orientation.

The letters in Putin's eyes are K . . . G . . . B, as Senator McCain said. I would say he is a classic Russian nationalist born a couple of centuries too late. He will be a difficult "partner" indeed.

LEADERSHIP CHALLENGES AND PITFALLS
McChrystal, Petraeus, Allen, . . . and Me

*All I can say for the United States Senate is that
it opens with a prayer and closes with an investigation.*
—Will Rogers

The difference between the military and the Senate is that the services don't start out with a prayer.

Many wonderful things come along as you rise through the ranks of military service. If you are lucky enough to become an admiral or general you get to travel to fascinating places, meet interesting people, and participate in events that would have been unimaginable before you put on stars. With all those benefits come burdens, although I know it is hard to generate much sympathy from the public in that regard. Believe me, though, the burdens are real. Along with the spotlight comes a microscope. Everything you do and don't do is scrutinized in minute detail. For the most part, it comes with the territory. As Luke 12:48 says: "For unto whomsoever much is given, of him much will be required; and to whom men have committed much, of him more will be asked." Keeping that biblical wisdom in mind sometimes requires more than the patience of Job.

I think it is useful to share some insight into the travails of four senior leaders who, in very different ways, came under very challenging scrutiny: Gen. Stanley McChrystal, Gen. David Petraeus, Gen. John Allen—and me. I count each of the three generals as a good friend, a strong colleague, and a staunch patriot.

STANLEY MCCHRYSTAL

Let me start with Stan McChrystal. Stan was a rising star in our military, one of a handful of senior officers who served brilliantly in top leadership positions in both Iraq and Afghanistan. He remains one of the most gifted and creative thinkers I have ever met, and our partnership in Afghanistan was professionally and personally rewarding. Above all, Stan understood that ultimately, we would not deliver security in Afghanistan through force of arms. Or as he said it, "We can't kill our way to success." Step by painful step he was getting the United States and its allies on a path that, for the first time, had a better than even chance of success.

That progress was not achieved without great personal cost. Stan slept no more than four hours a night, ate only one real meal a day, and staggered under the burden of the loss of each American and allied soldier. He struggled mightily to come up with a strategy that would give us the greatest prospect for establishing a secure Afghanistan—often overcoming objections from bureaucrats thousands of miles from the battle. Through it all, Stan was held in enormous respect by the troops serving by his side, and especially by the Afghans.

For all his achievements, Stan (and, more significant, members of his personal staff) made an error in judgment. They allowed a young journalist who was essentially unknown to them to spend long hours by their side during a rare period outside the war zone when they were letting their guard down. It is more than a little ironic that after making thousands of life-and-death battlefield decisions, Stan was brought down by a media interview.

The first I heard of the matter was in a wakeup call from the chairman of the Joint Chiefs of Staff delivered at 3:30 a.m. Turkish time—I was on the road at a NATO conference in western Turkey. "Have you read *Rolling Stone*?" Mike Mullen asked. Through my sleep-induced fog I think I managed to mutter, "Huh?" Mike correctly took that to mean, "No, sir," and he said he would e-mail the article to me and wait for my return call.

Fifteen minutes later I had skimmed enough of the article, titled "The Runaway General," to know that Stan's military career was likely over. The story portrayed Stan and his staff as dismissive and disrespectful of senior political leaders. Nevertheless, in subsequent phone calls with Mike I recommended that we do all we could to save him, reasoning that the downside of firing him—the negative impact on the Afghan campaign—outweighed any benefit. Almost all of the objectionable remarks quoted in *Rolling Stone* were attributed to his staff. And I just knew Stan so well—he had tremendous respect for the office of the president and had come to work well with President Obama. I figured the article might have been the result of a foolish moment by a collection of Stan's subordinates having an alcohol-fueled night on the town, so I held out hope he could be saved.

Shortly after that unpleasant awakening from the chairman I received an e-mail from Stan:

> Jim:
>
> The attached story is about to be released and will be very damaging to me—and our effort.
>
> I've offered to CJCS and SECDEF to remove myself from this position but both have asked/directed that I remain in it to prevent further disruption to our overall effort in Afghanistan.
>
> I've made calls to key people in the story: VP, etc.—but clearly the embedded access provided to this reporter turned out to be both inappropriate and damaging.
>
> I want to state my personal apology to you for the impact this will have on our shared effort. You've put too much of yourself into this to have our success endangered (or at least made more difficult) by my mistakes.
>
> V/R
> Stan

So Stan stayed in place while Mike Mullen, Secretary of Defense Robert Gates, senior administration leaders, and the chattering classes debated whether "The Runaway General" had irreparably derailed his career.

Over the next few days there were innumerable conference calls among the senior leadership. Stan was ordered back to Washington to explain himself to the president. It quickly became clear that the administration was in an untenable position. If President Obama allowed the perceived insubordination to go unchallenged, it might reinforce one of the many unfortunate themes of the *Rolling Stone* article—that he was intimidated by the military.

Once it became clear that Stan's departure was likely, the question of his replacement quickly arose. The best way to minimize the disruption of Stan's departure would be to announce the name of his successor immediately. The pool of logical candidates was not broad. Several names were bandied about: Gen. Jim Mattis, Gen. David Petraeus, Gen. Ray Odierno, and then–Lt. Gen. Lloyd Austin. I even saw my own name flicker across the landscape; I thought that unlikely given that I was already fully engaged as the supreme allied commander. Although by that time I was deeply steeped in the Afghan war and had gained a lot of experience dealing with insurgencies during my time at U.S. Southern Command, putting an admiral in charge of a land war in Afghanistan would have been another shock to a system that had already undergone too many shocks. The generals under consideration were all gainfully employed in other jobs. It was a tough call, but I felt the best overall contender was probably Dave Petraeus. I told Secretary Gates and others that Petraeus would "calm the markets" in ways that no one else could.

Stan McChrystal went to see President Obama on Wednesday June 23, 2010, with a letter of resignation in hand. It was not a long meeting. Shortly thereafter the president appeared in the Rose Garden not only to confirm the expected firing of Stan but with Stan's replacement, Dave Petraeus, standing by his side. The president said he didn't fire Stan out of "any sense of personal insult" but rather to enforce unity among the team prosecuting the war.

Stan's sudden disappearance left his staff in Afghanistan reeling. Fortunately, there were strong leaders in place, such as his British NATO deputy, General Sir Nick Parker, who reminded them of the president's remarks in the Rose Garden: the mission was bigger than any one man, and they owed it to Stan to soldier on. Perhaps the most poignant response to Stan's relief was from an Afghan Army captain, Khoshal Sadat, who wrote in an op-ed published in the *New York Times* on June 26, 2010:

> I have known many military officers, but not one who better represents what soldiers stand for—honor, sacrifice and courage—than Gen. Stanley McChrystal, who until

last week was the commander of American and NATO forces here.

During my time as the general's aide-de-camp, what struck me was how much he cared about what others thought and what they felt, even the most junior person in the room—which was, more often than not, me. We were frequently visited by some of the most important American and international leaders, and whenever they questioned the general about Afghanistan, he would always turn to me and say, "Let's ask an Afghan."

Sadat ended his tribute: "I never had the opportunity to say goodbye to General McChrystal. I hope he will return when there is peace in Afghanistan, because he will be the father of that peace."

A few weeks after Stan's ouster, I was in Washington for meetings and went to visit him in his graceful antebellum quarters at Fort McNair on the banks of the Potomac River. Boxes cluttered the rooms as he struggled to pack up the detritus of four decades of military service and move on with the next stage of his life. He was subdued and reflective. He said he had let all of us down. I disagreed.

I said, "Stan, you didn't let us down. If you'd had an affair with your aide, you'd have let us down. If you'd made some awful tactical decision and a couple of hundred of our soldiers were needlessly killed, you'd have let us down. This was a mistake for sure, but not at the level of personal shame for 'letting us down.'"

In a way, Stan seemed ready to move on. "I went to Nordstrom's and bought four suits," he said with a slight smile. We laughed. "Those are nice suits," I said.

As a parting gift I gave him my battered 1934 edition of *Goodbye to All That*, by the war poet Robert Graves. It is the lyrical story of a young British officer who comes of age in World War I and leaves his youth behind in the general disillusionment of that time. Sad, funny, and poignant, it is a tale of letting go.

About nine months after Stan's firing, the Pentagon's Inspector General delivered the results of their review of an Army IG investigation into the circumstances of the disastrous *Rolling Stone* interview. Their overarching conclusions were that there was "insufficient evidence to substantiate a violation

▲ Saluting Afghan police outside Kabul after their literacy training
Official NATO photo by Sgt. Peter Buitenhuis, Royal Netherlands Air Force

▼ My TED talk on smart power in Edinburgh has received more than 650,000 hits on YouTube and TED.com
Photo by James Duncan Davidson

▲ Appearing before the Portuguese parliament in Lisbon

Official NATO photo by Sgt. Sebastian Kelm, German Army

▶ Riding with Royal Canadian Mounties in Ottawa following briefings about their training mission in Afghanistan
Official NATO photo by Sgt. Sebastian Kelm, German Army

▲ Inspecting sailors at a change of command
Official NATO photo by MSgt. Edouard Bocquet, French Air Force

▼ Discussing NATO with President Shimon Peres of Israel
Official NATO photo by Sgt. Peter Buitenhuis, Royal Netherlands Air Force

▲ A visit to Poland

Official NATO photo by Sgt. Peter Buitenhuis, Royal Netherlands Air Force

▲ Meeting with then-Senator and now Secretary of State John Kerry in Munich at the annual security conference there
Official NATO photo by MC2 Stefanie Antosh, U.S. Navy

▼ A light moment with the president
Official NATO photo by Sgt. Sebastian Kelm, German Army

► With
Orthodox
bishop
Official
NATO
photo

▼ At Australia's magnificent war memorial in Canberra. The Australians
fought bravely in combat in Afghanistan for the coalition.
Official NATO photo by MSgt. Edouard Bocquet, French Air Force

▲ My closest friend in NATO circles, Giampaolo di Paola (left). He was chairman of the Military Committee, then became minister of defense of Italy.

Official NATO photo by MSgt. Edouard Bocquet, French Air Force

▲ Laura and I preparing to host the annual Christmas party for our team and the NATO ambassadors in Mons, Belgium

Official NATO photo by MSgt. Mick Howard, British Army

▲ Laura and I with Secretary of State Hillary Clinton
Official NATO photo by Sgt. Intisar Sabree, U.S. Army

▼ An enjoyable moment with Her Majesty, Queen Elizabeth, at the
U.S. ambassador's residence in London
Official White House photo by Pete Souza

▲ Retirement day with Laura
Official U.S. European Command photo by SSgt. Matt Lyman, U.S. Marine Corps

▲ Briefing the president with Secretary of Defense Leon Panetta, JCS Chairman Marty Dempsey, and Gen. Jim Mattis, among others

Official White House photo by Pete Souza

▶ Briefing U.S. airmen in Germany on combat operations over Libya
Official NATO photo by Sgt. Peter Buitenhuis, Royal Netherlands Air Force

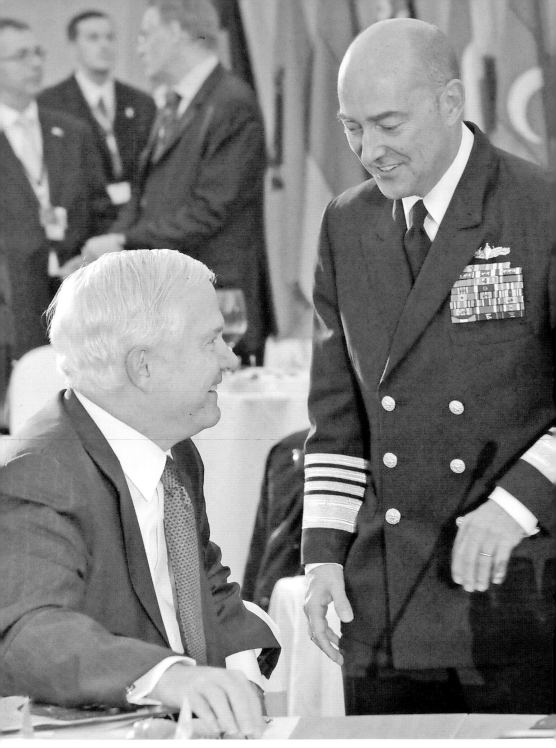

▲ Secretary of Defense Bob Gates told me the only thing that got him through NATO meetings was his crossword puzzles. I think he was kidding.

Official NATO photo

▲ Conferring with Dave Petraeus at NATO headquarters
Official NATO photo by Sgt. Sebastian Kelm, German Army

▼ In Berlin with Henry Kissinger
Official NATO photo by Sgt. Intisar Sabree, U.S. Army

▲ Briefing U.S. troops after awarding Silver Star medals in southern Afghanistan

Sgt. Ashley Curtis, U.S. Army

▶ At sea off Romania, observing special forces from a NATO destroyer

Official NATO photo by Sgt. Peter Buitenhuis, Royal Netherlands Air Force

▲ Service Dress Khakis, an experimental uniform that was eventually dropped. I loved it because it was a throwback to the Navy's World War II Pacific heritage.

Official NATO photo by MSgt. James Hennessey, British Army

▼ With the Ukrainian CNO on the Black Sea
Official NATO photo

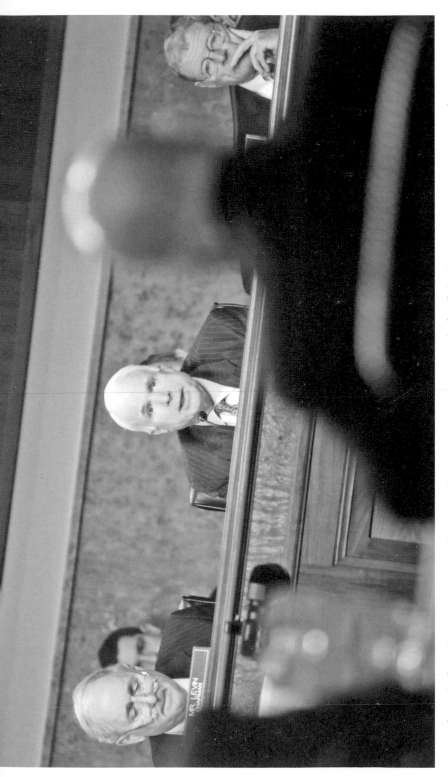

▲ Testifying before three senators, Carl Levin, John McCain, and James Inhofe of the Senate Committee on Armed Services. I had a good relationship with all three.

Official NATO photo by Sgt. Sebastian Kelm, German Army

▶ Inspecting Afghan soldiers at the Afghan National Training Center
Official NATO photo by Sgt. Intisar Sabree, U.S. Army

▲ It is all about smart power
Official NATO photo by Sgt. Sebastian Kelm, German Army

▼ Visiting airmen at Thule AFB Greenland, the northernmost point of my command—a long way from Kabul
Photo by EUCOM/821st Air Base group, Thule, Greenland

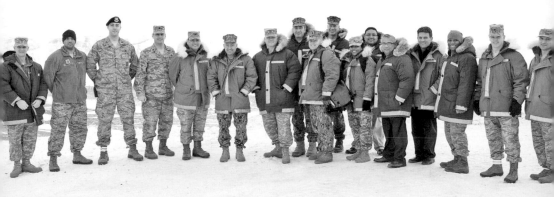

▲ Dismounting a helicopter in western Afghanistan
Official NATO photo by MSgt. Edouard Bocquet, French Air Force

▲ At a good point with President Karzai
Official NATO photo

▼ On a visit to Afghanistan
Official NATO photo by Sgt. Emily Langer, German Army

of applicable DoD standards" and that "not all of the events at issue occurred as reported in the article." I am sure that was of little comfort to Gen. Stanley McChrystal, U.S. Army (Ret.). He will be more interested in the verdict of history on his mission. I believe, as his former Afghan aide-de-camp said, that if one day there is peace in Afghanistan, he will be its father, or at least will deserve significant credit for that achievement.

David Petraeus

The decision to appoint Dave Petraeus to follow in Stan McChrystal's wake was brilliant. No one was better equipped to move in and take the helm of this important mission. It was clear that Dave would be able to quickly apply the lessons learned from his time in Iraq to his new job. Counterinsurgency, diplomacy, close relations with the interagency and international community, constant circulation with the troops, and careful management of the Afghan government would be key—and a good prescription.

Journalist Tom Ricks, who covered Petraeus extensively in Iraq, quoted Dave as having told him in Baghdad: "There are three enormous tasks that strategic leaders have to get right. . . . The first is to get the big ideas right. The second is to communicate the big ideas throughout the organization. The third is proper execution of the big ideas." Ricks noted that one of Dave's favorite words was "relentless," and that was the best one-word summary of his approach.

After a quick Senate vote (99–0) confirmed him, Dave came through Brussels on his way to Afghanistan. He visited my headquarters and I hosted a dinner for him at my home. Dave already knew the place well, having served in Mons twenty-five years earlier when he was a military assistant to one of my predecessors, Gen. John R. Galvin.

Ironically, just a few years before that, Dave had told me that being SACEUR was his dream job. But he was diverted to the Central Command position after its leader, Adm. Bill "Fox" Fallon, retired prematurely following some controversial comments that appeared in *Esquire* magazine. (Note to four-star officers: beware of magazine interviews.) What made Petraeus' sudden assignment to Central Command significant to me is that it probably resulted in my not getting what I considered *my* dream job—head of the Pacific Command in Hawaii—and being sent to be SACEUR instead. Life has ironic twists, to be sure.

Dave Petraeus came breezing into NATO appearing every bit the force of nature I knew him to be. He took meetings with the secretary general, the chairman of the Military Committee, the North Atlantic Council (all the ambassadors), and eventually with me. He was upbeat, smart, and very well prepared. He explained his views in great detail and was very, very careful. Just what the doctor ordered for that point in time.

At a formal dinner I hosted for him in the Chateau, he took over the table of fourteen very senior ambassadors and generals with ease. He asked everyone to give a burst on their thoughts on Afghanistan and ask him any questions they might have, and then settled down to provide his own views. It was a strong performance by a leader at the top of his game. We put him on the airplane the next morning and sent him south to the war. Dave immediately took charge in Afghanistan, as I knew he would. He is supremely talented and supremely confident, with enormous energy and enthusiasm.

I continued my practice of making frequent trips to Afghanistan and had regular meetings with Dave, just as I had done with his predecessor. As time wore on, I noticed to my surprise that while his enthusiasm never wavered, he seemed increasingly tired by the burdens he was shouldering. On one visit in particular, about eight months into his time in Kabul, I walked into the room to meet him and found the light extinguished from his face. His visage was white, flat, and tired. As he rose to welcome me, he seemed bent over and stooped. I'm a short fellow—five-five on a good day—and Dave, I think, is around five-ten or so; but as he greeted me we were eye-to-eye, a rare experience for me. I spoke with several of his key subordinates—Dave Rodriguez, his operational commander, and Bill Caldwell, his key leader for training the Afghan security forces—and both shared their own concern for his health.

On the other hand, Dave was—as always—in total control of the material. We talked about transition: the idea of when, where, and how the Afghan security forces would take over. Both Dave and I were receiving incredible pressure from both the United States and NATO on this. We agreed to a set of transition principles. Dave also shared with me that his son, an Army officer who is, like him, an infantry officer, was serving in southern Afghanistan— the most dangerous spot. That has to be a burden on him as well, I thought, although I certainly didn't hear that from Dave: just a father's quiet pride in a son doing a good job.

I also saw Dave frequently at NATO summit meetings and other gatherings. Such sessions seemed to energize him. At one NATO gathering in

Lisbon I was nearly trampled by reporters and paparazzi fighting each other to get access to the rock star General Petraeus. It was amusing to watch him play the media like a fiddle. Alice Roosevelt Longworth's comment about her father, Teddy Roosevelt, came to mind: "He wants to be the bride at every wedding, the corpse at every funeral, and the baby at every christening."

Toward the end of the year Dave spent in Afghanistan I met with him in Kabul, and he seemed recovered from his fatigue generally but perhaps a little down. Apparently it was dawning on him that his military career might be coming to an end at the end of his time in Afghanistan. I suggested that there was still time to take his former dream job (mine) and that he would be brilliant at it—far better than me, probably. The time for that had passed, he said; the only uniformed job he was interested in now was chairman of the Joint Chiefs. But there were media reports and other signals that the administration did not favor him for that portfolio although he was being considered for other important jobs.

Dave is talented, smart, good looking, dedicated, and clever. It would have been easy to be jealous of him if I had that tendency. I tried to be a good friend to Dave, and continue to do so to this day. Dave always stood a bit apart from his peers; perhaps he set himself apart by his extraordinary competence. I thought it must be lonely at the top of the mountain, where the strong winds blow.

I was surprised when word started to circulate that the administration was considering asking Dave to hang up his uniform to become director of the Central Intelligence Agency. It is a huge job, no doubt, but I wondered if a man with such a high media profile could prosper in an outfit that regarded clandestineness as the greatest of all virtues.

Before he headed back to Washington I had a final dinner with Dave in Afghanistan. At the end of the meal we exchanged gifts, and I thought each of us managed to find something that fit the other. I gave Dave a nice nautical compass—which I said he would need to navigate the waters in D.C. He is descended from Dutch sea captains and I think would have been a good sailor. He gave me a watercolor of the Afghan game of *buzai*, a sort of ruthless polo played with the corpse of a goat. It would help me remember Afghanistan, he said, and how brutal the culture really is. I thought to myself, good luck in Washington, Dave, where every day is *buzai* day.

I was completely gobsmacked (as my British colleagues like to say) when I heard a little more than a year later, in November 2012, that Dave

was stepping down from the CIA because of revelations that he had had an affair with his biographer, Army Reserve major Paula Broadwell. That a person at the pinnacle of his career could be brought down so suddenly and so thoroughly was both stunning and tragic. The nation lost the services of a supremely talented officer, but I suspect we will continue to see Dave take on big tasks and operate in the public eye.

There was another turn of the wheel to follow: As tragic as the fallout was for the Petraeus and Broadwell families, there was also heartbreaking collateral damage to others: the Allen family.

John Allen

The Department of Defense once again did a terrific job finding someone to replace a seemingly irreplaceable leader in Afghanistan when they nominated Gen. John Allen to follow Dave Petraeus. My admiration for John goes back nearly forty years. We started at the Naval Academy together in 1972.

If you had lined up the 1,400 incoming plebes at Annapolis on that hot, humid summer day in June 1972, you would have bet money that John Allen—tall, handsome, steady, and possessed of a strong intellect and a good sense of humor—would eventually be (1) a Marine and (2) a general. You would have looked at Jim Stavridis and said (1) don't they have a height requirement here? That guy is going to have trouble seeing over the bridge wing; and (2) he likely won't stay in the Navy past his obligated date. In the end, we were the only two members of the 1,400 plebes who started in the class of 1976 to achieve four stars.

I loved working with both Stan McChrystal and Dave Petraeus in Afghanistan, but it was a joy to have a Naval Academy classmate and one of my very closest friends in the world standing up to take over the NATO command. John is strategic, is thoughtful, and had a nice light touch with the allies. He can bounce back from a tragedy and thinks straight under pressure. Resilience and grace under pressure: What else really matters? I thought then—and think now—that I would trust him with my life. John did a great job in Afghanistan and eventually was nominated to be my successor in my twin jobs in Belgium and Germany. I was delighted with the choice.

But then, in the immediate aftermath of the Petraeus implosion, came word that John Allen was somehow involved in that affair. That can't possibly be, I assured myself. There is no straighter arrow, no one more a Boy Scout, than John Allen. Maureen Dowd wickedly but accurately categorized

him as "the Dudley Do-Right of Generals." It turned out that John and his wife were friends of Jill Kelley—the woman in Tampa who was the target of the threatening e-mails from Paula Broadwell that started the whole Petraeus investigation. Evidently someone at the FBI read the e-mail correspondence between John and this woman and decided that some of it was "inappropriate." Secretary Panetta, responding to the superheated atmosphere that senior leader ethics cases generate, quickly decided to put John's nomination hearing with the Senate Armed Services Committee on hold while the charge was investigated. In my heart, I knew how that was going to play out. Collecting "the relevant facts" takes forever.

In the meantime, my plans to depart my job five months hence were also on hold and—much more significant—my friend John Allen was left swinging in the breeze. I tried to call John, who still had a war to run in Afghanistan, every five days or so to keep up his morale. He never let his focus on mission be distracted, but I could tell that the uncertainty was causing a heavy toll not only on John but particularly on his wife, Kathy, who had been in ill health.

After John had spent three months in limbo, the Pentagon finally announced that its Inspector General's staff found no wrongdoing on his part. Many, including the White House, assumed that he was good to go as the next SACEUR. I quickly called John to offer my congratulations. I found his response very flat. All he said was, "Jim, I'll call you later." After the unfair, and indeed outrageous, beating he had taken in the media, and considering the delicate state of his wife's health, I wasn't surprised at his lack of enthusiasm. In my view, he didn't owe the administration or the Defense Department any particular loyalty. I suspected he had come to the same conclusion.

When we reconnected later in the day he said, "Jim, this is a hard call to make. I don't want you to be disappointed in me, but for personal and family reasons—and Kathy's health—I've decided not to accept the job as SACEUR."

I tried simply to tell him that as a classmate, friend, and admirer for forty years I supported his decision and fully understood. I talked in a sunny way about life after the Navy and Marine Corps.

John Allen spent eighteen brutal months in Afghanistan, served almost ten years as a general in the Marine Corps, and offered his country a lifetime of sacrifice: emotional, temporal, familial, and financial. He deserved so much better.

John continued to do his job in Afghanistan in his usual superb way. He sent an e-mail message to the chairman of the JCS and me just a week before

his scheduled change of command. In the subject line was: "Something Wonderful." He wrote:

> We held our weekly memorial service in front of my HQs this morning. As we stood in a gentle snowfall, for the first time in my command, there were no ISAF [U.S., NATO, or foreign allied] names read by the national representatives for those killed in action this week. It was something wonderful. We did, however, recognize the 25 ANSF [Afghans] killed this week.
>
> At the conclusion of the ceremony, the AFG officer who participates each week in the ceremony was in tears as he approached me, nearly joyous that none of our troops had been killed this week.
>
> The page has turned.

The page had turned for John Allen as well. I fully respected his decision. Even after he was cleared of wrongdoing he was subjected to an unending barrage of speculation about the content of the e-mails between him and Jill Kelley. It seemed obvious to me, despite his clearance by the IG, that the longer John remained in the public eye, the longer the rumors would swirl. So much pain had already been inflicted on him and his family that he was just unwilling to go forward. I'd have done the same in his position, frankly.

In this country we talk a lot about our troops and the effects of post-traumatic stress disorder (PTSD)—as we should. But I think we should spend a bit more time focusing on their commanders as well. The demands of time, space, and decision making on those holding senior positions are so intense, and the crucible of calculation so precise, that over time the insulation just starts to come off the wires. Mike Mullen told me that he did little else but sleep for a couple of months after giving up the CJCS job.

John asked me to speak at his retirement ceremony at Annapolis, and I was honored to say yes. Just before the event, however, I was directed to attend another ceremony instead—the abdication of Queen Beatrix of the Netherlands on behalf of her son, Prince Willem-Alexander. It was an impressive ceremony, but my heart was in Annapolis, where I would have much rather been.

I had written a lengthy speech to honor my classmate, and I was unable to give it. I was going to note that John was fond of saying that we work "shoulder to shoulder"—or "*shohna ba shohna*," as they say in Pashtun—with our

partners in Afghanistan, but that he and I had worked "my shoulder to his rib cage" all of our careers.

I had also planned to quote Rear Admiral Ronald Arthur of the Royal Navy, who gave us the poem "The Laws of the Navy," to discuss the ideals of naval service:

> On the strength of one link in the cable,
> Dependeth the might of the chain.
> Who knows when thou may'st be tested?
> So live that thou bearest the strain!

John had been tested over the previous four decades and had certainly "borne the strain."

Which brings me to the final member of the quartet.

James Stavridis

My saga goes back to February 2011 when I received a call from Secretary of Defense Bob Gates. He came right to the point: "Jim, we are considering you for the next chief of naval operations [CNO]." Thirty-nine years ago I had begun my career as a lowly plebe. The notion of being the head of my service was awe-inspiring indeed. While the service chiefs are not as powerful as they once were—they are no longer charged with running operations—they are the key figures in recruiting, training, equipping, and managing their services. The job would present a wonderful opportunity to leave my stamp on the service I love. I told the secretary I would be honored to serve if selected. After six years of joint duty, it would be great to get back to my home, the Navy. Nothing was certain, but I thought I had a chance at the job.

After Gates' call, I was walking on air. Later that week I went to London to attend a dinner on Lord Nelson's flagship, HMS *Victory*. How appropriate, I thought. It all seemed to fit. I was told that my nomination to be the CNO would be announced the following week, driving toward a summer change of command—it was incredibly exciting.

After a wonderful dinner on board *Victory*, I slept in a bit the next morning. An urgent knock on my door about 8 a.m. woke me. Capt. Ken Perry, my exec, was standing there when I opened it. His next words were as big a shock to my system as anything I'd felt in many years: "Admiral, I have some bad news. There has been an anonymous complaint against you through the Department of Defense Inspector General, alleging that you arranged trips

for personal benefit and that you bumped crew off the plane in order to seat your wife." I was stunned. Neither charge was true.

All of my trips as SACEUR and EUCOM were fully vetted by my team, and—by decision of my one-star executive officer—reviewed legally when necessary. When Laura flew with me for official representation purposes, she always sat in the VIP cabin with me, so by definition she could not "bump" anyone. But there it was, in black and white on a form letter mailed to the secretary of defense, the secretary of the Navy, and others. The DoD's IG process is a hammer, and I was about to become the nail.

I knew what it meant instantly: CNO was out of the question until this was resolved. Many IG investigations drag on for a year or more, and the window for CNO would be closed by then. I was crushed. Yet, ten minutes later I had to put on my game face and take a long tour of the British dockyards. It was a hard day.

When I flew back to my HQ in Belgium I met with my team. "We have to look at this in the right way," I said. "No repercussions against anyone; be totally open and honest with the inspectors; try to do it as quickly as we can; and hope that our procedures stand up." I was fairly confident they would. I attended many official events, some in beautiful locations, and had on occasion taken personal leave afterward—but only after sending the plan off for approval. All in accordance with the regulations as far as I knew. My team—my aide, exec, travel coordinator, and others—were honest and straightforward. I had never built a trip for personal enjoyment, and we had never bumped anyone from the jet to accommodate Laura. The accusations seemed surreal. I had seen many of these investigations take on a life of their own, however, so I understood that my future was very much up in the air.

In the days and weeks and months that followed, the issue hung over my head like a sword. The days when we heard something from the IG staff were bad; the days when we heard nothing were worse. I want to say that throughout the investigation I found the IG investigators to be professional, polite, serious, and—above all—thorough.

Meanwhile, I had to go about my business—supervising NATO's efforts in the war in Afghanistan, starting and stopping NATO's intervention in Libya, and the myriad other duties my job entailed. While the existence of the investigation was not yet public knowledge, it was well known around my headquarters. Some of my key staffers had a building sense of impending doom despite the fact that none of us knew of anything we had done wrong.

Soon two members of the IG staff arrived in Belgium to begin their examination of every element of every trip I had taken in my current job. The anonymous complainant got the ball rolling, and the IG took it from there. I had no prior experience with the IG because in thirty-five years of service I had never had a complaint filed against me. The whole process was very "star chamber": I had no idea who my accuser was, no idea of the specific allegations, and no idea what evidence had been gathered. It certainly didn't put much of a fire in my belly to continue government work. I quickly realized that any chance of becoming CNO was long gone, and that I would probably be retiring from this job. While that made me sad, on the one hand, on the other, life often opens one door when another closes. I've said for years that in the end the Navy will break your heart . . . if you let it. I didn't intend to have mine broken.

Finally, after some months, I was given an opportunity to meet with the Inspector General's team in Washington to make some points in my defense against these still fuzzy charges. I started by explaining that I had never before been subject of an IG investigation of any kind. Not even an allegation. My jobs, I explained—the U.S. European Command and NATO Command—consumed essentially 100 percent of my energy and time. In the past 20 months I had taken 165 official trips covering more than 360,000 air miles.

I also explained the three major reasons for all this travel. First, with fifty-one countries on the U.S. side, twenty-eight NATO nations, and forty-nine troop-contributing nations in the Afghan and Libyan coalitions, an enormous amount of diplomatic engagement was required. A second major reason for my travel was outreach to academics, thought leadership organizations, think tanks, media, and other places where public discourse occurs. I believed this was where we built support for our operational activity. Strategic communication and outreach were a huge part of what I did. The third key vector of my travel was Washington, D.C., and other governmental connections. The need to keep my bosses briefed and connected to my portfolio was essential.

As far as travel procedures went, I explained, my very senior front-office team, led by a one-star officer and a post–major command Navy captain, were in charge. I counted on them to vet each of the trips. Any trip that involved my wife traveling with me was cleared through my travel team, my front office, and lawyers. I trusted their judgment.

Laura's presence on the trips was unquestionably worthwhile; she added enormous diplomatic and service value. She brought positive engagement in

both overseas and U.S. venues, and her role as a senior spouse allowed her to focus on and positively affect the education and health of our military, both U.S. and allied. On the few occasions she traveled not under official auspices, I always ensured that we paid for it. My aide was responsible for determining the fare, collecting the check, and making sure it was turned in. In the course of the investigation, I learned that my aide had not deposited all of those checks. I immediately issued new checks to correct that oversight. We also discovered some administrative shortfalls in how we were collectively handling credit cards, cell phones, and other aspects of travel and gifts—all of which we corrected immediately.

And still the investigation dragged on and on. I likened it to being guillotined inch by inch.

In May 2011, ironically, I was asked to come back to Washington to accept an award from the Atlantic Council for my good work as SACEUR. At the award dinner, a journalist I know came up and whispered, "Hey, what is this I hear about a big IG investigation on you about travel? Do you want to knock it down right now?" I simply said I didn't want to talk about anything besides the alliance at the dinner and moved on through the crowded room. But, of course, news of the inquisition was spreading through the blogosphere and among our close friends (some of whom were sending me e-mails with oblique messages such as "are you ok?"). The trajectory of these things is predictable, and I figured it would be painful no matter how it all came out in the end.

About this time Mike Mullen told me what I already knew, that I was out of the running for CNO. Shortly thereafter I had a chance to see Secretary Gates. A very decent and kind man, he took time during a meeting of the NATO defense ministers for a one-on-one session that I suspect neither of us enjoyed. "Since we talked last about the possibility of you becoming the CNO, a lot has changed," he said. "I'm sorry. It isn't going to work." I told him I understood and respected the decision. I told him I felt I had done nothing wrong, although some administrative errors may have been made in the execution of my travel.

We talked about second acts in American lives, about thoughts for my future, about his plans post retirement. It was a good conversation under the circumstances. He gave me his private e-mail address and encouraged me to stay in touch. As in everything else, he was as good as his word. He remains a mentor and friend today, and I continue to count on him for advice in my new endeavors.

When I got back to the office, my team told me the IG investigators needed another four hours with me to discuss "issues." By this time I was more than ready to move on with the next phase of my life, but the lawyers advised me not to talk to potential employers or take any career actions until the IG matter could be cleared up. We were already about three months into the investigation. How much longer could it take?

A lot longer, apparently. In late October I found myself returning to Portsmouth, England, for the annual Trafalgar Night dinner on HMS *Victory*. By this point the investigation had been going on for eight months. My lawyer told me that the case was boring: "no sex, drugs, porn, or cash." That was the good news. The bad news was the glacial pace of the investigation.

In early 2012 we finally received the draft Inspector General's report. It was long, was highly detailed, and had plenty for us to push back on. After looking at well over a hundred trips in extreme detail, the only travel violation they thought they uncovered was during a trip I took to France, at which I spoke to about seven hundred globally influential people (in French) about NATO. I was in uniform throughout the event and in the company of the French chief of defense. I spent a good part of the time working on him to send more trainers to Afghanistan—which the French eventually did. Considering the speech and the hours of interaction with the French chief of defense, I felt the trip was official and good value to the government—I was on the ground in France less than twenty-four hours. The chairman of the Joint Chiefs and my boss, Mike Mullen, had appeared at the same event the year before, which was a key reason my team had believed it was a vetted event.

I submitted a fifty-page response, which again was met with a lengthy silence. Finally, in September 2012, more than a year and a half after the investigation began, I was asked to come back to Washington to meet with Secretary of the Navy Ray Mabus and hear the verdict. The timing was not propitious. It was an election year—never a good time to be in the spotlight. Nevertheless, the meeting was a tremendous relief. I went into the office with my heart beating hard. After a few minutes of pleasant conversation, Mabus, whose courtly southern manner belies a razor-sharp mind, came to the point. He told me that the secretary of defense (to whom the IG report was addressed) had determined that there was nothing in the IG report requiring adjudication, and so, in keeping with custom, he had passed it to Mabus, my service secretary, for any appropriate action.

Mabus read me the concluding paragraph of an eight-page memo that said, in a nutshell, that I did not abuse my office and that the administrative oversights had all been corrected. Case closed without any formal reprimand, only an "administrative counseling" to provide firmer oversight to my travel team. I was certainly content with that, and I sensed that the secretary was sorry this had taken twenty months and had knocked me out of further service. He looked me in the eye and said he was sorry I would not be doing another job in uniform, and he meant it. I said I was sorry too, and that my only regret in that regard was that I would not have the chance to work for him and the secretary of defense, both of whom I admired.

Baseball great Yogi Berra said, "The game ain't over till it's over." In the Pentagon, it's not over even then. Several news organizations had learned of the investigation and filed Freedom of Information Act requests for copies. Shortly, the whole matter would be out there for the world to see.

Before the report could be released, there remained a few administrative details to tie up, and a lengthy letter from Secretary Mabus—essentially exonerating me from serious wrongdoing—had to be crafted by his staff. For once I was not annoyed that the process took some time. As it turned out, the IG report and the secretary's response were released to the public in early November, when most eyes were focused on the recently concluded presidential election and then, days later, on the Petraeus-Broadwell story, which was considerably more dramatic than one about an admiral and his wife going to a dinner in France where wine was served.

Because news of my twenty-month travail escaped much public notice, it could be argued that I am foolish for including a discussion of it here. But I think it serves the public interest to be open about those events—and also to recognize that in any human endeavor, mistakes will be made. My travel team made a variety of administrative errors, and we needed to correct them. But what truly matters in any situation resulting from human error is the intent involved and how you respond.

There is no question that the responsibility for the travel mistakes, indeed *any* mistakes made by my team, was ultimately mine. When we were alerted to the errors we were making, we quickly corrected them and adjusted our way of doing things. The matter was resolved, and in that sense the system worked. We certainly never intended to do wrong; we learned and grew as a team, and we emerged from the IG investigation a stronger organization. But when I consider the length of time the investigation took and its repercussions

I shake my head—not in anger or bitterness, but in quiet sadness. I suspect the same is true of my contemporaries, although I cannot imagine how much more challenging it was for them given the national attention their situations generated.

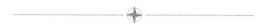

What did I take away from these four high-level cases? I would answer by telling you about a painting that hangs on the wall in my office. It depicts the turn-of-the-last-century battleship *Maine*. It is a gorgeous painting: the ship, trim and freshly painted, lies at anchor in Cuba, flags flying gaily in the breeze, huge guns pointed out to sea. *Maine* blew up in Havana Harbor on February 15 (my birthday, by the way), 1898. It sank within minutes, killing hundreds of the crew. Suspecting Spanish saboteurs, the United States declared war on Spain. The world spun dramatically on its axis, with combat in both Cuba (where Teddy Roosevelt led the charge up San Juan Hill for which he was awarded the Medal of Honor) and the Philippine Islands (where the U.S. Navy destroyed the Spanish Pacific Fleet in Manila Bay). *Maine* was immortalized in the battle cry "Remember the *Maine*."

Why do I display a painting of a doomed ship in my office? Simple. To remind me that anyone's ship can blow up at any moment. Life has a way of sending us down hidden paths. The Spanish say, "*Nunca sabe los caminos de Dios*," which literally means "no one knows the roads of God" but might be better translated "you never know." No matter how well things appear to be going, no matter how hard you are working, no matter how careful you are, no matter your virtues (or your sins), the ship can blow up at any time. Life can change dramatically in an instant.

The lesson for me is this: wherever you find yourself, no matter how high in the organization, you have to maintain your balance and perspective; recognize that things *will* go wrong; do your best to tell your side of the story and admit your mistakes when they do; then move forward with your life, correcting and adjusting as you go.

Throughout the trials I describe above, all four of us kept our perspective, focused on the tasks at hand, and did our best to sail forward. What else could we do?

TRICKS OF THE TRADE
How Leaders Make Things Happen

The leadership instinct you are born with is the backbone.
You develop the funny bone and the wishbone that go with it.
—Dwight D. Eisenhower

A s I look back over nearly four decades of Navy service, the basic ingredients for effective leadership are pretty clear to me. There are thousands of books about what good leaders must do, and I don't intend to repeat them in detail here. Instead, I thought it would be useful to briefly talk about how I approach leadership, because it was central to my four years at NATO, and to offer some thoughts—and a few personal examples—on why things go right in successful organizations.

Any leader worth his or her salt understands that leaders must work hard to get to know the people on the team as individuals and demonstrate sincere concern for their families. In addition, they must master the skills and technology of any job; encourage teamwork and demand determination and dedication to task and mission; build innovation as a core competency; and insist on civility. In essence, leaders do best when they approach their position with an attitude of "leader as servant," always treating their teams with dignity, honor, and respect. No mystery there—except, perhaps, why so few leaders actually put those tenets to use.

Beyond the basics of leadership, I'd like to offer a few thoughts on the tricks of the trade: important ways in which a good leader can put broad philosophical ideas into operation, make sure the goals of everyone in the

organization are aligned, and maintain grace under pressure and, as we say in the Navy, keep "weigh on the ship"—which simply means to keep moving forward. I don't take credit for any particularly original thought here, but these ideas—learned from some of the strong leaders for whom I have worked over the years—have worked well for me personally.

Speak and write with simplicity and precision, and don't accept imprecision from those around you. Casualness in speech and writing can lead to huge disconnects. This is particularly true with e-mail, which—when you hit Send—becomes etched in stone. I have seen many, many reputations and careers ruined by the careless release of an ill-worded text or e-mail. I try to keep e-mail messages relatively brief and simple, and to avoid anything that smacks of sarcasm, bitterness, or anger.

I spent two years working alongside Secretary of Defense Donald Rumsfeld. He didn't use e-mail at all, but he was a master of precision in his writing and conversation. Clearly not everyone agreed with him all of the time, to say the least, and I had the impression he would not have had it any other way. No one got away with a loose expression or thought around him. If you made an assertion, you had better be prepared to back it up. Woe to anyone who used phrases such as "they said" or "everyone knows" or submitted anything that wasn't direct, simple, and cleanly written. You didn't say that something was "very unique," for example, because he would immediately point out that something is either unique or not; unique doesn't run in degrees. He was certainly unique, and the hardest worker I've ever been around. He wrote a book called *Rumsfeld's Rules* that drives home the need for precise communication. I never had a more demanding boss or one who made me think more about the act of leadership itself.

Use humor often. Laughter can relieve tension in large meetings. I have seen strong leaders crack the strain at a meeting with a good one-liner. This shouldn't be overdone, of course, but generally a team looks to a leader to set a tone. If you are relaxed and self-confident enough to see the humor in things—even at dark moments—you will relax your team, and they will perform better knowing their boss has a sense of perspective too. One of the best people I have worked for in this regard was Sean O'Keefe, for whom I served as special assistant in the early 1990s.

Sean was a *very* young secretary of the Navy in those days, before he went on to become the administrator of NASA, the deputy director of the Office of Management and Budget, the chancellor of Louisiana State University,

and the chairman and CEO of a major defense and aerospace company. Sean always kept his sense of humor, had a good Irish joke or two up his sleeve at all times, and often refueled at the end of the day with his team around the table having a cold beer (served from a small refrigerator in his office—it was Olympia beer, as I recall; hopefully the statute of limitations has passed on consuming alcohol in the Pentagon). His ability to defuse even the tensest situations was essential in the personnel crises stemming from the Tailhook sexual assault scandal.

I will never forget Sean's last day as Navy secretary (he had been turned out of office with the change of administrations). He hired a musician who could play a passable rendition of "Anchors Aweigh" on the bagpipes and led a parade of his admirers on a last march through the corridors of the Pentagon (including, at one point, a trip through the secretary of the Air Force's personal office while a meeting was going on). Rather than depart quietly after his side had lost, Sean chose to go out memorably—and loudly. When he and his son survived a small plane crash in Alaska, I saw it as a validation of the "luck of the Irish"; certainly a big part of that luck is Sean's innate ability to see the humor in everything. He is both a friend and an American original.

Prepare thoroughly for key events. Make sure you understand which events *truly* matter. Don't let the chaff floating in the wind distract you from what is really important in your job. That remains true throughout long careers and at all senior levels. Leaders need to look ahead several months or even a year or two at a time; pick out the events that really matter; and spend an enormous amount of time, energy, and resources ensuring they are fully prepared.

When I led Deep Blue, the Navy's warfighting think tank created after the 9/11 attacks, I reported directly to the chief of naval operations, Adm. Vern Clark. A steady and quietly brilliant officer, Admiral Clark needed a key presentation prepared to show Secretary of Defense Rumsfeld what the Navy envisioned its potential role to be in the nascent Global War on Terror. You could still smell smoke in the building as we went to work on a PowerPoint presentation in the bowels of the Pentagon.

To give a sense of how motivated I was, 9/11 kicked off with me watching the two planes hit the World Trade Center Twin Towers on television in my office in the Pentagon. I was a newly minted one-star rear admiral working on unexciting budget issues. Suddenly, a huge explosion knocked me out of my chair onto the deck. I ran out into the hall and saw smoke and flames about 50 feet away down the corridor. I didn't know it at the time, but American

Airlines Flight 77 had just plunged into the building. The plane struck about 150 feet from my office and, fortunately for me, hit the second floor as it was going down. I was up on the fourth floor, and thus was spared. After trying uselessly to penetrate the flames, I ran outside and tried to help with the wounded on the lawn before being shooed away by professional firefighters and rescue teams—the real heroes of the day.

Like many others, I lost shipmates and friends that day—people like Bob Dolan, a Shakespeare-quoting, high-energy sea captain clearly on his way to an admiral's stars. I'd worked with Bob several times over the years and was heartbroken to learn he had been killed—along with many others. At his memorial service at Annapolis some time later, there were dozens of fellow sea captains in the audience. Whenever I visit the Pentagon, I go out to the Memorial Garden and sit on "his" bench, thinking about all that his family lost and all that he was denied.

The immediate aftermath of 9/11 was a hard time, of course, and all of us were scrambling to work with our bosses to get the initiative back from the terrorists. My first task at Deep Blue was to help the CNO put his brief together defining the Navy's role in that. I took the first version of the briefing to Admiral Clark and watched him flip through it. We had provided the typical Pentagon briefing, which is to say slides with lots of charts; many arrows and diagrams; plenty of acronyms; and words, words, words. I was quite proud of my team's efforts, which I felt would be important in setting the course for the Navy in this chaotic new post-9/11 world.

After we made the presentation to the CNO and a roomful of other senior admirals, Admiral Clark leaned back, gave me a half-smile, and in his Arkansas twang said, "Well, Jim, I'd call that a high UNSAT" ("highly unsatisfactory" in Pentagon-speak). My heart sank. Clark felt the pitch was too slick, too long, too wordy, and would be largely incomprehensible to Secretary Rumsfeld, who had only recently returned to the Pentagon after a twenty-four-year absence.

So we took it back and reworked it, and reworked it again—eight more times, with his guidance, until the CNO had it just the way he wanted it. In the end, we boiled it down to just half a dozen slides, each with two or three simple photographs. On each slide was only a word or two to cue the CNO, who would make the presentation personally. As we reworked it again and again, with lots of advice from very senior members of the staff, it was crystal clear to me that CNO Clark viewed this presentation as foundational to

the Navy's role. And so it was: it led to the creation of expeditionary strike groups, a naval version of NORAD, afloat forward staging bases, and expeditionary sailors operating a thousand miles from the sea. In effect, we created a network operating from the sea to integrate with our joint and interagency partners to face the emerging al-Qaeda network.

The point is that Admiral Clark knew how important that brief was going to be, blocked plenty of time on his schedule to create it, spent hours refining it, and when it was done "owned" the presentation. The concepts it contained were complex, but the presentation was anything but. It was a big success with Secretary Rumsfeld and helped the Navy fully integrate into global efforts against the terrorist networks.

Stay physically fit. Pursue medical issues aggressively. Too often, we (especially men) are willing to let our health take fourth or fifth place to everything else. We postpone our annual physical, forget to take our medication, and ignore minor aches and pains. My superb military doc in Belgium, John Baxter, once said to me that the four most dangerous words in the English language are "it will go away." I've certainly said that myself about a wide variety of ailments and sports injuries over the years, and often they *do* go away. But not always.

I worked for a couple of wonderful years for Secretary of the Navy Richard Danzig. He was a Rhodes scholar, a talented corporate lawyer, and a self-described mediocre but determined basketball player—"I may be small, but I'm slow," he would warn opponents with a smile. Danzig was among the smartest and funniest people I've ever been around. Among the many, many things I learned from him was to focus on medical issues—both my own and those of people on my team. He watched those around him, asked about their health, made sure we found time for our own appointments, and set the best example by taking care of himself.

Right after I arrived to work for Secretary Danzig, I managed to break my little finger playing pickup basketball. The injury—a "boxer's fracture"—was on my right (dominant) hand and was enclosed in a big cast that ran from my fingertip to my elbow. The three most important things an executive assistant does are (1) shake hands with people arriving and departing the office; (2) type endless e-mails and memos; and (3) carry bags for the boss. With a broken hand I couldn't do any of those very effectively, and creatively I decided to simply break off the cast myself, tape the little finger to the next one over, and gut it out. When I came to the office without the cast only a week after the

break, Danzig immediately grasped the idiocy of what I had done and sent me back to the Navy docs to have it reapplied. I did, and learned a good lesson.

Make sure you find the time to exercise—people want a leader who looks sharp and physically fit. You don't have to be Mr. or Ms. America, but work out regularly. Both your appearance and your energy level will benefit.

Be your own spokesperson. When things go wrong, it is much easier to find reasons why you should say nothing than to step up to your responsibilities. Leaders too often default to dodging questions or letting someone else speak on their behalf. A perfect example is the recent spate of sexual assaults occurring in the military. Well-meaning lawyers, I am sure, have convinced many senior leaders to avoid substantive comments because such statements would be "inappropriate" and might somehow affect future disciplinary actions. But that gives the impression that the senior leadership is uncaring or unaware. And this in turn has led to members of Congress pushing to strip from military leaders the right and responsibility to deal with major issues in their own chain of command. It is better to speak out and leave no doubt in the minds of people inside and outside your organization about the standards you demand than to remain silent out of some sense of propriety and give the impression that you just don't care.

After a sexual assault took place recently in the Australian Army, the Army's commander, General David Morrison, posted a hard-hitting video and made repeated personal appearances condemning such attacks in the strongest terms and telling the offenders in direct terms: "Get out of our Army." Similar assaults have plagued the U.S. military, but many senior commanders have held back, fearing that they will "prejudice potential juries" and "exert command influence." That is the wrong approach, in my view—being your own spokesperson means stepping up and calling it like you see it in public. The Aussies have it right.

Know where your time is going and spend at least one-fourth of your disposable time on personnel matters. This leads me to a very important question for senior leaders: How do you divide up your time? I try very hard to break my time into roughly fourths and use them as follows:

> One-fourth on personnel matters. This must include mentoring, building succession plans, trying to meet all the new people arriving in the organization, writing notes to people, reaching out to interesting individuals, and so forth.

One-fourth on operational challenges and issues—making the trains run on time, so to speak. Naturally this varies greatly in terms of what the operational issues are. I have a very different set of responsibilities as the dean of a graduate school than I had as a ship's captain and during my four years as the supreme allied commander at NATO. But in the end, operations are the forward motion of your machine, and you had better be paying close attention to what is happening in "real time."

One-fourth on planning. Too often, we just want to *do* something but don't really have a plan. Every organization needs a strategic plan generated at least every three to five years, depending on its size and structure. Often, the act of planning creates real alignment in an organization and spurs innovation.

One-fourth on innovation. Even the best business or organization needs a healthy dose of innovation. In many ways this is the most important long-term method to keep an organization healthy. I go into greater detail on innovation in chapter 13.

It is important to measure how you are doing in devoting your time to these four main areas. This is where a good executive assistant can help. In my new role as dean of the Fletcher School at Tufts University, my excellent exec, Linda Warner, helps me ensure that I am devoting the right amount of time to each of the four key function areas. We look at the schedule monthly, both reviewing the previous month and looking ahead at the next two to ensure we are roughly in balance. A color-coded calendar can illuminate time usage very clearly because it shows how much time isn't exactly wasted but isn't contributing to the broad direction you want to go either.

Carve out time to think. Write down your thoughts. Share them with others whose opinions you respect. Too many leaders spend so much of their time fighting brush fires that they lose sight of the fact that they may be in the wrong forest. Several of my bosses over the years were very willing to just close the door, put their feet up, and think about the big issues. Others complained because we didn't give them time on the schedule for doing so. It is crucial that a leader demand of his or her team that they provide enough time for *thinking*. There is always a tendency to fill the white space—don't let your schedulers do that!

Have a relaxing weekend routine. The opportunity to recharge away from the immediate venue is priceless. People in today's relentless society suffer

burnout without even realizing it. During my years in the Navy I reported directly to two secretaries of the Navy, two secretaries of defense, and two chiefs of naval operations, and with every one I could tell immediately on a Monday morning if the boss had recharged or had spent the weekend awash in the minutiae of the job. I watched Secretary Rumsfeld, the hardest-working man I have ever met, lug home two huge briefcases each Friday. I often hoped they would come back untouched—but they never did. On the rare occasions when he could take a break, it was immediately and positively evident on his return.

I take my own advice in this regard. I try to truly break away on week-ends. That doesn't mean completely putting away the Blackberry or iPhone; that just isn't possible in high-level jobs (or really any job these days). But it does mean at some point getting in a couple of good workouts, having a relaxing dinner, watching a movie, reading a book, going for a long walk, and focusing on loved ones.

Don't lunge at the ball. Too many decisions are made in haste, under pres-sure, based on emotional reaction, or with incomplete facts. Take the time to gather the information you need. Don't be driven by anyone else's time-line unless absolutely required (i.e., the law). I have made this mistake—par-ticularly, basing decisions on the emotion of the moment—several times. I remember vividly during my time at NATO being frustrated with the slow process up at NATO HQ in Brussels. I could never figure out why so many meetings were required to make a seemingly straightforward decision. On several occasions I picked up the phone and expressed my frustration to the secretary general, deputy secretary general, or some other key member of the team up there. One incident that sticks in my mind concerns our troop levels in Afghanistan after the coalition departed. We built a comprehensive oper-ational plan for the post-2014 period based on facts on the ground. It seemed self-evident to me that we needed to get it "on the street" so nations could plan their force levels. After telling us to hurry up and submit the plan, NATO HQ suddenly decided to slow everything down. It was very frustrating at the operational level, and I began to bang away on my interlocutors up in Brussels.

As is almost always the case, my ire had the opposite effect: in trying to respond to me, people became confused, overreactive, or resentful. It simply threw more sand in the gears without any really beneficial effect. If I had been smart, I would have smoothly down-clutched and let the political side take the time it needed—which, of course, is what happened. We have a saying in

north Florida, where I am from, that "sometimes you have to be for what is going to happen anyway." Taking the time to understand all the dynamics at play *before jumping in* is a good idea.

Details matter, but think big thoughts. Balance the time spent on absorbing and understanding details *and* that spent sitting back from the thicket of the day to day and trying to think through new ideas, concepts, and necessities for your family, your organization, and the nation. I understand the love of detail, although I am not a particularly effective point-by-point analyst; I instinctively gravitate to the big picture. What I've tried to do in each of my jobs is to have someone who *is* very detail oriented on my in-close team. Throughout my time at both Southern Command in Miami and NATO, I relied on my deputies for this. In Miami, I had the focused and detail-oriented Lt. Gen. Glenn Spears, a very analytical and sensible officer. He knew when to put the speed brakes on me and calibrate our responses using high-level and very metrically sound analysis. Likewise, at NATO I had a British four-star general, John McColl, who relished making sure that each of the nations managed to send exactly the right number of people to the precise task we put in front of them. The "force generation" process was at the heart of the operational structure in NATO, and John was a master of it. The key is finding people to be deputies or members of the close-in team (often called the commander's action group) to do this. I had both, and it made all the difference in big-signature operations like Afghanistan, the Balkans, counterpiracy, and Libya.

Understand the process. So often, the outcome is paradoxically less important than getting the process right. You need to be in on the takeoff in order to be in on the landing. Perhaps the best person at this was Secretary of the Navy Ray Mabus, my Navy boss during my time at NATO. A former governor of Mississippi, ambassador to Saudi Arabia, and seasoned politician, he knew exactly how to work the complex processes in Washington. He also kept a good balance between his roles in D.C. and "on the road" as the visible and figurative leader of the Navy. Knowing how to handle people, where the bodies are buried, and what the left and right limits are in D.C. is a talent. That talent can be developed in any situation by spending time learning, applying speed and rudder gingerly at first, and closing ruthlessly when the moment of culmination arrives.

Look at the law or regulation for yourself. Don't rely on summaries or a staff member's or lawyer's opinion as to what the law says. Get it and read it

yourself. If you are a lawyer, you will have a leg up on the rest of us; if you are not, don't underestimate the importance of common sense. If something goes wrong, you will have to explain it, and that isn't the time to be pulling out the regulations to see what should have been done.

Organize yourself. Don't turn over personal organization to assistants, no matter how good they are. Much of the value of getting organized—putting things in the right folders, following up on memos sent, building a day folder—is that it forces you to think holistically about events. The essential material thus gets into your head. There are countless different electronic tools available to help with this today; make sure you are capable of handling it yourself, even if the team is backing you up.

Carve out time to read. Take a balanced approach: fiction, nonfiction, professional journals, and so on. At both of my recent four-star commands I put out an annual reading list for my staff. It was not a homework or make-work assignment; there were no tests to see if people took the suggestion. You can learn things about your current challenges from a good book or a movie that all the briefing papers in the world cannot provide. Appendix D contains the reading list from my time as EUCOM commander to give an idea of the type of books I recommend. A good leader has a fairly strong handle on the literature of his or her field and should be able to jot down the titles of a dozen or so good books that subordinates should read. If you can't do that, start by doing more reading yourself.

Make mentorship a priority. Listen, learn, educate, and LEAD. Even if it were possible to find one person who could do all the thinking, planning, and work of an organization, I would not want him or her in charge. Should that person be hit by a truck on the way to work or run off to join the circus, the organization would be out of business. I want leaders who work on putting themselves out of business by raising a crop of new leaders any one of whom could step in and take charge should circumstances require it.

Walk around and listen to your team. And show up early for meetings. This is self-explanatory, and it works well at every level. Even as a very young officer I tried to spend much more time away from my desk than behind it, and I carried that approach throughout my time in uniform. If people see the boss walking around and asking a few questions (both about work and about their families), it makes all the difference. And by showing up a few minutes early for meetings you get to see a whole different side of your organization. Try it and see.

FOUR THINGS TO AVOID

Just as important as the things to do are a handful of things to avoid. For me the list includes the following.

Refusing to delegate. The graveyards are full of formerly indispensable people. While I am proud of the people for whom I used to work, I am more proud of the people who once worked for me and who have gone on to do great things in their own right.

Losing patience with people. I think back on all the bosses I had who cut me some slack—who resisted the urge to throw me over the side when my performance came up shorter than I am. It would have been so easy for them to practice leadership by shouting. I am not suggesting that it is wise to ignore poor performance, but I benefited most from bosses who helped me learn without the lash.

Obsessing on little things that don't matter in the long run. Remember the Y2K crisis? At midnight on New Year's Eve 1999 the world's computers were supposed to crash and civilization would end. It didn't happen. The military in particular spends a lot of time worrying about form over substance. I've seen senior officials consumed with whether the ribbons on a service member's chest were in the right order at the expense of focusing on what was going on in that person's mind and heart.

Working to exhaustion. Important organizations place an inordinate amount of stock on their own criticality. This breeds unhealthy imitation. If the boss works eighteen hours a day, assistants think they need to work nineteen. After a certain point your effectiveness starts to diminish. With each additional hour after that tipping point you do more damage than good. And it is critical always to have some energy left in your tank. If you are running on fumes to deal with one problem and a bigger issue crops up, you will have no reserves and are doomed to failure.

───────────────── ✦ ─────────────────

So, what is the bottom line for all of this?

The most enjoyable part of my job as NATO commander was spending time with the people on the team—from the four-star direct reports like my German chief of staff to the most junior French photographer on the public affairs support squad to the Bulgarian sergeant on the protocol team. People often tried to say as they were leaving NATO, "Admiral, I sure enjoyed working for you." I always gently corrected them to say, "No, we worked together.

You worked with me." I truly believe that. People will almost always become what you expect and tell them to be: if you are suspicious and certain that they are going to malinger and procrastinate and do anything they can to get out of work, they usually will; if you tell them that they are going to get things done in record time and give them the resources and goals to do so, they usually will. Naturally there will be times when people don't make the grade and must be professionally cut out of the team and moved somewhere else, where hopefully they can contribute. But the key is always "leader as servant," creating win-win situations, using the tricks of the trade listed above to boost your own productivity, and setting a good example.

I've been blessed by being able to work with many strong leaders. Leon Panetta was a joy to work for in every dimension. Son of Italian immigrants, he would often commence a conversation with me with a big smile and, "Buongiorno, Jacimo. Come sta?" and I would reply in my pidgin Italian, a mélange of Spanish and Greek. As people whose ancestors came (not so long ago) from the southern Mediterranean, we understood each other. Easy with a laugh, yet incisive and smart about Washington, he was a boss I was glad to serve. When I think of him, I am always reminded of the quote from the novel *Scaramouche:* "He was born with the gift of laughter and a sense that the world was mad." Secretary Panetta ran the building well through his deputy and undersecretaries, but you always knew he had his hand on the tiller. His qualities were best demonstrated throughout the Libyan crisis, when his connections to Italy were especially helpful; and his intimate knowledge of how to get things done in D.C. kept us moving forward.

Panetta's successor, Chuck Hagel, is a very different man—but an equally effective leader. I've known Senator, now Secretary, Hagel for more than eight years, having met him first when I was the commander of U.S. Southern Command. He is decent, smart, balanced, and centrist—qualities in short supply in Washington. In fact, he is so decent that I think he was genuinely surprised with the rough character of the reception he received at his confirmation hearing—he would never have treated another colleague as he was treated. But as the saying goes, "If you want a friend in Washington, get a dog." (I often thought of that maxim when I saw Secretary Panetta, Hagel's predecessor, moving around his office with his beloved golden retriever, Bravo.) Although I worked directly for Chuck Hagel for only six months, I found him direct, sensible, and well informed on the issues. In the run-up to Syria, he was very sensitive to Israel's role in the drama, as well as the role

the Europeans could and should play. As a former chairman of the Atlantic Council, he knows NATO well and will continue to be a strong transatlantic connector.

Napoleon said that a "leader is a dealer in hope." Exactly. Everyone is watching the leader, and everyone hopes for a good one. We create our own future in almost every situation. You can be that "dealer in hope" with practice, hard work, and belief in your people. They will not let you down unless you let yourself down.

THE POSTMAN NEVER RINGS TWICE

Strategic Communication

When it is over, tell them who won.
—Adm. Ernest King, chief of naval operations,
describing his press policy during World War II

Times have changed. I have learned about strategic communication the hard way too many times to count. For example, I was present on a hot, dusty day in Kuwait in 2004 when Secretary of Defense Don Rumsfeld uttered the seemingly immortal words, "You go to war with the army you have." He was responding to a soldier's heartfelt inquiry as to why the troops preparing for Iraq needed to weld homemade armor plating to their vehicles, creating so-called hillbilly armor. His reply, meant as a statement of fact explaining that when a war descends on a nation it has to begin with the inventory on hand, came across as brutally dismissive and callous— neither of which characterized Rumsfeld's true feelings.

For the next few weeks the secretary was pilloried across the country and around the world because he "didn't care about the troops." Nothing could have been further from the truth, but the damage was done. This was a classic case of failure to communicate strategically. I was a newly promoted vice admiral serving as the secretary's senior military assistant at the time, and I know it was a brutal period for my boss. The false impression left by his too-glib remark unfairly still hangs around his neck like an albatross.

Another series of challenging examples occurred during my time as the supreme allied commander, and thus the strategic commander for Afghanistan. Of all our generals in Afghanistan, the one who had the worst luck with strategic communication was probably John Allen—ironic because he is deeply versed in how to respond to challenges of this sort. In the course of an eight-month period he had to deal with a cross-border attack into Pakistan that caused a meltdown in our relations with the Pakistanis; a video that showed several Marines urinating on the corpses of fallen Taliban fighters; the accidental partial burning of a Koran caused by careless removal of paper from an alliance prison; and fallout from a deliberate Koran burning by a right-wing minister back in the USA. During that same period, a U.S. soldier walked off base and murdered sixteen Afghan civilians, and an obscure movie called *The Innocence of Muslims* inflamed the Muslim world because of its depiction of the prophet Mohammed as "a child of uncertain parentage, a buffoon, a womanizer, a homosexual, a child molester and a greedy, bloodthirsty thug" (*New York Times*, September 12, 2012). None of these events was remotely John's fault, but the continuing drumbeat of bad news forced him to spend uncountable hours on damage control and had a predictably bad effect on public opinion—especially in Afghanistan and Pakistan, but in the capitals of the fifty nations with troops serving in Afghanistan as well.

Let's face it: effective communication is the key skill a senior leader needs in today's world (along with the ability to innovate and lead change). Winston Churchill is said to have observed that the principal difference between management and leadership is communication. Effective communication requires the leaders of an organization to take an early and persistent role in deciding how ideas and decisions are shaped and delivered. Certainly in the national security arena, a leader can improve the impact of operations and policy planning by ensuring that the communications are considered as early as possible in the process. If planning is done in this fashion, then the communications associated with it will indeed be strategic rather than just reactive and tactical.

Simply stated, the objective of strategic communication is to provide audiences with truthful and timely information that will influence them to support the objectives of the communicator. In addition to truthfulness and timeliness, the information must be delivered to the target audience in a precise way. This generalized approach can be applied to essentially any organization. It may sound easy, but in practice it is as hard as hell. The U.S.

Department of Defense and NATO are *damn* good at launching Tomahawk missiles but can't launch an idea to save their lives, figuratively (and occasionally literally) speaking.

All of this is leading up to some general guidelines for effective strategic communication, occasionally referred to as "putting lipstick on a pig," remembering that strategic communication is vastly more art than science. Large organizations almost never get it right, at least at the beginning. For example, think of the British Petroleum Corporation's disastrous response to the Gulf of Mexico oil spill and CEO Tony Hayward's remark "I want my life back." Or Boeing's slow reaction when its 787 Dreamliners started to burst into flames on the ground. Or the Defense Department's broad response to sexual assault in the military services, which seemed to begin by blaming the victims (denial) and moved quickly to obfuscation: "We're doing everything we can, but nothing seems to work. And, oh, by the way, we can't comment on this because it might influence some courts-martial in progress."

Here are some things that I have seen work, although none of them is foolproof.

Remember that the postman never rings twice. You get only one chance to make a first impression on any story. Pick your spot to start talking carefully, think about the setting and the context, get expert advice, and get out in front—intelligently.

You can't unring a bell. Something once said can never be pulled back, especially in the media echo chamber, which demands constant content to fill the 24/7 news cycle. Ill-advised short, punchy, cute phrases can kill you. Before you speak, make sure you know exactly what you want to say. And remember, there are times when silence is golden.

Tell the truth. The most important principle is the simplest: always provide the truth to your audience. Nothing will more quickly doom strategic communication to failure than falsehood. A strategic communication team can have a superb message, excellent messengers, and a carefully crafted plan—yet a single lie can bring the entire effort crashing down. This has been demonstrated most often in "damage control" types of strategic communication. Political scandals, for example, tend to explode when revelations of lying to investigators emerge after the fact as opposed to during or immediately after the initial malfeasance. "Somebody hacked my social media accounts and I don't know where those pictures came from" is a classic example. The truth constitutes absolute bedrock for a program of strategic communication.

Tell the truth and emphasize that you *do* tell the truth. Over the long run, it is unquestionably the best approach.

Have a good message. The most brilliant strategic communication in the world will not sell a bad message, as the Japanese Empire discovered with the Greater East Asian Co-Prosperity Sphere. That brutal, extractive regime, which brought little or no benefit to the "partner" nations, could not be dressed up as anything other than imperialism.

Again, this seems self-evident, but there are many in the world of strategic communication who believe that a bad message can be sold effectively. It cannot. The strategic message must resonate with the audience because it shares appropriate human values such as liberty, justice, honesty, economic improvement, security, and fair treatment.

Naturally, there are times when the message is bad news. The world will always be full of mistakes, disasters, failures, and acts of incompetence. But when that happens, do not spin the truth. Tell what happened honestly, let people know just how bad it was, apologize when warranted, pledge improvement, and outline measures taken to prevent reoccurrence. You really *can't* put lipstick on a pig. Well, maybe you can, but the results won't be pretty and they won't fool anyone.

Understand the audience. At NATO, this was always my first question as we prepared to communicate a message, whether it was about Libya, Afghanistan, the Balkans, or piracy. This is the constantly rediscovered golden rule of strategic communication. Too many communicators develop plans in a vacuum without spending the time and resources necessary to understand the nuances of the audiences to whom they are pitching the product. Central and South America and the Caribbean are classic examples of areas where one message definitely does not fit all audiences. Ditto Asia. Even in Europe, where similar values and thousands of years of history are shared, the same thing applies: what works in Germany isn't going to go over big in Greece, or for that matter in Slovakia as opposed to Slovenia.

I learned this principle during my years at U.S. Southern Command. Can there be two more different countries in the world than enormous Portuguese-speaking Brazil and tiny English-speaking St. Kitts? Or Spanish-speaking, economically strong Chile and poverty-stricken French-Creole-speaking Haiti? The audience is different in each country or territory and each group of people, during each particular season. Therefore the messages must be evaluated and tailored with the diverse qualities of the receiver in mind.

Pull the trigger promptly. John Allen in Afghanistan was a master of this. Despite the string of disastrous episodes, he consistently got ahead of the problem. This too seems self-evident, but all too frequently an excellent plan comes to naught because it isn't executed in a timely manner. Do not let "perfect" become the enemy of "very good." Develop a reasonably good plan fast and execute it right away. Otherwise you are likely to end up back on your heels in the world of the perpetual news cycle. Leaders tend to want to wait until they have all the facts before acting, but they often won't have the time. Especially in this modern electronic media–driven world you will literally and figuratively be buried before all the facts come in.

Think at the strategic level. We worked hard at this during the Libyan campaign when other nations (Russia, China, and some Latin American countries) loudly objected to what NATO was doing. We had to have a strategic campaign that would achieve resonance globally, and we did it by focusing on the big picture. Public affairs and strategic communication are very different things. A strategic communicator must stay at the strategic level and not dip down to the tactical level represented by public affairs.

Indeed, strategic communication consists of a wide variety of tools and processes within a command such as U.S. European Command: public affairs, protocol, legal, political-military analysis, medical outreach, engineer and construction support, logistics, personnel, and many more. Each has a role to play in effective strategic communication at the tactical or operational level, but none of them is a substitute for a strategic plan operating at the level of the entire theater across time, space, language, and culture. At the strategic level, the intellectual firepower of the command must be brought most distinctly to bear.

Measure results. Many strategic communication plans flounder because the implementers, thrilled with having developed and "sold" the plan, are completely consumed with its execution and fail to take the most important single step: measuring its results. I fell into this "trap" with the deployment of hospital ships in Latin America but was rescued by my team, headed by Sarah Nagelmann, who insisted that we measure, measure, measure. We measured numbers of newspaper stories, radio spots, interviews, and the general tone thereof; surveyed patients as they entered and completed medical treatment; and asked for the opinions of local medical service personnel and local thought leaders (elected leaders, newspaper editors, educators, etc.). Effective polling (and cooperation with the local U.S. embassy, which does this) is critical.

The absolute key to effective communication is rolling out a plan, orga-
nizing it widely, executing it energetically, and then measuring its results.
"Organizing it widely" means making sure that all of the key stakeholders
are in on the formulation of the plan—essentially "in on the takeoff, in on the
landing." Too often strategic communication plans are cooked up by brilliant
public affairs professionals, vetted swiftly with the top leadership, and then
promulgated. Without wide support on the buildup, though, it is unlikely
there will be much ground-level support when the plan comes out.

There are many means of measuring your progress, of course, but a
few crucial ones include polling by reputable local firms and backing up the
polls with an international polling firm; contacting individual trusted and
sensible interlocutors for candid assessments; monitoring articles in jour-
nals, newspapers, and other publications; sampling Web content, including
blogs; observing television and radio coverage; and working with a local pub-
lic relations firm. NATO and the U.S. military are still in the infant stage in
this regard but are working hard to improve because it is the critical path for
achieving results.

Adjust fire. No strategic communication plan is perfect at conception.
All must be adjusted as time goes by. You may go to war armed with the ideas
you have, but you will not win unless you are willing and able to modify
those ideas along the way—discarding those that fail and welding on new
approaches as needed. One way to approach measurement is to adopt short-,
medium-, and long-term views. The short term is immediate reactions—say,
twenty-four to forty-eight hours. Medium-term measurement is done after
thirty to forty-five days. Long-term measurement takes place at the one-year
point. After each of these measurement windows, the plan should be evalu-
ated and recast according to what is working and what is not.

Add spice. Strategic communication should not be boring. The strate-
gic communication of the Cold War, for example, was rote, predictable, and
almost entirely ineffective on both sides until the Reagan administration
added spice to the diet with strategic communication tactics (e.g., describing
the Soviet Union as the "evil empire" and President Reagan ordering, "Mr.
Gorbachev, tear down this wall").

Industry is often a good guide for those crafting a strategic communica-
tion plan. The performance of Chrysler Corporation under Lee Iacocca pro-
vides a wonderful example of such a plan perfectly executed. To communicate
his vision Iacocca began with a simple message that inspired customers and

employees alike: "Quality, hard work, and commitment—the stuff America is made of. Our goal is to be the best. What else is there? If you can find a better car, buy it!" Chrysler's remarkable turnaround under Iacocca's leadership is a clear indication that following each of the principles above—from having a truthful plan to constantly measuring and adding spice when necessary—is the best approach.

NATO and the U.S. military are constantly seeking new ways to utilize the benefits of partnering with each other in our areas of expertise (e.g., conventional warfare à la Afghanistan, Libya, and the Balkans); strategic partnerships (e.g., the United States and Britain on nuclear submarine matters); training and general military-to-military relations; and counternarcotics and antismuggling activities. Such partnerships can range from new techniques (use of unmanned vehicles and subsurface surveillance) to better-packaged training for officers and soldiers of individual countries back in the United States. Mix it up!

Maintain steady pressure. Very seldom do strategic communication plans succeed overnight. Just as the careers of individuals take time to build to fruition, a good strategic communication plan needs steady pressure over a significant period to bear fruit. In U.S. Southern Command, we worked hard over the long term to make improvements across the board in reducing human rights violations by military forces in a region with a long tradition of such problems. At NATO, we used every means available to emphasize the alliance as a force for good in the world. At U.S. European Command, our mission was all about partnership and keeping the NATO alliance together.

All good strategic communication plans take time, sometimes generations, to fulfill. For NATO, our long-term plan included sending key allied officers and enlisted leaders to schools in the United States; our leadership giving speeches and writing articles on the subject; hosting regional conferences, often including international human rights groups; and myriad other initiatives. It is gradually bearing fruit, but there will be setbacks. The key is applying steady pressure.

Bursts of energy. The analogue to steady pressure, of course, is bursts of energy. In any strategic communication plan there will be moments when it is opportune to hit with bursts of energy. Such a moment might be immediately before or after an international conference or a national election, following a natural disaster, or on the anniversary of a particular event. A creative strategic planner is constantly looking for the right moment to come in high and

hard with an energy burst. Such moments become efficient ways to increase "bang for the buck" for a particular event, speech, or other strategic communication resource.

Accepting defeat and moving on. Some strategic communication battles are unwinnable. Sometimes the message is not going to have any effect no matter how effective the plan. This can occur for a wide variety of reasons, generally when the audience is simply unwilling to listen to anything at all.

For example, when the Persian Empire sought to invade Greece in 300 BCE, the Persian emperor Darius crafted a clever strategic communication plan that sought to divide the Greek city-states and offered reasonably benign terms to any state willing to sign on with the Persians. But the Greeks were utterly devoted to their nascent democracy and were unreceptive to the offer. Although Darius had a rational message, a fairly good group of messengers, and a coherent strategy, he was unable to find an outcome other than war. And when he was eventually defeated by a coalition of the Greek city-states, he was wise enough to turn his attentions to the east and move on. So it must be, occasionally, in the world of strategic planning.

Knowing when you win. Sometimes the hardest thing for any strategic planner is not accepting defeat but rather recognizing victory. As a general rule, "winning" in the world of strategic communication is never clean and seldom obvious. If your charter is to convince the populace of a given region that democracy and liberty are important values, it will not suddenly be obvious that you have succeeded. Tipping points are often hard to spot. But gradually, the benchmark measurements should turn in the right direction, media outlets should repeat messages, and trends should begin to turn. At such times, a determination must be made as to whether it is time to back out and let the audience find its own way forward, apply a final burst of energy, or continue steady pressure. Communication is an art, not a science.

Those are all good principles. But what should you *actually do* to improve, and what did I learn at NATO about effective communication? I have four final recommendations worth considering for strategic communication in the twenty-first century.

First, strategic communication is a team sport. It must be part of a joint, interagency, and commercial system. It does no good whatsoever to have a perfect strategic communication plan that is ultimately contradicted by other U.S. government agencies, as—unfortunately—is often the case. Each plan must be vetted properly and should become a combined effort. It should take

into account what U.S. private industry is doing in a given country or region so that inherent contradictions between public and private institutions do not undermine the entire effort. It must be crafted in a sensible, collaborative, collegial way and conducted in an appropriate voice.

Second, at least for strategic communication that goes beyond the shores of the United States (a safe assumption for virtually everything we do in this arena), the international community must be considered and then consulted often. Consider how the communication plan will affect individual countries and international organizations, and—if possible—make them part of the plan. In particular, international organizations have resources that can be used in execution and even in planning. Such was the case, for example, in the Libyan campaign and in Afghanistan generally, as well as the voyages of hospital ships such as USNS *Comfort* and the Pakistani earthquake relief effort by NATO. Likewise, little can be done effectively in a foreign country without the cooperation of the host nation and regional organizations, which often can contribute to strategic messaging. While there are clearly exceptions, consultation and cooperation frequently pay enormous dividends.

Third, as we develop and execute our strategic communication plans, we should ask the simple question: Who are the thinkers, the idea makers? Not everyone is good at strategic communication. Many commands, including NATO and most large U.S. military organizations, have hired individuals or commercial consulting firms to participate; Googling "strategic communication" will turn up thousands of them. But each strategic plan and each organization—and indeed each time a plan needs to be adjusted—may need a different set of thinkers. So look around the organization and even outside it, especially to non-U.S. sources of input and criticism, for advice, execution, measurement, and judgment. Recognize that the "strategic communication director" is more like the conductor of a band than an expert on a given instrument. Moreover, give the director of strategic communication unfettered access to the commander. At all my commands, and especially at NATO (and indeed, in my new civilian job), our director of strategic communication attended the daily morning standup meeting with the commander, interacted constantly with the senior leadership of the command, and was a prime mover in every sense in our organization.

Fourth, and finally, anyone who is trying to move a message must work with all the participants to arrive at a shared understanding of what constitutes strategic communication in an international context. This is an effort

that must involve practitioners at the Department of Defense, Department of State, NATO, and indeed at all cabinet and international organizations and national agencies engaged in international strategic communication on behalf of the United States or in the global arena. It is also an effort that can be informed by those in private industry who work in this milieu.

In the end, working in strategic communication for national security is a bit like working in a laboratory trying to find a cure for cancer. There are many false starts, mistakes, and incorrect leads. Resources are often difficult to obtain, especially because it is difficult to show significant results. Steady pressure is generally the right solution, and occasionally a true burst of energy can make great strides. There is unlikely to be a perfect single-point solution; expect incremental progress measured in years and only a series of partial palliatives obtained along the way. But it is all in a worthy cause, the work is fascinating, and in the end the efforts of the strategic communicator can be of enormous benefit to the national security of the United States and global entities such as NATO, especially in this complex and unsettled twenty-first century.

I learned a great deal about strategic communication in the course of my Navy career, especially at NATO. Indeed, I suspect for just about anyone, strategic communication is a bit of perpetual on-the-job training. No two situations are the same, and there is never a textbook solution. We never got quite as good at it as we were at launching Tomahawks, but we improved a great deal. We all need to work much harder at communicating, as the Arab Spring showed us (and continues to show us) so clearly. I would argue it is fundamental to our ability to shape this unruly world, and my impression is that we have a long way to go.

REQUIEM FOR STRATEGIC PLANNING?

A good plan, violently executed now,
is better than a perfect plan next week.
—George S. Patton Jr.

No battle plan survives contact with the enemy.
—Helmuth von Moltke

Everyone who has run a large organization (and most people who have run small ones) knows that planning is a key element of success. I have valued the process of strategic planning throughout my career, yet during my time at NATO I gradually began to lose my faith in the long-range strategic process. This was not due to any failure in our ability to produce coherent planning, but rather to the sense that we are departing the era of effective strategic planning and entering a very tactical world. Strategy is the big picture. It is the "what"—the overall goal that you are trying to achieve. Tactics are the "how"—the individual steps you take to get there.

Let me point out that I worked on strategic plans at every level in my nearly four decades of naval service, beginning with my first job as a division officer on a destroyer, where I crafted a long-range plan for the maintenance and inspection of our onboard nuclear weapons that were part of my responsibilities as the ship's antisubmarine warfare officer. Along the way, I wrote strategic plans for my destroyer, USS *Barry*; for the destroyer squadron

I commanded in San Diego; for the big carrier strike group centered on USS *Enterprise*, a nuclear-powered aircraft carrier; and for both of my four-star U.S. commands—the Southern Command in Miami and the European Command in Stuttgart, Germany.

I have also been very involved as an analyst and drafter for numerous strategic plans ashore. Strategic planning was among my defined Navy sub-specialties, meaning that while I was primarily a warfighter at sea on destroyers, cruisers, and carriers, I was expected to have demonstrable skills in building a strategic plan. I learned many of these skills at the various War College courses I attended over the years, especially at the Naval War College and the National War College.

I mention all of this simply to make the point that such training is very much a part of any officer's kit bag, and I am no exception. Given my background in international relations, I particularly enjoyed the sort of very high level strategic planning that took into account the broader world. I had faith in our ability to craft long-range, far-seeing documents that laid out a coherent way forward. Over the course of my four years at NATO, however, the small slivers of doubt that had been creeping into my mind about this approach since 9/11 began to take root and sprout.

In beginning any strategic planning process, the first thing to consider is the environment itself. During my time at NATO the progression of events accelerated and the flow of information available to decision makers, which was high when I arrived, seemed to expand each year, growing as information technology grew. The ideas and concepts that we felt secure in planning toward felt outdated and inappropriate within a year or two, much like a laptop that falls further and further behind into obsolescence.

The traditional strategic planning model for a large military organization such as NATO is quite straightforward. It begins with such bedrock documents as the NATO Treaty, which is a model of elegance and brevity: twenty-four sentences in fourteen sections (see appendix B). The bedrock is supplemented by national guidance provided by key political decision makers—most recently, in the case of NATO, the strategic concept agreed to by the twenty-eight heads of state and government who met at the Lisbon summit in 2010 (see appendix C). The Lisbon agreement defines key missions for the alliance and includes direction on building partnerships, establishing cybercapability, seeking a "true strategic partnership with the Russian Federation," and other tasks.

Armed with bedrock documents and national guidance, a planner ideally would conduct an assessment of the overall security environment and the progress on previous plans—taking a kind of navigational fix on the present. This should include some outside sources—both classified and unclassified—as well as the personal views of the commander. I liked to let my planners come and visit with me every couple of weeks during the strategic planning cycle so that I could continuously inject my ideas and views into this critical first assessment phase—about both the environment and where we stood at the moment.

This part of the cycle is where the first real difficulties in traditional strategic planning occurred. It is hard to assess an environment when things are changing rapidly, and certainly that was the case during my time at NATO. The obvious huge muscle movement was the Arab Spring (with attendant explosions in Libya, Egypt, and Syria). These revolutions quite literally reshaped the politics of the southern and Levantine borders of the alliance. We also saw the global economy lurch into the so-called Great Recession; the collapse of several economies on the southern European tier of the alliance; the failure of relations with Russia following the election of Vladimir Putin; Iran's accelerated pursuit of nuclear weapons; a constant shift in the tone and approach in Afghanistan; the disclosures of Edward Snowden, which more or less unglued the cyberworld; the dramatic reshaping of the global energy calculus as a result of shale gas exploitations; the expansion of social networks (Facebook and Twitter) to become the third and fifth largest "nations" in the world; and a thousand other radical changes. The old programmers' maxim "garbage in, garbage out" occurred to me as I contemplated our strategic planning process. If we didn't have a clear assessment of the environment and our place in it, and if things were changing every five minutes, what could we do?

The traditional planning process moves from the assessment to guidance development by the key leadership team and the production of a theater campaign plan—in layman's terms, a list of things you hope to accomplish. Sometimes strategic planning is boiled down to the real essentials: ends, ways, and means. The development of a campaign plan is the "ends," or simply where you want to end up. In the case of NATO, we leaned heavily on the strategic guidance, which meant that we needed to be ready to defend the alliance (through exercises and training), reach outside the alliance to build partnerships (as in Afghanistan, where the twenty-eight NATO nations are joined by twenty-two partners), conduct effective crisis management (a Libya-like

operation), and create at least amicability with Russia (getting harder and harder).

Once you have an assessment and a campaign plan, it is a relatively simple matter to decide on the capabilities you need to accomplish your goals—the "ways." Simply put, how are you going to do this? In the case of NATO, we could see that we needed more and better intelligence and surveillance (especially from unmanned platforms); more special forces; vastly improved cybercapability; stand-off strike weapons; better-honed strategic communication and legal skills; and a variety of other things.

During my time at NATO we were able to make some progress on most of that list, despite declining defense budgets. We built up the NATO special forces headquarters and brought online the new Global Hawk airborne unmanned vehicle, which has a terrific wide-area surveillance capability. As a result of the Libyan operation, we recognized the need for a variety of other "ways" to do business and tried to adjust the alliance's approach accordingly.

In all of this we were working closely with the supreme allied commander for transformation, General Stéphane Abrial of France. A tall, rangy, good-natured fighter pilot by trade, Stéphane was a superb partner in the world of strategic planning. He had an organization of about a thousand officers and enlisted personnel from the twenty-eight member nations who worked very hard to create more efficient ways to accomplish the mission under constantly changing operational, political, economic, and diplomatic conditions. His command, based in Norfolk, Virginia, had the lead on "ways" and did a good job—especially with the NATO Smart Defense initiative, which sought to rationalize the ways (and ultimately the means) of our strategy.

Which brings us to the third simple leg of strategic planning: "means," or the resources to get the job done. Most obviously, these resources are the defense budgets of the nations. Here there is both good and bad news, as is usual in strategic planning. It is a given that there is never enough funding to buy a military everything it wants—think of that as the iron rule of military strategic planning. But the good news is that NATO is an incredibly rich alliance. It represents more than 50 percent of the world's gross domestic product and spends more than $900 billion annually, about two-thirds of that from the United States and the rest from the other nations. Ideally that ratio of U.S. to non-U.S. spending would be roughly fifty-fifty, which would correspond to the GDP shares involved. But given that no non-NATO nation is spending more than $150 billion (China is at the top) annually on its military, it is clear

that NATO has plenty of resources to apply to this part of strategic planning. I was frustrated by the declining European defense spending (now mirrored in the United States as well), but it seems to me that we nevertheless have enough to defend the alliance adequately.

To summarize, the four elements of the classic strategic planning process are assessment and environment, guidance, capability determination, and resources—or, to simplify, ends, ways, and means. I have used them in many situations to develop solid strategic plans, ranging from the enormous Quadrennial Defense Review that guides the Pentagon every four years through a $600 billion budget and global operations involving millions of military and civilians to the tiny plan I made for the hundred sailors working for me as an operations officer on a cruiser in the mid-1980s.

But twenty-first-century planning seems to be departing the age of rational strategic planning and entering a relentlessly tactical period. Beyond the acceleration of knowledge and events that I discussed earlier, there are several other factors at work here, which can be illustrated with three characters from Greek mythology.

The first is Tantalus, whose name gives us the English word "tantalize." The Greek gods punished Tantalus for misbehavior by chaining him to an apple tree in Hades in water up to his waist and inflicting him with overpowering thirst and hunger. Unfortunately for Tantalus, every time he bent over to assuage his thirst, the water receded from his lips. Likewise, when he reached up to pluck an apple to satisfy his hunger, the wind would blow the branches just out of his reach. The same problem tends to manifest itself in strategic planning today: planners work too hard to write the perfect plan, only to see the effort drift just beyond their reach. With just a little bit more effort, a better and more perfect word, a little more time, we are certain we can finally write the perfect plan. Forget it. To paraphrase George Patton, a good (read "more tactical") plan executed now is better than a perfect plan that arrives next week (or never arrives at all, like the apples and water for Tantalus). The lesson here is write a plan, recognize that it needs to be produced quickly, and don't obsess over what you can't quite reach in terms of perfect information and assessment.

The second Greek character, Sisyphus, is perhaps a bit better known. He is the fellow who is forever rolling a boulder up a hill in Hades. Just as he gets it to the top, it crashes back down and he has to start over again—forever. It's a very apt metaphor for the outcome of many of our plans. We craft them

very carefully, assess them in minute detail, figure out how to accomplish our goals, put resources behind them, get ready to execute—the boulder is just at the top of the hill—and suddenly there is a great lurch and the plan has to be changed. Three good recent examples include 9/11 and the rise of global jihad, the Arab Spring across much of the Levant, and the emergence of shale gas as an energy source. All three are having and will continue to have dramatic effects on the global scene.

The third Greek I would introduce is Prometheus, who provided human-kind with fire against the wishes of the gods. Zeus had him chained to a rock and each day sent an eagle to eat his liver. Those who provide full transparency in strategic planning suffer a similar (although far less bloody) fate. And in today's world, *everything* has essentially become transparent. Most governments cannot protect even the most sacrosanct secrets and must assume that any strategic plan will be exposed to the light of day, to be picked apart by critics, adjusted by adversaries, and subverted by entrenched entities whose interests it gores. In other words, the plan's drafters (and those who try, generally fruitlessly, to execute it) are treated to a daily liver extraction.

The moral of these not-so-amusing Greek myths is not that strategic planning is an endless form of torment, although to some it may seem that way. The point is that the pursuit of perfection, the potential for sudden catastrophic change, and the ill effects of forced transparency that the myths illustrate have made strategic planning in this brave new world grueling, frustrating, unending, and of less use than it once was. Couple that with the accelerating rush of information and constantly changing tactical events, and it appears to me that we are witnessing at least a temporary requiem for grand levels of strategic planning, dear though they are to the military's heart.

What should we do instead?

A better approach, it seems to me, would drop the more grandiose planning efforts and instead start with a very broad guess at the five-to-ten-year future, recognizing that the prediction won't be very accurate. It would then move swiftly to a simple set of long-term goals in very general terms about the organization's desired direction, speed, and distance to travel—in the Navy, we would call these sailing directions. The real focus of planning in today's world should be on a detailed annual planning process that responds to the goals and the general sailing directions with tactical judgments.

At NATO, we would look very broadly each year at where the organization was supposed to be headed in general terms and then craft specific annual

goals to keep us moving in that direction. An example would be Afghanistan: the broad goal was to turn over security operations to the Afghans and withdraw the NATO and coalition forces over the next five to ten years. Each year we would work very hard defining the specifics of what we hoped to accomplish that year: how many Afghan police trained, how many Afghan infantry soldiers, how many Afghan special forces, how much logistics capability (trucks, planes, fuel) purchased, how many coalition bases handed over to the Afghans, how many children in schools, and so on. It was a very tactical set of annual goals, and we constantly measured our progress as the year went on. At the end of the year we would craft another set of annual goals.

Innovation is key in such tactical planning. It is easy to slip into repeating goals from year to year without injecting sufficient thought into change and new ideas. Having an innovation cell is critical, and that group should be a big part of the goal-setting process because they can think outside the box and help provide new directions to be undertaken in a given year.

Naturally, there will be some projects that have long-term components. But such projects should be taken on with a healthy respect for the fallibility of our predictions and recognition that today's world is far more tactical given the scope and pace of change. We should still have long-range goals in mind, but they should be general in nature and flexible to adjustments as we sail on.

The Greeks have an expression that translates loosely as "man plans, fate laughs." Expect plans to fail, even the tactical ones. Eisenhower once said, "In preparing for battle, I have always found that plans are useless, but planning is indispensable." I believe he meant that the teamwork, bonding, hard intellectual work, and goal setting involved in preparing a plan—be it strategic or tactical—pay off when events come fast and furiously. Never has that been truer than today. We are constantly bombarded with far more information than we can analyze, and detecting nuances is increasingly difficult.

My advice, based on four years in NATO, is this: plan with an eye toward the tactical and the annual horizon; recognize that the sailing directions for the long-distance voyage are going to be frequently revised as the wind and seas change; and, above all, keep the ship sailing forward with purpose and do not allow yourself to merely drift before the elements on an uncaring sea.

INNOVATION
The Father of All Necessity

The dogmas of the quiet past are inadequate to the stormy present. The occasion is piled high with difficulty, and we must rise with the occasion. As our case is new, so we must think anew and act anew.
—Abraham Lincoln

During my years as the supreme allied commander at NATO I kept a sign on my desk visible to everyone who walked into the room. It was another quote from Lincoln: "Nearly all men can stand adversity; if you would test a man's character, give him power." This is a truism that applies not just in the military or politics but in every aspect of civil society, and indeed in our families.

I like that quote for a couple of reasons. First and foremost, it reminded me every day that jobs steeped in power come with a built-in responsibility to exercise it in responsible, honest, and transparent ways. Second, and more subtly, the quote conveyed to me the ever-present need to overcome the day-to-day challenges—the adversities of the moment that constantly press in on a leader in any truly significant job. And frankly, while most men (and women) can *stand* adversity, it takes a lot of iron in your soul to step up and actually *overcome* the challenges and succeed at accomplishing the tasks at hand. It has been my good fortune to work with a lot of men and women who did overcome the adversity. A central lesson I took away is the value of innovation in success; whether in the military, government, or business, there are valuable lessons here. Let me explain how I arrived at that conclusion.

The central question for any leader, whatever the size or shape of his or her organization, is how to overcome adversity. What are the leadership and management tools that matter the most? There are many candidates: team-work, drive, determination, civility, alignment, presentational skills, and strategic communications, to name a few; the list of useful tools and skills goes on and on. All are important. But at the top of my list is *innovation*. This was not a sudden epiphany that came upon me like enlightenment came to Paul on the road to Tarsus. Indeed, I came to the view that innovation is the critical ingredient in overall organizational achievement relatively slowly over the course of a couple of decades.

As you start out in the military, there is an enormous and obvious premium placed on repetitive training in order to improve. If a military organization wants to "up its game," the normal prescription is lots and lots of practice, drills, and exercises. And, of course, this makes sense. To use a sports analogy, if you want a better jump shot, go out and shoot jump shots—thousands and thousands and thousands of them. Think of Larry Bird as a boy in his backyard in Indiana spending hour after hour shooting baskets. It works. Slowly. In that sense, many organizations—particularly military ones, with a predisposition for uniformity and conservative approaches, but also civilian and governmental enterprises—are seduced into regimes that focus almost entirely on repetitive training to improve.

But what if you added innovation to repetition?

Back to Larry Bird. How about new technology? Suppose he had been given a pair of brand-new, spring-loaded, light-yet-tough Nike Air Jordans. Would they have given the aspiring ballplayer that extra bounce, that modicum of support that could help improve his shots? You bet.

Or how about technique? What about a change in procedure, breaking the wrist in a more pronounced way, applying more backspin to the ball and a slightly higher arc, taking advantage of a "larger" target by a sharper angle of descent to the rim? Would that innovation in technique have a positive effect? Clearly it would.

The problem, of course, is that most organizations don't devote enough resources to the innovation part of their games, especially to *disruptive technologies* or *disruptive innovations*—technologies or ideas that essentially create a new market by changing a fundamental value equation, thus reshaping an existing marketplace, usually rapidly and somewhat unexpectedly. Clay Christenson, a noted thinker and writer about innovation, has repeatedly

pointed out the need to find, evaluate, and embrace disruptive innovations and technologies—even when it is not obvious that their time has come.

An example of disruption would be the arrival of the telephone during the era of the telegraph. Telegraph lines already crisscrossed the country, and there were trained operators, delivery boys to run the messages, huge investments, and lots of profit in all that. Why would anyone want to have a telephone? But the technology enabled the innovation of real-time conversation, thus reshaping the marketplace for communication. Such marketplace innovation has occurred often through history and seems to be accelerating in the twenty-first century.

I began reading and learning about innovation seriously about twenty years ago, and the more I look at big organizations and how leaders manage them, the more I believe in the need for it. The most important approach to innovation I've employed over the years is the use of "innovation cells." This means simply carving out a few very bright and mildly untethered people from the organization and giving them the authority, resources, and above all the charter to find and try new ideas. I tried this first about fifteen years ago when I was a young captain at sea in command of a group of about a dozen destroyers. I had a good group of ship captains in command of the individual ships, but I saw no real innovators among them, so I asked each of the ship captains to propose a junior officer for my innovation cell. I did the same with the various aircraft squadrons that were part of my command. After interviewing all of the candidates, I chose five of them, attached them to temporary duty to my staff, and told them to think about antisubmarine warfare and strikes at sea on enemy combatant ships.

"Your job is to make everyone upset with your crazy ideas," I told them. "And don't worry if most of your schemes fail. In fact, I expect most of them to fail. This is like baseball—if you're hitting .250, and one in four of your ideas bears some fruit, you're having a solid season. You hit on one in three and it's .333—a career year for almost any ballplayer. Anything better than that is a Hall of Fame year, which I'm not expecting (but it would be nice)." I gave them a small budget, the luxury of time to work on their ideas, and turned them loose.

Many of their ideas were goofy and unmanageable. I remember one proposal to use old fifty-gallon oil drums tied together to simulate submarines for target practice. They tried to attach unclassified communication devices to our military systems in ways that would have violated every element of policy and regulation on the books. And they had lots of other unworkable ideas.

But they also came up with several new ways to employ our detection systems in synergistic ways, fusing the data. This means taking inputs from various sensors—such as a radar, which uses electromagnetic radio waves to measure a physical object; a sonar, which uses sound waves to do the same; and infrared detectors, which measure heat—and merging them together to create a coherent location and picture of a target. We did this both at sea and on the ground in Andean and Central American jungles.

The team did some superb work using emerging technologies, including tiny unmanned air vehicles dubbed "wasps" and real-time translation devices that we called "phraselators." They also explored ways to attack very low radar cross-section high-speed patrol craft, an increasing threat in coastal warfare.

Above all, the innovation cell had a synergistic effect as people throughout my command—about three thousand folks in all—saw that the leadership valued (indeed demanded) innovation. People who were not part of the innovation cell started to talk about new ways of doing business as a matter of routine. Ideas were batted back and forth across the wardroom table and in the squadron ready rooms. It was an awakening of sorts. And, of course, we continued to do the basic blocking and tackling that comes with the job of military preparation. But by adding to our effort through innovation, we were able to bring our game up to a new level.

That experience made me a believer. In each of my subsequent jobs I set up an innovation cell of some sort and tried to encourage new ways of thinking, reading, writing, and sharing ideas on innovation.

For the military broadly, of course, all this came into sharp focus after 9/11 when we were suddenly confronted with a very new sort of opponent—essentially a network of opponents who were superb innovators. Gradually over the post-9/11 decade our own innovations began to kick in, and we were able to create new ways of thinking about conflict and the tools, techniques, and procedures necessary to construct our own networks (leveraging special operations forces); deploying new types of sensors (unmanned vehicles, especially armed drones); collecting intelligence through big data (the cyberworld); using existing platforms in new ways (intercontinental ballistic missile–launching submarines converted to Tomahawk cruise missile shooting platforms, large deck amphibious ships providing "lily pad" bases for special forces); describing and implementing new ways of looking at conflict through international law; and other innovations.

Indeed, after the 9/11 strikes on New York and Washington, it was clear that we—the military—needed to develop very new ways of thinking about

conflict. I was asked by Adm. Vern Clark, the chief of naval operations, to stand up an innovation cell. We built Deep Blue (after the IBM chess-playing machine and also a play on words connoting the deep ocean) on the backbone of the Navy Operations Group, the small think tank that Rear Adm. Joe Sestak had created immediately after 9/11. Our job at Deep Blue was to come up with new ideas, forging them in the intensity of what we felt at the time was a new era of warfare.

Some of our ideas failed; for example, a "sea swap" to keep ships forward deployed and fly their crews back and forth—although the concept is getting a new look in view of today's more resource-constrained environment. We designed new types of combat groups (expeditionary strike groups) centered on large amphibious ships combined with destroyers and submarines, carrying drones and special operations forces. Another idea was to repackage communications using chat rooms, e-mail, and primitive versions of social networks to leverage lessons learned operationally. We looked at unmanned vehicles on the surface of the sea, below the ocean, and in the air. We created training simulators using off-the-shelf video games as bases. And Deep Blue also looked at the idea of the "expeditionary sailor," reflecting the fact that tens of thousands of sailors would soon be serving far from the sea in the deserts of Iraq and the mountains of Afghanistan. How to train, equip, and prepare them for duty like that? Innovation!

Around this time I attended a conference at which all the Navy flag officers were present. I was a newly minted one-star admiral heading up Deep Blue. It was a memorable meeting for a couple of reasons. At one point a vastly senior four-star admiral approached me during a coffee break. He was a naval aviator, and he was very displeased with the emphasis we were placing on drones and other unmanned air vehicles. His comments, in a nutshell, were that I was "standing into danger," as we say in the Navy, in a career sense. And being a typical aviator, he was not subtle. "Stavridis," he said, "your career is over unless you learn how to stay in your lane." That was fairly unsettling but not entirely unexpected. When I mentioned this to a senior surface officer, a three-star who was a mentor and leader in the community, his comment was, "You better trim your sails, Jim." Hardly reassuring.

The other memorable revelation at the all–flag officer conference was delivered by the CNO. He talked at length about a study of flag officer traits that he had commissioned by a well-regarded consulting firm specializing in leadership training. The results of that study were compared with those of

similar studies of very senior executives in private industry. The Navy admirals scored very high in almost every desirable trait: leadership, organization, dedication, energy, alignment, and peer review. But there was an exception to this parade of good news: Navy admirals scored the lowest in . . . willingness to take career risk—essentially the willingness to try new things, to champion innovation and change. I found it extremely ironic that this group of admirals—all of whom had demonstrated extreme reserves of physical courage in flying high-performance aircraft, spending months at sea, and conducting dangerous special operations—were simply *afraid* to take the bureaucratic risks that come with innovation.

Despite these obvious indications that I was perhaps not in the mainstream with my colleagues in this regard, I continued to try to build my innovation cell and hoped for the best. After all, I had never planned to make it past lieutenant, so I was playing with house money. Luckily for me, the CNO was a fan of what we were doing at Deep Blue, and my career did not come to a screeching halt. Shortly thereafter I was sent back to sea, perhaps before I could annoy the entire senior leadership of the Navy.

My new carrier strike group command in Florida was an ideal position for me: back in my home state; away from the two big fleet concentration areas of Norfolk and San Diego, where plenty of senior admirals would have been watching me a little too closely; and in the middle of the first few years of the post-9/11 era. I set up the innovation cell and turned them loose. By this time, a spirit of innovation was actually beginning to take hold in the Navy, pushed by a new generation of young commanders facing operational challenges of a different sort.

We sailed to the Arabian Gulf with a major load of innovative gear and ideas to try, including a midsized unmanned surface boat, the Spartan Scout; the phraselator translation devices mentioned earlier; several types of unmanned air surveillance vehicles of various sizes; simulator software to train our tactical watch officers "in stride"; and a group of young junior officers we called "innovation fellows" who came to the flag staff with a ton of good ideas. Not all of it worked out; in fact, we probably batted around .300 or a little less. But we learned a great deal, we failed fast, and our partnerships with other organizations tasked with innovation (e.g., the Defense Advanced Research Projects Agency, or DARPA) were very productive.

By the time I got to my first four-star job at Southern Command in Miami a few years later I had a mini-network of bright, disruptive thinkers at my disposal. People such as Capt. Kevin Quarderer, call sign "Q," brought a fusion of technical and tactical acumen to the idea of innovation. Kevin had been with me on several innovation cells earlier in my career, and he held several advanced technology degrees as well as a true bent for challenging the given orthodoxy. He brought other thinkers on board, and we set out to use innovation to tackle the challenges of drug smuggling and hostage taking through the jungles of South and Central America. Among many other ideas, Kevin developed new detection systems that could at least partially "see through" the thick triple-canopy jungle by fusing several different sensor inputs— radar, heat seeking, and biological. We used a high-tech, high-speed surface ship, the *Stiletto*, to literally run down the drug boats. I gave this innovation to my two-star Army general, Keith Huber, and he proved to be a pretty good sailor, using the *Stiletto* in lots of creative ways in shallow water that would have made a more traditional ship handler blanch.

We used commercial satellites to map the region and find anomalies as well as to respond after disasters such as fire and flooding so that we could sharpen our reactions. The innovation cell turned to business leaders and asked a group of them to function as a mock drug cartel and model for us the business case and transportation/logistic concepts that the actual cartels might be using—after all, business is business. That enabled us to essentially reverse-engineer the trafficking routes and methods and apply our resources to killing them. Some of what we did is highly classified, but I can say that our innovation techniques and ideas had a powerful impact on stopping narco-trafficking: we took down the largest levels ever recorded in 2006–9 using these innovations.

When I took on the job as SACEUR in 2009, I found myself in the middle of one of the most conventional and conservative organizations in the world: the North Atlantic Treaty Organization. Founded in the early 1950s, it remains steeped in tradition. The large and heavily bureaucratic structure at NATO headquarters in Brussels includes nearly four hundred standing committees ready to parse the smallest detail of any idea of change—and then usually block it. Every decision has to gain the approval of all twenty-eight NATO nations, a process described technically as consensus but more accurately

depicted by picturing a steering wheel with twenty-eight pairs of hands on it. I knew that bringing innovation to NATO was going to be a supreme challenge.

Luckily, I quickly found a pair of very bright officers: Navy captain Jay Chesnut and Air Force colonel Pete Goldfein. Both were career aviators, but in smaller communities—Jay was an antisubmarine warfare expert flying the S-3 Viking and Pete was a special forces aviator who flew a wide variety of very special small aircraft. They brought a sense of partnership with private sector entities as well as working closely with DARPA. Over the course of our time in NATO they were able to bring along several key innovations. The most interesting was a biological sensing system that could be used to detect humans moving through unmanned zones—highly useful in everything from counterterrorism to stopping human trafficking.

In the end, of course, innovation is not all about technology. Chesnut and Goldfein were also both instrumental, along with Cdr. Tesh Rao, an electronics warfare pilot, in redesigning the entire NATO command structure. I had been tasked by the secretary general to figure out how to reduce the size of the standing command structure—the many headquarters scattered around Europe and the world. It was big and unwieldy, including as it did more than 15,000 officers and enlisted staff members across 11 major headquarters. I wanted to reduce our size by at least 20 percent and was willing to consider cuts up to about one-third. I turned to my innovation cell and brought in other collaborators from across the NATO enterprise. We considered using a contractor to examine solutions with us, but I have always shied away from bringing in "outside experts," which seems to me almost a contradiction in terms for a military organization—we have to be our own experts.

In order to bring this bureaucratic innovation home, I tried to build a shared sense of the value of change. Lots of the NATO nations wanted to reduce overhead and save money, and their ambassadors were amenable to some fairly radical redesigns. Other nations were more traditionally rooted in the defensive structure of the alliance (and liked having jobs for their top military officers), so I offered them the allure of new technologies that could streamline our ability to respond to twenty-first-century challenges—not a sudden invasion of NATO from the East, but rather the endless crises of Afghanistan, Libya, the Balkans, piracy, Syria, and so on that kept popping up in small, fast, discrete firestorms.

In the end, my innovation cell brought together a new plan for redesigning the overall command structure, closing 6 of the 11 headquarters, and

reducing manpower from 15,000 to just under 9,000 personnel "on watch" assigned to some headquarters at any given time. Not too bad, really, for an organization with 3 million men and women under arms and 28 nations engaged. We sold the plan to the top leadership—not without arguments and pushback—and the secretary general moved it in the political sphere with the help of the ambassadors from the leading nations. Secretary of Defense Gates came in as the closer and delivered the product. We also added several smaller, lighter, faster command elements to balance the loss of the big head-quarters. For example, we closed a major land force HQ, a large maritime HQ, and one of our two air defense HQs—but we added a very lethal special forces HQ, a lighter strike HQ, and added significant missile defense technology to the remaining air HQ. Essentially, we moved from the lingering Cold War structure into an organization better prepared for twenty-first-century con-flict. It all worked out fairly well.

What do I take away from all these years of trying to build innovation?

First, it is crucial to recognize the importance of innovation and the value of change. Leaders should emphasize it at every turn, pointing out his-torical examples (both from broader society and from the organization's own history). For example, I often spoke about the post–World War I 1920s–30s period of naval innovation led by Billy Mitchell and other early pioneers of aviation at sea and on nascent aircraft carriers. They overcame the entrenched bureaucracy of battleships and essentially invented the U.S. Air Force. *Self-talk matters.* What we say about ourselves at every level in an organization—communicated through briefings to the team, Web sites, annual "state of the command" addresses, videos posted on YouTube, and personnel policies—constitutes the internal strategic communication. This is particularly impor-tant coming from the leadership. Self-talk about innovation can be worth its weight in gold.

Second, you have to work hard to find innovators. This is difficult. At NATO (and indeed earlier) I tried to mine the small and somewhat disadvan-taged service communities; for example, people from aviation communities that were "going out of business" but previously had performed somewhat oddball missions: special forces pilots, electronic warfare operators, tactical communication platforms. Generally (and there are, of course, exceptions), people in the "mainstream communities" of high-performance fighters,

Aegis missile defense ships, aircraft carriers, nuclear submarines, and so forth are less inclined to embrace change and innovation. Why? Because they are doing just fine in their careers given the high premium paid to them by the standing organization. Searching out the officers and enlisted personnel who are just a half beat off the music and don't always stay in their lane is a valuable exercise.

Third, the innovators must report directly to the top of the organization. Reports filtered to the top through intermediate levels are "dumbed down" to the lowest common denominator by the time they reach it. There will be institutional resistance to doing this. I can't count the number of times my front office team came to me with proposals to downsize, eliminate, or reassign the people and resources devoted to the innovation cells. This also means the organization's leader must find the time to take the innovation briefs, evaluate them and decide where to put emphasis, and then move the idea into the mainstream—where it will again encounter resistance because it was "not invented by the main staff." The imprimatur of the leader is crucial to keeping innovation alive in an organization.

Fourth, resource the innovators! This means carving out sufficient amounts of money, people, and time to allow your innovation cell to flourish. It does not mean *huge* levels of resources; for even very large organizations, a relatively small number of people (say a dozen) can achieve big throw weight. Deep Blue in the Navy, Checkmate in the Air Force, the Policy Planning Staff at the State Department, and Google Ideas within Google are all examples of this. In terms of money, the best approach is to encourage (and sometimes require) the innovation cells to reach out in entrepreneurial fashion and find "other people's money" to fund their ideas.

Fifth, reward them appropriately. This can range from cash and bonus awards for civilians to better evaluations and medals for military personnel. And again, this kind of message moves through the organization, and people begin to know that the leadership and the organization itself reward those who take the risks of innovation—despite their frequent failures.

And speaking of frequent failures, sixth, accept that many ideas will fail. Not every well you drill will be a gusher—but a handful of successful wildcat wells can make you rich. Encourage recognition of failure early in the process—the so-called fail-fast approach that many corporations take today. Don't keep hammering away when something isn't working—move on to the next good idea.

Seventh, publicize successes in real time. This means up, out, and down: talking about the wins within your organization, as we did frequently at NATO; telling your bosses (in my case both the NATO secretary general and the U.S. secretary of defense) about them in weekly/monthly "innovation alerts"; and briefing subordinate commands about the good ideas (and encouraging them to use them) at command conferences, semiannual gatherings, and in annual reports such as the posture statement required to be submitted to Congress. The occasional blog post, social network tweet or post, and even articles in traditional journals all help.

Finally, recognize that there will be doubters, skeptics, naysayers, and the occasional ad hominem attack associated with trying to change things. For instance, I gave a talk at the 2012 TED Global Conference. TED—Technology, Entertainment, and Design—is an annual gathering of innovators who give eighteen-minute talks on "the idea of their life." My subject was open source security: trying to create security in the turbulent twenty-first century through a fusion of international, interagency, private-public, and strategic communications in a "smart power" approach. I've received plenty of positive feedback, but the hundreds of thousands of hits have also included lots of "this will never work" and "who the hell is this guy and why is he so foolish and naïve."

Jonathan Swift, the great satirist, lampooned those who sail against the wind by depicting them as believing that "so shall ye know a genius is among you: there will be a confederacy of dunces allied against him." I am far from a genius, and those disagreeing with me are seldom dunces, but I am willing to suffer the slings and arrows of public criticism to champion the occasional disruptive innovation or technology.

In the end, much of human progress comes because of people who could never quite stay in their lane, as annoying as they can be. The trick, as always, is balance: find the way to maintain the value of current innovations and technologies, resource the disruptive possibilities, understand how the value proposition changes, analyze the market, and then bring the new online while gracefully removing the old. Of course, it doesn't always go smoothly. As in mountain climbing, it is good to have a firm grip on the next rock before you completely let go of the one you have. But to get up the mountain you have to climb, not just cling to a couple of rocks. And remember that the top of the mountain is where the strongest winds blow.

NATO
Quo Vadis?

*Future U.S. political leaders, those for whom the Cold War
was not the formative experience that it was for me, may not
consider the return on America's investment in NATO worth the cost.*
—Secretary of Defense Robert Gates, June 10, 2011

S ecretary of Defense Bob Gates, my former boss, delivered a blistering farewell speech to NATO as he was leaving office. Taken as a whole, the speech is fairly balanced; but sound bites like the one above were quite hurtful across the Atlantic. Which brings me to the most frequently asked questions about NATO. The most consistent NATO question I heard over the four years I served as the supreme allied commander was very simple: Does NATO still matter? The clear implication was that it was a tired organization that had done a fine job in its day but was clearly long past its prime, if not headed for the knacker's yard any minute.

I disagree. Indeed, throughout my time behind the desk first used by Gen. Dwight Eisenhower, NATO's esteemed military founder, I continued to think the alliance mattered. But there are really two parts to the question, and it is worth answering both of them to fully understand why NATO still matters.

The first question relates to the United States and is a variant on the basic one of NATO's importance. Does NATO matter *for the United States*? The line of thought that would answer this question in the negative normally follows the theory that World War II and the Cold War are long since over,

the Europeans have stopped trying to kill each other as they did throughout the two previous millennia, and U.S. interests are far more vitally engaged in other parts of the world nowadays, notably Asia. Under this theory, it seems ridiculous to still have thousands of soldiers, sailors, airmen, and Marines operating out of Europe; and equally ridiculous to fund a dozen or so big bases and many smaller sites across the "old continent."

But I believe that both Europe and therefore NATO continue to matter deeply for the United States.

Let's begin at the beginning—with values. Most of the concepts we cherish in the United States, concepts that are deeply enshrined in our Constitution and indeed in our political DNA, came from Europe: democracy, freedom of speech, freedom of religion, freedom of assembly, freedom of education, and on and on. These values evolved in the Enlightenment, were tested in revolutions in both Europe and the nascent United States (and are being tested today in the Arab Spring), and remain at the core of who we are as a nation. Nowhere else in the world does the United States enjoy such a reliable pool of partners who share our fundamental values.

Second, Europe and NATO matter to the United States because of geography—something that is unlikely to change much in the coming centuries. Europe is strategically located on an important piece of real estate. As I have said many times, quoting a think tank report, NATO's bases are not "bastions of the Cold War," as some have called them; they are the forward operating bases of the twenty-first century. Europe provides critical access to North Africa, the Levant (where our key ally, Israel, is located), and central Asia. By staging forward in Europe, U.S. forces are far more capable of reaching the location of the next crisis soon enough to have real impact. Given the events in the Arab world over the past several years, this seems particularly important.

Third, follow the money. Europe and the United States are each other's largest trading partner when Europe is viewed as a block. Each represents about 25 percent of the world's gross domestic product—indeed, the twenty-eight nations of NATO are collectively responsible for just over half of all the goods and services produced in the world. Nearly $4 trillion worth of goods move across the North Atlantic each year, and the interconnections of the U.S. and European economies remain profoundly important.

Fourth, Europe provides the most capable, highly trained, and battle-tested group of military operators in the world outside of the United States. Collectively, the Europeans spend nearly $300 billion annually on defense.

While that is only half of what the United States spends (and I would argue not enough because it doesn't represent much above an anemic 1.5 percent of their GDP), it is still the second largest pool of defense spending in the world. It is well ahead of China and Russia combined, for example. Having military partners who have stood and fought with us in the Balkans, Afghanistan, Iraq, Libya, and on counterpiracy missions (and that is just lately) is a key strategic plus for the USA.

Finally, there is the fact of the alliance itself, the richest and most capable in history. We have 3 million men and women under arms on active duty, and another 4 million or so in the reserves; and 24,000 military aircraft, 800 oceangoing warships, and 50 AWACS long-distance air surveillance airplanes. They are the highest-technology and the best-trained military forces in the world after a decade of combat in Afghanistan. Most important, and least appreciated, NATO has a standing command structure of about 9,000 men and women from all the nations (plus many liaisons from partners) at locations all over the alliance who can quickly conduct detailed planning, take command of a mission, and move out. Granted the political tempo is not always brisk, but the fact of the standing command structure is extremely valuable in situations like Libya, for example. NATO thus remains a fundamental part of the international security backbone and is carefully manned by the member nations with top-performing military personnel.

So when you look at the rich basket of benefits that the United States derives from its partnerships with Europe—especially through the NATO military channel—it seems to me the answer to the first question about the importance of Europe, and therefore NATO, to the United States is a strong yes.

The second and more interesting (and difficult) question to ponder is the one I posited at the beginning: Does NATO matter? Those who pose this question generally mean does NATO matter in this globalized world, given that it is essentially a regional alliance? I think it does, for a variety of important reasons.

First, just look at the footprint. This is not your father's NATO, hunkered down along the Fulda Gap in Europe awaiting a Soviet attack. NATO during my time in command had more than 170,000 troops on active service across 3 continents—130,000-plus in Afghanistan, 20,000 in Libya, 10,000–15,000 in the Balkans, 5,000–7,000 on antipiracy missions, and 1,000 manning Patriot missiles in southern Turkey. We also had a training mission in

Iraq, connections to the African Union, and partnership exercises literally around the world. That is clear prima facie evidence that NATO is a global organization.

Second, from a diplomatic perspective, NATO continues to be very important in the counsels of international politics. The NATO summits in Lisbon (2010) and Chicago (2012) brought together not only the twenty-eight heads of state and government from the NATO members, but also many of the state leaders from our twenty-two partners, including Afghanistan and other partners from the Mediterranean basin and the Gulf states. Secretary General Anders Rasmussen is a fixture at high-level diplomatic conferences and discussions around the world and has immediate entrée to virtually any leader. He consults on security matters with the UN secretary general and the leaders of the European Union (notably with Baroness Catherine Ashton) on a routine basis. At the military level, both the chairman of the Military Committee (my friend and colleague General Knud Bartels of Denmark) and the supreme allied commander were part of the military discussions about security issues ranging from central Asia to the implications of global warming in the High North. NATO is fully engaged in the global conversation and will continue to be so engaged.

Third, NATO has a role in training and standardizing military operations around the world. The Partnership for Peace Program conducts officer and enlisted exchanges, intelligence sharing, exercises in the field and on tabletops, student courses, and many other functional engagements with nations as diverse as Russia, Mongolia, and New Zealand. NATO standards for operations are largely adopted in the militaries around the world, and NATO observers participate in virtually all large-scale global war games.

Fourth, NATO has responded to natural disasters, including the Pakistan earthquake in 2005, the Haiti earthquake in 2010, and various other fires, floods, and dire events both within Europe and globally.

Lastly, NATO has been called on by the UN Security Council to take on significant security operations that were beyond the reach of the UN itself—most recently and notably in Libya. While not without controversy, the Libyan operations serve as a good example of NATO's useful role in providing stability and security. All of the other operations I noted above were under UN auspices as well, by the way.

All of this brings us to the most interesting question of all: Quo vadis NATO? Where is the alliance headed in this chaotic twenty-first century? That's hard to say with certainty, but here are some of the vectors that make the most sense to me.

First, I think NATO will continue to be a significant part of broad global security mechanisms. That is different from being the world's policeman, an outcome that few of the nations (if any) would support. The columnist Roger Cohen said early on in my time as SACEUR that "NATO isn't a global actor, but it is an actor in a global world." That makes sense to me. It means picking and choosing causes and operations, effectively saying yes to Libya, no to Mali, and maybe to Syria, to give three recent examples.

Second, NATO must move out on three key technologies: cyberspace, unmanned vehicles, and special forces. In terms of cyberspace, NATO should be setting up a separate cyberspace command, perhaps as a memorandum-of-understanding organization much like the Special Operations Command in Mons. Individual nations (as always) could decide whether and at what level to provide personnel and funds. Given the potential for cyberspace activity in military and security contexts, there should be quite a bit of interest in this. In terms of unmanned vehicles, NATO is adding the Global Hawk–inspired Alliance Ground Surveillance (AGS) system, which will arrive in 2015 and operate out of Sigonella, Italy. This is a start, and we should be looking to add other unmanned technologies, including small drones, undersea vehicles, and land-based vehicles (for mine clearing, scouting, disaster relief, and the like). Finally, NATO has a fairly mature Special Operations Command, headed by an American three-star general or admiral, that is a voluntary contribution portion of the command structure. The Special Operations Command is a bit of a NATO hybrid, in that rather than being a formal part of the command structure, and thus filled as a high priority by the nations, it is essentially a volunteer organization filled when the nations want to do so. Fortunately, the special operations community is very well regarded across the nations, and there is no problem filling the billets. Over time, I would like to see this volunteer organization become part of the mandatory command structure and be filled as a matter of routine by the nations.

A third factor to consider as we ponder the future of the alliance is expansion. This is, of course, a political decision for the civilian leadership to make, but from a military perspective, there are some reasonable candidate nations in the mix. I believe that over the next few years Montenegro and Macedonia

will become alliance members, taking the total number to thirty. Georgia and Bosnia are both candidates, but at the moment each has political challenges that will be difficult to overcome (Bosnia has a dicey tripartite governance structure, and Georgia is partially occupied by Russia).

In addition to full-blown alliance members we should be considering expanding and strengthening the number of partners. There are currently two fairly active partnership groups—the Mediterranean Dialogue of states around the Med; and the Istanbul Cooperation Initiative, which includes Arabian Gulf states. Both were useful vehicles in counterpiracy operations and during the Arab Spring. It would be valuable to expand partnerships for NATO to Asia, perhaps including those nations who participated strongly in the Afghan mission: Australia, New Zealand, Japan, South Korea, Mongolia, and others. There may be some equivalent work that could be done in sub-Saharan Africa (with piracy as a potential centerpiece). More difficult, but worth exploring, would be a relationship (perhaps for disaster relief or counternarcotics) with Latin American and Caribbean nations. Colombia has considered participating in Afghanistan, for example. There are always anti-NATO strains flowing through Latin America (linked to historical anti-American feelings), but this idea remains worth exploring and keeping communications open. I believe this region will be a growth area for the alliance.

Certain high-technology missions are also likely to become of increasing importance to NATO. Missile defense, where we have already begun, will be one of them. It is a controversial mission in the minds of the Russians, but certainly one that will expand as unstable nations (e.g., Syria, Iran, and North Korea) obtain long-range ballistic missile technology. Linked to this will be additional work involving counterproliferation of weapons of mass destruction, including not only nuclear but also chemical and biological weapons. As discussed previously, cybertechnology and unmanned vehicles will certainly be part of this. Over time, NATO may take on a role in biological defense against both manmade agents and naturally occurring pandemics. All of these are expensive, high-tech applications that will require a well-resourced organization like NATO to be a leader globally.

Russia will remain problematic for the alliance while President Putin remains in power, and that is likely to be for a long time to come. While I believe that over time we will fulfill the mandate of the 2010 strategic guidance with regard to Russia ("forge a true strategic partnership"), it will be

difficult to do that under the current political construct. The Edward Snowden affair; disagreements over Georgia, Syria, and Ukraine; and a lingering sense of encirclement on the part of the Russians as they look at NATO expansion will stand in the way. Nonetheless, we should continue to seek positive zones of cooperation wherever we can—Afghanistan, piracy, narcotics, terrorism, and possibly cyberspace come to mind, although none of it will be easy.

Unbalanced levels of defense spending will pose a significant challenge for the alliance going forward. If European nations' spending continues to decline (it is below 1.5 percent of GDP and falling), the alliance will lose its sense of balance. Burden sharing has been a bone of contention for many years in the alliance, but Europe's ongoing struggles with budgets and the euro may continue to be a negative factor. While U.S. defense spending is in decline as well, we will by almost any measure continue to outspend the European allies (and Canada) by more than two to one. That is unsustainable over the long haul. American politicians will not indefinitely tolerate what they view as Europeans' "free ride." However, we should remember that while the Europeans have not met the NATO spending goals of 2 percent of GDP (with the exception of Britain, Greece, Turkey, and several other smaller countries), they still spend in the aggregate about $300 billion.

The key will be spending intelligently and using the principles of comparative advantage in what each nation buys. Smaller nations can purchase less expensive systems like minesweepers, helicopters, diesel submarines, and the like, somewhat freeing up larger nations to concentrate on super-high-tech systems like nuclear submarines, aircraft carriers, and advanced fighter jets. The key is that all the nations in the alliance should be at least close to (and preferably over) the 2 percent of GDP target we have all set for ourselves. Will this happen? I suspect we will see a moderate decline in U.S. spending, perhaps to around 3 percent of GDP, while our European allies will hopefully improve to around 2 percent as their economies come back. Whether that happens only time will tell, but if it does not, the stress on the alliance will be palpable.

Finally, there is a fundamental question about where NATO should operate in the time ahead. This is an important discussion if not a fault line in the alliance. Generally, some of the members (United States, United Kingdom, France) have an expansive view of where the alliance should operate, believing (as I do) that security threats in the twenty-first century are not bounded by geography. Dangers come from all around the world, and to meet them

we cannot restrict ourselves to the territory within the alliance. Extremism, cyberattacks, convergence, weapons of mass destruction, and so on can come from anywhere, and thus we must be ready to go anywhere. Other member nations believe that we should tend to our knitting in Europe, put the alliance on a very defensive crouch inside the borders of the North Atlantic (a big area, but hardly the world), concentrate on exercising and training, and (by the way) reduce defense spending. Personally, I think the latter approach, while understandable—especially after Iraq and Afghanistan—would be a mistake and eventually would doom the alliance to irrelevance.

For NATO to matter—both to the United States and to the world—it must be willing, albeit carefully, thoughtfully, and reluctantly, to intervene with military force not only within the borders of the alliance but outside them when called upon to do so and in accordance with international laws and norms.

WHAT KEEPS ME AWAKE AT NIGHT

Convergence*

Don't cross the streams!
—Dr. Egon Spengler, *Ghostbusters* (1984)

Throughout my time as the NATO strategic commander, I was often asked what kept me awake at night. After nearly forty years as a Navy officer that included active combat around the world, time in Iraq and Afghanistan, and the 9/11 attack on the Pentagon (which almost killed me), I am very highly attuned to dangers posed in the international environment, and there is no shortage of frightening answers to that question. Iran, North Korea, the insurgency in Afghanistan, civil war in Syria, cyberattacks, chemical weapons, terrorism, piracy—the list is long. But my simple one-word answer to what *really* kept me awake may surprise you: convergence.

Convergence is the dark side of globalization. It is the merger of a wide variety of globally mobile human activities, each of them individually dangerous but representing a far greater threat when they combine. In other words, the sum of the danger they present is far greater than the individual threat posed by each alone. The most obvious example of this kind of convergence has already entered the lexicon of global security as the hybrid word "narco-terrorism." Drug cartels possess the ability to use sophisticated and effective

*Material in this chapter first appeared in a *Washington Post* op-ed, "The Dark Side of Globalization" by James Stavridis, May 31, 2013.

trafficking routes to move huge amounts of heroin, cocaine, and methamphet-amines. Terrorists can in effect "rent" these routes by co-opting the drug cartels through money, coercion, or ideological persuasion. These organizations can then move weapons, personnel, cash, or—at the dark end of the spectrum—a weapon of mass destruction clandestinely to the United States.

I spent a great deal of time working with the Drug Enforcement Admin-istration (DEA) during my career, especially from 2006 to 2013. There is no more dedicated, energetic, and accomplished group of people working for the U.S. government, in my view. When I first went to the DEA in mid-2006 and met with the agency's leadership team, I shared with them an image I liked to use in my presentations. It showed two individuals with flamethrowers shoot-ing jets of flames into the sky. The two streams of flame joined together and created, quite literally, a fireball. It was a perfect example of the adage from the 1980s movie *Ghostbusters*, in which Harold Ramis' character warns the other Ghostbusters not to let the streams of their weapons cross. When you let the twin streams of terrorism and narcotics cross, the result is unpredict-able, frightening at the tactical level, and potentially strategically disastrous.

If a drug cartel decided to sell its trafficking routes to a terrorist organi-zation like al-Qaeda, or to a rogue nation like North Korea or Syria, for exam-ple, the potential that a weapon of mass destruction might enter the United States proper would be a very real concern. The odds of North Korea shooting a missile at the United States are frankly very low because we could instantly detect the origin and retaliate. But what if the North Koreans were to build a primitive device and pay a drug dealer to bring it into Galveston harbor on a semisubmersible craft? For the drug dealer, the financial attraction is obvious. For the owner of the weapon of mass destruction, the advantage is the ability to inflict huge economic damage on an adversary (the 9/11 attacks cost the U.S. economy well over $1 trillion) without any defined attribution.

Laboratories in North Korea, Iran, and Syria are right now producing or researching the production of sophisticated weapons of mass destruction. If these two streams merge—global trafficking routes and weapons of mass destruction—the result will be catastrophic. That's enough to keep anyone awake at night. Other globally trafficked illicit goods move on these narco-trafficking routes as well: stolen and counterfeit intellectual property, illegal migrants, human slaves, laundered cash, and sophisticated armaments.

An emerging special case of this kind of convergence happens in the world of cyberspace. Here we see the greatest mismatch between our level of

threat (high) and our level of preparation (low). Across the world's servers, fiber optic cables, and routers move high-threat packages in the service of nations, anarchic organizations, and garden-variety hackers. Trillions of dollars' worth of cybercrime occurs globally each year; if the cybercapability and the resultant cash converge with terrorist groups or with pariah states like Iran and North Korea, the potential for a catastrophic result is high. And, as with moving a weapon of mass destruction on a narcotics or criminal route, the risk of attribution is very low.

What to do about it? First and foremost, we must recognize the threat posed by this kind of deviant globalization. Convergence of mobile illicit activities can rapidly undermine global security norms. We too often focus on single-point threats—drugs, money laundering, human trafficking, weapons trading, or the production of weapons of mass destruction—without recognizing that the true threat lies in their ultimate convergence. The Obama administration's *Strategy to Combat Transnational Organized Crime*, published in 2011, is a step in the right direction. When I saw it, I thought, this is terrific! Someone is paying attention. Unfortunately, the continuing attention is near zero.

The iron law of politics is that there is room for only one crisis at a time. Think of the national security infrastructure as *Battlestar Galactica* orbiting the earth. They can tune in on a couple of key issues—today Afghanistan plus one other, with the one other rotating between North Korea, Syria, cyberthreats, and the crisis du jour. This isn't really their fault. Managing the slipstream of public diplomacy, Congress, the media, the international partners, the private sector, and so on is limited by the capacity of a small number of human beings to manage the information flow. What gets lost is the long-term but low-excitement-factor threat—like convergence—that does not present an immediate concern but in the long term is the real problem. The solution, easier to say than to accomplish, is to get the long-term challenges—like this idea of convergence—on the screen.

Second, we must recognize that it takes a network to confront another network. We are facing converging networks of criminal and terrorist activities, so we need to build network solutions. This means we must combine international, interagency, and private-public mechanisms for cooperation across the spectrum of threat—what I have elsewhere called open source security. Cybercrime, for example, cannot be dealt with in isolation—it needs the private sector fully cooperating; linkages between the Departments of

Defense, State, Commerce, Homeland Security, and Justice; and international partners, beginning with NATO.

A powerful force in this is the particular partnership that could be achieved between the Department of Defense special operators (notably the Joint Special Operations Command in Fort Bragg, North Carolina) and the DEA operational teams. By bringing them together—perhaps with private sector and Department of Justice expertise looking at financing—we could go after the threat of convergence very early in its development. Another example would be in the maritime world, where bringing the Navy, Coast Guard, DEA, NOAA, and private sector shipping companies together to exchange information, coordinate sailing routes, and act in sequence would have a powerful effect.

Third, we must follow the money. The basic fuel for the "engine of threat" is cash from trafficking activities. The huge sums not only finance terrorists and insurgencies such as the Taliban, but also create corruption and undermine fragile democracies. One key element of going after terrorists is to "follow the money" and determine the source of the financing that allows the bad guys to fund their efforts. By finding and then cutting off such sources, we can reduce the capabilities of terrorists and insurgents. This "threat financing" must be fused in the international context, move across agency lines here in the United States, and find cooperation from the private sector institutions that are involved. As mentioned above, getting the top folks together across agencies has great appeal. This is an area in which NATO and our other allies around the world (Japan, Colombia, Thailand, South Korea, etc.) could be very helpful as well. Working with the major international actors would have a very positive effect. This is not "little kids' soccer" where everyone jumps on the same ball—we need players spread across the field to detect the dangers, share information, and move forward together.

Private sector assistance will also be crucial in many ways. International finance is complex, to say the least, and the probability that any single government—or even a consortium of governments—can master the complexities is low. Bringing the major private sector financial transaction firms together with threat finance experts from around the world is an example of the sort of private-public partnering that must be expanded.

Fourth, we must shape and win the narrative. We often say we are in a "war of ideas," but that is not quite the right image. We are in a "marketplace of ideas." Our ideas are sound: democracy, liberty, freedom of speech and religion—all are the values of the Enlightenment. They have an important

role in confronting the ideological underpinnings of both crime and terror, and our strategic communication efforts are an important part of keeping our own networks aligned and cohesive.

In many ways, shaping the narrative is the key to countering convergence. By ensuring that our top operators are working together to "write the script" of counterconvergence, we can succeed together. This is complicated, obviously. The key will be ensuring agreement on the potential threat of convergence; crafting a narrative that emphasizes the need for all parties (public and private) to protect the global commons (including cyberspace) from menace; telling stories of successful partnerships (maritime counterpiracy, crushing global money-laundering schemes, etc.); and using social networks to move the message. This will encourage other actors to engage collectively in effective partnerships offering the best protection from convergent threats—no one of us is as strong as all of us acting together. In effect, we will use the positive convergence of the international community to ensure that the dark side of globalization does not permit the convergence of threatening elements: making sure the streams don't cross.

Fifth, and finally, we must sort out the balance between civilian and military activities in such areas as counternarcotics and cyberspace. There are legal complexities, issues of privacy, and appropriate jurisdictional questions that need to be answered. But the simple bottom line is that both have a role to play—witness the cooperation between the DEA and Department of Defense for positive examples.

A very necessary adjunct to these efforts is the creation of a cyberspace protection force for the nation. Much as we needed an air force when aviation became a dominant element in the global culture, economy, and security dimensions, today we need cyberpolice to protect cyberspace. Such a cyberforce would probably be a mix of military and civilian specialists; it would have a very different pay, benefit, and promotion system than seen heretofore in the Department of Defense; it would have a significant interagency component; and it would be inherently international in its search for effective partners around the world.

Just over a century ago, the poet Thomas Hardy wrote "The Convergence of the Twain," a poem about the deadly collision of the *Titanic* and the iceberg that sank it, which includes the following lines:

> *And as the smart ship grew*
> *In stature, grace, and hue*
> *In shadowy silent distance grew the Iceberg too.*

There is an iceberg out there ahead of us in the form of weapons of mass destruction. We need to worry about the convergence of such a weapon with a sophisticated global trafficking route enabled by cybercrime and the cash it generates. That is the convergence we must do all in our power to prevent.

Unfortunately, we haven't made a great deal of progress in that regard over the past decade, and the threat is outpacing the solution. We need to recognize convergence for the threat that it is, open ourselves to better partnerships and networks (international, interagency, and private-public), build and launch a more compelling strategic communication narrative, and employ the right people so that we can keep the streams from crossing.

GOING ASHORE*

All good things must come to an end.
—Geoffrey Chaucer, 1374

The Navy, more so perhaps than the other services, and certainly more so than other professions or parts of government, is all about tradition. When a sailor leaves a ship, he or she presents himself to the officer of the deck, salutes, and requests permission to go ashore. And when a sailor retires, the ceremony is performed one last time: the sailor is symbolically piped over the side and sails off into the unfamiliar world of civilian life.

Having spent my entire adult life (and part of my adolescence) in uniform, I found leaving the Navy a surreal experience. I had known it was coming since the day they shaved my head and issued me a sailor suit at Annapolis more than four decades before. My departure had been considered and delayed numerous times: from the early 1980s when I thought I was going to law school, to the 1990s when a senior admiral told me my career was over because he didn't like an article I wrote, and even recently when my handpicked successor at NATO beat me to the exit.

But finally, in the early summer of 2013, my time had come. When you are a four-star admiral your departure, like your career, is not a short one—and the proceedings left me plenty of time to reflect on my lengthy journey. Among the thoughts swirling about my head were some special feelings about the uniforms I had worn.

Navy officers have three principal uniforms. The one worn at any given time is generally defined by the season and the events in which the officer is

*Material in this chapter first appeared in a July 1, 2013, article in *The Atlantic*, "37 Years in the Navy" by James Stavridis.

engaged. The first is officially called Service Dress Whites, but those of us who have worn it refer to it as "chokers." It is the classic white, high-collared uniform with medals that Richard Gere made famous in the final scene of *An Officer and a Gentleman*. The second is the double-breasted dark blue suit with gold stripes at the sleeves, black necktie, and ribbons known in the Navy as Service Dress Blues. And the third is the day-to-day uniform that the Navy officer corps wore on ships at sea during the vast majority of my career: the classic short-sleeved Working Khakis. In my final days on active duty I got to wear each of those uniforms one last time.

I put on the Service Dress Whites on a hot, humid morning in Washington, D.C., carefully pinning on the medals, ensuring I had the requisite white gloves ready. I drove to the Iwo Jima Memorial adjacent to Arlington National Cemetery to participate in a very special ceremony. My twenty-two-year-old daughter Julia was to be commissioned in the U.S. Navy. A slender runner in build, Julia earned honors at Georgetown and chose to become a Navy nurse through the Naval Reserve Officer Training Corps program. I had been invited to be the graduation speaker for her NROTC class, and so I stood in front of several dozen young men and women about to become ensigns in the Navy or second lieutenants in the Marine Corps. I led them in the oath to the Constitution just as Donald Rumsfeld, in his first tour as secretary of defense, had led me in mine thirty-seven years before.

Julia was radiant in her whites, and when I looked at her and the entire class I saw the future—of the Navy and Marine Corps, of our nation, and indeed of our family. My father was a Marine Corps officer for more than thirty years, retiring from active duty shortly before I entered the service. The pedigree goes back even further on her mother's side. Julia is the fourth generation in her family line to take an officer's commission. I remember thinking how appropriate it was that the day of a bright new ensign was dawning as the grizzled old admiral sailed off into the sunset.

The opportunity to wear my Service Dress Blues a final time came a day or so later when I paid a final call on the president of the United States in the White House. I like to think I had come to know the president pretty well over the previous four years. As always, he was gracious, focused, and kind. Spending time with him in a one-on-one final courtesy call was a significant privilege. We discussed events in Afghanistan, NATO and its future, relations with Russia, and Syria. As a good leader does, the president took advantage of the opportunity not just to thank me for my service but to probe for ideas

that could make my successor's tour more profitable. I had worn my Blues countless times over the decades since Annapolis, and again, this seemed an appropriate place to wear them for the last time, showing the respect and deference to our civilian leadership that is the backbone of the U.S. military.

That left the uniform I had worn by far the most—khakis were always the everyday uniform for my many, many years at sea. I had totaled it up, looking through logbooks: in the course of thirty-seven years since Annapolis, I had spent nearly ten years under way, day for day, on the deep ocean out of sight of land. When would I wear khakis for the last time?

Too soon. The following week, after flying to my home in Florida, I put on Working Khakis to visit a ship at the Mayport Naval Station. I had chosen to visit an *Arleigh Burke*–class destroyer, USS *Carney*, a destroyer identical with the one I had commanded back in the mid-1990s. The captain and the executive officer were bright young commanders whom I had known and mentored for a decade. They had invited me to take a tour and have lunch with their officers in the wardroom.

It was a lovely, nostalgic visit. I chatted with the young officers and listened to their stories—the triumphs and setbacks of a ship's company preparing for a fall deployment. As I listened to them it was my own voice I heard echoing across the decades—striving to sound confident but a bit unsure in the presence of this ancient mariner with four stars on his collar. After lunch I drove off the base, and in the rearview mirror I saw an electronic sign at the main gate flashing, probably for the last time, "Welcome Admiral Stavridis."

Then I went home, to a small beachfront condo Laura and I had rented for a few weeks as we transitioned out of the Navy. It overlooked a beautiful stretch of north Florida beach, shimmering and white under the afternoon sun. As I looked toward the horizon at sunset, I saw two Navy ships—a cruiser and a frigate—sailing gracefully along the coast, headed into their berths at Mayport. By evening they would be tied to the pier, the lights going out throughout the ship, watches posted, and the majority of the crew headed home to families and friends for the long weekend ahead. For those warships, the smooth rhythms of the Navy and the sea and the sailors would slowly come to a halt over a nice Florida weekend; but for me, they were done forever.

It would not have been hard for me to let sadness overwhelm me. But fortunately I had already charted my next course. I had been selected to become dean of the Fletcher School of Law and Diplomacy at Tufts University, the oldest school in the United States dedicated solely to graduate-level study of

foreign affairs. It was the same place the Navy had sent me three decades before to earn my PhD, the place where I raised my focus beyond the horizon visible from the bridge of a ship. The prospect of helping young students "know the world," as the school's motto goes, raised my spirits immensely.

I hasten to say that I love my new job at the Fletcher School—it allows me to continue to wrestle with the challenges and opportunities of the international world. And above all I love being with brilliant faculty members who enlighten and inform my views every day; and with marvelous young students, all of whom are just beginning the gorgeous trajectory of their lives in the international world. What could be better for an accidental admiral?

But I will miss being a member of the U.S. military, and especially I will miss the Navy, the ships, the sailors, and the boundless sea. The cap and gown of academia are comforting, but I will miss putting on those uniforms—Whites, Blues, and Khakis—the cloth of my nation.

I shall miss it terribly.

GEN. JOHN KELLY'S E-MAIL
ON THE DEATH OF HIS SON, ROBERT

In November 2010 my friend John Kelly (then a three-star Marine general, later promoted to four stars) and his wife received the worst news imaginable: their son Robert had been killed in action in Afghanistan. Below is the e-mail message that John sent to friends and family after receiving the dreaded early-morning knock on the door. John would be the first to tell you that the death of *every* serviceman and -woman in combat brings equal sadness.

> From: Kelly LtGen John F
> Date: November 12, 2010, 10:23:20 p.m. EST
> Subject: My Boy
>
> Family and Friends,
>
> As I think you all know by now our Robert was killed in action protecting our country, its people, and its values from a terrible and relentless enemy, on 9 Nov, in Sangin, Afghanistan. He was leading his Grunts on a dismounted patrol when he was taken. They are shaken, but will recover quickly and already back at it. He went quickly and thank God he did not suffer. In combat that is as good as it gets, and we are thankful. We are a brokenhearted— but proud—family. He was a wonderful and precious boy living a meaningful life. He was in exactly the place he wanted to be, doing exactly what he wanted to do, surrounded by the best men on this earth—his Marines and Navy Doc.
>
> The nation he served has honored us with promoting him posthumously to First Lieutenant of Marines. We will bury our son, now 1stLt Robert Michael Kelly USMC, in Arlington National Cemetery

on 22 Nov. Services will commence at 1245 at Fort Myers. We will likely have a memorial receiving at a yet to be designated funeral home on 21 Nov. The coffin will be closed. Our son Captain John Kelly USMC, himself a multi-tour combat veteran and the best big brother on this earth, will escort the body from Dover Air Force Base to Arlington. From the moment he was killed he has never been alone and will remain under the protection of a Marine to his final resting place.

Many have offered prayers for us and we thank you, but his wonderful wife Heather and the rest of the clan ask that you direct the majority of your prayers to his platoon of Marines, still in contact and in "harm's way," and at greater risk without his steady leadership.

Thank you all for the many kindnesses; we could not get through this without you all. Thank you all for being there for us. The pain in unimaginable, and we could not do this without you.

Semper Fidelis
John Kelly

THE NORTH ATLANTIC TREATY

The Parties to this Treaty reaffirm their faith in the purposes and principles of the Charter of the United Nations and their desire to live in peace with all peoples and all governments.

They are determined to safeguard the freedom, common heritage and civilisation of their peoples, founded on the principles of democracy, individual liberty and the rule of law. They seek to promote stability and well-being in the North Atlantic area.

They are resolved to unite their efforts for collective defence and for the preservation of peace and security. They therefore agree to this North Atlantic Treaty:

ARTICLE 1

The Parties undertake, as set forth in the Charter of the United Nations, to settle any international dispute in which they may be involved by peaceful means in such a manner that international peace and security and justice are not endangered, and to refrain in their international relations from the threat or use of force in any manner inconsistent with the purposes of the United Nations.

ARTICLE 2

The Parties will contribute toward the further development of peaceful and friendly international relations by strengthening their free institutions, by bringing about a better understanding of the principles upon which these institutions are founded, and by promoting conditions of stability and well-being. They will seek to eliminate conflict in their international economic policies and will encourage economic collaboration between any or all of them.

ARTICLE 3

In order more effectively to achieve the objectives of this Treaty, the Parties, separately and jointly, by means of continuous and effective self-help and mutual aid, will maintain and develop their individual and collective capacity to resist armed attack.

ARTICLE 4

The Parties will consult together whenever, in the opinion of any of them, the territorial integrity, political independence or security of any of the Parties is threatened.

ARTICLE 5

The Parties agree that an armed attack against one or more of them in Europe or North America shall be considered an attack against them all and consequently they agree that, if such an armed attack occurs, each of them, in exercise of the right of individual or collective self-defence recognised by Article 51 of the Charter of the United Nations, will assist the Party or Parties so attacked by taking forthwith, individually and in concert with the other Parties, such action as it deems necessary, including the use of armed force, to restore and maintain the security of the North Atlantic area.

Any such armed attack and all measures taken as a result thereof shall immediately be reported to the Security Council. Such measures shall be terminated when the Security Council has taken the measures necessary to restore and maintain international peace and security.

ARTICLE 6[1]

For the purpose of Article 5, an armed attack on one or more of the Parties is deemed to include an armed attack:

on the territory of any of the Parties in Europe or North America, on the Algerian Departments of France,[2] on the territory of or on the Islands

1. The definition of the territories to which Article 5 applies was revised by Article 2 of the Protocol to the North Atlantic Treaty on the accession of Greece and Turkey signed on October 22, 1951.
2. On January 16, 1963, the North Atlantic Council noted that insofar as the former Algerian Departments of France were concerned, the relevant clauses of this Treaty had become inapplicable as from July 3, 1962.

under the jurisdiction of any of the Parties in the North Atlantic area north of the Tropic of Cancer; on the forces, vessels, or aircraft of any of the Parties, when in or over these territories or any other area in Europe in which occupation forces of any of the Parties were stationed on the date when the Treaty entered into force or the Mediterranean Sea or the North Atlantic area north of the Tropic of Cancer.

ARTICLE 7

This Treaty does not affect, and shall not be interpreted as affecting in any way the rights and obligations under the Charter of the Parties which are members of the United Nations, or the primary responsibility of the Security Council for the maintenance of international peace and security.

ARTICLE 8

Each Party declares that none of the international engagements now in force between it and any other of the Parties or any third State is in conflict with the provisions of this Treaty, and undertakes not to enter into any international engagement in conflict with this Treaty.

ARTICLE 9

The Parties hereby establish a Council, on which each of them shall be represented, to consider matters concerning the implementation of this Treaty. The Council shall be so organised as to be able to meet promptly at any time. The Council shall set up such subsidiary bodies as may be necessary; in particular it shall establish immediately a defence committee which shall recommend measures for the implementation of Articles 3 and 5.

ARTICLE 10

The Parties may, by unanimous agreement, invite any other European State in a position to further the principles of this Treaty and to contribute to the security of the North Atlantic area to accede to this Treaty. Any State so invited may become a Party to the Treaty by depositing its instrument of accession with the Government of the United States of America. The Government of the United States of America will inform each of the Parties of the deposit of each such instrument of accession.

Article 11

This Treaty shall be ratified and its provisions carried out by the Parties in accordance with their respective constitutional processes. The instruments of ratification shall be deposited as soon as possible with the Government of the United States of America, which will notify all the other signatories of each deposit. The Treaty shall enter into force between the States which have ratified it as soon as the ratifications of the majority of the signatories, including the ratifications of Belgium, Canada, France, Luxembourg, the Netherlands, the United Kingdom and the United States, have been deposited and shall come into effect with respect to other States on the date of the deposit of their ratifications.[3]

Article 12

After the Treaty has been in force for ten years, or at any time thereafter, the Parties shall, if any of them so requests, consult together for the purpose of reviewing the Treaty, having regard for the factors then affecting peace and security in the North Atlantic area, including the development of universal as well as regional arrangements under the Charter of the United Nations for the maintenance of international peace and security.

Article 13

After the Treaty has been in force for twenty years, any Party may cease to be a Party one year after its notice of denunciation has been given to the Government of the United States of America, which will inform the Governments of the other Parties of the deposit of each notice of denunciation.

Article 14

This Treaty, of which the English and French texts are equally authentic, shall be deposited in the archives of the Government of the United States of America. Duly certified copies will be transmitted by that Government to the Governments of other signatories.

Washington, D.C., April 4, 1949

3. The Treaty came into force on August 24, 1949, after the deposition of the ratifications of all signatory states.

THE NATO LISBON SUMMIT DECLARATION

Issued by the Heads of State and Government participating in the meeting of the North Atlantic Council in Lisbon

1. We, the Heads of State and Government of the member countries of the North Atlantic Alliance, have gathered in Lisbon to chart NATO's future course. We reaffirm our commitment to the common vision and shared democratic values embodied in the Washington Treaty, and to the purposes and principles of the United Nations Charter. Based on solidarity, Alliance cohesion and the indivisibility of our security, NATO remains the transatlantic framework for strong collective defence and the essential forum for security consultations and decisions among Allies. NATO's fundamental and enduring purpose is to safeguard the freedom and security of all its members by political and military means. The Alliance must and will continue fulfilling effectively, and always in accordance with international law, three essential core tasks—collective defence, crisis management, and cooperative security—all of which contribute to safeguarding Alliance members.

2. We have adopted a new Strategic Concept that lays out our vision for the Alliance for the next decade: able to defend its members against the full range of threats; capable of managing even the most challenging crises; and better able to work with other organisations and nations to promote international stability. NATO will be more agile, more capable and more cost-effective, and it will continue to serve as an essential instrument for peace. In accordance with the detailed provisions of this Declaration, we have also:

 * decided to enhance NATO's contribution to a comprehensive approach to crisis management as part of the international

community's effort and to improve NATO's ability to deliver stabili-
sation and reconstruction effects;

- encouraged the Secretary General to continue to work with the Euro-
pean Union High Representative and to report to the Council on the
ongoing efforts in time for the NATO Foreign Ministers' meeting in
April 2011;

- invited Russia to deepen its cooperation with us on the areas where
we have common interests;

- agreed to further enhance our existing partnerships and to develop
new ones with interested countries and organisations;

- agreed to continue to review NATO's overall defence and deterrence
posture;

- agreed that, consistent with the Strategic Concept and their com-
mitments under existing arms control treaties and frameworks,
Allies will continue to support arms control, disarmament and non-
proliferation efforts;

- decided to develop a missile defence capability to protect all NATO
European populations, territory and forces, and invited Russia to
cooperate with us;

- agreed to enhance our cyber defence capabilities;

- agreed an Action Plan to mainstream United Nations Security Coun-
cil Resolution 1325 on Women, Peace and Security into NATO-led
operations and missions;

- tasked the development of Political Guidance for the further improve-
ment of our defence capabilities and the military implementation of
the new Strategic Concept;

- agreed the Lisbon package of the Alliance's most pressing capability
needs;

- directed the implementation of a more effective, leaner and afford-
able Alliance Command Structure, and the consolidation of the
NATO Agencies; and

- tasked the Secretary General and the Council to take forward the
reform process in all necessary areas without delay.

3. We express our profound gratitude for the professionalism, dedication
and bravery of the more than 143,000 men and women from Allied and

partner nations who are deployed on NATO's operations and missions. We owe a deep debt of gratitude to all those who have lost their lives or been injured during the course of their duties, and we extend our deepest sympathies to their families and loved ones. We pledge to support our veterans. To further advance this important objective, Allies will share, where beneficial, national best practices and lessons learned.

4. As expressed in the Declaration by the Heads of State and Government of the nations contributing to the UN-mandated, NATO-led International Security Assistance Force (ISAF) in Afghanistan, our ISAF mission in Afghanistan remains the Alliance's key priority, and we welcome the important progress that has been made. Afghanistan's security and stability are directly linked with our own security. In meeting with President Karzai, all our 21 partners in ISAF, the United Nations, the European Union, the World Bank and Japan, we reaffirm our long-term commitment to Afghanistan, as set out in our strategic vision agreed at the Bucharest Summit and reaffirmed at the Strasbourg/Kehl Summit. We welcome the valuable and increased contributions made by our ISAF partners and would welcome further contributions. We are entering a new phase in our mission. The process of transition to full Afghan security responsibility and leadership in some provinces and districts is on track to begin in early 2011, following a joint Afghan and NATO/ISAF assessment and decision. Transition will be conditions-based, not calendar-driven, and will not equate to withdrawal of ISAF troops. Looking to the end of 2014, Afghan forces will be assuming full responsibility for security across the whole of Afghanistan. Through our enduring partnership with the Government of the Islamic Republic of Afghanistan, we reaffirm our long-term commitment to a better future for the Afghan people.

5. We remain steadfast in our commitment to regional stability and security throughout the Balkans region. KFOR remains in Kosovo on the basis of United Nations Security Council Resolution 1244 to support a stable, peaceful and multi-ethnic environment, cooperating with all relevant actors, in particular the European Union Rule of Law Mission in Kosovo (EULEX), and the Kosovo Police, in accordance with NATO agreed decisions and procedures. We welcome the progress made by the Kosovo Security Force, under NATO's close supervision, and the Kosovo

Police, and commend them for their readiness and growing capability to implement their security tasks and responsibilities. Reflecting the improving security situation, KFOR is moving towards a smaller, more flexible, deterrent presence. We expect this process of transition to a deterrent posture, implying further troop reductions, to continue as fast as conditions allow, and will keep it under political review. KFOR's capability to carry out its mission throughout the transition process will be maintained.

6. The Alliance is also contributing to peace and security through other operations and missions:

- Operation Active Endeavour (OAE), our Article 5 maritime operation in the Mediterranean, is making a significant contribution to the fight against terrorism.
- Operation Ocean Shield off the Horn of Africa demonstrates NATO's commitment to contribute to the sustained comprehensive international effort to help counter piracy and armed robbery at sea.
- At the request of the African Union (AU), we are providing support to its mission in Somalia and the development of its long-term peacekeeping capabilities, including the African Stand-by Force. At the request of the UN Secretary-General, we are also escorting UN chartered vessels in support of the African Union Mission in Somalia.
- The NATO Training Mission in Iraq (NTM-I) demonstrates the Alliance's support for the Government and people of Iraq. We stand ready to consider requests for further training. We also stand ready to advance our partnership with Iraq through the Structured Cooperation Framework.

7. We welcome the 10th Anniversary of UNSCR 1325 on Women, Peace and Security. Guided by the Policy that we developed together with our Partners in the Euro-Atlantic Partnership Council, we have already taken significant steps to implement it and its related Resolutions. We have today endorsed an Action Plan to mainstream the provisions of UNSCR 1325 into our current and future crisis management and operational planning, into Alliance training and doctrine, and into all relevant aspects of the Alliance's tasks. We are committed to the implementation of this Policy and Action Plan as an integral part of our work to improve the Alliance's effectiveness, and today we endorsed recommendations to

this end. We have tasked the Council to provide a progress report to our Foreign Ministers in December 2011 and at the next Summit.

8. Our operational experience has taught us that military means, although essential, are not enough on their own to meet the many complex challenges to our security. Both within and outside the Euro-Atlantic area, NATO must work with other actors to contribute to a comprehensive approach that effectively combines political, civilian and military crisis management instruments. Its effective implementation requires all actors to contribute in a concerted effort, based on a shared sense of responsibility, openness and determination, and taking into account their respective strengths, mandates and roles, as well as their decision-making autonomy.

9. A number of important principles and lessons have been identified and these should be taken into account as the Alliance approaches the next phase of development of its contribution to an effective comprehensive approach by the international community. As a general rule, elements of stabilisation and reconstruction are best undertaken by those actors and organisations that have the relevant expertise, mandate, and competence. However, there can be circumstances which may hamper other actors from undertaking these tasks, or undertaking them without support from NATO. Based on the detailed political guidance which we have endorsed at this Summit, the Alliance must, therefore, have the ability to plan for, employ, and coordinate civilian as well as military crisis management capabilities that nations provide for agreed Allied missions. To improve NATO's contribution to a comprehensive approach and its ability to contribute, when required, to stabilisation and reconstruction, we have agreed to form an appropriate but modest civilian capability to interface more effectively with other actors and conduct appropriate planning in crisis management, as addressed in the political guidance mentioned above. We have also noted the progress achieved in the implementation of the Comprehensive Approach Action Plan agreed at our 2008 Bucharest Summit, and have tasked the Council to update this Action Plan before Foreign Ministers meet in April 2011.

10. We are committed to strong and productive cooperation between NATO and the United Nations. We welcome the strengthened practical cooperation following the Joint Declaration on UN/NATO Secretariat

Cooperation of September 2008. We aim to deepen this practical cooperation and further develop our political dialogue on issues of common interest, including through enhanced liaison, more regular political consultation, and enhanced practical cooperation in managing crises where both organisations are engaged.

11. NATO and the European Union (EU) share common values and strategic interests, and are working side by side in crisis management operations. We are therefore determined to improve the NATO-EU strategic partnership, as agreed by our two organisations. We welcome the recent initiatives from several Allies and the ideas proposed by the Secretary General. Building on these initiatives and on the guidance provided by the new Strategic Concept, we encourage the Secretary General to continue to work with the EU High Representative and to report to the Council on the ongoing efforts in time for the NATO Foreign Ministers' meeting in April 2011.

12. The Organisation for Security and Cooperation in Europe (OSCE) is an important regional security organisation and a forum for dialogue on issues relevant to Euro Atlantic security, as demonstrated by the Corfu Process. Encompassing the political/military, economic/environmental, and human dimensions, the OSCE plays an important role in promoting security and cooperation. We aim to further enhance the Alliance's cooperation with the OSCE, both at the political and operational level, in particular in areas such as conflict prevention and resolution, post-conflict rehabilitation, and in addressing new security threats. As we celebrate the 20th anniversary of the Paris Charter, we look forward to the OSCE Summit in Astana, Kazakhstan, on 1–2 December 2010.

13. In accordance with Article 10 of the Washington Treaty, NATO's door will remain open to all European democracies which share the values of our Alliance, which are willing and able to assume the responsibilities and obligations of membership, which are in a position to further the principles of the Treaty, and whose inclusion can contribute to the security of the North Atlantic area.

14. We reiterate the agreement at our 2008 Bucharest Summit to extend an invitation to the former Yugoslav Republic of Macedonia as soon as a mutually acceptable solution to the name issue has been reached within the framework of the UN, and urge intensified efforts towards that end.

We will continue to support and assist the reform efforts of the Government of the former Yugoslav Republic of Macedonia.[1] We welcome the former Yugoslav Republic of Macedonia's increased contribution to ISAF.

15. In the strategically important Western Balkans region, democratic values, regional cooperation and good neighbourly relations are important for lasting peace and stability. We will continue to actively support Euro-Atlantic aspirations in this region.

16. We welcome the considerable progress that Montenegro has made on its road to Euro-Atlantic integration and its contribution to security in the region and beyond, including through its participation in ISAF. Its active engagement in the Membership Action Plan (MAP) process demonstrates Montenegro's firm commitment to join the Alliance. We look forward to the successful implementation of its first Annual National Programme and will continue, through the MAP, to support Montenegro's continuing efforts to reform.

17. We fully support the membership aspiration of Bosnia and Herzegovina. We welcome the orderly conduct of elections in October 2010; progress on reform; its ongoing efforts to destroy surplus arms and munitions; and its contribution to international security, including through its new ISAF commitment. In accordance with the Statement by our Foreign Ministers in December 2009, we encourage Bosnia and Herzegovina's political leaders to work together to re-double their efforts to improve further the efficiency and self-reliance of state-level institutions and to advance essential reform priorities. We reaffirm the decision taken by NATO Foreign Ministers in Tallinn in April 2010 to invite Bosnia and Herzegovina to join the Membership Action Plan, authorizing the Council to accept Bosnia and Herzegovina's first Annual National Programme under the MAP only when all immovable defence properties identified as necessary for future defence purposes have been officially registered as the state property of Bosnia and Herzegovina, for use by the country's Ministry of Defence. The Alliance would welcome Bosnia and Herzegovina accelerating the process of achieving its Euro-Atlantic aspiration. For our part, we will continue to provide technical assistance

1. Turkey recognises the Republic of Macedonia with its constitutional name.

to Bosnia and Herzegovina's reform efforts, including to aid necessary progress for commencing MAP.

18. We welcome, and continue to support, the Government of Serbia's stated commitment to Serbia's Euro-Atlantic integration. We welcome the increasing cooperation between NATO and Serbia. We reiterate our openness to Serbia's further aspirations, including taking advantage of NATO's partnership opportunities for political consultation and practical cooperation. We call upon Serbia to maintain its efforts with a view to fully cooperating with the International Criminal Tribunal for the former Yugoslavia (ICTY) in order to achieve additional positive results, the most critical issue being the arrest of the remaining fugitives, and their transfer to the ICTY.

19. We call upon Serbia to support further efforts towards the consolidation of peace and stability in Kosovo. We urge both to take full advantage of the opportunities offered by the European Union–facilitated dialogue between them, which was welcomed in the United Nations General Assembly Resolution of 9 September 2010 as a contribution towards peace, security and stability in the region. We encourage progress in consolidating the rule of law. We welcome progress and encourage further efforts to protect ethnic minorities and communities, as well as historical and religious sites in Kosovo.

20. Stability and successful political and economic reform in Georgia and Ukraine are important to Euro-Atlantic security. We will continue and develop the partnerships with these countries taking into account the Euro-Atlantic aspiration or orientation of each of the countries.

21. At the 2008 Bucharest Summit we agreed that Georgia will become a member of NATO and we reaffirm all elements of that decision, as well as subsequent decisions. We will foster political dialogue and practical cooperation with Georgia, including through the NATO-Georgia Commission and the Annual National Programme. We strongly encourage and actively support Georgia's continued implementation of all necessary reforms, particularly democratic, electoral and judicial reforms, as well as security and defence sector reforms, in order to advance its Euro-Atlantic aspirations. We welcome the recent opening of the NATO Liaison Office in Georgia which will help in maximising our assistance and support for the country's reform efforts. We welcome Georgia's

important contributions to NATO operations, in particular to ISAF. We reiterate our continued support for the territorial integrity and sovereignty of Georgia within its internationally recognised borders. We encourage all participants in the Geneva talks to play a constructive role as well as to continue working closely with the OSCE, UN and the EU to pursue peaceful conflict resolution in the internationally-recognised territory of Georgia. We continue to call on Russia to reverse its recognition of the South Ossetia and Abkhazia regions of Georgia as independent states.

22. A stable, democratic and economically prosperous Ukraine is an important factor for Euro-Atlantic security. Recognising the sovereign right of each nation to freely choose its security arrangements, we respect Ukraine's policy of "non-bloc" status. NATO remains committed to providing the relevant assistance to Ukraine for the implementation of wide-ranging domestic reforms. We welcome the Ukrainian Government's commitment to continue to pursue fully Ukraine's Distinctive Partnership with NATO, including through high-level political dialogue in the NATO-Ukraine Commission, and reform and practical cooperation through the Annual National Programme, and in this context, we recall that NATO's door remains open, as stated in the Bucharest Summit decision. We remain convinced that mutually beneficial cooperation between NATO and Ukraine will continue to be of key importance for peace and security in the Euro-Atlantic area and beyond, and appreciate the constructive role Ukraine plays in this respect, including through its participation in NATO-led operations. We welcome Ukraine's interest in developing new areas of cooperation.

23. NATO-Russia cooperation is of strategic importance, as reflected by today's meeting of the NATO-Russia Council (NRC) at the level of Heads of State and Government in Lisbon. In light of common security interests, we are determined to build a lasting and inclusive peace, together with Russia, in the Euro-Atlantic Area. We need to share responsibility in facing up to common challenges, jointly identified. We want to see a true strategic partnership between NATO and Russia, and we will act accordingly, with the expectation of reciprocity from Russia. We recommit ourselves to the goals, principles and commitments which underpin the NRC. On this firm basis, we urge Russia to meet its commitments with respect to Georgia, as mediated by the European Union

on 12 August and 8 September 2008.[2] Over the past year, NATO-Russia cooperation has progressed and produced notable results. We welcome, in particular, the completion of the Joint Review of 21st Century Common Security Challenges, which has identified practical cooperation projects on Afghanistan, including counter-narcotics; non-proliferation of weapons of mass destruction and their means of delivery; counter-piracy; counter-terrorism; and disaster response. We also welcome the new extended arrangements offered by Russia to facilitate ISAF transit to and from Afghanistan. We are actively pursuing cooperation with Russia on missile defence, including through the resumption of theatre missile defence exercises. We will also want to discuss in the NRC a range of other topics, including Afghanistan; implementing OSCE principles; military deployments, including any that could be perceived as threatening; information sharing and transparency on military doctrine and posture, as well as the overall disparity in short-range nuclear weapons; arms control; and other security issues. We look forward to discussing all these matters in the NRC, which is a forum for political dialogue at all times and on all issues, including where we disagree. Our dialogue and cooperation with Russia also help us to resolve differences by building trust, mutual confidence, transparency, predictability and mutual understanding.

24. Partnerships enhance Euro-Atlantic and wider international security and stability; can provide frameworks for political dialogue and regional cooperation in the field of security and defence; contribute to strengthening our common values; and are essential to the success of many of our operations and missions. They enable us to share expertise; support broader reform; promote transparency, accountability and integrity in the defence sector; train and assist our partners in developing their own capabilities; and prepare interested nations for membership in NATO. They are also important in addressing emerging, and continuing, trans-national challenges such as proliferation, terrorism, maritime-, cyber- and energy security.

25. We remain committed to further developing political dialogue and practical cooperation with our partners. In doing so, we will carry forward

2. As complemented by President Sarkozy's letter dated August 16, 2008, and subsequent correspondence on this issue.

the important achievements of NATO's partnerships policy and continue to respect the specificity of our existing multilateral partnerships:

- The Euro-Atlantic Partnership Council (EAPC) and Partnership for Peace (PfP) are central to our vision of a Europe whole, free and at peace. We reiterate our commitment to further develop the EAPC/PfP as the essential framework for substantive political dialogue and practical cooperation, including enhanced military interoperability, and will continue to develop policy initiatives;

- Peace and stability in the Mediterranean region are essential for Euro-Atlantic security. We intend to further develop the Mediterranean Dialogue (MD) by raising its political and practical dimensions, in order to build mutual confidence and to deal together with the common security challenges in this region;

- We welcome the progress achieved in the framework of the Istanbul Cooperation Initiative (ICI) since its establishment in 2004. NATO and ICI countries have intensified political consultations and enhanced practical cooperation in various areas. We look forward to working with ICI partners with a view to further developing and strengthening this Initiative; and

- NATO's relationships with other partners across the globe are expanding and deepening, reflecting common goals in the area of security.

26. NATO's partnership mechanisms have evolved substantially over the past 20 years and they, like NATO itself, would benefit from a focused reform effort to make our dialogue and cooperation more meaningful, and to enhance the strategic orientation of our cooperation through a better assessment of the cooperation activities conducted with partners. To this end, we will:

- streamline NATO's partnership tools in order to open all cooperative activities and exercises to our partners and to harmonise our partnership programmes;

- better engage with our partners across the globe who contribute significantly to security, and reach out to relevant partners to build trust, increase transparency and develop practical cooperation;

- develop flexible formats to discuss security challenges with our partners and enhance existing fora for political dialogue; and

- build on improvements in NATO's training mechanisms (including the NATO Training Cooperation Initiative) and consider methods to enhance individual partners' ability to build capacity.

27. We have tasked the Council to develop a more efficient and flexible partnership policy for the April 2011 Foreign Ministers' meeting in Berlin, while continuing to implement agreed measures expeditiously. We will consult with all interested partners on the development and implementation of this policy to ensure their full ownership.

28. We greatly value the contributions made by partner countries to our operations and missions. These contributions demonstrate our partners' commitment, alongside NATO, to promote international security and stability. We have today tasked the Council to consult with partners and, building on lessons learned and reinforcing the habit of cooperation established through KFOR and ISAF, to review the Political-Military Framework for NATO-led PfP Operations, in order to update how we work together and shape decisions with partner countries on the operations and missions to which they contribute; this work should be completed in time for the meeting of NATO Defence Ministers in June 2011, with a progress report for Foreign Ministers in April 2011.

29. Security and stability in the Black Sea region continue to be important for Euro-Atlantic security. We welcome the progress in consolidating regional cooperation and ownership, through effective use of existing initiatives and mechanisms, based on transparency, complementarity and inclusiveness. We encourage these efforts and stand ready to support them, as appropriate, based on regional priorities and dialogue and cooperation among the Black Sea countries and with the Alliance.

30. Our Strategic Concept underscores our commitment to ensuring that NATO has the full range of capabilities necessary to deter and defend against any threat to the safety of our populations and the security of our territory. To that end, NATO will maintain an appropriate mix of conventional, nuclear, and missile defence forces. Missile defence will become an integral part of our overall defence posture. Our goal is to bolster deterrence as a core element of our collective defence and contribute to the indivisible security of the Alliance. We have tasked the Council to continue to review NATO's overall posture in deterring and defending against the full range of threats to the Alliance, taking into

account changes in the evolving international security environment. This comprehensive review should be undertaken by all Allies on the basis of deterrence and defence posture principles agreed in the Strategic Concept, taking into account WMD and ballistic missile proliferation. Essential elements of the review would include the range of NATO's strategic capabilities required, including NATO's nuclear posture, and missile defence and other means of strategic deterrence and defence. This only applies to nuclear weapons assigned to NATO.

31. Consistent with the Strategic Concept and their commitments under existing arms control treaties and frameworks, Allies will continue to support arms control, disarmament and non-proliferation efforts. We are resolved to seek a safer world for all and create the conditions for a world without nuclear weapons in accordance with the goal of the Nuclear Non-Proliferation Treaty (NPT). We welcome the conclusion of the New START Treaty and look forward to its early ratification and entry into force. With the changes in the security environment since the end of the Cold War, we have dramatically reduced the number of nuclear weapons stationed in Europe and our reliance on nuclear weapons in NATO strategy. We will seek to create the conditions for further reductions in the future. We are committed to conventional arms control, which provides predictability, transparency, and a means to keep armaments at the lowest possible level for security. We will work to strengthen the conventional arms control regime in Europe on the basis of reciprocity, transparency, and host nation consent. In order to maintain, and develop further, appropriate consultations among Allies on these issues, we task the Council to establish a Committee to provide advice on WMD control and disarmament in the context of the review above, taking into account the role of the High Level Task Force (HLTF).

32. The Alliance reaffirms its continued commitment to the CFE Treaty Regime with all its elements. Although agreement has not yet been reached on how to strengthen and modernise the arms control regime for the 21st Century, we welcome progress to date and encourage the 36 participating nations, on an equal footing, including all Allies and CFE States Parties, to redouble efforts to conclude a principles-based framework to guide negotiations in 2011. Building on the CFE Treaty of 1990, the Agreement on Adaptation of 1999, and existing political commitments, our goal would be to take a significant step toward ensuring the

continued viability of conventional arms control in Europe and strength-ening our common security. We look forward to making concrete prog-ress toward this end this year. The results of our work in the coming weeks and months will guide our future decisions on continued imple-mentation of CFE obligations, given that, as we said at the Strasbourg/Kehl Summit, the current situation, where NATO CFE Allies implement the Treaty while Russia does not, cannot continue indefinitely.

33. We continue to be concerned about the proliferation of weapons of mass destruction (WMD). We recall our Declaration at Strasbourg/Kehl and the United Nations Security Council's serious concern with Iran's nuclear programme, and call upon Iran to comply fully and with-out delay with all relevant UNSCRs. In this context, we welcome the resumption of talks between the P5+1 and Iran. We are also deeply con-cerned by the nuclear programme of the Democratic People's Republic of Korea and call on it to comply fully with UNSCRs 1718 and 1874, and relevant international obligations.

34. We call for universal adherence to, and compliance with, the Nuclear Non-Proliferation Treaty (NPT) and to the additional protocol to the International Atomic Energy Agency Safeguard Agreement, and call for full implementation of UNSCR 1540. We will continue to implement NATO's Strategic-Level Policy for Preventing the Proliferation of WMD and Defending Against Chemical, Biological, Radiological and Nuclear Threats. We task the Council to assess and report, before the meeting of Defence Ministers in June 2011, on how NATO can better counter the proliferation of WMD and their means of delivery.

35. With our vision of a Euro-Atlantic area at peace, the persistence of pro-tracted regional conflicts in South Caucasus and the Republic of Mol-dova continues to be a matter of great concern for the Alliance. We urge all parties to engage constructively and with reinforced political will in peaceful conflict resolution, and to respect the current negotiation formats. We call on them all to avoid steps that undermine regional security and stability. We remain committed in our support of the terri-torial integrity, independence and sovereignty of Armenia, Azerbaijan, Georgia and the Republic of Moldova, and will also continue to support efforts towards a peaceful settlement of these regional conflicts, taking into account these principles.

36. The threat to NATO European populations, territory and forces posed by the proliferation of ballistic missiles is increasing. As missile defence forms part of a broader response to counter this threat, we have decided that the Alliance will develop a missile defence capability to pursue its core task of collective defence. The aim of a NATO missile defence capability is to provide full coverage and protection for all NATO European populations, territory and forces against the increasing threats posed by the proliferation of ballistic missiles, based on the principles of the indivisibility of Allied security and NATO solidarity, equitable sharing of risks and burdens, as well as reasonable challenge, taking into account the level of threat, affordability and technical feasibility, and in accordance with the latest common threat assessments agreed by the Alliance.

37. To this end, we have decided that the scope of NATO's current Active Layered Theatre Ballistic Missile Defence (ALTBMD) programme's command, control and communications capabilities will be expanded beyond the protection of NATO deployed forces to also protect NATO European populations, territory and forces. In this context, the United States European Phased Adaptive Approach is welcomed as a valuable national contribution to the NATO missile defence architecture, as are other possible voluntary contributions by Allies. We have tasked the Council to develop missile defence consultation, command and control arrangements by the time of the March 2011 meeting of our Defence Ministers. We have also tasked the Council to draft an action plan addressing steps to implement the missile defence capability by the time of the June 2011 Defence Ministers' meeting.

38. We will continue to explore opportunities for missile defence cooperation with Russia in a spirit of reciprocity, maximum transparency and mutual confidence. We reaffirm the Alliance's readiness to invite Russia to explore jointly the potential for linking current and planned missile defence systems at an appropriate time in mutually beneficial ways. NATO missile defence efforts and the United States European Phased Adaptive Approach provide enhanced possibilities to do this. We are also prepared to engage with other relevant states, on a case by case basis, to enhance transparency and confidence and to increase missile defence mission effectiveness.

39. Instability or conflict beyond NATO borders can directly threaten Alliance security, including by fostering extremism, terrorism, and transnational illegal activities such as trafficking in arms, narcotics and people. Terrorism in particular poses a real and serious threat to the security and safety of the Alliance and its members. All acts of terrorism are criminal and unjustifiable, irrespective of their motivations or manifestations. We will continue to fight this scourge, individually and collectively, in accordance with international law and the principles of the UN Charter. In accordance with the Strategic Concept, we will continue to enhance both the political and the military aspects of NATO's contribution to deter, defend, disrupt and protect against this threat including through advanced technologies and greater information and intelligence sharing. We reiterate our continued commitment to dialogue and practical cooperation with our partners in this important area. We deplore all loss of life and extend our sympathies to the victims of terrorism. What they suffer is a visible demonstration of the evil of terrorism and should help mobilise civil society against it.

40. Cyber threats are rapidly increasing and evolving in sophistication. In order to ensure NATO's permanent and unfettered access to cyberspace and integrity of its critical systems, we will take into account the cyber dimension of modern conflicts in NATO's doctrine and improve its capabilities to detect, assess, prevent, defend and recover in case of a cyber attack against systems of critical importance to the Alliance. We will strive in particular to accelerate NATO Computer Incident Response Capability (NCIRC) to Full Operational Capability (FOC) by 2012 and the bringing of all NATO bodies under centralised cyber protection. We will use NATO's defence planning processes in order to promote the development of Allies' cyber defence capabilities, to assist individual Allies upon request, and to optimise information sharing, collaboration and interoperability. To address the security risks emanating from cyberspace, we will work closely with other actors, such as the UN and the EU, as agreed. We have tasked the Council to develop, drawing notably on existing international structures and on the basis of a review of our current policy, a NATO in-depth cyber defence policy by June 2011 and to prepare an action plan for its implementation.

41. A stable and reliable energy supply, diversification of routes, suppliers and energy resources, and the interconnectivity of energy networks,

remain of critical importance. The Alliance will continue to consult on the most immediate risks in the field of energy security in accordance with decisions at previous Summits and in line with our new Strategic Concept. We will further develop the capacity to contribute to energy security, concentrating on areas, agreed at Bucharest, where NATO can add value. In advancing our work, we will enhance consultations and cooperation with partners and other international actors, as agreed, and integrate, as appropriate, energy security considerations in NATO's policies and activities. We task the Council to prepare an interim report on the progress achieved in the area of energy security for the Foreign Ministers' meeting in December 2011, and a further report for consideration at our next Summit.

42. Key environmental and resource constraints, including health risks, climate change, water scarcity and increasing energy needs, will further shape the future security environment in areas of concern to NATO and have the potential to significantly affect NATO planning and operations.

43. Having adopted a new Strategic Concept, we have tasked the Council to develop Political Guidance for the continuing transformation of our defence capabilities and forces and the military implementation of our new Strategic Concept for approval by Defence Ministers at their meeting in March 2011.

44. We reaffirm our resolve to continue to provide the resources, including the forces and capabilities required to perform the full range of Alliance missions. Particularly in light of these difficult economic times, we must exercise the utmost financial responsibility over defence spending. We are determined to pursue reform and defence transformation and continue to make our forces more deployable, sustainable, interoperable, and thus more usable. We will ensure that the Alliance is effective and efficient. In this context, we welcome the outcome of the France–United Kingdom Summit on 2 November 2010 which will reinforce their security and defence cooperation by introducing innovative methods of pooling and sharing. We believe that such bilateral reinforcements of European capabilities will contribute to NATO's overall capabilities.

45. We have endorsed the Lisbon package of the Alliance's most pressing capability needs and thereby provided a renewed focus and mandate to ensure these critical capabilities are delivered within agreed budgetary

ceilings and in accordance with the Alliance's defence planning process. The Lisbon package will help the Alliance to:

- Meet the demands of ongoing operations—including through developing further capabilities to counter improvised explosive devices, and the greater use of collective logistics for medical support and other operational requirements.
- Face current, evolving and emerging challenges—including through expanding the current theatre missile defence programme, and defending against cyber attacks.
- Acquire key enabling capabilities—including information systems for more effective decision-making and command and control, and improved arrangements for sharing intelligence.

46.　We have tasked the Council, in time for the meeting of NATO Defence Ministers in March 2011, to conduct further conceptual work on multinational approaches and other innovative ways of cost-effective capability development. We welcome cooperation with the EU, as agreed. Together, and avoiding unnecessary duplication, we will continue to address common shortfalls, which include the areas of countering improvised explosive devices, providing medical support and increasing the availability of heavy-lift helicopters.

47.　The NATO Response Force (NRF) provides a rapidly deployable, credible force for collective defence and crisis operations, as well as a visible assurance to all Allies of NATO's cohesion and commitment to deterrence and collective defence, including through planning, training and exercises. We welcome the more flexible structure adopted for the NRF, which continues to be a vehicle for pursuing transformation and capability development for NATO and nations.

48.　The essential core tasks identified in our new Strategic Concept will require that we continue to adapt our Alliance. This calls for an ambitious and coherent package of reform measures, building upon those already introduced, including review of the NATO Command Structure and Agencies Reform, comprehensive Resource Management Reform, and Headquarters Reform, which should also take into consideration the move into the new Headquarters building. We underline our strong support for the Secretary General's initiatives to streamline NATO's civilian and military structures and to improve the management of NATO's resources.

49. We have agreed a framework for a new NATO Command Structure, which will be more effective, leaner and affordable. It will also be more agile, flexible, and better able to deploy on operations, including Article 5 contingencies and providing visible assurance. The new structure represents a significant reduction in the number of headquarters and a manpower saving of 35%, representing almost 5,000 posts, or more, if and where possible. It will have a new relationship with our national headquarters, and will also ensure a regional focus. A final decision on a new NATO Command Structure, including its geographic footprint, will be taken no later than June 2011, and we have tasked the Secretary General to prepare proposals to this end.

50. For the NATO Headquarters, we welcomed progress towards a structure and organisation which can best deliver informed timely advice for our consensual decision-making. We welcome the reform of intelligence support, and the Secretary General's initiative on emerging security challenges. His review of personnel requirements will also be key in achieving demonstrable increased effectiveness, efficiency and savings. In the coming months, we look forward to further improvements, including co-location of military and civilian staff wherever possible, on a functional basis, to achieve more coherent advice to shape Alliance decisions.

51. NATO's Agencies are making a valuable contribution to addressing the Alliance's most pressing capability needs. We have approved the consolidation and rationalisation of the functions and programmes of the NATO Agencies into three Agencies, and task the Council to prepare a plan for implementing this reform, with a view to achieving improved governance, demonstrable increased effectiveness, efficiency and savings, focusing on outputs, taking into account the specific needs of multinational programmes, for approval by Defence Ministers in March 2011. The plan should include a quantified target for savings, while preserving capability and service delivery, in particular support to operations. Agreed proposals should then be swiftly implemented. A decision on the recommended major geographic footprints[3] will be presented to Defence Ministers at the March 2011 Ministerial, with the finalised geographic footprints presented for decision by the June 2011 Ministerial.

3. Including location of the Agencies' Headquarters.

52. Resource reform will underpin our broader transformation efforts. As responsible and reliable Allies, we are committed to reforming the way in which NATO's common funded resources are managed. Accordingly, we welcome progress in this area. The implementation of improved financial management, accountability and oversight is an essential element of comprehensive resource management reform. This ensures a clear proactive and continuous process to balance resources and requirements in order to sustain more efficiently the Alliance's integrated structures, support our commitment to operations, and deliver our highest strategic priorities.

53. We task the Secretary General and the Council to take forward the reform process in all necessary areas without delay, including the implementation of: Reviews of the Agencies and NATO Command Structure; comprehensive Resource Management Reform; Headquarters Reform, including the new Headquarters project; and an end-to-end rationalisation review of all structures engaged in NATO capability development. We further task the Council to report back to Defence Ministers by March 2011 and subsequent Defence Ministers' meetings, on progress on this package of measures and possible additional steps necessary to ensure an Alliance capable of delivering on our new Strategic Concept.

54. We express our appreciation for the gracious hospitality extended to us by the Government of Portugal. At our meeting in Lisbon, we have set a clear course for NATO's next decade. NATO will remain an essential source of stability in an uncertain and unpredictable world. With its new Strategic Concept, NATO will be more effective, more engaged, more efficient, and better able to address the 21st century security challenges. We will meet again in the United States in 2012 to review progress.

November 20, 2010

Reading List

At each of my four-star commands I shared with my subordinates a recommended reading list. The idea was to bring together a well-rounded collection of works that covered the gamut of history, policy, international relations, political science, biography, strategy, and—my particular love—fiction. It was not an assignment, but rather a series of well-considered suggestions. The intent of the lists was to give those assigned to my command a resource they could dip into for their professional development and personal enjoyment. The list is not exhaustive, of course; thousands of other books could just as easily have gone on it. I looked on the list as a resource to help people better understand the world in which we were operating.

Below is the list I shared with my U.S. European Command colleagues in 2009 (the descriptions are drawn and excerpted from the publishers, Amazon.com, etc.). I had a similar list focused on Latin American and Caribbean topics when I was at the U.S. Southern Command.

General

Barzini, Luigi. *The Europeans.* Simon & Schuster, 1983.

> In the 1980s this eminent Italian scholar-journalist called for an examination of European culture and history and of the nations that must be the base of a unified Europe with one will, one voice, and a unified foreign policy.

Cohen, Eliot A. *Supreme Command: Soldiers, Statesmen and Leadership in Wartime.* Free Press, 2002.

> The relationship between military leaders and political leaders has always been complicated, especially in times of war. Cohen examines four great democratic war political leaders—Abraham Lincoln, Georges Clemençeau, Winston Churchill, and David Ben-Gurion—and how they directed their military commanders.

Crowley, Roger. *Empires of the Sea: The Siege of Malta, the Battle of Lepanto, and the Contest for the Center of the World.* Random House, 2008.

In the sixteenth century the West was involved in a "clash of civilizations" with Islam under the Ottoman Turks. The key was the control of the eastern Mediterranean.

Gay, Peter. *The Enlightenment: An Interpretation.* 2 vols. W. W. Norton, 1995 (1966–69).

The Enlightenment was a decisive moment in the development of the transatlantic world in the eighteenth century. Gay describes the philosophes' program and views of society. His masterful appraisal provides insights into the Enlightenment's critical method and its humane and libertarian vision. Volume 1 was awarded the National Book Award in 1967.

Howard, Michael. *War in European History.* Oxford University Press, 2007 (1976).

Wars have often determined the character of European society, and society in exchange has determined the character of wars. Howard surveys a thousand years of history and draws a broad outline of developments.

Luttwak, Edward N. *The Grand Strategy of the Roman Empire: From the First Century A.D. to the Third.* Johns Hopkins University Press, 1976.

Luttwak asks, "How did the Romans defend the frontier?" His answer has stirred controversy but also provoked valuable thinking about how imperial powers can meet their strategic challenges.

Mortenson, Greg, and David Oliver Relin. *Three Cups of Tea: One Man's Mission to Fight Terrorism and Build Schools—One School at a Time.* Viking, 2006.

Drawing upon Mortenson's experiences in Pakistan, the authors show development can really help the people who need it most. They argue that the United States must fight Islamic extremism through collaborative efforts to alleviate poverty and improve access to education, especially for girls.

Sheehan, James J. *Where Have All the Soldiers Gone?: The Transformation of Modern Europe*. Houghton Mifflin Harcourt, 2008.

> Sheehan charts perhaps the most radical shift in Europe's history: its transformation from war-torn battlefield to peaceful, prosperous society. For centuries, war was Europe's defining narrative, affecting every aspect of life. After World War II Europe began to reimagine statehood, rejecting ballooning defense budgets in favor of material well-being, social stability, and economic growth. Sheehan reveals how and why this happened, and what it means for America and the rest of the world.

Taylor, A. J. P. *The Struggle for Mastery in Europe, 1848–1918*. Oxford University Press, 1980 (1954).

> The revolutions of 1848 heralded an era of unprecedented nationalism, which culminated in the collapse of the Habsburg, Romanov, and Hohenzollern dynasties by 1918. In this classic study in diplomatic history, Taylor shows how the changing balance of power determined the course of European history.

EUROPE AND AMERICA

Kagan, Robert. *Of Paradise and Power: America and Europe in the New World Order*. Vintage, 2004.

> Europe, Kagan argues, has moved beyond power into a self-contained world of laws, rules, and negotiation, while America operates in a "Hobbesian" world where rules and laws are unreliable and military force is often necessary. Tracing how this state of affairs came into being over the past fifty years and fearlessly exploring its ramifications for the future, Kagan reveals the shape of the new transatlantic relationship.

Reid, T. R. *The United States of Europe: The New Superpower and the End of American Supremacy*. Penguin, 2004.

> An experienced journalist reports on a new global challenger and contrasts it with the United States. Americans, he claims, have largely ignored this revolution.

First World War and Aftermath

MacMillan, Margaret. *Paris 1919: Six Months That Changed the World*. Random House, 2002.

> The Europe of today is largely a product of a diplomatic conference convened at the end of "the war to end all wars." U.S. president Woodrow Wilson, British prime minister David Lloyd George, and French premier Georges Clemençeau met in Paris to shape a lasting peace. Those fateful days saw new political entities—Iraq, Yugoslavia, and Palestine, among them—born out of the ruins of bankrupt empires and the borders of the modern world redrawn.

Neiberg, Michael S. *Fighting the Great War: A Global History*. Harvard University Press, 2005.

> Tracing the war from Verdun to Salonika to Baghdad to German East Africa, Neiberg illuminates the global nature of the conflict. More than four years of mindless slaughter in the trenches on the western front, World War I was the first fought in three dimensions: in the air, at sea, and through mechanized ground warfare. New weapons systems—tanks, bomber aircraft, and long-range artillery—all shaped the battle environment.

Tuchman, Barbara W. *The Guns of August*. Random House, 1962.

> Tuchman recounts the political events leading up to World War I and the first thirty days of that war. The account reaches back to the origins of the Anglo-German rivalry and concludes with the Battle of the Marne, which saved Paris and turned the Germans back. President Kennedy drew upon the book's lessons to avoid an accidental nuclear war during the Cuban Missile Crisis. The book won the Pulitzer Prize.

Second World War and Aftermath

Davies, Norman. *No Simple Victory: World War II in Europe, 1939–1945*. Viking, 2007.

> A leading historian reexamines World War II and its outcome. Davies asks readers to reconsider what they know about World War II and how received wisdom might be wrong. The answers and their implications will surprise even those who consider themselves experts on the subject.

Murray, Williamson, and Allan R. Millett. *A War to Be Won: Fighting the Second World War.* Harvard University Press, 2000.

> Murray and Millett analyze the operations and tactics that defined the conduct of the war in both the European and Pacific theaters. Moving between war room and battlefield, we see how strategies were crafted and revised, and how the multitudes of combat troops struggled to discharge their orders. The authors present incisive portraits of military leaders on all sides of the struggle, demonstrating the ambiguities they faced, the opportunities they took, and those they missed. *A War to Be Won* is the culmination of decades of research by two of America's premier military historians.

Cold War and Aftermath

Bush, George H. W., and Brent Scowcroft. *A World Transformed.* Viking, 1999 (1998).

> Former president Bush and his national security advisor, Brent Scowcroft, tell the story of the extraordinary series of international events that took place during the end of the Cold War. They use behind-the-scenes accounts of critical meetings in the White House and of summit conferences and insights on the importance of personal relationships in diplomacy. Bush and Scowcroft candidly recount how the major players sometimes disagreed over issues and analyze mistakes.

Cooper, Robert. *The Breaking of Nations: Order and Chaos in the Twenty-First Century.* 2nd ed. Atlantic Monthly Press, 2004 (2003).

> Cooper shows that the greatest question facing postmodern states is how to deal with a world in which missiles and terrorists ignore borders and where alliances no longer guarantee security. He argues that when dealing with a hostile outside enemy, civilized countries need to revert to tougher methods from an earlier era: force, preemptive attacks, and deception if we are to safeguard peaceful coexistence throughout the civilized world. He also advocates a doctrine of liberal imperialism in which postmodern states have a right to intervene in the affairs of modern and premodern states if they pose a significant enough threat.

Gaddis, John Lewis. *The Cold War: A New History*. Penguin, 2005.

> The dean of Cold War historians presents his definitive account of the global confrontation that dominated the last half of the twentieth century. Drawing on newly opened archives and the reminiscences of the major players, Gaddis explains not just what happened but why from the months in 1945 when the United States and the Soviet Union went from alliance to antagonism to the barely averted holocaust of the Cuban Missile Crisis to the maneuvers of Nixon and Mao, Reagan and Gorbachev. Brilliant, accessible, almost Shakespearean in its drama, this book stands as a triumphant summation of the era that, more than any other, shaped our own.

Mills, Nicolaus. *Winning the Peace: The Marshall Plan and America's Coming of Age as a Superpower*. John Wiley & Sons, 2008.

> Politicians frequently invoke the Marshall Plan in support of programs aimed at using American wealth to extend the nation's power and influence, solve intractable third-world economic problems, and combat world hunger and disease. Do any of these impassioned advocates understand why the Marshall Plan succeeded where so many subsequent aid plans have not? Mills explores the Marshall Plan in all its dimensions to provide valuable lessons from the past about what America can and cannot do as a superpower.

France

Elting, John R. *Swords around a Throne: Napoleon's Grand Armée*. Da Capo, 1997 (1988).

> Napoleon used his Grand Army to dominate Europe for over a decade. Elting examines every facet of this incredibly complex human machine: its organization, command system, logistics, weapons, tactics, discipline, recreation, mobile hospitals, camp followers, and more.

De Gaulle, Charles. *The War Memoirs*. 3 vols. Trans. from the French. Viking, 1955–60 (1954–59).

> In 1940 Brigadier General de Gaulle first commanded a tank brigade, then left the country to organize the Free French resistance. Four years later he led victorious French troops back into France alongside their British and American allies, insisted on a French

zone in occupied Germany, and served as president of the provisional government.

Horne, Alistair. *A Savage War of Peace: Algeria 1954–1962.* New York Review of Books, 2006 (1977).

The Algerian War brought down six French governments, led to the collapse of the Fourth Republic, returned de Gaulle to power, and came close to provoking a civil war on French soil. Above all, the war was marked by an unholy marriage of revolutionary terror and repressive torture. Today it looks like a full-dress rehearsal for today's struggles in which questions of religion, nationalism, imperialism, and terrorism take on a new and increasingly lethal intensity.

Schama, Simon. *Citizens: A Chronicle of the French Revolution.* Knopf, 1991.

The author devotes his considerable narrative and scholarly gifts to the French Revolution and to the transformation that permanently altered the face of Europe. Schama presents an ebullient country before the revolution, vital and inventive, infatuated with novelty and technology. He argues that the old regime fell not because it was stagnant but because it was moving too fast. Unlike Marxists and new historians, Schama stresses the importance of individual events and people. He detects the emergence of a patriotic culture of citizenship in the decades preceding 1789 and explains how citizenship came to be a public expression of an idealized family.

United Kingdom

Churchill, Winston S. *The Second World War.* 6 vols. Houghton Mifflin, 1948–53.

Churchill's memoir-history is remarkable for its sweep and sense of personal involvement. It is universally acknowledged as a magnificent historical reconstruction and an enduring work of literature, for which he was awarded the Nobel Prize in Literature.

Ferguson, Niall. *Empire: The Rise and Demise of the British World Order and the Lessons for Global Power.* Basic Books, 2004.

Ferguson boldly recasts the British Empire as one of the world's greatest modernizing forces. In this important work of synthesis and revision, he argues that the world we know today is in large measure the product of Britain's Age of Empire. The spread of capitalism,

the communications revolution, the notion of humanitarianism, and the institutions of parliamentary democracy—all these can be traced back to the extraordinary expansion of Britain's economy, population, and culture from the seventeenth century until the mid-twentieth.

Belgium and the Netherlands

Buruma, Ian. *Murder in Amsterdam: Liberal Europe, Islam, and the Limits of Tolerance.* Penguin, 2007.

A revelatory look at what happens when political Islam collides with the secular West. On a cold November day in Amsterdam in 2004, the celebrated and controversial Dutch filmmaker Theo van Gogh was shot and killed by an Islamic extremist for making a movie that insulted the prophet Mohammed. The murder sent shock waves across Europe and around the world. Shortly thereafter, Buruma returned to his native land to investigate the event and its larger meaning as part of the great dilemma of our time.

Schama, Simon. *The Embarrassment of Riches: An Interpretation of Dutch Culture in the Golden Age.* Vintage, 1997 (1987).

Schama explores the mysterious contradictions of the Dutch nation that invented itself from the ground up, attained an unprecedented level of affluence, and lived in constant dread of being corrupted by happiness. Drawing on a vast array of period documents and sumptuously reproduced art, Schama re-creates in precise detail a nation's mental state, how the Dutch celebrated themselves, and how they were slandered by their enemies.

Schama, Simon. *Rembrandt's Eyes.* Knopf, 1999.

This biography charts the troubled painter's rivalry with the worldly, successful Peter Paul Rubens. It is also an in-depth portrait of seventeenth-century Holland, politically and socially.

Germany

Garton Ash, Timothy. *The File: A Personal History.* Vintage, 1998.

Garton Ash visited East Germany frequently as a journalist during the Cold War. After the fall of the Berlin Wall, he returned and

gained access to his Stasi (secret police) file. In this memoir he describes what it was like to rediscover his younger self through the eyes of the Stasi, and then to go on to confront those who actually informed against him to the secret police. Moving from document to remembrance, from the offices of British intelligence to the living rooms of retired Stasi officers, he presents a story that is gripping, disquieting, and morally provocative.

Mazower, Mark. *Hitler's Empire: How the Nazis Ruled Europe.* Penguin, 2008.

Mazower focuses on the ambitions and foibles of the Nazi leaders, who believed that all of Europe could be made to serve German interests. As he shows, almost nothing about the occupation had been planned beforehand. The Nazis improvised as their armies raced through Poland, the Soviet Union, and the Low Countries, and Nazi generals and old-line bureaucrats fought among themselves for power and spoils.

Ozment, Steven. *A Mighty Fortress: A New History of the German People.* Harper-Collins, 2004.

The Romans used the word "German" as early as the first century BC to describe tribes in the eastern Rhine Valley. Nearly two thousand years later, the richness and complexity of German history have faded beneath the long shadow of the country's darkest hour in World War II. Ozment gives us the fullest portrait possible of the German people from antiquity to the present, holding a mirror up to an entire civilization—one that has been alternately Western Europe's most successful and most perilous.

Stern, Fritz. *Five Germanies I Have Known.* Farrar, Straus and Giroux, 2006.

Born in the Weimar Republic, exposed to five years of National Socialism before being forced into exile in 1938 to America, Stern became a world-renowned historian whose work opened new perspectives on the German past as it slid into catastrophe and later regained its rightful place in the community of nations. He brings to life the five Germanies he has experienced: Weimar, the Third Reich, postwar West Germany and East Germany, and the unified country after 1990.

Italy

Ginsborg, Paul. *Italy and Its Discontents: Family, Civil Society, State, 1980–2001*. Palgrave Macmillan, 2003.

> Ginsborg, a professor of contemporary history in Florence, paints a brilliant portrait of contemporary Italian society and politics, a fascinating and definitive account of how Italy has coped or failed to cope as it moves from one century to the next.

Saviano, Robert. *Gomorrah: A Personal Journey into the Violent International Empire of Naples' Organized Crime System*. Trans. from the Italian by Virginia Jewiss. Farrar, Straus and Giroux, 2008 (2006).

> A groundbreaking best seller in Italy, this is a gripping account of the decline of Naples under the rule of the Camorra, an organized crime network with a large international reach and stakes in construction, high fashion, illicit drugs, and toxic-waste disposal. Known by insiders as "the System," the Camorra affects cities and villages along the Neapolitan coast. *Gomorrah* is a bold and important work of investigative writing that holds global significance, one heroic young man's impassioned story of a place under the rule of a murderous organization.

Spain and Portugal

Hooper, John. *The New Spaniards*. 2nd ed. Penguin, 2006 (1986).

> Modern-day Spain is changing at bewildering speed. In less than half a century, a predominantly rural society has been transformed into a mainly urban one. A dictatorship has become a democracy. Hooper's portrayal explores the causes behind these changes, from crime to education, gambling to changing sexual mores, creating the essential guide to understanding twenty-first-century Spain: a land of paradox, progress, and social change.

Menocal, Maria Rosa. *The Ornament of the World: How Muslims, Jews, and Christians Created a Culture of Tolerance in Medieval Spain*. Little, Brown, 2002.

> A rich and thriving culture where literature, science, and religious tolerance flourished for seven hundred years is the subject of this enthralling history of medieval Spain. Living side by side in the

Andalusian kingdoms, the "peoples of the book" produced states-
men, poets, and philosophers who influenced the rest of Europe in
dramatic ways. Menocal explores this lost history whose legacy and
lessons have a powerful resonance in today's world.

Preston, Paul. *The Spanish Civil War: Reaction, Revolution and Revenge.* Rev.
ed. W. W. Norton, 2007.

Preston, the world's foremost historian of Spain, has written the
definitive work on the Spanish Civil War. Tracking the emergence of
Francisco Franco's brutal (and, ultimately, extraordinarily durable)
fascist dictatorship, he assesses the ways in which the war presaged
World War II.

Central and Eastern Europe

Davies, Norman. *Heart of Europe: The Past in Poland's Present.* Rev. ed.
Oxford University Press, 2001.

Davies provides a key to understanding modern Poland in this lucid
and authoritative description of the nation's history. Beginning with
the period since 1945, he travels back in time to highlight the long-
term themes and traditions that have influenced present attitudes.

Havel, Václav. *To the Castle and Back.* Trans. from the Czech by Paul Wilson.
Vintage, 2008 (2006).

A dissident playwright–turned-statesman, Havel led central Europe
out of communism and into the twenty-first century before step-
ping down as Czech president in 2003. With this book, Havel reflects
upon his fourteen years at Prague Castle, combining retrospective
commentary with excerpts from memos written to his staff while
in office.

Miłosz, Czesław. *The Captive Mind.* Trans. from the Polish by Jane Zielonko.
Vintage, 1990 (1953).

Miłosz was a Polish writer and poet who defected in 1951. His
book, published abroad in 1953, points out that it is too easy to lose
our intellectual independence and become slaves to a set of ideas.
It examines the moral and intellectual conflicts faced by men and
women living under totalitarianism of the left or right. He was
awarded the Nobel Prize in Literature in 1980, the same year Polish
workers organized the trade union Solidarity.

The Balkans

Clark, Wesley K. *Waging Modern War: Bosnia, Kosovo, and the Future of Combat.* PublicAffairs, 2001.

> Clark recounts his experience as SACEUR leading NATO's forces to a hard-fought and ultimately successful victory in Kosovo in 1999. The problems posed and overcome in the war in Kosovo—how to fight an air war against unconventional forces in rough terrain and how to coordinate U.S. objectives with those of other nations—are the problems that America faces in today's world.

Glenny, Misha. *The Balkans, 1804–1999: Nationalism, War and the Great Powers.* Penguin, 2000 (1999).

> Glenny provides essential background to recent events in this war-torn area. He offers profound insights into the roots of Balkan violence and vividly explains the origins of modern Serbia, Croatia, Bosnia, Greece, Bulgaria, Romania, and Albania.

Kaplan, Robert D. *Balkan Ghosts: A Journey through History.* St. Martin's, 1993.

> Kaplan completed this enthralling political travelogue just as communism in Eastern Europe was being overthrown and Yugoslavia was disintegrating into violent chaos. From the assassination that set off World War I to the ethnic warfare that swept Bosnia and Croatia in the 1990s, the Balkans have been the crucible of the twentieth century—the place where terrorism and genocide were first practiced as tools of policy.

O'Hanlon, Michael E., and Ivo H. Daalder. *Winning Ugly: NATO's War to Save Kosovo.* Brookings Institution Press, 2000.

> After eleven weeks of bombing in the spring of 1999, the United States and NATO ultimately won the war in Kosovo. Serbian troops were forced to withdraw, enabling an international military and political presence to take charge in the region. But was this war inevitable or was it the product of failed Western diplomacy prior to the conflict? And once it became necessary to use force, did NATO adopt a sound strategy to achieve its aims of stabilizing Kosovo?

RUSSIA, SOVIET UNION, AND CENTRAL ASIA

Applebaum, Ann. *Gulag: A History.* Doubleday, 2003.

> Applebaum undertakes a fully documented history of the Soviet camp system from its origins in the Russian Revolution to its collapse in the era of glasnost. Her book, which was awarded the Pulitzer Prize, is an epic feat of investigation and moral reckoning that places the Gulag where it belongs: at the center of our understanding of the troubled history of the twentieth century.

Bellamy, Chris. *Absolute War: Soviet Russia in the Second World War.* Vintage, 2007.

> The battle on the Eastern Front between 1941 and 1945 was arguably the single most decisive factor of World War II, fixing the course of world history over the next half century. Drawing on sources newly available since the collapse of the Soviet Union and the reunification of Germany, Bellamy presents the first full account of this deadly conflict.

Brown, Archie. *The Rise and Fall of Communism.* Ecco, 2009.

> The inexorable rise of communism was the most momentous political phenomenon of the first half of the twentieth century. Its demise in Europe and its decline elsewhere have produced the most profound political changes of the last few decades. Brown provides a comprehensive history as well as an original and highly readable analysis of an ideology that has shaped the world and still rules more than a fifth of humanity.

Khalid, Adeeb. *Islam after Communism: Religion and Politics in Central Asia.* University of California Press, 2007.

> Khalid combines insights from the study of both Islam and Soviet history in this sophisticated analysis of the ways that Muslim societies in Central Asia were transformed by the lengthy Soviet presence in the region.

King, Charles. *The Ghost of Freedom: A History of the Caucasus.* Oxford University Press, 2008.

> This first general history of the Caucasus, stretching from the beginning of Russian imperial expansion up to the rise of new countries after the Soviet collapse, reveals how tsars, highlanders,

revolutionaries, and adventurers have contributed to the fascinating history of this borderland, providing an indispensable guide to the complicated histories, politics, and cultures of this intriguing frontier.

Kotkin, Stephen. *Armageddon Averted: The Soviet Collapse, 1970–2000.* Oxford University Press, 2008 (2001).

Kotkin shows that the Soviet collapse resulted not from military competition but, ironically, from the dynamism of communist ideology, the long-held dream for "socialism with a human face." He vividly demonstrates the overriding importance of history, individual ambition, geopolitics, and institutions, and deftly draws out contemporary Russia's contradictory predicament.

Lucas, Edward. *The New Cold War: Putin's Russia and the Threat to the West.* Palgrave Macmillan, 2008.

Lucas offers a harrowing portrait of Russia from 1999 to today as well as a sobering political assessment of what the new cold war will mean for the world. A longtime journalist for *The Economist,* Lucas brilliantly anticipates what is in store for the new Russia and what the world should be doing.

Merridale, Catherine. *Ivan's War: Life and Death in the Red Army.* Metropolitan, 2006.

Merridale reveals the singular mixture of courage, patriotism, anger, and fear that made it possible for these underfed, badly led troops to defeat the Nazi Army. Of the 30 million who fought, 8 million died. The men and women of the Red Army, a ragtag mass of soldiers, confronted Europe's most lethal fighting force and by 1945 had defeated it. Merridale tells how the ordinary Russian soldiers died, but also describes how they lived, how they saw the world, and why they fought.

TURKEY AND THE OTTOMAN EMPIRE

Finkel, Caroline. *Osman's Dream: The History of the Ottoman Empire.* Basic Books, 2006.

In this magisterial work, Finkel lucidly recounts the epic story of the Ottoman Empire from its origins in the thirteenth century through its destruction on the battlefields of World War I.

Kinzer, Stephen. *Crescent and Star: Turkey between Two Worlds*. Rev. ed. Farrar, Straus and Giroux, 2008.

In the first edition of this widely praised book, Kinzer claimed that Turkey was the country to watch. It is poised between Europe and Asia, between the glories of its Ottoman past and its hopes for a democratic future, between the dominance of its army and the needs of its civilian citizens, between its secular expectations and its Muslim traditions. In this revised edition, he adds much important new information on the many exciting transformations in Turkey's government and politics, and also shows how recent developments in both American and European policies have affected this unique and perplexing nation.

ISRAEL AND PALESTINE

Morris, Benny. *1948: A History of the First Arab-Israeli War*. Yale University Press, 2008.

Morris, an Israeli historian, has written a history of the foundational war in the Arab-Israeli conflict that is groundbreaking, objective, and deeply revisionist. A riveting account of the military engagements, it also focuses on the war's political dimensions. He probes the motives and aims of the protagonists on the basis of newly opened Israeli and Western documentation. The Arab side—where the archives are still closed—is illuminated with the help of intelligence and diplomatic materials.

Oren, Michael B. *Six Days of War: June 1967 and the Making of the Modern Middle East*. Oxford University Press, 2002.

Oren has written a thorough analysis of the events that combusted to produce a maelstrom in the Middle East. He traces the origins of the Six-Day War to several causes that were in no way resolved by the conflict, and underlines one of its effects—the Israeli conquest of the Sinai Peninsula and the West Bank—that remains a subject of controversy today.

Fiction

Aksyonov, Vasily. *Generations of Winter.* Trans. from the Russian by John Glad and Christopher Morris. Vintage, 1995 (1994).

> Written in the great tradition of epic Russian fiction, this magnificent saga captures one of the most fascinating chapters in modern history—the Soviet Union between 1925 and 1945. Breathtaking in its scope, masterful in its command of historical events and its understanding of timeless human truths, the novel has been likened to a twentieth-century *War and Peace.*

Balzac, Honoré de. *La Comédie humaine.* Trans. from the French. BiblioLife, 2009 (1842).

> Balzac's multivolume collection of interlinked novels and plays depicts French society between the Restoration and the July Monarchy (1815–48). Often compared to Charles Dickens, Balzac paints a realistic, panoramic portrait of all aspects of French society.

Boyd, William. *The New Confessions.* Vintage, 2000 (1987).

> Boyd has created a fictional memoir of a Scotsman who becomes obsessed with making a twentieth-century film version of the most famous eighteenth-century memoir, Jean-Jacques Rousseau's *Confessions.* The novel describes a complicated life lived between Europe and America from World War I through Weimar Germany to Hollywood in the 1940s.

Camus, Albert. *The Stranger.* Trans. from the French by Matthew Ward. Vintage, 1989 (1942).

> In this novel by one of the most influential French authors of the twentieth century, Camus uses the story of an ordinary man unwittingly drawn into a senseless murder on an Algerian beach to explore what he termed "the nakedness of man faced with the absurd." Camus was awarded the Nobel Prize in Literature in 1957.

Dostoyevsky, Fyodor. *The Brothers Karamazov.* Trans. from the Russian by Richard Pevear and Larissa Volokhonsky. Farrar, Straus and Giroux, 2002 (1880).

> One of the greatest Russian novels tells the story of intellectual Ivan, sensual Dmitri, and idealistic Alyosha Karamazov, who collide in

the wake of their despicable father's brutal murder. Dostoyevsky poured in all of his deepest concerns: the origin of evil, the nature of freedom, the craving for meaning, and, most important, whether God exists.

Dostoyevsky, Fyodor. *Crime and Punishment.* Trans. from the Russian by Richard Pevear and Larissa Volokhonsky. Vintage, 1993 (1866).

Dostoyevsky's classic novel focuses on the mental anguish and moral dilemmas of an impoverished St. Petersburg ex-student who kills a hated, unscrupulous pawnbroker, thereby solving his financial problems and at the same time ridding the world of an evil, worthless parasite.

García Lorca, Federico. *The Selected Poems of Federico García Lorca.* Trans. from the Spanish. New Directions, 2005 (1955).

Although the life of Federico García Lorca (1898–1936) was tragically brief, the Spanish poet and dramatist created an enduring body of work that remains internationally important. This selection of fifty-five poems represents some of his finest work. The poems are imbued with Andalusian folklore, rich in metaphor, and spiritually complex.

Goethe, Johann Wolfgang von. *Faust.* Parts I and II. Trans. from the German by David Constantine. Penguin, 2005–9 (1808–32).

Goethe's famous play, one of the greatest works of German literature, turned the legendary German alchemist into one of the central myths of the Western world. Faust is an audacious man who boldly wagers with the devil: unlimited power on earth in exchange for his immortal soul. An unforgettable parable of science and power, religion and morality.

Gogol, Nikolay. *Dead Souls.* Trans. from the Russian by Robert A. Maguire. Penguin, 2004 (1842).

A comic epic of greed and gluttony that is admired not only for its colorful cast of characters and devastating satire, but also for its sense of moral fervor. Although Gogol spends much of the novel exposing the evils of the Russian gentry through absurd and hilarious satire, he also expresses a passionate love for his country.

Grass, Günter. *The Tin Drum*. Trans. from the German by Ralph Manheim. Vintage, 1990 (1959).

> Grass begins his story in Danzig, today's Gdańsk in Poland, but then a contested city on the Polish-German border. The protagonist is a twisted child with a scream that can shatter glass and a drum rather than a shadow. First published in 1959, the novel's depiction of the Nazi era created a furor in Germany. Grass uses savage comedy and magical realism to capture not only the madness of war, but also the black cancer at the heart of humanity that allows such degradations to occur. Grass was awarded the Nobel Prize in Literature in 1999.

Hašek, Jaroslav. *The Good Soldier Švejk and His Fortunes in the World War*. Trans. from the Czech by Cecil Parrott. Penguin, 1990 (1923).

> A rambling satire depicting the adventures of a hapless soldier in the Austro-Hungarian army during World War I. He is dismissed for incompetence, only to be pressed into service by the Russians (where he is captured by his own troops). The author, a mischief maker, bohemian, and drunk, demonstrated his wit in this classic novel of the Czech character and the preposterous nature of war.

Kafka, Franz. *The Castle*. Trans. from the German by J. A. Underwood. Penguin, 2000 (1926).

> In this classic of modern literature, a protagonist known only as K. struggles to gain access to the mysterious authorities of a castle who govern the village where he wants to work as a land surveyor. The novel is about alienation, bureaucracy, and the seemingly endless frustrations of man's attempts to stand against the system.

Lederer, William J., and Eugene Burdick. *The Ugly American*. W. W. Norton, 1999 (1958).

> A searing political exposé, published as a novel, of how America was losing the struggle against communism in the Third World through a lack of cultural sensitivity and language skills. One of the heroes (Colonel "Hillandale") was modeled on the real-life Air Force counterinsurgency expert Lt. Gen. Edward Lansdale.

McEwan, Ian. *The Innocent*. Anchor, 1998 (1990).

> This historical novel is set in Cold War Berlin at the time of Operation Gold in 1955–56, the attempt by the British MI6 and the

American CIA to tunnel into the Soviet sector and infiltrate Soviet communication systems. McEwan also focuses on broader issues of the early Cold War and the opposed political philosophies of communism and capitalism.

Pamuk, Orhan. *Snow*. Trans. from the Turkish by Maureen Freely. Vintage, 2005 (2002).

Turkish author Orhan Pamuk, who received the Nobel Prize in Literature in 2006, tells a story that encapsulates many of the political and cultural tensions of modern Turkey and successfully combines humor, social commentary, mysticism, and a deep sympathy with its characters.

Pasternak, Boris. *Doctor Zhivago*. Translated from the Russian by Max Hayward and Manya Harari. Pantheon, 1997 (1958).

Pasternak had the manuscript of this novel of revolution and civil war smuggled out of the country for publication. The book not only brings the Russian Revolution and the early Soviet era to life, it tells the stories of some of the most memorable characters to be found in all of literature. He was awarded the Nobel Prize in Literature in 1958.

Petterson, Per. *Out Stealing Horses*. Trans. from the Norwegian by Anne Born. Picador, 2008 (2003).

In 1948 when he is fifteen Trond spends a summer in the country with his father. An early morning adventure out stealing horses leaves Trond bruised and puzzled by his friend Jon's sudden breakdown. The tragedy that lies behind this scene becomes the catalyst for the two boys' families to gradually fall apart. As a sixty-seven-year-old man Trond has moved to an isolated part of Norway to live in solitude. But a chance encounter with a character from the fateful summer of 1948 brings the painful memories flooding back and will leave Trond even more convinced of his decision to end his days alone.

Remarque, Erich Maria. *All Quiet on the Western Front*. Trans. from the German by Brian Murdoch. Vintage, 2005 (1929).

Written after World War I by a German combat veteran of the trenches, this book shows the war's horrors and the deep detachment

from German civilian life felt by many men returning from the front. It persuaded many Europeans in the 1930s and later that all wars were futile and immoral.

Saramago, José. *The Cave*. Trans. from the Portuguese by Margaret Jull Costa. Harvest Books, 2003 (2000).

Cipriano Algor, an elderly potter, lives with his daughter Marta and her husband, Marçal, in a small village on the outskirts of The Center, an imposing complex of shops, apartments, and offices to which Cipriano delivers his pots and jugs every month. On one such trip he is told not to make any more deliveries. Unwilling to give up his craft, Cipriano tries his hand at making ceramic dolls. Astonishingly, The Center places an order for hundreds, and Cipriano and Marta set to work—until the order is canceled and the three have to move from the village into The Center. When mysterious sounds of digging emerge from beneath their apartment, Cipriano and Marçal investigate, and what they find transforms the family's life.

Schlink, Bernhard. *The Reader*. Trans. from the German by Carol Brown Janeway. Vintage, 1999 (1995).

This troubling book deals with the difficulties subsequent generations have in comprehending the Holocaust; specifically, whether a sense of its origins and magnitude can be adequately conveyed solely through written and oral media.

Shteyngart, Gary. *Absurdistan*. Random House, 2006.

This novel follows its protagonist and narrator from St. Petersburg (or St. Leninsburg, as he prefers to call it) to a fictional country in the Caucasus called Absurdistan, where a multisided conflict is raging.

Solzhenitsyn, Aleksandr. *One Day in the Life of Ivan Denisovich*. Trans. from the Russian by Ralph Parker. Penguin, 2000 (1963).

From the icy blast of reveille through the sweet release of sleep, Ivan Denisovich endures. A common carpenter, he was one of millions imprisoned for years on baseless charges, sentenced to the waking nightmares of the Soviet work camps in Siberia. Even in the face of degrading hatred, where life is reduced to a bowl of gruel and a rare cigarette, hope and dignity prevailed. This powerful novel, published in 1963 after Stalin's death, is a scathing indictment of

communist tyranny and an eloquent affirmation of the human spirit. Solzhenitsyn was awarded the Nobel Prize in Literature in 1970, but expelled from the Soviet Union in 1974.

Tolstoy, Leo. *War and Peace.* Trans. from the Russian by Richard Pevear and Larissa Volokhonsky. Vintage, 2007 (1869).

In this famous, and perhaps greatest, novel of all time, Tolstoy tells the story of five families struggling for survival during Napoleon's invasion of Russia in 1812–13 and the slow awakening of the Russian nation. Tolstoy, a veteran of fighting in the Caucasus and the Crimea in the 1850s, brilliantly describes individuals and societies at war and seeks to demolish the "great man" theory of history.

INDEX

ABOUT THE AUTHOR

A 1976 distinguished graduate of the U.S. Naval Academy, **ADM. JAMES STAVRIDIS** spent more than thirty-five years on active service in the Navy. He commanded destroyers and a carrier strike group in combat and served for seven years as a four-star admiral, including four years as the first Navy officer chosen as supreme allied commander for global operations at NATO. Admiral Stavridis has written several books and hundreds of articles on global security issues.

The Naval Institute Press is the book-publishing arm of the U.S. Naval Institute, a private, nonprofit, membership society for sea service professionals and others who share an interest in naval and maritime affairs. Established in 1873 at the U.S. Naval Academy in Annapolis, Maryland, where its offices remain today, the Naval Institute has members worldwide.

Members of the Naval Institute support the education programs of the society and receive the influential monthly magazine *Proceedings* or the colorful bimonthly magazine *Naval History* and discounts on fine nautical prints and on ship and aircraft photos. They also have access to the transcripts of the Institute's Oral History Program and get discounted admission to any of the Institute-sponsored seminars offered around the country.

The Naval Institute's book-publishing program, begun in 1898 with basic guides to naval practices, has broadened its scope to include books of more general interest. Now the Naval Institute Press publishes about seventy titles each year, ranging from how-to books on boating and navigation to battle histories, biographies, ship and aircraft guides, and novels. Institute members receive significant discounts on the Press's more than eight hundred books in print.

Full-time students are eligible for special half-price membership rates. Life memberships are also available.

For a free catalog describing Naval Institute Press books currently available, and for further information about joining the U.S. Naval Institute, please write to:

Member Services
U.S. Naval Institute
291 Wood Road
Annapolis, MD 21402-5034
Telephone: (800) 233-8764
Fax: (410) 571-1703
Web address: www.usni.org